THE VOICES
OF SILENCE

BOLLINGEN SERIES XXIV · A

André Malraux
THE VOICES
OF SILENCE

Translated by Stuart Gilbert

BOLLINGEN SERIES XXIV · A
PRINCETON UNIVERSITY PRESS
PRINCETON, NEW JERSEY

Reissued 1978 by Princeton University Press. Originally published 1953 by Doubleday & Co., Inc.; reprinted by arrangement. Original edition based on *The Psychology of Art* by André Malraux (Bollingen Series XXIV, 3 vols., 1949, 1950).

LCC 77-92101
ISBN 0-691-01821-9 (paperback edition)
ISBN 0-691-09941-3 (hardcover edition)

Printed in the United States of America
by Princeton University Press, Princeton, New Jersey

First PRINCETON PAPERBACK printing, 1978

For MADELEINE

CONTENTS

PART ONE

MUSEUM WITHOUT WALLS

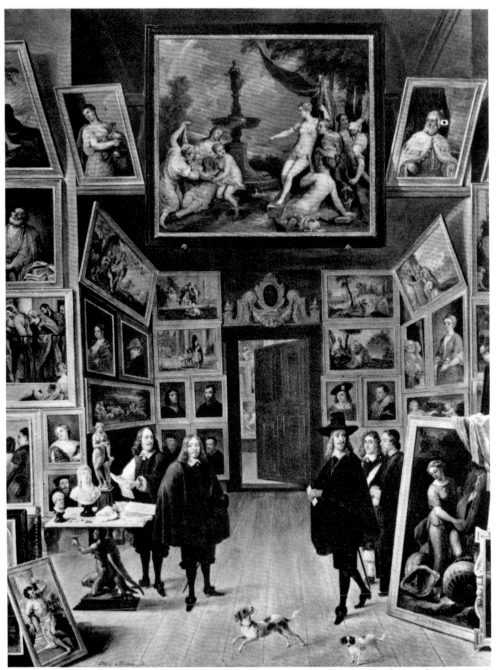

TENIERS: THE GALLERY OF THE ARCHDUKE LEOPOLD AT BRUSSELS (DETAIL)

THE NATIONAL GALLERY AT WASHINGTON

MUSEUM WITHOUT WALLS

I A Romanesque crucifix was not regarded by its contemporaries as a work of sculpture; nor Cimabue's *Madonna* as a picture. Even Pheidias' *Pallas Athene* was not, primarily, a statue.

So vital is the part played by the art museum in our approach to works of art to-day that we find it difficult to realize that no museums exist, none has ever existed, in lands where the civilization of modern Europe is, or was, unknown; and that, even amongst us, they have existed for barely two hundred years. They bulked so large in the nineteenth century and are so much part of our lives to-day that we forget they

have imposed on the spectator a wholly new attitude towards the work of art. For they have tended to estrange the works they bring together from their original functions and to transform even portraits into "pictures". Though Caesar's bust and the equestrian *Charles V* remain for us Caesar and the Emperor Charles, *Count-Duke Olivares* has become pure Velazquez. What do we care who the *Man with the Helmet* or the *Man with the Glove* may have been in real life? For us their names are Rembrandt and Titian. The men who sat for these portraits have lapsed into nonentity. Until the nineteenth century a work of art was essentially a representation of something real or imaginary, which conditioned its existence *qua* work of art. Only in the artist's eyes was painting specifically painting, and often, even for him, it also meant a "poetic" rendering of his subject. The effect of the museum was to suppress the model in almost every portrait (even that of a dream-figure) and to divest works of art of their functions. It did away with the significance of Palladium, of Saint and Saviour; ruled out associations of sanctity, qualities of adornment and possession, of likeness or imagination. Each exhibit is a representation of something, differing from the thing itself, this specific difference being its *raison d'être*.

In the past a Gothic statue was a component part of the Cathedral; similarly a classical picture was tied up with the setting of its period, and not expected to consort with works of different mood and outlook. Rather, it was kept apart from them, so as to be the more appreciated by the spectator. True, there were picture collections and *cabinets d'antiques* in the seventeenth century, but they did not modify that attitude towards art of which Versailles is the symbol. Whereas the modern art-gallery not only isolates the work of art from its context but makes it forgather with rival or even hostile works. It is a confrontation of metamorphoses.

The reason why the art museum made its appearance in Asia so belatedly (and, even then, only under European influence and patronage) is that for an Asiatic, and especially the man of the Far East, artistic contemplation and the picture gallery are incompatible. In China the full enjoyment of works of art necessarily involved ownership, except where religious art was concerned; above all it demanded their isolation. A painting was not exhibited, but unfurled before an art-lover in a fitting state of grace; its function was to deepen and enhance his communion with the universe. The practice of pitting works of art against each other, an intellectual activity, is at the opposite pole from the mood of relaxation which alone makes contemplation possible. To the Asiatic's thinking an art collection (except for educational purposes) is as preposterous as would be a concert in which one listened to a programme of ill-assorted pieces following in unbroken succession.

For over a century our approach to art has been growing more and more intellectualized. The art museum invites criticism of each of the

expressions of the world it brings together; and a query as to what they have in common. To the "delight of the eye" there has been added —owing to the sequence of conflicting styles and seemingly antagonistic schools—an awareness of art's impassioned quest, its age-old struggle to remould the scheme of things. Indeed an art gallery is one of the places which show man at his noblest. But our knowledge covers a wider field than our museums. The visitor to the Louvre knows that he will will not find the great English artists significantly represented there; nor Goya, nor Michelangelo (as painter), nor Piero della Francesca, nor Grünewald—and that he will see but little of Vermeer. Inevitably in a place where the work of art has no longer any function other than that of being a work of art, and at a time when the artistic exploration of the world is in active progress, the assemblage of so many masterpieces—from which, nevertheless, so many are missing—conjures up in the mind's eye *all* the world's masterpieces. How indeed could this mutilated possible fail to evoke the whole gamut of the possible?

Of what is it necessarily deprived? Of all that forms an integral part of a whole (stained glass, frescoes); of all that cannot be moved; of all that is difficult to display (sets of tapestries); of all that the collection is unable to acquire. Even when the greatest zeal has gone to its making, a museum owes much to opportunities that chance has thrown in its way. All Napoleon's victories did not enable him to bring the Sistine to the Louvre, and no art patron, however wealthy, will take to the Metropolitan Museum the Royal Portal of Chartres or the Arezzo frescoes. From the eighteenth to the twentieth century what migrated was the portable; far more pictures by Rembrandt than Giotto frescoes have found their way to sales. Thus the Art Museum, born when the easel-picture was the one living form of art, came to be a pageant not of color but of pictures; not of sculpture but of statues.

The Grand Tour rounded it off in the nineteenth century. Yet in those days a man who had seen the totality of European masterpieces was a very rare exception. Gautier saw Italy (but not Rome) only when he was thirty-nine; Edmond de Goncourt when he was thirty-three; Hugo as a child; Baudelaire and Verlaine, never. The same holds good for Spain; for Holland rather less, as Flanders was relatively well known. The eager crowds that thronged the Salons—composed largely of real connoisseurs—owed their art education to the Louvre. Baudelaire never set eyes on the masterpieces of El Greco, Michelangelo, Masaccio, Piero della Francesca or Grünewald; or of Titian, or of Hals or Goya—the Galerie d'Orléans notwithstanding.

What had he seen? What (until 1900) had been seen by all those writers whose views on art still impress us as revealing and important; whom we take to be speaking of the same works as those we know, and referring to the same *data* as those available to us? They had visited two or three galleries, and seen reproductions (photographs, prints or

copies) of a handful of the masterpieces of European art; most of their readers had seen even less. In the art knowledge of those days there was a pale of ambiguity, a sort of no man's land—due to the fact that the comparison of a picture in the Louvre with another in Madrid was that of a present picture with a memory. Visual memory is far from being infallible, and often weeks had intervened between the inspections of the two canvases. From the seventeenth to the nineteenth century, pictures, interpreted by engraving, had *become* engravings; they had kept their drawing but lost their colors, which were replaced by "interpretation," their expression in black-and-white; also, while losing their dimensions, they acquired margins. The nineteenth-century photograph was merely a more faithful print, and the art-lover of the time 'knew' pictures in the same manner as we now 'know' stained-glass windows.

Nowadays an art student can examine color reproductions of most of the world's great paintings, can make acquaintance with a host of second-rank pictures, archaic arts, Indian, Chinese and Pre-Columbian sculpture of the best periods, Romanesque frescoes, Negro and "folk" art, a fair quantity of Byzantine art. How many statues could be seen in reproduction in 1850? Whereas the modern art-book has been pre-eminently successful with sculpture (which lends itself better than pictures to reproduction in black-and-white). Hitherto the connoisseur duly visited the Louvre and some subsidiary galleries, and memorized what he saw, as best he could. We, however, have far more great works available to refresh our memories than those which even the greatest of museums could bring together. For a "Museum without Walls" is coming into being, and (now that the plastic arts have invented their own printing-press) it will carry infinitely farther that revelation of the world of art, limited perforce, which the "real" museums offer us within their walls.

II Photography, which started in a humble way as a means of making known acknowledged masterpieces to those who could not buy engravings, seemed destined merely to perpetuate established values. But actually an ever greater range of works is being reproduced, in ever greater numbers, while the technical conditions of reproduction are influencing the choice of the works selected. Also, their diffusion is furthered by an ever subtler and more comprehensive outlook, whose effect is often to substitute for the obvious masterpiece the significant work, and for the mere pleasure of the eye the surer one of knowledge. An earlier generation thrived on Michelangelo; now we are given photographs of lesser masters, likewise of folk paintings and arts hitherto ignored: in fact everything that comes into line with what we call a style is now being photographed.

For while photography is bringing a profusion of masterpieces to the artists, these latter have been revising their notion of what it is that makes the masterpiece.

From the sixteenth to the nineteenth century the masterpiece was a work that existed "in itself," an absolute. There was an accepted canon preconizing a mythical yet fairly well-defined beauty, based on what was thought to be the legacy of Greece. The work of art constantly aspired towards an ideal portrayal; thus, for Raphael, a masterpiece was a work on which the imagination could not possibly improve. There was little question of comparing such a work with others by the same artist. Nor was it given a place in Time; its place was determined by its success in approximating to the ideal work it adumbrated.

True, this aesthetic was steadily losing ground between the Roman sixteenth and the European nineteenth centuries. Nevertheless, until the Romantic movement, it was assumed that the great work of art was something unique, the product of unconditioned genius. History and antecedents counted for nothing; the test was its *success*. This notion, narrow if profound, this Arcadian setting in which man, sole arbiter of history and his sensibility, repudiated (all the more effectively for his unawareness of it) the struggle of each successive age to work out its own perfection—this notion lost its cogency once men's sensibility became attuned to different types of art, whose affinities they glimpsed, though without being able to reconcile them with each other.

No doubt the picture-dealers' shops, which figure in so many canvases up to *L'Enseigne de Gersaint*, had (until, in 1750, the "secondary" paintings of the royal collection were exhibited) enabled artists to see different kinds of art aligned against each other; but usually minor works, subservient to an aesthetic as yet unchallenged. In 1710 Louis XIV owned 1299 French and Italian pictures and 171 of other schools. With the exception of Rembrandt—who impressed Diderot for such curious reasons ("If I saw in the street a man who had stepped out of a

Rembrandt canvas, I'd want to follow him, admiringly; if I saw one out of a Raphael, I suspect I'd need to have my elbow jogged before I even noticed him!")—and especially of Rubens, at his most Italianate, the eighteenth century regarded all but the Italians as minor painters. Who indeed in 1750 would have dared to set up Jan van Eyck against Guido Reni? Italian painting and the sculpture of classical antiquity were more than mere painting or statuary; they were the peakpoints of a culture which still reigned supreme in the imagination. Neither Watteau nor Fragonard wanted to paint like Raphael, nor did Chardin; but they did not think themselves his equals. There had been a Golden Age, now defunct, of art.

Even when, at last, in Napoleon's Louvre the schools joined vigorous issue, the old tradition held its ground. What was not Italian was evaluated, as a matter of course, in terms of the Italian hierarchy. To speak Italian was a prime condition of admittance to the Academy of the Immortals (even if the artist spoke it with Rubens' accent). In the eyes of critics of the period a masterpiece was a canvas that held its head up in the august company of masterpieces. But this august company was much like the Salon Carré; Velazquez and Rubens were tolerated in it thanks to their compromise with Italianism—Rembrandt, a magnificent, disturbing figure, being relegated to the outskirts,—a compromise that was to reveal itself before the death of Delacroix as nothing but academicism. Thus a rivalry of the canvases between themselves replaced their former rivalry with a mythical perfection. But in this Debate with the Illustrious Dead, in which every new masterpiece was called on to state its claim to rank beside a privileged élite, the test of merit (even when Italian supremacy was on the wane) was still the common measure of the qualities those time-honored works possessed. Its scope was narrower than at first sight it seemed to be: that of the three-dimensional oil paintings of the sixteenth and seventeenth centuries. A debate in which Delacroix had his say with difficulty; Manet not at all.

Photographic reproduction was to aid in changing the tenor of this debate; by suggesting, then imposing, a new hierarchy.

The question whether Rubens was admired because he proved himself Titian's equal in some of his less Flemish canvases loses much of its point when we examine an album containing Rubens' entire output—a complete world in itself. In it *The Arrival of Marie de Medici* invites comparison only with Rubens' other works.* And in this context the portrait of his daughter (in the Liechtenstein Gallery), and certain sketches such as the *Atalanta, The Sunken Road* and the *Philopoemen*

* Exhibitions of an artist's work ("one-man shows") produce the same effect. But they are of limited duration. Also, they are due to the same evolution of our artistic sensibility. The great romantic artists used to exhibit at the Salon—to which our great contemporaries send their canvases only as a friendly gesture.

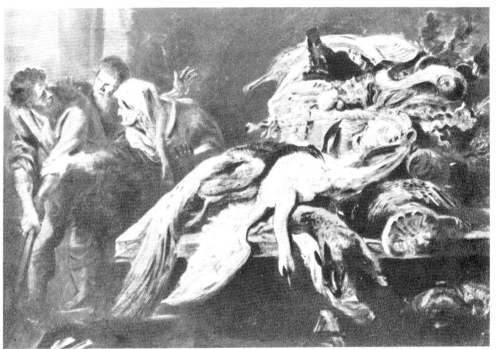

RUBENS: THE RETURN OF PHILOPOEMEN

acquire a new significance. A true anthology is coming into being.
For we now know that an artist's supreme work is not the one in best
accord with any tradition—nor even his most complete and "finished"
work—but his most personal work, the one from which he has stripped
all that is not his very own, and in which his style reaches its climax.
In short, the most significant work by the inventor of a style.

Just as, formerly, the masterpiece that made good in the conflict
with the myth it conjured up of its own perfection, and, thereafter, the
masterpiece acclaimed as such in the company of the Immortals, was
joined and sometimes replaced by the most *telling* work of the artist in
question, so now another class of work is coming to the fore: the most
significant or accomplished work of every *style*. By presenting some
two hundred works of sculpture, an album of Polynesian Art brings out
the quality of some; the mere act of grouping together many works of
the same style creates its masterpieces and forces us to grasp its purport.

The revision of values that began in the nineteenth century and
the end of all *a priori* theories of aesthetics did away with the prejudice
against so-called clumsiness. That disdain for Gothic art which prevailed
in the seventeenth century was due, not to any authentic conflict of
values, but to the fact that the Gothic statue was regarded at that time,

not as what it really is, but as a botched attempt to be something quite different. Starting from the false premise that the Gothic sculptor aimed at making a classical statue, critics of those days concluded that, if he failed to do so, it was because he could not. This theory that the imitation of classical models was beyond the capacities of the artists of that age, or else that the models themselves were lost—though actually copies of the antique were being made in the eleventh century in Southern France, and though it was enough for Frederick II of Hohenstaufen to give the word, for Roman art to reappear, and though Italian artists walked past Trajan's Column daily—this fantastic theory was generally accepted only because idealized naturalism had in fact necessitated a series of discoveries in the craft of exact portrayal, and because nobody could believe that Gothic artists would not have tried to make the same discoveries. That exclamation of Louis XIV, "Away with those monstrosities!" applied equally to Notre-Dame. It was the same attitude which at the beginning of the nineteenth century caused the canvas of *L'Enseigne de Gersaint* to be cut in two, and enabled the Goncourts to pick up their Fragonards for a song, in junk-shops. A "dead" style is one that is defined solely by what it is *not;* a style that has come to be only negatively felt.

Isolated works of any imperfectly known style—unless this style comes into sudden prominence as a precursor, as Negro art was of Picasso—almost always provoke these negative reactions. Thus Negro art, for instance, had been regarded for many centuries as the work of sculptors who hardly knew the first thing of their craft. And—like the fetishes—the Greek archaics, the sculpture of the Nile and the Euphrates Valley began by entering our culture timidly and piecemeal. Single works and groups of work alike, even cathedral statuary, had to insinuate themselves almost furtively into the artistic awareness of those who now "discovered" them, and win a place in a company of masterpieces, more homogeneous and exclusive, though vaster, than the *corpus* of literary masterpieces. Théophile Gautier disdained Racine on the strength of Victor Hugo, and perhaps Poussin on the strength of Delacroix; but not Michelangelo, or even Raphael. A great Egyptian work of art was admired in proportion to its congruity, subtle as this might be, with the Mediterranean tradition; we, on the contrary, admire it the more, the further it diverges from that tradition. Traditional works were compared, classified and reproduced, while the others were relegated to an obscurity from which but a few emerged, as fortunate exceptions, or as examples of an alleged decadence. That is why the connoisseur of the period was so ready with this charge of "decadence" and to define it primarily in terms of what it lacked. Thus a portfolio of Baroque art is a rehabilitation, since it rescues the Baroque artists from comparison with the classical; and we realize that theirs was an independent art, not a debased, voluptuous classicism.

Moreover, much as Gothic seems to have been led towards classical art by a series of gradations, a similar process, in reverse, led to the rediscovery of Gothic art. This rediscovery, associated with the rise of Romanticism at the close of the eighteenth century, began neither with Chartres nor with the high austerity of Romanesque, but with Notre-Dame of Paris. Every "resurrection" in art has a way of beginning, so to speak, with the feet. But the Museum without Walls, thanks to the mass of works its sets before us, frees us from the necessity of this tentative approach to the past; by revealing a style in its entirety—just as it displays an artist's work in its entirety—it forces both to become *positive*, actively significant. To the question "What is a masterpiece?" neither museums nor reproductions give any definitive answer, but they raise the question clearly; and, provisionally, they define the masterpiece not so much by comparison with its rivals as with reference to the "family" to which it belongs. Also, since reproduction, though not the cause of our intellectualization of art, is its chief instrument, the devices of modern photography (and some chance factors) tend to press this intellectualization still farther.

Thus the angle from which a work of sculpture is photographed, the focussing and, above all, skilfully adjusted lighting may strongly accentuate something the sculptor merely hinted at. Then, again, photography imparts a family likeness to objects that have actually but slight affinity. With the result that such different objects as a miniature, a piece of tapestry, a statue and a medieval stained-glass window, when reproduced on the same page, may seem members of the same family. They have lost their colors, texture and relative dimensions (the statue has also lost something of its volume); each, in short, has practically lost what was specific to it—but their common style is by so much the gainer.

There is another, more insidious, effect of reproduction. In an album or art book the illustrations tend to be of much the same size. Thus works of art lose their relative proportions; a miniature bulks as large as a full-size picture, a tapestry or a stained-glass window. The art of the Steppes was a highly specialized art; yet, if a bronze or

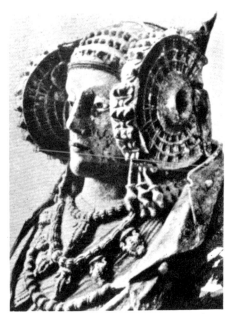

FIRST PHOTO OF THE LADY OF ELCHÉ

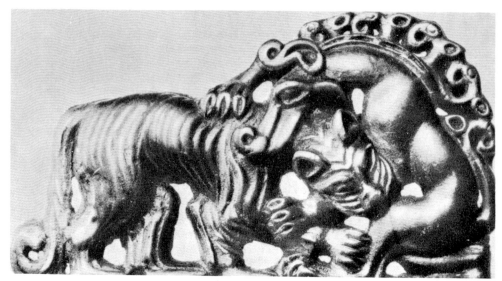

ART OF THE STEPPES (FIRST CENTURY): ANIMALS FIGHTING

gold plaque from the Steppes be shown above a Romanesque bas-relief, in the same format, it becomes a bas-relief. In this way reproduction frees a style from the limitations which made it appear to be a minor art.

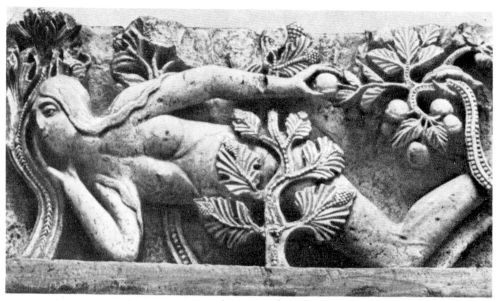

ROMANESQUE ART (EARLY 12th CENTURY): EVE

IBERO-PHOENICIAN ART (3rd CENTURY B.C.): LAST PHOTO OF THE LADY OF ELCHÉ

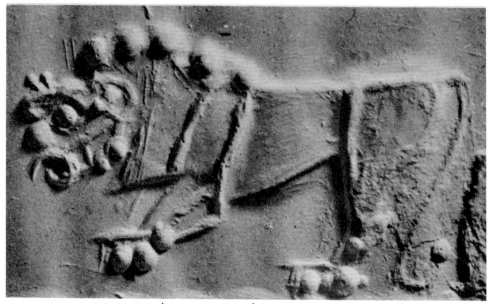

ART OF SUSA (BEFORE 3000 B.C.): CYLINDER SEAL (ENLARGED)

Indeed reproduction (like the art of fiction, which subdues reality to the imagination) has created what might be called "fictitious" arts, by systematically falsifying the scale of objects; by presenting oriental seals the same size as the decorative reliefs on pillars, and amulets like statues. As a result, the imperfect finish of the smaller work, due to its limited dimensions, produces in enlargement the effect of a bold style in the modern idiom. Romanesque goldsmiths' work links up with the sculpture of the period, and reveals its true significance in sequences of photographs in which reliquaries and statues are given equal dimensions. True, these photographs figure solely in specialist reviews. But these reviews are made by artists, for fellow artists—and do not fail to take effect. Sometimes the reproductions of minor works suggest to us great styles which have passed away—or which "might have been." The number of great works previous to the Christian era which we have retrieved is trifling compared with the number of those which are lost for ever. Sometimes, too, drawings (those of the Utrecht Psalter) or pottery (that of Byzantium) show us styles—or "idioms"—of which few other traces have survived; and we can detect in their succession, by way of modulations hitherto unobserved, the persisting life of certain forms, emerging ever and again like spectres from the past.

In the realm of what I have called fictitious arts, the fragment is king. Does not the *Niké of Samothrace* suggest a Greek style divergent from the true Greek style? In Khmer statuary there were many admirable

heads on conventional bodies; those heads, removed from the bodies, are now the pride of the Guimet Museum. Similarly the body of the *St. John the Baptist* in the Rheims porch is far from bearing out the genius we find in the head, when isolated. Thus by the angle at which it is displayed, and with appropriate lighting, a fragment or detail can tell out significantly, and become, in reproduction, a not unworthy denizen of our Museum without Walls. To this fact we owe some excellent art-albums of primitive landscapes culled from miniatures and pictures; Greek vase paintings displayed like frescoes; and

BYZANTINE FOLK ART: CERAMIC

FUNERARY LECYTHUS (5th CENTURY B.C.)

the lavish use in modern mono-
graphs of the expressive detail.
Thus, too, we now can see Gothic
figures in isolation from the teeming
profusion of the cathedrals, and
Indian art released from the lux-
uriance of its temples and frescoes;
for the Elephanta caves, as a
whole, are very different from their
Mahesamurti, and those of Ajanta
from the "Fair Bodhisattva." In
isolating the fragment the art book
sometimes brings about a meta-
morphosis (by enlargement); some-
times it reveals new beauties (as
when the landscape in a Limbourg
miniature is isolated, so as to be
compared with others or to present
it as a new, independent work of
art); or, again, it may throw light
on some moot point. Thus, by

SEE FOLLOWING PAGE

means of the fragment, the photo-
grapher instinctively restores to
certain works their due place in the
company of the Elect—much as in
the past certain pictures won theirs,
thanks to their "Italianism."

Then, again, certain coins, cer-
tain objects, even certain recognized
works of art have undergone a
curious change and become subjects
for admirable photographs. In
much the same way as many ancient
works owe the strong effect they
make on us to an element of mutil-
ation in what was patently intend-
ed to be a perfect whole, so, when
photographed with a special light-
ing, lay-out and stress on certain
details, ancient works of sculpture
often acquire a quite startling, if
spurious, modernism.

SEE PAGE 29

SUMERIAN ART (3rd MILLENNIUM B. C.): FERTILITY?

SUMERIAN ART (EARLY 3rd MILLENNIUM B.C.): DEMON

Classical aesthetic proceeded from the part to the whole; ours, often proceeding from the whole to the fragment, finds a precious ally in photographic reproduction.

Moreover, color reproduction is coming into its own. It is still far from being perfect, and can never do justice to an original of large dimensions. Still, there has been amazing progress in the last twenty years. As yet, the color reproduction does not compete with the masterpiece, it merely evokes it, and rather enlarges our knowledge than satisfies our contemplation—performing, in fact, much the same function as engravings did in the past. For the last hundred years (if we except the activities of specialists) art history has been the history of that which can be photographed. No man of culture can have failed to be impressed by the unbroken continuity, the inevitability, of the course of Western sculpture, from Romanesque to Gothic, and from Gothic to Baroque. But how few cultured persons are aware of the parallel evolution of the stained-glass window, or of the drastic transformations that took place in Byzantine painting! The reason why the impression that Byzantine art was repetitive and static prevailed so long is, simply, that its drawing was bound up with a convention— whereas its life-force, genius and discoveries were recorded in its color. Formerly, years of research, ranging from Greek to Syrian monasteries, from museums to private collections, from picture sales to antique shops (and therewith a prodigious memory for color) were needed for a knowledge of Byzantine painting. Thus, until recently, its history was the history of its drawing—and its drawing, we were told, "had no history"! But drawing is going to lose, for the art-historian, the supremacy, threatened at Venice, which was regained with the advent of black-and-white photography. How could photography have enabled us to glimpse all modern painting behind Hals's *Governors of the Almshouse* and Goya's *Burial of the Sardine?* Indeed a reproduction used to be thought the more effective because the color was subordinated to the drawing. The problems peculiar to color are at last being frankly faced, however, and Chardin will no longer combat Michelangelo, disarmed. Thus the whole world's painting is about to permeate our culture, as sculpture has been doing for a century. And the imposing array of Romanesque statues is now confronted by that of frescoes unknown to all but art-historians before the 1914 war, and likewise by the miniature, tapestry and, above all, the stained-glass window.

As a result of photographic juggling with the dimensions of works of art, the miniature (like small-scale carving) is by way of acquiring a new significance. Reproduced "natural size" on the page, it occupies about the same space as a "reduced" picture; its minutely detailed style jars on us no more than does the faint grimace imposed on the latter by its diminution. However the miniature must still be regarded as a minor *genre*, owing to its being an applied art, to its dependence on

conventions and its addiction to the so-called "celestial palette"; we need only compare a first-rank Italian miniature with Fra Angelico's predellas to perceive the gulf between a convention and an authentic harmony. (Still, we must not undervalue that convention; the miniature has no mean kingdom of its own, comprising as it does the West, Persia, India, Tibet and—in a less degree—Byzantium and the Far East.) And what of the Irish and Aquitanian illuminators, and the Carolingian miniaturists from the Rhine to the Ebro? And those miniatures in which a master has *invented* a personal style, and not merely transposed pictures or imitated previous miniatures? Surely the master of *The Love-stricken Heart* can claim a place in our Museum without

THE LOVE-STRICKEN HEART (LATE 15th CENTURY): THE KING'S HEART

TRÈS RICHES HEURES DU DUC DE BERRY (CA. 1410): CHATEAU DE LUSIGNAN (DETAIL)

Walls. The *Très Riches Heures du Duc de Berry* do not become frescoes but fall in line with Flemish paintings, the Broederlam triptych, yet without resembling them. Moreover, the subjects used by the Limbourgs and even Fouquet for the miniature were such as they never would have dreamt of using for a picture. (But their style is none the less significant for that.) If we want to know what landscape meant to a Northern artist in 1420, we must turn to Pol de Limbourg. Like enlarged coins, certain works of this kind, when isolated by reproduction, suggest sometimes a great art, sometimes a school that died untimely (a thought which gives food for the imagination). In certain works by the Master of the *Heures de Rohan* we glimpse a precursor of Grünewald; the *Ebo Gospel Book*, given back its colors, shows less genius perhaps but no less originality than the Tavant frescoes.

HEURES DE ROHAN (EARLY 15th CENTURY): DEPOSITION FROM THE CROSS (DETAIL)

EBO GOSPEL-BOOK (9th CENTURY): ST. MARK

TAVANT (11th or 12th century): lust

APOCALYPSE OF ANGERS (LATE 14th CENTURY): THE SEVEN SOULS AND THE ALTAR

Tapestry which, owing to its decorative functions, was so long excluded from objective contemplation and whose color shared with stained glass the right of diverging from the natural colors of its subjects, is becoming, now that reproduction obliterates its texture, a sort of modern art. Thus we respond to its "script" (more obvious than that of pictures), to the scrollwork of the Angers *Apocalypse*, to the quasi-xylographic flutings of fifteenth-century figures, to the *Lady with the Unicorn* and its faint damascenings. For any refusal to indulge in illusionist realism appeals to the modern eye. The oldest tapestries, with their contrasts of night-blues and dull reds, with their irrational yet convincing colors, link up with the great Gothic plain-song. Minor art though it be, tapestry can claim a place in our Museum without Walls, where the Angers *Apocalypse* figures between Irish illumination and the Saint-Savin frescoes.

But the stained-glass window is to play a far more important part in our resuscitations.

Stained-glass has been considered an ornamental art, but here we must walk warily; the frontiers of the decorative are highly imprecise when we are dealing with an early form of art. Obviously an eighteenth-century casket is decorative; but how should we regard a reliquary? Or, for that matter, a Luristan bronze, a Scythian plaque, a Coptic fabric, or certain Chinese animal-figures, not to mention tapestry? A figure on a reliquary is subordinated to the object it adorns; but obviously less than a pier-statue is subordinated to the edifice incorporating it (and the influence of goldsmiths' work on Romanesque stone-carving is now generally recognized). The limits of the decorative can be precisely defined only in an age of humanistic art. And it was by humanistic standards that the stained-glass window came to be defined in terms of what it was *not*—in much the same way as the

STAINED GLASS WINDOW AT BOURGES (13th CENTURY): ST. MATTHEW

seventeenth century judged Gothic sculpture. True, the window is conditioned by a structural lay-out, sometimes of a decorative nature (though even in this respect we must avoid any hasty decision), but its color is far more than ornamental or mere filling-in, however brilliant; it has a message of its own and speaks a color language not without analogies with the lyricism of the art of Grünewald and Van Gogh. In fact the reason why the birth of religious painting in Northern Europe came so late is that, for the colorist, stained glass was its most powerful medium of expression. And our color-obsessed geniuses of the close of the last century seem often to invoke the medium of stained glass, to which such canvases as *Le Père Tanguy* and *The Sunflowers* come much nearer than to Titian and Velazquez. We are misled by the fact that the term "painting" is linked up with pictures; the supreme paintings of the West, before Giotto, were neither frescoes nor miniatures—they are in the Great Window of Chartres Cathedral.

No doubt stained glass is decorative *as well;* as indeed is all Romanesque art, even the statuary. Indeed the statue would often be quite submerged by the huge ornamental masses crowding in on it, were it not that the human face sponsors its individuality. For, though the drapery of the pillar-statue is integrated with the portal, not so the head which crowns it. And the twelfth, even the thirteenth-century window stands out as emphatically as does the face of the Romanesque pillar-statue. Aided by photography, each of us isolates instinctively in his mind's eye the statues of the Royal Portal of Chartres, but stained glass has not yet been rescued from the medley of strap-work in which Our Lady of the Great Window is engulfed. The service done the statue by the face (which liberates it from its surroundings) is rendered to the stained-glass window by its direct appeal to our emotions—quite as specific as that of music: a form of expression whose specificity no artist can fail to recognize if he contrasts it with other plastic expressions of Romanesque, such as the fresco or mosaic. We need but compare the great Romanesque windows with the frescoes of Le Puy, and with the mosaics that preceded them, to realize that these windows are not a decoration but exist—supremely —in their own right.

True, the stained-glass window is eminently "monumental"; no fresco harmonizes so well with the edifice containing it as does the window with the Gothic edifice and, when we have it at its best, no other art achieves such splendor. When the great windows were stored away during the recent war and white glass took their place, we realized how much more than mere ornamentation they had been. Though indifferent to the spatial dimensions of what it portrays, stained glass is not indifferent to the changes of the light which, when our churches were thronged with worshipers at successive hours, endowed it with a vitality unknown to any other form of art. It replaced the mosaic set in a gold ground, as the free light of day replaced the furtive glimmer

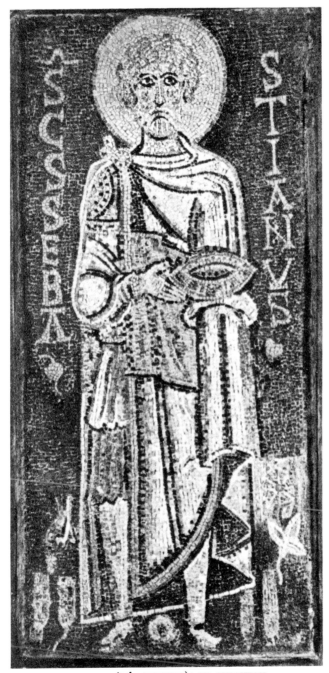

MOSAIC (7th CENTURY): ST. SEBASTIAN

FRESCO AT MONTOIRE (11th-12th CENTURY)

of the crypts—throughout the centuries of Christendom triumphant that silent orchestra of the Chartres windows has been conducted by the baton which the Angel holds above the sundial.

The inspiration of the stained-glass window ceases when the smile begins. Once humanism comes in, drawing becomes paramount, and literal imitation of objects and living beings a criterion of value. But the Romanesque world, untouched by humanism, had other modes of expression. There is much of the pier-statue in the *Tree of Jesse* at Chartres, and we find the jagged intensity of the great stained-glass windows in the Autun tympanum. Those obscure forces which took their rise in the eternal sameness of the desert and had refined the plurality of Rome into the abstractions of Byzantium were calling for their lyrical expression in the West. Stained glass is a mosaic given its place in the sun; the stiff Byzantine trunk, nourished by barbarian migrations, breaks into blossom in the *Tree of Jesse* window as brilliantly as one of Bellini's voices finds its orchestration in the splendor of the Tintorettos of San Rocco. Linked to sunlight as the fresco to the wall, early stained glass is not a mere fortuitous adornment of a world where man has not yet come into his own and impinges on the microcosm of primitive Christendom only in the guise of the Prophets or the cowering hordes of Judgment Day; it is, rather, the supreme expression of that world. As are the tympanums in which Christ is still submerged in God the Father, and the Creation and Last Judgment take precedence of the Gospels; as at Moissac, where the human element was allowed a place under the Christ in Majesty only in the guise of the Elders of the Apocalypse. But soon Christ was to become the Son of Man, and the blood of his pierced hands, quenching the fiery abstractions of the Old Dispensation, was to quicken a harvest of scenes of human toil and rustic craftsmanship, in which the cobblers and vinedressers of the Chartres windows replaced the lost souls of Autun and the Elders of Moissac, while at Amiens blacksmiths beat swords into ploughshares. But soon the first fine glow of lyrical emotion began to dwindle; from Senlis to Amiens, from Amiens to Rheims, and from Rheims to Umbria, Man waxed in stature until he broke through these stained-glass windows which were not yet to his measure and had ceased to be to God's.

Stained glass has an immediate appeal to us, by reason of its emotivity, so much akin to ours, and its impassioned crystallization. But the blaze of color, kindled by the Prophets, which consumed all human things till only that queerly fascinating Byzantine skeleton remained, took another course in the world of Islam. The art of Byzantium, which owed its being to the insistent pressure of an oriental God wearing down indefatigably the multitude of his creatures, after becoming petrified in the mosaic, branched out in two directions: towards Chartres and towards Samarkand. In the West, the window; in the East, the carpet.

Islam's two poles are the abstract and the fantastic: the mosque and

The Arabian Nights. The design of the carpet is wholly abstract; not so its color. Perhaps we shall soon discover that the sole reason why we call this art "decorative" is that for us it has no history, no hierarchy, and no meaning. Color reproduction may well lead us to review our ideas on this subject and rescue the masterwork from the North African bazaar as Negro sculpture has been rescued from the curio-shop; in other words, liberate Islam from the odium of "backwardness" and assign its due place (a minor one, not because the carpet never portrays Man, but because it does not *express* him) to this last manifestation of the undying East.

JAPAN, NARA (7th OR 8th CENTURY): BODHISATTVA

WEI DYNASTY, CHINA (CA. 5th CENTURY). YUN KANG: BUDDHIST FIGURE

And then, after the sculpture, banners and frescoes of ancient Asia, the great schools of Far-Eastern painting will, no doubt, come to the fore. The relatively faithful reproductions now available of Chinese wash-drawings have, quite unjustly, created a bias against those of Chinese painting. These works are scattered; no real art museum exists in China and many collectors and custodians of temples will not allow the scrolls in their keeping to be photographed. Also, the apparatus of color reproduction in China is rather primitive and the masterpieces of Chinese painting could be reproduced in color, with relative fidelity, only by direct photography or by the technique perfected by the Japanese. Thus most of the works known to us are in Japanese collections or in art galleries of the West. We need only picture what our knowledge of European art would be were it restricted to the canvases in America—and our painting is far better represented in America than is Chinese painting in the entire West.

Little known though it is, Sung painting is beginning to whet the curiosity of our painters. Its seeming humanism answers none of our contemporary problems but, once freed from the *fin-de-siècle* "Japanism" which still travesties it for us, it would reveal an attitude of the painter to his craft that the West has never known, and a new function assigned to painting—which was regarded by these artists as a means of communion between man and the universe. Above all it would bring to us a conception of Space utterly unlike ours; in this respect, while its calligraphy could teach us nothing, its spirit might be a revelation. We shall see, presently, how far removed this spirit is from any Christian humanism. But when, thanks to modern methods of reproduction and a growing demand, it becomes possible to familiarize the public with this painting, it will also point the way to a better understanding of Far-Eastern art, from Buddhist figures to Japanese twelfth-century portraits. Amongst the paintings having no affinities with our culture only frescoes and miniatures have, so far, been reproduced. Shown a faithful reproduction of the *Portrait of Yoritomo*, what artist could fail to recognise in it one of the world's supreme works of art?

Reproduction has disclosed the whole world's sculpture. It has multiplied accepted masterpieces, promoted other works to their due rank and launched some minor styles—in some cases, one might say, invented them. It is introducing the language of color into art history; in our Museum without Walls picture, fresco, miniature and stained-glass window seem of one and the same family. For all alike—miniatures, frescoes, stained glass, tapestries, Scythian plaques, pictures, Greek vase paintings, "details" and even statuary—have become "colorplates." In the process they have lost their properties as *objects;* but, by the same token, they have gained something: the utmost significance as to *style* that they can possibly acquire. It is hard for us clearly to realize the gulf between the performance of an Aeschylean tragedy, with the instant

CHINA (EARLY 13th CENTURY). MA YUAN: A POET LOOKING AT THE MOON

Persian threat and Salamis looming across the Bay, and the effect we get from reading it; yet, dimly albeit, we feel the difference. All that remains of Aeschylus is his genius. It is the same with figures that in reproduction lose both their original significance as objects and their function (religious or other); we see them only as works of art and they bring home to us only their makers' talent. We might almost call them not "works" but "moments" of art. Yet diverse as they are, all these objects (with the exception of those few whose outstanding genius sets them outside the historic stream) speak for the same endeavor; it is as though an unseen presence, the spirit of art, were urging all on the same quest, from miniature to picture, from fresco to stained-glass window, and then, at certain moments, it abruptly indicated a new line of advance, parallel or abruptly divergent. Thus it is that, thanks to the rather specious unity imposed by photographic reproduction on a multiplicity of objects, ranging from the statue to the bas-relief, from bas-reliefs to seal-impressions, and from these to the plaques of the nomads, a "Babylonian style" seems to emerge as a real entity, not a mere classification—as something resembling, rather, the life-story of a great creator. Nothing conveys more vividly and compellingly the notion of a destiny shaping human ends than do the great styles, whose evolutions and transformations seem like long scars that Fate has left, in passing, on the face of the earth.

Galleries, too, which exhibit replicas and plaster casts bring together widely dispersed works. They have more freedom of choice than other art galleries, since they need not acquire the originals, and in them the seeming antagonism of the originals is reconciled in their manifestation of a vital continuity, emphasized by the chronological sequence in which such galleries usually display the replicas. They are immune from that virus of the art book which inevitably features style at the expense of originality, owing to the absence of volume and, in many cases, to the reduced size of the reproductions; and, above all, to their proximity and unbroken sequence—which bring a style to life, much as an accelerated film makes a plant live before our eyes. Thus it is that these imaginary super-artists we call styles, each of which has an obscure birth, an adventurous life, including both triumphs and surrenders to the lure of the gaudy or the meretricious, a death-agony and a resurrection, come into being. Alongside the museum a new field of art experience, vaster than any so far known (and standing in the same relation to the art museum as does the reading of a play to its performance, or hearing a phonograph record to a concert audition), is now, thanks to reproduction, being opened up. And this new domain—which is growing more and more intellectualized as our stock-taking and its diffusion proceeds and methods of reproduction come nearer to fidelity—is for the first time the common heritage of all mankind.

III But the works of art that comprise this heritage have undergone a strange and subtle transformation.

Though our museums conjure up for us a Greece that never existed, the Greek works in them patently exist; Athens was never white, but her statues, bereft of color, have conditioned the artistic sensibility of Europe. Nor have the painstaking reconstitutions made at Munich succeeded in replacing by what the Greek sculptors probably envisaged what the statues certainly convey to us today. The Germans tried to bring the real Greece back to life, alleging that her works of art reached our museums in the state of corpses. Singularly fertile "corpses" in that case; nor did the gallery of waxworks intended to replace them have any such fertility. The theory was, of course, that "we should see these works as those for whom they were created saw them."

But what work of the past can be seen in that manner?

If the impression made on us today by a painted and waxed Greek head is not that of a work of art recalled to life, but that of a grotesque, the reason is not simply that our vision has been warped; it is also that this one resuscitated style emerges among so many others that are not resuscitated in this manner. In the East almost all statues were painted; notably those of Central Asia, India, China and Japan. Roman statuary was often in all the colors different marbles could provide. Romanesque statues were painted, so were most Gothic statues (to begin with, those in wood). So, it seems, were Pre-Columbian idols; so were the Mayan bas-reliefs. Yet the whole past has reached us . . . colorless.

The slight traces of color surviving on Greek statuary embarrass us chiefly because they hint at a world so very different from that of the Greek drawing and sculpture with which we are familiar. Even such elements of Alexandrian art as we have allowed to enter into our conception of "ancient Greece" are difficult to reconcile with figures in three colors. Actually a period is expressed no less by its color than by its drawing; but though we can see that Greek draftsmanship, Gothic fluting and Baroque extravagance link up with their respective periods, the connection assumed to exist between a culture and its color amounts to little more than a tentative belief that the painting of harmonious civilizations favors light tones, and that of dualistic civilizations, dark. A mistaken belief, obviously, since the painting contemporaneous with the Chartres *Kings* is usually light-hued; and so is Gauguin's. It is on a par with believing that the music of heroic ages consists of military marches. In a period indifferent to realism the color of a statue is rarely realistic. Greek statues were polychrome, but Plato tells us that in his time the pupils of their eyes were painted *red*. Bleached to whiteness by the passage of time, these statues are not diminished, but transmuted; a new, coherent system, no less acceptable than the original

GREECE (5th CENTURY B.C.). MASTER OF THE REEDS: LECYTHUS

system, has replaced it. With the partial exception of Egypt, the role of color in the great cultures of the past (no less distinctive and legitimate than the part played by forms) is conveyed to us by a few fragments only; the multitude of living figures which our world-wide resuscitations have conjured up is voiceless.

Retrieved without its color, the past—until the Christian era—has been retrieved without its painting. What conception would a future archeologist who knew its sculpture only have of nineteenth-century art? It would seem that Greek painting in the days of Pericles was two-dimensional, and perhaps we can get an inkling of its style from the elements in common between the white lecythi and the Naples *Women playing at Knuckle-bones*. As for hoping to guess what it was by studying Pompeian art (five centuries posterior to Pericles), we might as well believe that in the year 4000 it will be possible to understand the art of Raphael by studying our contemporary posters. Those Greek artists whose grapes, we are told, were so realistic that even the birds were taken in, were contemporaries of Alexander, not of Themistocles; of Praxiteles, not of Pheidias. The sculpture of the latter hints at the

(FIRST CENTURY B.C.). ALEXANDER OF ATHENS: WOMEN PLAYING AT KNUCKLEBONES (DETAIL)

49

existence of a "flat" unrealistic painting with incisive drawing, and devoid of archaism. The discovery of a humanistic painting in two dimensions—in the sense in which this term applies to the *Horsemen of the Acropolis*—would set our art-historians, and others too, perhaps, some major problems.

No doubt we are quite aware that the Greek world and the Mesopotamian have come down to us transformed. But what of the Romanesque world? Its pillars were ribboned with vivid color; some of its tympana and effigies of Christ were as strongly colored as Polynesian fetishes, while some others were painted in the colors favored by Braque. No more realistic than those of the miniature and the stained-glass window (which would surprise us less had the Vézelay tympanum come down to us intact), their colors illuminated a world that the Romanesque frescoes are beginning to reveal to us—a world utterly different from that of the monochrome churches. Gothic ends up with the motley of Sluter's *Well of Moses*, the base of a "Calvary"; Moses' garment was red, his mantle lined with blue; the pedestal was spangled with gold suns and initials, and painted, like the entire "Calvary," by Malouel; while Job wore real gold spectacles! Where Gothic works have retained their primitive color it is lustreless, though often as intense as that of Fouquet's red and blue angels. Where they have kept the color of a later phase, it aims at a realism sometimes akin to that of the illuminators, sometimes to that ambivalent naturalism which reappeared in Spanish polychrome wood-carvings. Indeed during the Middle Ages there existed a sort of cinema in colors of which no trace has survived; just as in the sudden dawning of a larger hope amongst men who had not forgotten the dark age whence they had emerged but yesterday—a dawning symbolized by the great cathedrals soaring heavenwards—there was a splendid confidence in the future, not unlike that of America

Wherever the painting on the statues has survived, it has come down to us transformed by a patina and, inevitably, by decay as well; and the transformation due to these two factors affects its very nature. Our taste, not to mention our aesthetic, is no less responsive to this subtle attenuation of colors, once bright to the point of garishness, than that of the last century was to the layers of varnish on the pictures in museums. If we regard a well-preserved Romanesque Virgin (Italy has several such) and a time-scarred Virgin of Auvergne as belonging to the same art, this is not because the Auvergne Virgin is a mutilated replica of the other, but because the intact Virgin shares, *in a less degree*, the characteristics we perceive in the time-worn Virgin. Romanesque art as we know it is an art of stone carving: of bas-reliefs and pier-statues. Our museums house figures akin to the bas-reliefs, removed from their setting and usually damaged. Indeed when it chances to be intact, a Romanesque

ROMANESQUE VIRGIN OF AUVERGNE

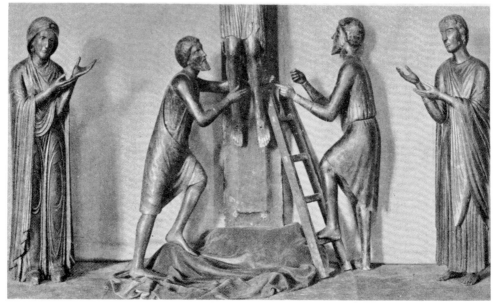

Deposition from the Cross seems often to reduce the majesty of "true" Romanesque to the art of Breton wayside crosses or the Christchild's crib. Thus we are no more anxious to restore its pedestal to the great Romanesque crucifix in the Louvre than her arms to the Venus of Melos; of the two versions of Romanesque we have chosen ours.

Our feeling for a work of art is rarely independent of the place it occupies in art history. This historic sense, a by-product of our place in time and conditioned by the here-and-now, has transformed our artistic heritage (which would be no less transformed were we to relinquish it). Thus mediaeval art acquires different significances according as we see in it an art of "darkness" or that of a massive building-up of Man. We have seen how greatly a history of color would modify the art history we know—which is in fact a history of drawing, given its form by Florence and, above all, by the Rome of Julius II. That of the seventeenth and eighteenth centuries was dominated by Venice; Velazquez revered Titian and disdained Raphael. (Whereas that of France, shaped by engravings and black-and-white photography, sponsored Rome far more than Venice.) We are now beginning to glimpse in the Gossaert of Berlin a kinsman of El Greco, and in the Naples Schiavone a progenitor of the Fauves. Always there comes a time when the long beams of the searchlight that plays across the course of art history—and, indeed, all human history—linger on a great work hitherto neglected, relegating others to partial obscurity. Thus it is only

recently that Piero della Francesca has emerged as one of the world's greatest artists; and since then Raphael has greatly changed for us.

A period that does not set out to "filter" an art of the past makes no effort to resuscitate it in its original form, but merely ignores it. That in the Middle Ages the statues of antiquity, though they were there to see, were never looked at, is partly due to the fact that theirs was a dead style; partly to the fact that certain cultural periods banned metamorphosis as passionately as ours has welcomed it. It was not because of any feeling for the past that Christian art admitted echoes of Pompeii in some of its miniatures of the High Middle Ages. The notion of art as such must first come into being, if the past is to acquire an artistic value; thus for a Christian to see a classical statue as a statue, and not as a heathen idol or a mere puppet, he would have had to begin by seeing in a "Virgin" a statue, before seeing it as the Virgin.

That (to quote a famous definition) a religious picture "before being a Virgin, is a flat surface covered with colors arranged in a certain order," holds good for us, but anyone who had spoken thus to the men who made the statuary of St. Denis would have been laughed out of court. For them as for Suger and, later, for St. Bernard, what was being made was a Virgin; and only in a very secondary sense an arrangement of colors. The colors were arranged in a certain order not so as to be a statue but so as to be *the* Virgin. Not to represent a lady having Our Lady's attributes, but to *be*; to win a place in that otherworld of holiness which alone sponsored its quality.

Since these "colors in a certain order" do not merely serve purposes of representation, what purpose do they serve? That of their own order, the modernist replies. An order variable, to say the least: since it is a style. No more than Suger would Michelangelo have admitted that word "before" in "before being a Virgin" He would have said: "Lines and colors must be arranged in a certain order so that a painted Virgin may be worthy of Our Lady." For him, as for Van Eyck, plastic art was, amongst other things, a means of access to a world of the divine. But that world was not separable from their painting, as is the model from the portrait; it took form through the expression they achieved of it.

The Middle Ages were as unaware of what we mean by the word "art" as were Greece and Egypt, who had no word for it. For this concept to come into being, works of art needed to be isolated from their functions. What common link existed between a "Venus" which *was* Venus, a crucifix which *was* Christ crucified, and a bust? But three "statues" can be linked together. When, with the Renaissance, Christendom selected, from amongst the various forms created for the service of other gods, its most congenial method of expression, there began to emerge that specific "value" to which we give the name of art, and which was, in due time, to equal those supreme values in whose

service it had arisen. Thus, for Manet, Giotto's *Christ* was to become a work of art; whereas Manet's *Christ aux Anges* would have meant nothing to Giotto. By "a good painter" had been meant a competent painter, capable of convincing the spectator by the quality of his "Virgin" that she was more the Virgin than was an average artist's Virgin—and this called for superior craftsmanship. Thus, when art became an end in itself, our whole aesthetic outlook underwent a transformation.

But it was not a belief in painting as an absolute value that supervened on the age of faith; that belief came later. What came next was "poetry." Not only was the poetic sense, throughout the world and for many centuries, one of the elements of art, but over a long period painting was poetry's most favored mode of expression. Between the death of Dante and the birth of Shakespeare how trivial seem the poets of Christendom as compared with Piero della Francesca, Fra Angelico, Botticelli, Piero di Cosimo, Leonardo, Titian and Michelangelo! What poems contemporary with Watteau rank beside his art?

The distinction we make today between the specific procedures of painting and its poetic elements is as indefinite as the distinction between form and content. They once comprised an indivisible domain. Thus it was at the bidding of his poetic sense that Leonardo's colors were "arranged in a certain order." *Painting*, he wrote, *is a form of poetry made to be seen*. Until Delacroix, the ideas of great painting and poetry were regarded as inseparable. Can we suppose it was due to some aberration that Duccio, Giotto, Fouquet, Grünewald, the Masters of the Italian Renaissance, Velazquez, Rembrandt, Vermeer, Poussin—and all Asiatic artists— took this for granted?

After having been a means to the creation of a sacrosanct world, plastic art was chiefly, during several centuries, a means to the creation of an imaginary or transfigured world. And these successive worlds were far from being what we call "subjects" for the artists; it is obvious that the Crucifixion was not a "subject" for Fra Angelico, nor (though

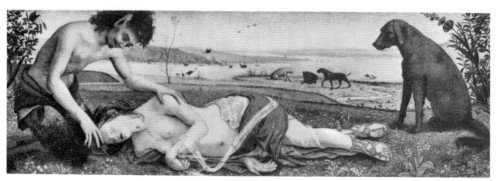

PIERO DI COSIMO: THE DEATH OF PROCRIS

54

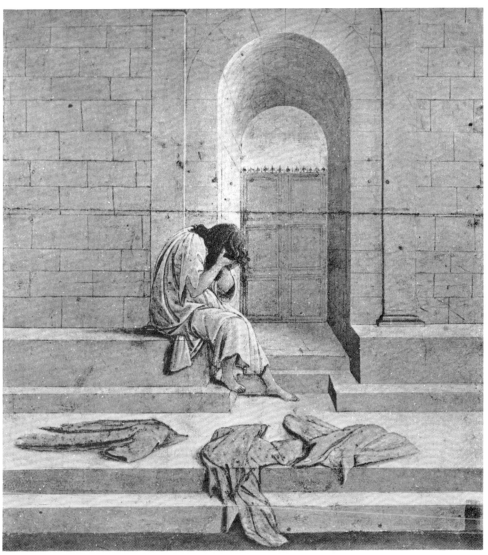

BOTTICELLI: LA DERELITTA

here the distinction is subtler) was *The School of Athens* for Raphael, or even *The Entry of the Crusaders into Constantinople* for Delacroix merely a "subject"; each was a means of conquering, by way of painting, a world that was not exclusively the domain of art. In those days people spoke of "big" subjects—and the adjective conveys a whole attitude. When modern art arose, "official" painting had replaced that

conquest by the artist's subordination to a romantic or sentimental theme, often linked up with history—a sort of theatrical performance freed from its narrow stage, if not from its gestures. Reacting from this realistic treatment of the imaginary, painting rediscovered the poetic emotion, once it ceased illustrating the "poetry" of history and sponsoring that of the *pleinairistes*, and took to *making its own poetry*. Cézanne's *Montagne Noire*, Renoir's *Moulin de la Galette*, Gauguin's *Riders on the Beach*, Chagall's *Fables*, Dufy's scenes of gay life and Klee's knife-edged phantoms owe nothing of their lyricism to their subjects; these artists use them as vehicles for their own poetic emotion, each in his own manner. Goya's drawings hold us as the countless scenes of martyrdom in academical Baroque can never do. And then we have Piero, and Rembrandt We respond effortlessly to the enchanting harmony of pinks and grays in *L'Enseigne de Gersaint*, but the appeal of Boucher or an Alexandrine to our sensuality (like that of Greuze or a Bolognese to our sentimentality) evokes little or no response. We are moved by Rouault's *Old King*, but the glimpse of Napoleon on a muddy road in Meissonier's *1814* leaves us cold. If the subjects of the "official" Salon artists are meretricious, this is because, far from being conjured up by the art of those who painted them, they are models to which this art submits itself. Titian did not "reproduce" imagined scenes; it was from the nightbound forests of Cadore he got his "Venus."

MEISSONIER: 1814

ROUAULT: THE OLD KING

Far from excluding poetry from painting, we should do better to realize that all great works of plastic art are steeped in poetry. How can we fail to see it in the art of Vermeer, Chardin, Brueghel and Courbet (in his major works)? We profess to admire only their color in Bosch and Titian, but if we propose to treat their color—the means of expression of their poetry—as separable from it, we shall have to begin by assuming that their art was a technique of *representation*. Realistic as this color may seem, it is a link between the *Juggler* and the *Temptations;* the trees in Titian's finest works belong *also* to that magic realm of poesy. And this poetic "glamour" is not something superadded to his painting; it is still less separable from it than is the fantastic from the art of Bosch. Nor is it due to the taste prevailing then in Venice (as is the calligraphy of his decorative compositions); it is due solely to his art. This is becoming clearer with the advance in color reproduction and the comprehensiveness of modern exhibitions thanks to loans of masterpieces; far more than the drawing, the color expresses the poetry in his art. Titian, one of the world's greatest poets, seems often no more than a master of tapestry design, when he is reproduced in black and white. True, some of our painters say they would prefer Titian with his "Venus" left out—meaning that they prefer those still lifes in which Venus, though no less present than in the Prado, is not visibly present. As though *Laura de Dianti, Venus and Adonis,* the Vienna *Callisto,* the *Nymph and Shepherd,* belonged to the world of Cézanne, or even that of Renoir! Is that which differentiates Rembrandt's from almost all Hals's portraits only the unlikeness of two palettes? And even, we might add, that which differentiates the *Governors of the Almshouse* from the *Archers?*

With poetry in this sense painting has always, to say the least of it, collaborated, and the art of the age of religion collaborated no less than does our modern art. But from the Renaissance up to Delacroix there was more than mere collaboration; poetry was wedded to painting as it had been to faith. Leonardo, Rembrandt and Goya seek and achieve both poetic and plastic expression, often simultaneously. Pisanello's hanged men, Leonardo's daylight vistas and Bosch's nightbound recessions, Rembrandt's light and Goya's phantoms belong to both categories. The Queen of Sheba is conjured up by Piero's art, the Prodigal Son by Rembrandt's, Cythera by Watteau's, a limbo of spectres by Goya's. Poetry comes as naturally to this art as the flower to a plant.

Italian Mannerism affected Europe rather as a school of poetry than through its forms; Jean Cousin and Jan Matzys were votaries of a dream and a dream alone. Like their Italian masters, the painters of the various Schools of Fontainebleau were illustrators in their minor works; nevertheless their ornamental art, in quest—beyond mere ornament—of poetry and often the mysterious, was put to the service not of the poets but of poetry and, rather than aiming at the depiction

LEONARDO DA VINCI: THE VIRGIN, CHILD AND ST. ANNE (DETAIL: ST. ANNE)

REMBRANDT : THE PRODIGAL SON

of a poetic world, was seeking for a poetic expression of the world they saw around them. Is there less poetry in *The Harvesters* at the Louvre or *Descent into the Cellar* than in *Eva Prima Pandora*, in Caron's pictures and countless "Dianas"? That elongation, those forms half glimpsed through veils and arabesques so often directed towards a focal point and nearer those of glyptics than those of Alexandria, are essentially pictorial, not anecdotal procedures. It was not Venice but Rosso who discovered

JEAN GOURMONT (1537): DESCENT INTO THE CELLAR

those curious color harmonies which Spanish Baroque was, later, to use to such effect. And in that chariot with its dark horses carrying away Niccolo dell'Abbate's Proserpine to the Shades, how separate the illustrative and the poetic elements?

That certain old-time pictures are imbued with a truly modern poetic emotion—that Piero di Cosimo is near akin to Chirico—is plain

NICCOLO DELL' ABBATE: THE RAPE OF PROSERPINE (DETAIL)

to see. Some unfinished etchings by Rembrandt in which he comes very near our modern sense of the mysterious have been discovered; but let us make no mistake regarding this. Our modern taste has been shaped by a, so to speak, sectarian poetry which adjusts its world to perspectives of the dream and the irrational. No doubt all true poetry is irrational in the sense that it substitutes a new system of relations between things for the established order. But, long before peopling

REMBRANDT : THE PAINTER AND HIS MODEL

the solitude of an artist, that new system had come to men as an ecstatic revelation—a panic conquest of the joys and wonders of the earth; or that, not of a world of dreams, but of the star-strewn darkness which broods upon the august presence of the Mothers or the slumber of the gods. Mallarmé is not a greater poet than Homer, or Piero di Cosimo than Titian; and what do the vividest realizations of our painters amount

MICHELANGELO : NIGHT (DETAIL)

to if we compare their impact with what that first great vision of a nude woman—her of the Panathenaea, on whom the first butterfly alighted—must have meant to those who saw her then, or that of the first sculptured face in which Christ ceased to be symbol and "came alive"? The poetry of the dream has not always vanquished that of ecstasy; Baudelaire's vision of "night" ensues on that of Michelangelo, but has not effaced it.

Midway between Man's fleeting world and the transcendent world of God, a third world found its place in several phases of culture, and art was subordinated to it as once it was to faith. We have a tendency to treat this intermediate world as a mere *décor;* its function is not actually denied, but, rather, disregarded. The association in our culture of very different types of art is rendered feasible only by the metamorphosis that the works of the past have undergone, not merely through the ravages of time but also because they are detached from certain elements of what they once expressed: their poetry no less than the faith of their makers and the hope of enabling man to commune with the cosmos or the dark demonic powers of nature. Indeed every work surviving from the past has been deprived of something—to begin with, the setting of its age. The work of sculpture used to lord it in a temple, a street or a reception-room. All these are lost to it. Even if the reception-room is "reconstructed" in a museum, even if the statue has kept its place in the portal of its cathedral, the town which surrounded the reception-room or cathedral has changed. There is no getting round the banal truth that for thirteenth-century man Gothic was "modern," and the Gothic world a present reality, not a phase of history; once we replace faith by love of art, little does it matter if a cathedral chapel is reconstituted in a museum, stone by stone, for we have begun by converting our cathedrals into museums. Could we bring ourselves to feel what the first spectators of an Egyptian statue, or a Romanesque crucifixion, felt, we would make haste to remove them from the Louvre. True, we are trying more and more to gauge the feelings of those first spectators, but without forgetting our own, and we can be contented all the more easily with the mere knowledge of the former, without experiencing them, because all we wish to do is to put this knowledge to the service of the work of art.

But though a Gothic crucifix becomes a statue, as being a work of art, those special relations between its lines and masses which make it a work of art are the creative expression of an emotion far exceeding a mere will to art. It is not of the same family as a crucifixion painted today by a talented atheist—out to express his talent only. It is an object, a picture or a work of sculpture, but it is also a Crucifixion. A Gothic head that we admire does not affect us merely through the ordering of its planes; we discern in it, across the centuries, a gleam

of the face of the Gothic Christ. Because that gleam *is there*. We have only a vague idea as to what the aura emanating from a Sumerian statue consists of; but we are well aware that it does not emanate from a Cubist sculpture. In a world in which the very name of Christ had left men's memories, a Chartres statue would still be a statue. And if the idea of art had survived in that civilization, the statue still would speak a language. What language? it may be asked. But what language is spoken by those Pre-Columbians of whom we still know next to nothing, or by the coins of ancient Gaul, or by those bronzes of the Steppes as to which we do not even know who were the peoples that cast them? And what language by the bisons of the caves?

It is no vain quest seeking to ascertain to what deep craving of man's nature a work of art responds, and we do well to realize that this craving is not always the same. Throughout the ancient East the craftsmen manufactured gods, but not haphazard; the styles imposed on these images were devised by the artists, who also devised the successive transformations of these styles. The sculptor's craft served the making of the gods, and art served to express, and doubtless to promote, a special form of intercourse between Man and the Divine. In Greece the sculptors continued making gods; the artists wrested these gods from the realm of the non-human, of death and "the terror that walks by night." The theocratic spirit of the East had imparted even to objects of daily use the style invented for the effigies of the gods; indeed the Egyptian perfume-spoons look as if they had been carved for use in the netherworld. Whereas, with Hermes and Amphitrite, Greece succeeded in imposing idealized human forms on the gods. Thus while in both cases art depicted gods, it is obvious that, in doing this, it directed its appeal to different elements of the human soul.

We know how very different are the basic emotions to which art makes its appeal in, for example, a Sung painting, the Villeneuve *Pietà*, Michelangelo's *Adam*, a picture by Fragonard, by Cézanne or Braque; and, at the very heart of Christendom, in the guise of the paintings in the Catacombs and those in the Vatican, in the art of Giotto and Titian. We, however, discuss these works *as paintings*—as though they all belonged to the same domain. In most of them art ranked second for their makers, whereas we subordinate them all to art; indeed, if it became the general opinion that the artist's function is to serve (for instance) politics, or to act on the spectator in the manner of the advertisement, the art museum, and our artistic heritage, would be utterly transformed in under a century.

For since our museums were constituted at a time when it was taken for granted that every painter wished to make what *we* call a picture, they were filled with the pictures that our art invited to figure in them. It is always at the call of living forms that dead forms return to life. The Gothics were regarded as uncouth by the man of the seventeenth

century because the contemporary popular sculptors to whom he likened them were obviously less competent than Giraudon; above all, because had his craftsmanship resembled that of the Gothics, a contemporary sculptor would certainly have been "uncouth". This habit of projecting the present on the past persists, but nowadays we would not regard a sculptor whose work resembled pre-Romanesque as clumsy; we should call him "expressionist." In our resuscitations of pre-Romanesque art Uccello comes to the fore, while Guercino fades out. (How could anyone care for Guercino? we ask. After all, why not, considering that Velazquez did, and bought his pictures for the King of Spain?) The most permanent European values have been served in successive periods by arts that were not merely different but hostile; as against the Gothics the seventeenth century (notably La Bruyère) vaunted the architecture and sculpture of antiquity, not for their stylization but for their "truth to nature," and it was on precisely the same grounds that the Romantics extolled Gothic, as against seventeenth-century art. Like these periodic metamorphoses of the notion of "truth to nature," every resuscitation, in reviving and revealing a forgotten art, casts great tracts of shadow over other aspects of the past. For us today Uccello is neither what he was for his own age nor what he was for the eighteenth century; and the same applies to Guercino.

True, we are less inclined than it would seem to take Titian for another Renoir, Masaccio for a Cézanne, or El Greco for a Cubist; nevertheless, in the case of Masaccio, as in that of El Greco, we select certain elements for our admiration, and shut our eyes to the others. Every "resurrection" sorts out what it recalls, as is evident in the earliest collections of antiques, restorations notwithstanding. Today our museums welcome torsos but not limbs. That fortunate mutilation which contributes to the glory of the Venus de Melos might be the work of some inspired antiquary; for mutilations, too, have a style. And the choice of the fragments we preserve is far from being haphazard; thus we prefer Lagash statues without their heads, Khmer Buddhas without their bodies, and Assyrian wild animals isolated from their contexts. Accidents impair and Time transforms, but it is we who choose.

Indeed Time often works in favor of the artist. Doubtless many masterpieces are lost for ever. Yet the very rarity of those which have come down to us confers on them a solitary grandeur (which may perhaps mislead our judgment). Thus, were the huge output of Jan van Eyck available, might it not impair the lonely eminence of *The Mystic Lamb*? And surely the name of Rogier van der Weyden would have a deeper resonance had he painted one picture only, the *Deposition* of the Escorial. After seeing the ten canvases which rank Corot with Vermeer, we can hardly believe that those charming, trivial landscapes which adorn our provincial museums bear his authentic signature. Who can tell if the scrap-heap of Rubens' studio would not be more akin

to Renoir's than to those massive harmonies, voices of the earth, that echo through the *Kermesse*, and in certain immortal landscapes and portraits? The judgment of Time is more selective than that of any given phase of culture.

It is common knowledge that during the nineteenth century the successive layers of varnish put on pictures were by way of creating a "museum style," sponsoring a preposterous kinship between Titian and Tintoretto—pending the day when cleaning was to put a stop to this absurd fraternity. Neither Titian nor Tintoretto had asked posterity to overlay his canvases with a yellow gloss; and if the ancient statues have gone white, Pheidias is not to blame, nor is Canova. Yet it was only after painting had become light-hued that these coats of varnish came to seem intolerable to the curators of our museums.

By the mere fact of its birth every great art modifies those that arose before it; after Van Gogh Rembrandt has never been quite the same as he was after Delacroix. Often discoveries in fields quite foreign to each other have the same effect; thus the cinema is undermining every art of illusionist realism, perspective, movement—and tomorrow will usurp relief as well. If Louis David did not see the works of classical antiquity as Raphael did, that is because his approach to them was different; also because, having access to a wider range of them, he did not see the same ones.

We interpret the past in the light of what we understand. Thus from the time when history set up as a mental discipline (not to say, an obsession) until 1919, inflation was a relatively rare phenomenon. Then it became frequent, and modern historians see in it a cause of the decline of the Roman Empire. Similarly since 1789 history has had a new perspective, revolution being a successful revolt, and revolt a revolution that has failed. Thus a new or rediscovered fact may give its bias to history. It is not research-work that has led to the understanding of El Greco; it is modern art. Each genius that breaks with the past deflects, as it were, the whole range of earlier forms. Who was it reopened the eyes of the statues of classical antiquity—the excavators or the great masters of the Renaissance? Who, if not Raphael, forced an eclipse on Gothic art? The destiny of Pheidias lay in the hands of Michelangelo (who had never seen his statues); Cézanne's austere genius has magnified for us the Venetians (who were his despair); it is in the light of those pathetic candles which Van Gogh, already mad, fixed round his straw hat so as to paint the Café d'Arles by night, that Grünewald has come into his own. In 1910 it was assumed that the Winged Victory, when restored, would regain her ancient gold, her arms, her trumpet. Instead, she has regained her prow and, like a herald of the dawn, crowns the high stairway of the Louvre; it is not towards Alexandria that we have set her flight, but towards the Acropolis. Metamorphosis is not a matter of chance; it is a law governing the life

of every work of art. We have learned that, if death cannot still the voice of genius, the reason is that genius triumphs over death not by reiterating its original language, but by constraining us to listen to a language constantly modified, sometimes forgotten—as it were an echo answering each passing century with its own voice—and what the masterpiece keeps up is not a monologue, however authoritative, but a *dialogue* indefeasible by Time.

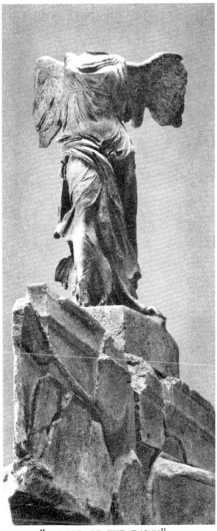

"HERALD OF THE DAWN"

IV The art which is taking over, sorting out and imposing its metamorphosis on this vast legacy of the past is by no means easy to define. It is our art of today—and obviously a fish is badly placed for judging what the aquarium looks like from outside. The antagonism between it and the museum art of its day becomes still clearer in its relations with the past; those whom it has slain have all a family likeness, and so have those it has revived. Our resuscitations cover a far wider field than our contemporary art; but the latter gives us our bearings in our rediscovery of art's "sacred river" by setting up painting as something that exists in its own right against the criteria of the museum.

For five centuries (from the eleventh to the sixteenth) European painters, in Italy as in Flanders, in Germany as in France, concentrated their efforts on liberating art, stage by stage, from its two-dimensional limitations, and from what they took for the clumsiness or ignorance of their predecessors. (Far-Eastern art, linked up as it was with an ideographic script written with a hard brush, had made much quicker progress in mastering its medium.) Gradually they discovered the secrets of rendering volume and depth, and they attempted to replace those symbolic intimations of space which we find in Romanesque and Byzantine art, and later in Tuscan art, by the illusion of actual space. In the sixteenth century complete illusion was achieved.

To Leonardo, doubtless, goes the credit for the decisive technical advance. In all the painting known to Leonardo's world—that of Greek vases and Roman frescoes, the art of Byzantium and the East, of Christian Primitives of various lands, of the Flemings, Florentines, Rhine-

FILIPPO LIPPI: DETAIL OF ROCKS

landers and Venetians (as in almost all the painting we have discovered since his day: Egyptian, Mesopotamian, Persian, Buddhist Indian, Mexican)— whether they were painting in fresco, in miniature or in oils, painters had always composed *in terms of outlines*. It was by blurring outlines, prolonging the boundaries of objects into distances quite other than the abstract perspective of his predecessors (Uccello's and Piero's perspective tends to emphasize rather than attenuate the isolation of each object)—it was by merging all things seen into a

background suffused in various tones of blue that Leonardo, a few years before Hieronymus Bosch, invented (or organized) a way of rendering space such as Europe had never known before. No longer a mere neutral environment for bodies, his Space (like Time) enveloped figures and observers alike in its vast recession and opened vistas on infinity. Not that this Space was a mere hole in the picture surface; its very translucence owes everything to painting. Not until this discovery had been made could Titian break up his contour lines, or Rembrandt fulfill his genius in his etchings. But in Italy, during that period, all a painter needed to do was to adopt Leonardo's technique—whilst being careful to omit the qualities of transfiguration and insight that Leonardo's genius imparted to all his work—for the painting to be a faithful reproduction of what the eye perceives, and the figures to "come to life." While

LEONARDO DA VINCI: DETAIL OF ROCKS

to the contemporary spectator with his taste for illusionist realism, a picture by Leonardo or Raphael seemed more satisfying as being more lifelike than one by Giotto or Botticelli, no figure in the centuries that followed was more alive than Leonardo's; it was merely different. The technique of strongly "illusionist" painting which he introduced at a time when Christianity, already losing grip and soon to be divided against itself, was ceasing to impose on visual experience that hieratic stylization which proclaimed God's presence in all His works—this technique of the lifelike was destined to change the whole course of painting. Perhaps it was not a mere coincidence that, of all the great masters, the one who had the most far-reaching influence was the only painter for whom art was not his sole interest in life, his *raison d'être*.

Thus Europe came to take it for granted that one of painting's chief functions was the creation of a semblance of reality. Yet, though hitherto art had aspired to master a certain range of visual experience, it had always been recognized as different in kind from the world of appearances; the striving for perfection implicit in all works of art

incites it far more to stylize forms than to imitate them. Thus what was asked of art in the period following Leonardo's was not a transcript of reality but the depiction of an idealized world. And, though resorting to every known device for rendering texture and spatial recession, and attaching so much importance to the modeling of its figures, this art was in no sense realistic; rather, it aspired to be the most convincing expression possible of an imagined world of harmonious beauty.

The prelude to a work of fiction is always a "Let's make believe...." But there had been no make-believe about the Monreale *Christ;* it was an affirmation. Nor was the Chartres *David* make-believe; nor Giotto's *Meeting at the Golden Gate.* Still there begin to be traces of it in a *Virgin* by Lippi or Botticelli; and Leonardo's *Virgin of the Rocks* is frankly so. A Crucifixion by Giotto is a declaration of faith; Leonardo's *Last Supper,* sublime romance. Behind this lay undoubtedly a change in the religious climate. Religion was ceasing to mean Faith, and its images were entering that speculative limbo whose color is the very color of the Renaissance, and where, while not quite estranged from truth, they are not yet wholly fiction, but in process of becoming it.

In the thirteenth century the artist was chary of introducing this element of fiction into his work; but by the seventeenth century all religious art was frankly a product of the imagination, and in this new world of fantasy the artist felt himself supreme. More factual than the musician, and on a par at least with the poet, he began to draw in Alexandrines. None better than he could conjure into being a woman of ideal beauty; because it was less a matter of conjuring her up than of building her up, of amending, idealizing, keying up his drawing—harmonious and idealized already; and because his art, even his technique, seconded his imagination no less than his imagination served his art.

Pascal's "What folly to admire in art anything whose original we should not admire!" is not the fallacy it seems but an aesthetic judgment —meaning not so much that only beautiful things should be painted, but only such things as would be beautiful, did they exist. A view that found its justification in the style of antiquity, this was the theory behind Alexandrine art and the ornate Roman copies of certain Athenian masterpieces (to which, however, it did not in the least apply). The reason why Michelangelo, in his innocence, was so much impressed by the *Laocoön* was that he had never seen, never did see, a single figure of the Parthenon. And this style forced a preposterous but none the less impressive unity on the originals of five centuries of classical art. Alexandria "expressed" Themistocles. Hence came the idea of a beauty independent of any given age; a beauty whose prototypes were immutable and which it was the artist's duty to visualize and to body forth. Hence, too, came the notion of an absolute style, of which other styles were but the infancy or the decline. How different from this myth is our view of Greek art today!

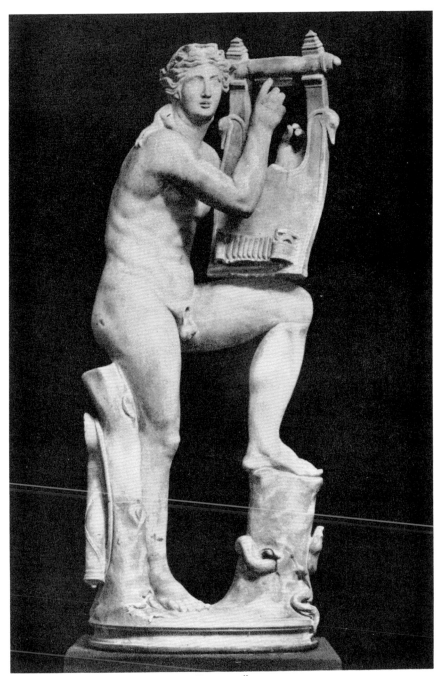

"ANTIQUE"

This myth arose in close conjunction with Christian art at the time when Julius II, Michelangelo and, still more, Raphael regarded the Greeks as allies—it was only much later that they were considered enemies. But we are now familiar with the arts of the ancient East, and if Pheidias to our thinking sharply contrasts with both the Christian and our modern artists, he is no less in conflict with the Egyptian sculptors and with those of Iran and the Euphrates. For many of us the supreme discovery of the Greeks was their new approach to the universe: the spirit of enquiry. With their philosophers who taught men the art of living, their gods who changed their nature with every change made in their statues and were becoming rather helpers than ruthless lords of destiny—what the Greeks changed was the very meaning of art. Despite that evolution of forms in the course of which, century by century, the sense of an ineluctable order written in the stars had submerged more and more the life of Egypt—as in Assyria a tyranny of blood— art had never yet been other than an answer given by these civilizations once and for all to destiny. But then, within a space of

EGYPTIAN ART. IVth DYNASTY (3rd MILLENNIUM B.C.): CHEPHREN

fifty years, that stubborn *questioning* which was the very voice of Hellas silenced those Tibetan litanies. Ended was the rule of oneness over the multiplicity of things; ended, too, the high prestige of contemplation and of those psychic states in which a man dreams he attains the Absolute by surrendering to the vast cosmic rhythms and losing himself in them. Greek art is the first art that strikes us as being "secular." In it man's basic emotions are given their full human savor; ecstasy assumes the simpler name of joy. In it even the depths of being become humanized; that ritual dance in which the forms of Hellas make their first appearance is the dance of mankind joyously shaking off the yoke of destiny.

In this respect Greek tragedy may mislead us. Actually, the doom of the House of Atreus was the epitaph of the great Oriental sagas of fatality. In Greek tragedy the gods show as much concern for man as men for the gods. For all their netherworldly air the protagonists have no roots in the timeless sands of Babylon; rather, like men marching in step with men, they have won free from these. And when man faces destiny, destiny ends and man comes into his own.

EGYPTIAN ART. IVth DYNASTY (3rd MILLENNIUM B.C.): KING DEDEFRÊ

NEO-SUMERIAN ART (3rd MIL. B.C.): GODDESS

Even today, for a Mussulman of Central Asia, the tragedy of Oedipus is much ado about nothing; how regard Oedipus as an illstarred exception, when every man is Oedipus? And what the Athenians admired in the art that made stage tragedies of them was not man's defeat but the poet's victory over destiny.

Within every artichoke is an acanthus leaf, and the acanthus is what man would have made of the artichoke, had God asked him his advice. Thus, step by step, Greece scaled down the forms of life to man's measure, and similarly adjusted to him the forms of foreign arts. We may be sure that a landscape by Apelles suggested a landscape made by man, not by cosmic forces. The cosmos is less an enemy than vehicle of a communion; by contrast with the cowering immobility of Asiatic statuary, the movement of the Greek statue—the first movement known to art—was the very symbol of man's emancipation. The Greek nude came into its own without heredity and without blemish, even as the Greek world is a world rescued from its servitudes: such a world as might have been created by a god who had not ceased being a man.

Thus, too, the language of Greek forms, into whatever decadence, whatever concessions to the meretricious it sometimes lapsed, regained something of the lustre of its golden age each time it put forth a challenge, timid or outspoken, to the lingering influence of the great stylizations of the East: in the Gothic art of Amiens and Rheims to defunctive Romanesque; in Giotto to Gothic art and, notably, Byzantium; in the sixteenth century to the medieval artists. And on each occasion it resuscitated human forms, not what came to be called Nature. (The Bolognese, rightly enough, dubbed Giotto's figures "statues.") Forms chosen by man and made to man's measure: forms whereby man enlarged his values till they matched his conception of the universe.

Since the days of the Catacombs we have seen enough of what

ASSYRIAN ART (8th CENTURY B.C.): WINGED BULL WITH HUMAN HEAD (DETAIL).

a world in which man's values are at odds with his environment may mean, to realize the vast significance of this reconcilement. In the Acropolis it is this that makes up linger in front of the *Head of a Youth* and the *Koré of Euthydikos*, the first faces to be wholly human. On those statues of uncertain origin, which still kept their archaic frontalism, something was taking form that neither Egypt nor Mesopotamia,

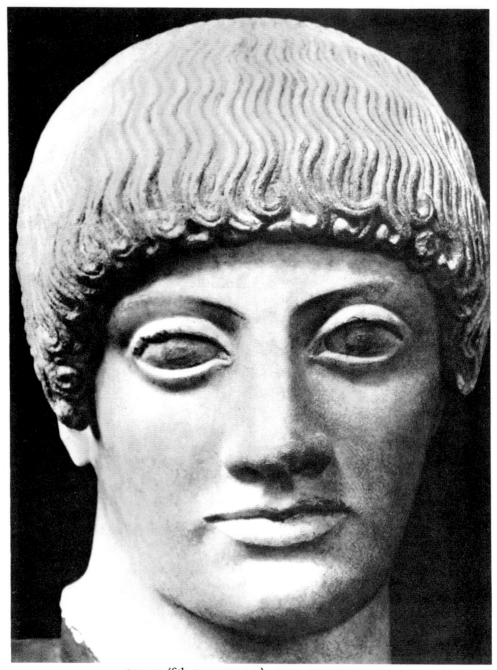

GREECE (6th CENTURY B.C.): HEAD OF A YOUTH

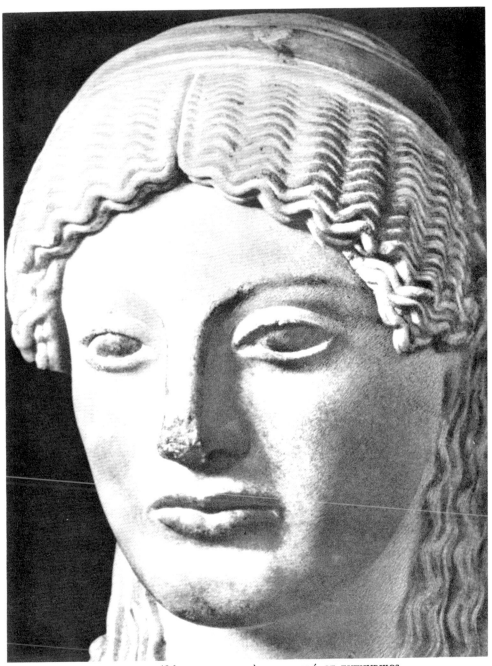

GREECE (6th CENTURY B.C.): THE KORÉ OF EUTHYDIKOS

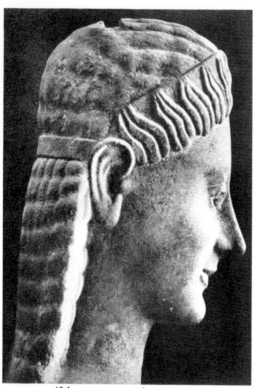

GREECE (6th CENTURY B.C.): BOY OF KALIVIA

neither Iran nor any ancient art had ever known—something that was to disappear from the solemn faces of the Acropolis, and that something was *the smile*.

Far more than in the ripples of its drapery, all Hellas is in the curves of those faintly pouting lips and this is neither the Buddhist smile, nor the smile that hovers on some Egyptian faces; for, primitive or sophisticated, always it is directed towards the person looking at it. Whenever it recurs, something of Greece is in the point of breaking into flower—whether in the smiling grace of Rheims or that of Florence; and whenever man feels himself in harmony with the world, he regains his precarious sway of that limited yet never to be forgotten kingdom which he conquered for the first time on the Acropolis of Delphi.

The smile, girls dancing at the call of instinct not of ritual, the glorification of woman's body in the nude—these are some tokens, amongst many others, of a culture in which man bases his values on his predilections. In the Eastern cultures neither happiness nor man had ranked high in the scale of values, and thus all that might express them had little place in art. The art of the Euphrates valley was as aloof as modern art from forms bespeaking pleasure. True, the East knew sexuality; but sexuality is an instrument of destiny, the antithesis of pleasure.

That word "Greece" still calls up in our minds a host of strong, if ill-assorted, associations—in which intermingle (singularly enough) not only Hesiod and the poets of the Anthology but the *Head of a Youth* of the Acropolis and the last Alexandrian sculptors. Actually it was by way of Alexandria and Rome that Europe discovered Greece; but let us try to picture how things would have been had Greek art come to an end when Pheidias made his first works of sculpture. (A whole cycle of Greek culture ended with Pericles, and it is no more absurd to picture a Hellenism in which that culture whose art was set in such high honor

first by the sixteenth, then by the seventeenth century, had no place, than to see in Praxiteles an aftermath and an expression of Aeschylus.) Though beauty would hardly come into the picture, would the spirit of Hellas be less present? Who could assimilate the *Delphi Charioteer*, the figures in the Acropolis, or the "Boy of Kalivia" to an Egyptian or Mesopotamian statue?

The nude woman's figure, which came later still than the quest of beauty, suggests to us sensual pleasure, and indeed expresses it. Firstly, because it is set free from any ritual "paralysis," its gestures being merely in abeyance like those of a living woman in her sleep. But above all because the hieratic order of the firmament with which it was once linked has ceased to be fatalistic and has changed to harmony; and because Mother Earth has included in her conquest of what was once the awe-inspiring realm of the Mothers, the cosmos too. We need only cease observing the Greek nude through Christian eyes, and compare it not with the Gothic but with the Indian nude—and its nature promptly changes; the erotic elements fade into the background, we see it radiant with new-won freedom and in its amply molded forms find hidden traces of the drapery of the figures from which it has gradually broken free, and which the Greeks called "Victories."

GREECE (5th CENTURY B.C.). PAEONIOS: VICTORY

81

INDIA, KHADJURAHO (10th CENTURY): APSARA WITH SCORPION

THE VENUS OF CNIDOS (ANCIENT REPLICA OF PRAXITELES)

GREECE, DELPHI (CA. 475 B.C.): AURIGA

The artist of the East had *translated* forms into a style (the same procedure was followed, later, by the Byzantines) which re-fashioned the visible world in terms of other-worldly values, the most constant of which was timelessness. Whereas an art which owes allegiance to the world of men stems from a close alliance with the human, an art bound up with fatalism and focused on the eternal draws its strength from its disharmony with the human; it is unconcerned with art or beauty, nor has it "a style"; it *is* style. This is why the art of Greece in its struggle

PRAXITELES (LATE 4th CENTURY B.C.): HERMES

against that of the ancient East, and the artists first of Rheims and then of Italy when they took arms against the oriental elements of Christendom, solved the problem of portraying movement in the same manner. That smoothing-out of planes which in the age of Pericles replaced the clean-cut ridges (especially in lips and eyelids) of the earlier figures foreshadowed Leonardo's softened outlines. It was their search for methods of countering the hieratic immobility of Eastern art that led the Greeks as it subsequently led the Italians (once the technique of illusive realism was mastered) to regard art as solely a means to creating a make-believe world on the grand scale.

Thanks to its zest for enquiry Greek art changed its forms more thoroughly within two centuries (from the vith to the ivth) than Egypt and the East had changed theirs in twenty. And the moving spirit of Greek art—the myth behind the quest—was its tireless cult of man. But all those discoveries and inventions which, from the Euthydikos *Koré* to the Parthenon, constitute the glory of Hellas, crystallized in the age of the great European monarchies into a single discovery: art's ability to create an imaginary world. This imaginary world was made

to gratify not that human instinct which, from the Mesopotamian period up to the medieval, had sought to transcend art and see in it merely the raw material of religious pageantry, but that no less innate craving to remake the scheme of things after our hearts' desire.

Hence it was that a Gothic artist came to be regarded as a man who would have liked to paint like Raphael, but could not. And the theory of a steady progress in art, from the primitive to the antique and from the "barbarians" to Raphael, was more and more widely accepted. Thus art had its age of enlightenment and the artist's aim came to be the expression not of himself but of a certain form of culture. And now its only goal was beauty.

What exactly beauty means is one of the problems of aesthetics —but only of aesthetics. (Actually aesthetic theory, a late development, was chiefly a rationalization of attitudes already existing.) When art was enlisted as beauty's handmaid, what was meant was clear enough. Beauty was that which everyone prefers to see in real life. No doubt tastes vary greatly, but men find it easier to agree about woman's beauty than about the beauty of a picture; since almost every man has fallen in love, but connoisseurs of painting are relatively few. This is why Greece so easily reconciled her taste for a monumental art with her taste for elegance (statues of Pallas Athene and Tanagra statuettes); and also why she moved on so naturally from Pheidias to Praxiteles. This, too, explains why the eighteenth century could combine so well its admiration of Raphael with its enjoyment of Boucher. From this, and not from allegations of the superior "truth" of the antique nude as against Gothic nudes, academicism derived its efficacy. The women in the Bourges "Resurrection" are more like women than is the Aphrodite of Syracuse; but the latter is the type of woman men prefer.

When, on its renascence in the sixteenth century, the academicism of the ancient world seemingly endorsed the artistic value of sensual appeal, Christendom had gradually, and not without setbacks, been shaking off the fear of hell. The forms of a world haunted by visions of hell-fire had been replaced by those of Purgatory, and soon all that Rome retained of the hopes and fears of Christendom was a promise of Paradise. Byzantine art had never got beyond portraying angels announcing the Last Judgment, figures deriving from Greek *Victories* and resembling Prophets. Fra Angelico had obviously forgotten how a devil should be painted. That day when Nicolas of Cusa wrote "Christ is Perfect Man" closed a cycle of Christendom and, with it, the gates of hell; now Raphael's forms could come into happy being.

Man had climbed up from hell to paradise through Christ, *in* Christ, and the inhuman aloofness which had hitherto characterized the hieratic arts vanished together with his fears. From Chartres to Rheims and from Rheims to Assisi, in every land where under the Mediator's outspread hands a world of seedtime and harvest, figured

in bas-reliefs of the Seasons, was permeating human lives (where until now there had been room for God alone)—in every land artists were discovering the forms of a world released from fear. And now that the devil owned little more than a dim hinterland of Purgatory, how could the lesson of the Greeks have been other than that of the acanthus? Thus now it was that this message from the past was codified; the "divine proportion" exemplified in the human body became a law of art and its ideal measurements were invoked to govern the whole composition.

A dream both grandiose and rich in intimations. But when it ceased being the justification for a cult of harmony—when the artist used it as the starting-point of his works instead of causing it to emanate from them—not discovery but adornment became his aim. He set out to transform the world into acanthus-leaves; gods and saints and landscapes into patterns of beauty. Hence the quest of ideal beauty, *le beau idéal*.

"Rational beauty" would be the better term. It aspired to manifest itself in literature, in architecture and also, though more cautiously, in music. Above all it sought to be transposable into life—sometimes in a subtle manner. Since a Greek nude is more voluptuous than a Gothic, would the Venus of Melos, if she came to life, be a beautiful woman? The criterion of this rational beauty was that it should be one regarding which men of culture, though with no special interest in painting, could agree with each other, and each with his own sense of what was fitting. The type of beauty in which both picture and model can be admired, and which Pascal preconized (though it is very different from the beauty we find in his own sharply etched, Rembrandtesque style). A beauty that the artist did not create, but *attained;* in terms of which a picture gallery should not be an *ensemble* of paintings but a permanent display of carefully selected, imaginary scenes.

For despite its claim to rationality this art was the expression of a world created for the joy of the imagination. The very notion of beauty, especially in a culture for which the human body is the supreme object of art, is wrapped up with the imaginary and sexual desire; it is founded on a fiction. This is why the art deriving from it lavished on the fiction as much fervor as medieval art had lavished on faith (and as much fervor as that with which our modern art bans realistic make-believe). It aimed at making good its fictions by their *quality*, and it was this idea of quality—not so much that of the picture itself as that of the scene depicted—which enabled it to regard itself as art. For, though aspiring to conform to the evidence of our senses and setting out to charm, it did not limit its charm to mere sensual appeal; what it sought, above all, to captivate in the spectator was his culture.

Culture, indeed, took charge of art, the cultivated man became art's arbiter. Not as a lover of painting but as a lover of culture, and because he regarded *his* culture as an absolute standard of value.

Until the sixteenth century every important discovery of the means of rendering movement had linked up with the discovery of a style. If the archaic sculptors in the Acropolis Museum seemed to carry more conviction than those of Aegina (and less than Pheidias), Masaccio more than Giotto, and Titian more than Masaccio, the spectator had always confused their power of carrying conviction with their genius; in fact, in his eyes it was this power that made their genius. He was all the less capable of distinguishing between these inasmuch as the tidal movement of Italian art—which had borne man on towards a reconciliation with God and swept away, together with the tragic dualism that was the legacy of Gothic, the last traces of the powers of evil in the forms of art —was all in favor of the human; and because every discovery in the way of expression enlarged the artist's freedom from the thrall of Romanesque dramatization and Byzantine symbolism; withdrew him further from hieratic immobility. Masaccio did not make his works more lifelike than Giotto's because he was more anxious to create an illusion of reality, but because the place of man in the world he wished to body forth was not the same as the place of man in Giotto's world. The motives urging him to liberate his figures were the same as those which had led Giotto to emancipate his figures both from the Gothic tradition and the Byzantine; but the same motives were to lead El Greco to distort and stylize his figures—to wrest them violently from their emancipation. The parallelism between expression and representation, owing to which the personal genius of each great artist had acted so strongly on the contemporary spectator, came to an end once the technique of representation had finally been mastered.

The Italians' approach to their art history reminds us of our modern outlook on the progress of applied science. No painter or sculptor of the past was ever preferred to a contemporary one until the time of the rivalry between Leonardo, Michelangelo and Raphael (that is to say, before the technique of portrayal was fully mastered). True, Duccio and even Giotto were revered as precursors but, until the nineteenth century, no one would have dreamed of preferring their work to Raphael's; it would have been like preferring a sedan chair to an aeroplane. The history of Italian art was that of a series of "inventors," each with his attendant school.

For Florence to repudiate her art the *spirit* behind it had first to be challenged; Botticelli's works were burnt for the same reason as that for which modern Europe may some day destroy her machinery. And, be it noted, Botticelli himself was the first to burn them. Savonarola, had he won the day, might perhaps have conjured up an El Greco— but it was he who was burnt.

Fiction had always played a part in art; the new development was that it came to permeate even religion so deeply that Raphael hellenized or latinized the Bible without a qualm and Poussin could harmonize

his Crucifixion with his Arcadia. When painting is put to the service of a fiction regarded as a cultural value, art is inevitably called on to promote an established idea of civilization; its values *qua* art take second place and its task is to present realities or fancies in an attractive guise. Humanistic though it was, the language of the forms of Pheidias and the pediment of Olympia had been as distinctive as that of the Masters of Chartres and Babylon, or the abstract sculptors, because it voiced the *discovery* of a culture and did not merely illustrate one. In Italy the course of painting and sculpture had been an advance into the unknown; Masaccio after Giotto and, after Masaccio, Piero knew only whence they were setting forth. But from now on painters were expected to know where they were going and to comply with a preconceived idea of painting's function. The artist's impulse to destroy the forms which gave him birth—to which the Greek archaics and the makers of the Parthenon, like those of Chartres and Yun Kang owed their creative genius—was ceasing to be comprehensible.

Discussions between painters regarding their special problems gave place to discussions between intellectuals, whose interest centered on the *subject* of the picture. And now that painting was being absorbed into culture, art criticism was coming on the scene.

Obviously it was easier for the intellectual to regard a painting as a portrayal of some imagined scene, than to recognize it as speaking a language of its own. (Even today we hardly understand the language of the stained-glass window.) That language becomes apparent only when we bring together paintings differing in spirit—by the recognition of some sort of pluralism. But at that time the arts existing outside Europe and the best Greek sculpture were unknown; connoisseurs had seen only a limited range of pictures and the Gothics were styled "barbarians." Moreover, the classical mentality was anything but pluralist in outlook. But when the forms of antiquity were found unsuitable for expressing the new relationship between man and God (whether because man was beginning to stand up to God, or because the Jesuit type of piety, which was replacing religion as religion had replaced faith, called for a more emotional and dramatic handling of figures), art which aspired to be classical became what it was bound to be: not a new classicism, but—a quite different thing— a neo-classicism. Poussin may sometimes have "re-invented" the line of Pheidias (of whom he had seen only interpretations), but David frankly copied the drawing of the bas-reliefs he admired. The painters' exploitation of the art of antiquity gave the impression of being a style because it imitated, not the painting of the Greco-Romans (none of which survived), but the statues. Actually the resuscitation of ancient sculpture spelt the *end* of the great statuary of the West, which did not re-emerge until academicism was in its death throes. Michelangelo, who from the Bruges *Madonna* to the Rondanini

Pietà strained his genius to the breaking-point in his struggle to break away from, not to approximate to, antiquity, is the last great sculptor comparable with the Masters of the Acropolis, of Chartres, and of Yun Kang. And with Michelangelo ended the supremacy of sculpture.

In the countries with classical traditions painting (which now took precedence of sculpture) called for a mental attitude opposed to that which Gothic art demanded and modern art demands. A statue in Chartres Cathedral takes effect by the insertion into a self-contained world, that of sculpture, of a form which, outside art, would be a king; a landscape by Cézanne takes effect by its insertion into a self-contained world—that of Cézanne's painting—of a scene that, outside art, would be a landscape. But in the age of classical culture a picture made good by the projection of a delineated form into an imaginary world, and it was all the more effective, the more emphatic and exact was the suggestion the figure conveyed. The methods employed came to be such as would have entitled the subject, could it have come to life, to occupy a privileged position in the scheme of things. But the nature of this privilege was changing; the rectified world that art was invited to create, and which hitherto had been rectified to satisfy man's spiritual needs, was now beginning to be adjusted to his aesthetic enjoyment. The view that the philosophers of the Enlightenment took of religion made them blind to all great religious art, and even more allergic to the Gothics and the work of the Byzantine school than they were to contemporary pictures on sacred subjects. Though Diderot appreciated Rembrandt, he called his etchings "mere scrawls." Of course there had always been semi-barbarians in the Netherlands with a feeling for color! . . . Neither Voltaire nor the Jesuits were particularly qualified for realizing that hieratic anti-realism is the most potent method of expression in an age of fervent faith. Thus art problems were rationalized more and more—just as religious problems were being rationalized by the Encyclopedists.

Moreover in the course of their campaign against the Protestants, which was followed up by one against the new Enlightenment, the Jesuits discovered that painting could be a useful ally, especially if of such a nature as to appeal to the masses. Obviously the style best fitted for this was one that created a complete illusion of reality. Giotto's message had been addressed to men of his own kind, not to the lukewarm, and he painted for his fellow-Christians as he would have painted for St. Francis. But the new painting was not intended for saints; it aimed less at bearing witness than at giving pleasure; hence its readiness to adopt all the methods of seduction, beginning with those which had proved most successful in the past. Hence, too, the popularity of the academic notion of "combining the strength of Michelangelo with the suavity of Raphael." This was the first frankly propagandist painting

that Europe had known, and like all good propaganda it implied a relative clear-sightedness on the part of its purveyors as to the means employed. It was no longer necessary that they should, personally, be true believers; their task was to encourage piety in others. Indeed there was remarkably little cohesion between the precepts of Suger and the practice of the Jesuits.

Now that painting had become less the means of expression of a humbly, or tragically, sacred world than a means of conjuring up an imaginary world, it came in contact with another and a highly effective stimulus to the imagination: the theater. This was taking an ever larger place in contemporary life; in literature, the chief place—and in Jesuit churches it was imposing its style on religion. The Mass was being overlaid with stage effects, as the mosaics and frescoes of the past were being overlaid by the new painting. No longer suggesting Arcadian scenes, pictures evoked, first, tragic events; then, frankly, dramas. Thus during three centuries the will to theatrical effect took the place of what during the age of faith had been the will to truth and, from the Romanesque visions of the Creation to the first flowering of the Renaissance, had been the will to a vast, universal Incarnation.

The part taken by Baroque in the great pictorial pageant-play of Europe is difficult to define; apparently, no doubt, it played the lead—but it often played the lead for our benefit and *against* its own masterpieces. To the illusion of movement in depth (achieved at the beginning of the sixteenth century) it added gesture. Like their master Michelangelo in his *Last Judgment*, the later frescoists had often worked as decorators commissioned to paint huge surfaces, which they did not divide up into parts. The decorative style they thus created was popularized by Jesuit architecture and the sculpture appended to it. Subsequently, during two centuries, this style, detached from its original function and deprived of its vital principle, was taken over by easel painting.

But the creators of Baroque were painters, too. At Venice they restored to painting the power of lyrical expression. Tintoretto's *St. Augustine healing the Plague-stricken* and his San Rocco *Crucifixion*, Titian's Venice *Pietà*, Rubens' landscapes and the Louvre *Kermesse* belong as distinctively to painting as the tombs of the Medici, the Barberini and Rondanini *Pietàs* belong to sculpture.

Day takes its place beside the *Crucifixion*, the *Pietà* and *The Burial of Count Orgaz* on a gaunt, tragic mountain-top as far removed from the theater as from the mundane; in that haunted solitude where, later, Rembrandt joins them. The spectator has ceased to count for them. Upon an art of extravagance, of billowing draperies, was based the austerest stylization known in ten centuries to the Western world, that of El Greco. In Michelangelo's frescoes and the *Pietà*, even in the San Rocco *Crucifixion*, the colors blend into a turbid stormlight as remote

from reality or "glamour" as are the *St. Maurice* of the Escorial, the most sumptuous Titians, and that dazzling *St. Augustine healing the Plague-stricken*. Painting for his own satisfaction, Rubens is less histrionic; he discards the "operatic" in favor of bold flights into a realm of fantasy. While he was conquering Europe, Baroque was stifling the tempestuous melodies of its early inspiration under the trumpery refrains of Naples, and it was Roman Baroque alone that sought to recapture the spirit of the *Last Judgment*. But Rubens' truer dramatic sense and his purely painterly execution were destroying the world of the theatrical, because they were destroying illusionist realism.

The Jesuits, however, tolerated the flights of Baroque fancy only in that lavish decoration which turned the church into a stage set, and soon they forced the Baroque gesture into the service of realistic effects and a type of painting that lifted to spectacular heights those *tableaux vivants* on which the Jesuit fraternities set so much store. Hence the almost aggressively secular nature of this art which purported to be so religious. Those Baroque holy women were neither altogether women nor altogether saints; they had become actresses. Hence, again, came the interest shown in emotions and faces; the painter's means of expression was no longer primarily line and color, it was the human personality.

The *genre* scenes of Greuze are in the direct line from Jesuit painting; Greuze took the same view of art's function as did the Jesuit artists. And Jesuits and philosophers, whether admirers of the former or the latter, found common ground in their scorn of all painting previous to Raphael.

Neo-classicism, while reacting against Baroque gesticulation, likewise paid homage to the gods of the theater; only it found its gods in classical, not in Jesuit tragedy. We can see at once how much David's *Oath of the Horatii* has in common with a tragedy by Voltaire. Though he often paints theatrical characters, Delacroix, when depicting movement, rarely illustrates gestures; in Ingres' classical scenes we can admire without a feeling of discomfort only those from which theatrical gesture is excluded.

Two of the artists whom our century has restored to the front rank are Italians: Uccello and Piero della Francesca. Uccello's were perhaps the first battle-scenes regarding which the painter seems to feel no personal emotion; they are no less stylized than Egyptian bas-reliefs, and their arrested movement, that of a ritual ballet, bodies forth an hieratic symbolism rendered in terms of color. Creator of one of the most highly developed styles that Europe has known, Piero was also one of the first artists to use aloofness as the ruling expression of his figures and, like Uccello's, his statuesque forms come to life in the measures of a sacred dance. In *The Flagellation* uninterested soldiers are scourging a Victim whose thoughts seem far away; the three standing

PAOLO UCCELLO: BATTLE OF SAN ROMANO (DETAIL)

PIERO DELLA FRANCESCA: THE FLAGELLATION

figures in the foreground have their backs turned to the tragic scene. And in *The Resurrection* Christ pays as little heed to the sleeping soldiers as to the spectator. Even Le Nain when we compare him with Le Sueur seems like the frontage of a massive prison contrasted with a mere stage setting. What does Vermeer's *Young Girl* express? From Georges de Latour to Greco, even up to Chardin's day, all the painters we have resuscitated show the same indifference to making faces "expressive." Piero, indeed, might be the symbol of our modern sensibility, our desire to see the expression of the painter, not that of the model, in his art.

But in the eighteenth century the expression specific to painting had become subordinated to the "rational" expression of the person portrayed. In the countries of classical culture none but the painters themselves and a handful of connoisseurs realized that the plastic arts might have —or, rather, be—a language of their own, like music. Then, at the close of the century, an aesthetic of sentiment joined forces with that of Reason; it was only a matter of appealing to the heart instead of appealing to the head. Stendhal did not blame the selection committee of the Salon for their general outlook, but for judging by rule of thumb (i.e., insincerely), and he suggested replacing them by the Chamber of Deputies. (As who should have, a century earlier, proposed replacing them by the Court.) He was, in fact, simply endorsing the Jesuits' and

Encyclopedists' notion that a work of art is good if it pleases the average cultured and right-minded man; and a painting pleases such a man, not *qua* painting, but according to the quality of the scene or incident it illustrates. What Stendhal appreciated in Correggio was the delicacy and subtlety of his rendering of women's feelings; most of his eulogies would apply, word for word, to a great actress—and some, indeed, to Racine. For everyone who has no specific response to painting instinctively projects a picture into real life, and judges it in terms of the scene it represents. In 1817 Stendhal wrote:

Had we to list the components of the beau idéal, *we would name the following forms of excellence: first, a look of very keen intelligence; secondly, gracefully molded features; thirdly, glowing eyes—glowing not with the dark fires of passion but with cheerful animation. The eyes give liveliest expression to the play of the emotions, and this is where sculpture fails. Thus modern eyes would be extremely candid. Fourthly, much gaiety; fifthly, great underlying sensibility; sixthly, a slender form and, above all, the sprightly grace of youth.*

He thought he was attacking David and Poussin; actually he was setting up one theatrical procedure against another. This explains why English painting (**Van Dyck's** aftermath), for all its brilliancy and brio, shares in the indifference we feel towards Italian eclecticism, Alexandrinism and French academicism.

Eighty years later Barrès (though he, anyhow, does not invoke *le beau idéal*) echoes Stendhal and endorses those notions of art which identify painting with culture and pictorialized fiction.

I have not the least hesitation in ranking Guido, Domenichino, Guercino, the Carracci and their compeers, who give such powerful and copious analyses of passion, above the Primitives and even the painters of the first half of the Cinquecento. I can understand that archeologists find pleasure in harking back to the sources—to such painters as Giotto, Pisano and Duccio. And I can also see why aesthetes, enamored of the archaic, who have deliberately emasculated their virile emotions in quest of a more fragile grace, relish the poverty and pettiness of these minor artists. But anyone who judges for himself and refuses to be influenced by the pedantic prejudice in favor of sobriety, or by the fashions of the day—any man, in short, who is fascinated by the infinite diversity of the human soul—will find, when contemplating good examples of seventeenth-century art in the museums, that these were the work of men whose driving force came, not from outside, but from within them; men who did not look to ancient statuary or any models for guidance, but externalized deeply felt and fully realized emotions.

Though the modern world disdains them, these artists often touch sublimity in dealing with the tender emotions, and especially in the expression of sensual pleasure keyed to its highest pitch. Here the emotive effect is heightened by its pathological veracity. We need only look at Bernini's famous statue of St. Teresa at Santa Maria della Vittoria in Rome. A great lady—would we not say?—swooning with love. Let us bear in mind what the seventeenth and eighteenth centuries aimed at; and Stendhal and Balzac, too. Like them, these painters

PROCACCINI: MAGDALEN

placed their characters in predicaments which brought out precisely those sentiments —of embarrassment, perhaps, or helplessness—which were most apt to make us understand them, and to stir our feelings.

But whereas Stendhal thought he was speaking for the future, anyhow the immediate future, Barrès hardly hoped as much.

While an aesthetic of descriptive art was spreading over two thirds of Europe, painting, under the aegis of Velazquez and Rembrandt, followed its predestined path. Gone were the days when all great artists, from Cimabue to Raphael and Titian, reaped their reward of comprehension and public esteem. Until the sixteenth century great painters had indulged happily in the narrative, deepening its significance by their discoveries; minor painters likewise indulged in it, though without making discoveries. But now the time had come when great artists were to make discoveries without recourse to narrative. The conception of the function of painting which had led first to Italian eclecticism, then to the concept of an ideal (and sentimental) beauty, came to its end, during the period between Stendhal and Barrès, in the vast mausoleum of nineteenth-century academicism. Here, too, the time-proved recipes, rendered more appetizing on occasion by a dash of inventiveness, were put to the service of an art which catered primarily to a public with no special interest in painting. The only difference was that the historical subject replaced the religious anecdote. The Jesuit venture, which had begun with fiction and an exploitation of the Italian masters' genius, ended with the passing of the anecdote, with Manet's triumph.

MANET: PORTRAIT OF CLEMENCEAU

V For the break that took place between the romantics and the classicists in literature had no equivalent in painting—except in the case of Goya, whose influence made itself felt later. The romantics took arms against that classical literary aesthetic which had held almost absolute sway in Europe during the seventeenth century, and against all works deriving from it. Though the artists too joined issue with this aesthetic code, they did not attack the major works of art produced during its ascendancy; rather, they carried these works a stage further. While Racine "corresponds," we might say, to Poussin, what writer could be said to correspond to Velazquez, Rembrandt or Hals, all of whom died in the same decade as Poussin (between 1660 and 1670). France, though paramount in literature, held no such lead in painting. The art contemporary with the French literary classics was the great oil painting of Europe, which was a development, in depth, of the Roman, and especially the Venetian, art of the sixteenth century. And Géricault, Constable and Delacroix found a place in the art museum as naturally as their great forerunners. In the field of painting the romantic movement was far less in conflict with the broad trend of classicism than with the narrowness of neo-classicism; it was not a style, it was a school. Not until Manet was there any question of breaking with traditional painting, as the great poets of the early nineteenth century broke with literary tradition.

Once he had got into his stride, Manet moved on to *Olympia*, then from *Olympia* to the *Portrait of Clemenceau*, and from this to the small *Bar des Folies-Bergère*—just as painting progressed from academicism to modern art. Thus he points us towards whatever in the traditional past seems called on to figure in the new art museum, in which his *accoucheurs*—Goya, obviously, to begin with—rank as the great masters.

Goya foreshadows all modern art; nevertheless painting is not in his eyes the *supreme* value; its task is to cry aloud the anguish of man forsaken by God. The seemingly picturesque elements in his work have always a purpose and are linked up—as the great Christian art was linked up with faith—with certain deep-rooted collective emotions, which modern art has chosen to ignore. His *Shootings of May Third* voices the outcry of suffering Spain; his *Saturn*, mankind's oldest cry. The fantastic in his work does not stem from albums of Italian *capricci*, but from the underworld of man's lurking fears; like Young, like most pre-romantic poets, but with consummate genius, he hymns the powers of the Night. What is modern in him is the freedom of his art. For his colors, though not derived from Italy, are not invariably different from those of the museum; the *May Third*, the *Burial of the Sardine*, are pure Goya, but a comparison of his various *Majas on the Balcony* with, say, Murillo's *Courtesans* can be revealing. True, it would be easy to glean from his output (as from Victor Hugo's) a truly modern anthology —but its general trend is in another direction. His painting and his

FRANS HALS: THE WOMEN GOVERNORS OF THE ALMSHOUSE (DETAIL)

passion for Velazquez point us back towards the last period of Frans Hals (the hands in *The Women Governors* strike perhaps the first aggressively modern note in painting); his drawing, towards those sketches in which Titian in his old age breaks peremptorily the continuous outline of Florentine and Roman drawing; and, ultimately, towards Rembrandt. On the margin of this lineage, less obviously akin, come certain works by the Venetians, the Spaniards, some English portrait-painters; and, at a later date, by Géricault, Delacroix, Constable, Turner and Courbet —even Decamps and Millet.

But what appeals to the modern eye is not so much their output as a whole as certain "accents" in the work of these artists; for often they "tell a story." And the distinguishing feature of modern art is that it *never* tells a story.

Before modern art could come into its own, the art of historical fiction had to pass away—and it died hard. In the eighteenth century historical painting, though it retained its place "on the line" beside the

portrait, was moribund. By way of Watteau's fantasies and ballets painting slipped away, with nothing to check its lapse, towards the *genre* scene and still life, towards Chardin's and Fragonard's semi-nudes (even the *Enseigne de Gersaint* is a *genre* picture). Then came the end. Delacroix in *The Barricades*, Manet in *Maximilian* tried to bring historical painting up to date; but for Manet the *Maximilian* proved a dead end. Though Courbet set out to break new ground and did not wish to tell a story but to depict something different from what his predecessors had depicted, nevertheless he, too, aimed at representation—and this is why in our eyes he belongs to the traditional art museum. When Courbet replaced Delacroix's subjects by *The Funeral at Ornans* and *The Atelier,* he was combating the art museum in as superficial a manner as Burne-Jones when he painted Botticellian subjects, and his genius played no part in this replacement. The truth was that the "subject" was bound to disappear, because a new subject was coming to the fore, to the exclusion of all others, and this new subject was the presence of the artist himself upon his canvas. To realize his *Portrait of Clemenceau* Manet, greatly daring, had to be everything in the portrait, and Clemenceau next to nothing.

DAUMIER: THE CHESS PLAYERS

Though we cannot fail to see in parts of Manet's work his indebtedness to his juniors (despite the high prestige of Daumier, his senior), his name has come to symbolize a new art era. For it was his exhibitions that ushered in conspicuously the conflict between the old and the new in painting; the new values were not merely latent in his work but boldly proclaimed. Whereas Daumier, it would seem, hardly realized the import of his art. Daumier the man was abashed by the genius of Daumier the painter, and he painted even more for his own satisfaction than for posterity. Like Goya, he belongs at once to the museum and to modern art. His pictures of everyday subjects (*The Washerwoman, The Soup*) are in no sense anecdotal; in them the sufferings of poverty are sublimated on to a higher plane. His illustrations (*Don Quixote, The Two Thieves*) rise above mere illustration, just as his Dutch subjects (print-collectors, picture-hunters, players of games) rise above the anecdotal thanks to the boldness of their style, their disdain of illusive realism and a lay-out that is unmistakably modern. Nevertheless the true modern differs from Daumier in his rejection of *all* values that are not purely those of painting, and in the nature of his harmonies.

Manet's *Execution of Maximilian* is Goya's *May Third*, without what the latter signifies; similarly *Olympia* is the *Maja Desnuda*, and *The Balcony*

GOYA: THE SHOOTINGS OF MAY 3, 1808

MANET: THE EXECUTION OF MAXIMILIAN

the *Majas on the Balcony, minus* Goya's "message"; with Manet, the devil's emissaries have become two innocent portraits. A *Washerwoman* by Manet would have been the same as Daumier's, *minus* what the latter signifies. For the trend that Manet tried to give his painting ruled out such significances. And in his art this exclusion of the "message" was bound up with the creation of that "harmony of discords" which we find in all modern painting. Daumier's *Chess Players* has little more significance than most of Manet's canvases; nevertheless the faces in it are still expressive—and it is not due to mere chance that Manet was, above all, a great painter of still lifes. Striking as it is, the harmony of *The Chess Players* follows the conventions of museum art. Manet's contribution, not superior but radically different, is the green of *The Balcony*, the pink patch of the wrap in *Olympia*, the touch of red behind the black bodice in the small *Bar des Folies-Bergère*. His temperament, no less than his deference to authority, led him to begin by indulging in a wealth of Spanish-Dutch browns, that were not shade, contrasted with

bright passages, that were not light—thus reconciling tradition with the pleasure of painting for painting's sake. Next, the juxtaposition of colors, dispensing more and more with browns and glazes, added a new vigor to the canvas. (Though *Lola de Valence* is not quite the "black-and-pink jewel" of the poet's description, *Olympia* is tending in that direction—and in Cézanne's *Still Life with Clock* the marble clock is actually black and the big shell actually pink.) This new harmony of colors *between themselves*, instead of a harmony between colors and dark passages, led on to the use of pure, unbroken colors. The dark passages of museum art were not the garnet-reds of the Middle Ages, but those of the *Virgin of the Rocks:* tones born of depth and shade. This use of shade had served to temper the discords of Spanish Baroque painting. Now, with the disappearance of shade, these tones, too, disappeared, and the use of the discord, though hesitant to start with, paved the way for the resuscitation of two-dimensional painting. From Manet to Gauguin and Van Gogh, from Van Gogh to the Fauves, this cult of dissonance gained strength in modern art, so much so indeed that it embraced the stridences of the figures of the New Hebrides. Thus in an age when, along with naïve sculpture and the popular picture-sheet, pure color looked like dying out, it not only took a new lease of life in a highly sophisticated form of painting but opened up communication with a neglected past. Indeed it was this triumph of pure color that brought the most far-reaching change to the contents of the museum.

What exactly were these contents at the period of which we are speaking? Ancient art, with Roman works preponderating over Greek; Italian painting beginning with Raphael; the Dutch and Flemish masters; the Spaniards beginning with Ribera; French artists from the seventeenth, and English from the eighteenth century onwards; Dürer and Holbein rather in the background, along with a few Primitives.

Essentially it was a collection of painting in oils; a kind of painting in which the conquest of the third dimension had been all-important and for which a synthesis between illusive realism and plastic expression was a *sine qua non*. A synthesis which involved the rendering not only of the shapes of things but of their volume and texture (disregarded in all arts other than those of the West); in other words, a simultaneous impact on both sight and touch. A synthesis, moreover, which did not aspire to suggesting Space as an infinitude—as do Sung paintings— but at confining it in a frame. (Hence the attention given to the play of light and angles of illumination; in the whole world, since the dawn of painting, Europe alone casts shadows.) This synthesis involved not only the presence of what we see and touch, but also that of what we know is there. Our Primitives painted a tree leaf by leaf not because they thought they saw it thus, but because they knew it was like that. Which gave rise to the detail linked up with depth, not to be found in any art but ours.

In its efforts to attain this synthesis (which, whenever it was transcended, seemed destroyed), Western painting made a series of discoveries. We have already observed that a Giotto fresco looked more "true to life" than one by Cavallini; a Botticelli than a Giotto; a Raphael than a Botticelli. In the Low Countries as in Italy, in France as in Spain, seventeenth-century artists applied their genius to research in this direction, and the now generalized use of oils was at once a symptom of, and an effective adjunct to their quest of complete realism. The rendering of movement, light and texture had been mastered; the technique of foreshortening (like that of chiaroscuro and painting velvet) had been discovered, and each successive discovery had promptly been incorporated in the common stock of knowledge—as in our time the devices of *montage* and the traveling shot have become the stock-in-trade of film directors. Whenever it told a story, painting, like the theater to which it was steadily drawing nearer, was becoming a "show," a performance. Hence came the notion that a strict conformity between the work of art and natural appearances was both the supreme form of expression and the criterion of value, as it had been in what was then called the art of antiquity. Hence, too, the practice of subordinating the execution of the picture to what it represented.

But along with Gothic art (whose dramatic and picturesque elements alone had caught the fancy of Romanticism) the nineteenth century began to discover the arts of Egypt and the Euphrates, and the pre-Raphael frescoes. Tuscan art, too, was discovered, and the discovery was made, as usual, piecemeal; by traveling upstream in time: from the sixteenth to the fifteenth century, from the fifteenth to the fourteenth. In 1850 Botticelli was still a "Primitive." Nineteenth-century observers thought they were discovering merely a special range of themes and a special kind of drawing (this gave rise to the Pre-Raphaelite movement); actually they were discovering two-dimensional painting.

True, the medieval Flemish painters were well known. But while their color was esteemed, their drawing was held to be sadly unworthy of it. Moreover, being a late development, it had no equivalent in the sculpture which was then gradually becoming known, as far back as Romanesque. In fact, Flemish color belonged more to the museum than to the forms of art opposed to the museum. The hieratic composition of the Chartres Portal approximated it to two-dimensional painting, and from this the art of the Van Eycks and Van der Weyden, with its close attention to detail, its color-patterns and its (relative) depth, was very different.

At first it appeared that the august rivalry between the Dutchman Rembrandt and Velazquez the Spaniard was becoming less a matter of geography than one of history; actually the differences between them were quite other than those discriminating both from, say, an Egyptian

or Romanesque statue; from Giotto, too, perhaps; from Byzantium assuredly. A fundamental concept, that of *style*, was involved.

If we wish to understand what is meant by this new conception of style, it is Byzantine art (Gothic and especially Romanesque began by being regarded as dramatic versions of Byzantinism) that will serve us best. The Byzantine painter did not "see" in the Byzantine style, but he interpreted what he saw in the Byzantine style. For him what made the artist was this ability to *interpret;* thus he lifted figures and objects on to a supramundane plane and his procedure joined up with ritual and ceremonial symbolism.

This habit of "painting Byzantine" (as a man might "speak Latin") had only one point of contact with traditional museum art; both aspired to a kingdom not of this world. Raphael and Rembrandt, Piero and Velazquez shared, each in his manner, in this quest, and sought after what they might have described as "intimations of divinity." Similarly Poussin stylizes his figures, Rembrandt showers his with light so as to raise them above man's estate; just as the mosaicist of Monreale stylized his figures so that they might participate in his vision of transcendence.

But Romanesque, even in the Quattrocento, did not answer to the religious and emotional cravings that Gothic art had satisfied at the beginning of the century; they appealed primarily to the aesthetic sense. While in its heyday Romanesque art had aspired to glorify God in all His creatures, in its renaissance God had no place. The nineteenth century forced it to become an *ensemble* of works of art, as the museum converted the crucifix into statuary. And now at last the Romantic attitude showed itself in its true colors. It had been generally agreed that a picture could lay claim to beauty when what it depicted, had it become real, would have been a thing of beauty; this theory which directly applied to Raphael and Poussin could also be applied, if deviously, to Rembrandt. But how could one conceive of a pier-statue, or even a Romanesque head, "coming to life?"

This newly found sculpture seemed utterly remote from any known kind of painting, and equally from all the sculpture figuring in museums. It conjured up notions of some imaginary painting. Far more than that of the Flemish Primitives, a painting truly akin to Gothic sculpture could have been found in the Villeneuve *Pietà*, which, however, did not enter the Louvre until 1906—and as for Romanesque painting, it was then quite unknown. Nor was it easy to extricate the true lesson of the Middle Ages from the glamour of the Quattrocento "picturesque." If those great Romantics, Géricault, Constable and Delacroix had never seen a cathedral, would it have changed a single line of their pictures?

As against the compact, massive unity of the Autun figures traditional sculpture was coming to look theatrical and thin. And now the revelation of the style of Romanesque and styles of the Ancient East had dramatic consequences. For these styles were not in conflict with this

artist or that, or whith any particular school, but with the museum as a whole. Idealized faces, realistic faces, Raphael, Rembrandt and Velazquez were grouped together in one collective style, and against this the "accents" of the newly found arts were calling for a totally new conception of art, ill-defined, perhaps, but far-reaching.

A conception that had not even a name assigned to it. Arts had been classified as imitative or decorative (how many styles began as decorative before being recognized as arts in their own right!). But now it was discovered that great forms of human self-expression existed which owed nothing to imitation, and that between them and the ornament or hieroglyph there was some connection. With the revelation of the Elgin *Parcae* and of all those Greek statues whose emergence killed the myth of Hellas, as it killed their Roman copyists, it became apparent that Pheidias owed nothing to Canova (Canova discovered this for himself, at the British Museum, with rueful stupefaction)—and meanwhile the Pre-Columbian forms of art were coming to the fore. "I have in mind," wrote Baudelaire in 1860, "that streak of inevitable, synthetic, childlike savagery which is still perceptible in many a perfect type of art (Mexican, Ninevite, Egyptian, for instance), and comes from a desire to see things on the grand scale and, notably, with an eye to their *ensemble*." Those elongations and distortions of the human form which the Romanesque style employed in its hieratic transfigurations made it plain that a system of organized forms dispensing with imitation can defy the scheme of things and, indeed, recreate the world.

True, Baroque also distorted the human figure, but—with the exception of El Greco, regarded at the time by those familiar with his art as more of a belated Gothic than a Baroque artist—flamboyant Baroque belonged to a world in which everything was subordinated to emotion, and emotion, for artists of the time, meant certainly something quite other than a means of escape from the tyranny of the senses. Romanesque had nothing in common with the theater: whether the stage-effects of the fifteenth-century *Pietàs*, so dear to the Romantics, or those of Italian Baroque. On the contrary, it proved that the most poignant way of expressing an emotion is not necessarily the representation of a victim of that emotion; that for rendering grief there is no need to show us a weeping woman, and that a style in itself can be a means of expression. Obviously this art owed much of its impressiveness to its close association with architecture; but this association was less felt when photography began to isolate groups or fragments from their architectural context—and in any case the artist does not trouble overmuch about the context of works that fire his imagination. Moreover, since Romanesque did not express the psychological, rather sentimental Christianity of the nineteenth century and, for the artists and connoisseurs of the later period, the twelfth-century Christ was a remote, legendary figure, Romanesque art, now that it was freed from its setting

TOULOUSE-LAUTREC: SKETCH

and parted from its God, proved that such works of art can affirm the genius implicit in them, not only by a harmony and rhythm between the parts, but also by the harmony immanent in their style, uniting the saints and the lost souls of the tympana in a single, grandiose composition. And likewise it proved that art can subdue life's teeming forms to the artist's genius, instead of subjecting the artist to the forms of Nature. None of the arts discovered in our times, however exotic, has challenged the heritage of tradition so effectively as did this joint incursion of Romanesque, Mesopotamian and Egyptian sculpture.

In the traditional museum, which excluded the archaics of Olympia no less than fetishes, and in which Michelangelo's largest works passed for "unfinished," Greek art began with Pheidias. The quality that all the works of sculpture consecrated by tradition shared was "finish;" whereas the quality common to all the arts whose rediscovery was beginning was their lack, their wilful lack, of "finish." Hence the discovery which Baudelaire, speaking of Corot, summed up in the remark that a work of art need not be finished to be complete, and a work, though perfectly finished, was not necessarily perfect. In Primitive Egyptian art, as in the work of Corot, there was the same absence of finish; but (most noticeably in Egyptian art) this was not due to incompetence or remissness. That an Egyptian statue was a work of art none could deny; and it followed that its style was the artist's chosen means of expression. Just as in an art whose merits lie in its conformity with what we see, the finish is no more than a means of expression.

Sculptural problems, these—which the artists' quest of new fields to conquer transposed into problems of draftsmanship. Egyptian art being still more detached from its gods than Romanesque was from its

God, the problem, it seemed, could only be one of forms. The understanding of architecture is not a bad preliminary to the understanding of Giotto, but these new styles, with their vast, compelling simplifications, had no equivalent in painting. Or, rather, only one kind of painting gave an impression of power somewhat akin to these sculptors'—but gave it as it were *sub rosa*—and that was the sketch.

What was usually described as a sketch was the early state of a work of art, before its completion. But another kind of sketch existed, in which the painter, oblivious of the spectator and indifferent to the "realism" of his picture, reduced a perceived or imagined scene to its purely pictorial content: an aggregate of patches, colors, movements.

There is often failure to distinguish between the two kinds of sketch: the working

TOULOUSE-LAUTREC: DRAWING

sketch (or study) and the sketch which records the artist's direct, "raw" impression—just as there is some confusion between the Japanese sketch and the great synthetic wash-drawings of the Far East; between the preparatory sketches of Degas or Toulouse-Lautrec and the draftsmanship of some of their lithographs, which often seem to have been dashed off on the impulse of the moment. The rough sketch is a memorandum; the expressive sketch an end in itself. And being an end in itself, it differs essentially from the completed picture. An artist like Delacroix or Constable, when completing certain sketches, did not set out to improve on them but to interpret them—by adding details linked up with depth, so that (in Delacroix's case) the horses became more like real horses, and (in Constable's case) the hay wain more literally a hay wain, while the picture came to be as much an actual scene or a "story" carrying conviction as a work of art. Thus it achieved complete realism by means of that "finish" put in to gratify the spectator,

a mere survival in such cases, which the sketch had dispensed with, as the rediscovered sculpture had dispensed with it.

Artists had guessed as much already, and now were getting more and more alive to it. The sketches which the greatest painters had marked out for preservation—Rubens, for instance, and Velazquez (in the case of his *Gardens*)—do not strike us as unfinished pictures, but as self-sufficient expressions which would lose much of their vigor, perhaps all, were they constrained to be representational. Though Delacroix declared the finished picture superior to the sketch, it was no mere accident that he preserved so many of his sketches; indeed their quality as works of art is equal to that of his best pictures. He remembered Donatello's sketches, Michelangelo's, and the unfinished *Day*. Nor is it due to mere chance that Constable, first of modern landscape painters, treated some of his most important subjects sketchwise, before painting the so-called completed versions. The latter he exhibited; whereas he practically hid away those wonderful sketches, regarding which he wrote that *they* were the real pictures.

Not that the sketch was held to be, inevitably, superior to the completed work. Sketches thus regarded were of a special kind, like Leonardo's *Adoration of the Magi*, some "unfinished" Rembrandts and almost all of Daumier. Raphael's sketches for portraits were presumably of this kind; Ingres' sketch for his *Stratonice* is inferior to the picture at Chantilly. Sketches such as these, which are really "states" of a picture or rehearsals for it, conform to the same principles as the picture itself. Whereas the sketch of the *Narni Bridge* conforms to Corot's personality, and the completed picture to the standards of his day. Like Constable again, Corot kept in his studio, unexhibited, those works of his youth with which across the years his last works, in his most individual style, were to link back. Rubens' sketches are not merely "states." And all these artists combated "finish" just as the religious art of Byzantium had combated realism.

In any case the dividing line between the sketch and the picture was becoming less clearly defined. In many acknowledged masterpieces, in some Venetian works, in the last pictures by Hals and in some English pictures whole passages were treated sketchwise. For Corot as for Constable, Géricault, Delacroix and Daumier the sketch style was a way of escape to a freedom more and more sought after, though always somewhat conscience-stricken at its escapades.

So now that illusionist realism was losing its ascendancy, two-dimensional painting became better understood and, though no one realized it yet, modern Europe was making its first contacts with the arts of the rest of the world. For two-dimensional painting was, and is, world-wide; it prevailed in Egypt, Mesopotamia, Greece, Rome, Mexico, Persia, India, China and Japan—even, except for a few centuries, in Western Europe.

DELACROIX: PIETA

Though for yet awhile the art museum tradition, in its loftiest form, was given pride of place in art history, it had at least ceased to *be* art history to the exclusion of all else. That great tradition formed a compact *bloc*, isolated from the new territories which were in process of being discovered and opening vistas on an as yet uncharted world. The proper sphere of oil painting was becoming that which, beyond all theories and even the noblest dreams, had brought together the pictures in the museums; it was not, as had been thought until now, a question of technique and a series of discoveries, but a language independent of the thing portrayed—as specific, *sui generis*, as music. True, none of the great painters had been unaware that this language existed, but all had given it a subordinate place. Thus to think of painting as an end in itself involved a new conception of the whole function of painting. What art was groping for, and what was discovered by Daumier's cautious and by Manet's intrepid genius, was not some modification of the great tradition, like the changes made successively by earlier Masters, but a complete break, like that which follows the resurgence of a long-forgotten style. A different style and not a different "school"—this would have been unthinkable in periods when the mere notion of a new style never crossed the artists' minds.

Thus at last the painter's talent was no longer pressed into the service of description. His talent, but not his painting as a whole. For, long after the turn of the century, our artists went on piling up "subjects" and "stories" and the walls of our official Salons were cluttered up with these; only henceforth these were the works of artists who no longer counted. Poetry shared in the great adventure and was similarly transformed; with Baudelaire it utterly discarded the "story," though traditionalist poetry continued wallowing for years in narrative and dramatic lyrics. That Zola and Mallarmé could unite in an admiration for Manet is less puzzling than it might seem; different, sometimes contradictory as were their points of view, naturalism, symbolism and modern painting combined to deal its deathblow to the Colossus of the narrative, whose last avatar was the historico-romantic.

Painting and poetry now were called on to give first place to the manner of expression peculiar to each, and this was tantamount to asking for a poetry more purely poetry and painting more intrinsically painting. Some would have added, "and less poetic," but, more accurately, this was poetry of a special, non-descriptive kind. By rejecting illustration, painting was led to reject both that fictional art which had become no more than a caricature of authentic painting, and a world distinct from that of the pleasure of the eye—in the same sense that certain passages in Vittoria, Bach and Beethoven lie beyond the pleasure of the ear. And thus it ceased to feel concerned with the so-called sublime and the transcendental; a man could fully enjoy this art, it seemed, without his soul's being implicated. A rift was developing between art and beauty,

and it went deeper than that which had developed with the decay of "Italianism."

What then was painting by way of becoming now that it no longer either imitated or transfigured? Painting! And this it was coming to mean even in the museum, now that the museum, crowded to overflowing, was no longer more than a challenge to research. For artists had decided that henceforth painting was to dominate its subject-matter instead of being dominated by it.

Rubens with the thick broken-up arabesques of his sketches, Hals (precursor of modern art in this respect) with his figures' strongly stylized hands, Goya with his accents of pure black, Delacroix and Daumier with their rageful slashes— all these men seemed to wish to stamp their personalities on the canvas, like the Primitives who inserted their own faces beside the donors'. The provocative script of each was like a signature, and the painters who thus "signed" their work appeared to have been far more interested in their medium itself than in what was represented.

DAUMIER: THE SCULPTOR'S STUDIO

DELACROIX: ROGER ET ANGÉLIQUE

Yet both medium and drawing remained at the service of representation. In Titian's last phase and in the art of Tintoretto the strongly marked brushstrokes implement dramatic lyricism; and the same is true of Rembrandt, though his lyricism lies beneath the surface. Not without qualms did Delacroix indulge in his fierce slashes, like Rubens at his stormiest. Goya goes farthest of them all, now and again; but then Goya (if we exclude his "voices" and the heavy shadows he inherited from the museum) *is* modern art.

Also, there was one of Guardi's manners, and one of Magnasco's. Where we have Magnasco at his best, the frenzied line, all in notes of exclamation, seems to follow the play of a light fringing the contours

MAGNASCO: PULCHINELLO

of objects and figures—that "frill of light" which Ingres thought beneath the dignity of art. Always this light serves his turn; even when he does not represent it, the brushstrokes follow its unseen ripples. But, amazing as was the achievement of that dazzling Italian tragicomedy, it had quite definite limits, limits which he clearly respects in his Inquisition scenes.

All that modern art took over from him was the artist's right freely to express himself. Problems of light mean little to our painters. (Incidentally, in *Olympia* and *Le Fifre* does the light *really* come from in front?) Modern art began when what the painters called "execution" took the place of "rendering." It used to be said that Manet was incapable of painting a square inch of skin; that the drawing of *Olympia* was done in wire. Those who spoke thus forgot one thing: that for Manet the drawing, the rendering of skin, came second; his sole object was to make a picture. The pink wrap in *Olympia*, the reddish balcony in the little *Bar* and the blue material in *Le Déjeuner sur l'Herbe* are obviously color-patches signifying nothing except color.

MANET: THE SMALL "BAR DES FOLIES-BERGÈRE"

MANET
THE SMALL « BAR DES FOLIES-BERGÈRE » (DETAIL)

Here the picture, whose background had been hitherto a recession, becomes a surface, and this surface becomes not merely an end in itself but the picture's *raison d'être*. Delacroix's sketches, even the boldest, never went beyond dramatizations; Manet (in some of his canvases) treats the world as—uniquely—the stuff of pictures.

For though the touch of color had already been allowed, on occasion, the independence it was to claim henceforth, this had always been done for some effect of emotion, to the communication of which the painting was regarded as a means. "This world of ours," Mallarmé once remarked, "has all the makings of a great book." It would have been as true, indeed truer, to say: "the makings of these pictures."

Hence the affinity between all the major works that followed, and hence, too, the curious anomalies of impressionist theory. The relations between theory and practice in every kind of art often give scope to irony. Artists build theories round what they would like to do, but they do what they can. The work that answers best to the preface of *Cromwell* is certainly not *Ruy Blas* and undoubtedly *L'Annonce faite à Marie*. And, compared with his painting, Courbet's theories seem ludicrous. After Manet had forced his way into recognition, and at the time when Impressionism was vaunting its discoveries and proclaiming its conquest of the true colors of nature—much as if it set out to be an open-air school directed by opticians—at this very time Cézanne (soon to be followed by Gauguin, Seurat and Van Gogh) was creating the most uncompromisingly stylized art that, since El Greco, the Western world had known. The theoreticians of Impressionism asserted that the function of painting was a direct appeal to the eye; but the new painting appealed far more to the eye *qua* picture than *qua* landscape. While the relations between the artist and what he called Nature were being changed, the theorists appraised in terms of, and by reference to, Nature what the painters themselves with admirable self-consistence, if not always deliberately, were achieving in terms of painting. That the banks of the Seine looked more like nature in Sisley's than in Theodore Rousseau's work was beside the point. What the new art aimed at was a reversal of the old subject-picture relationship; the picture now, as picture, took the lead. The landscape had to shift for itself—just as Clemenceau in his portrait was made to look as the painter wanted him to look. This method of judging value only by the eye meant a break with traditional art, in which a painted landscape was subordinated to what is known and thought about it; in Impressionist landscapes distance is not representative but allusive, and very different from Leonardo's distance. Actually when these artists sought for a keener perception of the outside world this was not with a view to reproducing it more faithfully but with a view to intensifying the painting itself. Manet was born in 1832, Pissarro in 1830, Degas in 1834; within a

VAN GOGH: THE CHAIR

space of two years (1839-1841) Cézanne, Sisley, Monet, Rodin, Redon and Renoir were born, and for each of these artists the visible world was a heaven-sent pretext for speaking his own language. Keenness of vision was but a means to an end, that end being the transposition of things seen into a coherent, personal universe. And soon Van Gogh was to come upon the scene. Representation of the world was to be followed by its annexation.

The description of modern art as "the world seen through a temperament" is wrong, for modern art is not just a "way of seeing things." Gauguin did not see in frescoes, Cézanne did not see in volumes, nor Van Gogh in wrought iron. Modern art is, rather, the annexation of forms by means of an inner pattern or schema, which may or may not take the shape of objects, but of which, in any case, figures and objects are no more than the expression. The modern artist's supreme aim is to subdue all things to his style, beginning with the simplest, least promising objects. And his emblem is Van Gogh's famous *Chair*.

For this is not the chair of a Dutch still life which, given its context and lighting, helps to create that atmosphere of slippered ease to which the Netherlands in their decline made everything contribute. This isolated, so little easy chair might stand for an ideogram of the painter's name. The conflict between the artist and the outside world, after smoldering so long, had flared up at last.

The modern landscape is becoming more and more unlike what was called a landscape hitherto, for the earth is disappearing from it, and modern still lifes are ever less like those of the past. We look in vain for the velvety bloom of Chardin's peaches; in a Braque still life the peach no longer has a bloom, the picture has it. Gone are the copper pots and pans and all the other "light-traps"; in still lifes of today the glitter of Dutch glassware has given way to Picasso's packets of tobacco. A still life by Cézanne stands in the same relation to a Dutch still life as does a Cézanne figure to a Titian nude. If landscapes and still lifes —along with some nudes and depersonalized portraits (themselves still lifes)—have come to rank as major *genres*, this is not because Cézanne liked apples, but because he could put himself more effectively into a picture of apples than Raphael could into his portrait of Leo X.

I remember hearing one of our great modern painters remark ironically to Modigliani: "You can paint a still life just as the fancy takes you, and your customer will be delighted; a landscape, and he'll be all over you; a nude—maybe he'll look a bit worried; his wife, you know . . . it's a toss-up how she'll take it. But when you paint his portrait, if you dare to tamper with his sacred phiz—well, he'll be jumping mad!" Even amongst those who genuinely appreciate painting there are many who fail, until confronted with their own faces, to understand this curious alchemy of the painter, which makes their loss

his gain. Every artist of the past who acted thus was modern in some sense; Rembrandt was the first great master whose sitters sometimes dreaded seeing their portraits. The only face to which a painter sometimes truckles is his own—and how queerly suggestive these self-portraits often are! Painting's break with the descriptive and the imaginary was bound to lead to one of two results: either the cult of a total realism (which in practice never was attained, all realism being directed by some value in pursuance of which it employs its technique of imitation); or else the emergence of a new, paramount value—in this case the painter's total domination of all that he portrays, a transmutation of things seen into the stuff of pictures.

When painting was a means of transfiguration, this process, while operating freely on a portrait or a landscape (as in Rembrandt's art), had given rein to the imagination and been persistently endowed with anecdotal glamour. In this connection let us imagine what would have happened had Tintoretto been commissioned to paint three apples on a plate, just that, without any sort of setting. We feel at once that his personality would have stamped itself emphatically on this still life, more so indeed than in any Baroque extravaganza or even the spectacular *Battle of Zara*. For he would have had to transmute the apples by dint of painting and painting alone.

Thus the painter, when he abandoned transfiguration, did not become subservient to the outside world; on the contrary he annexed it. And he forced the fruit to enter into his private universe, just as in the past he would have included it in a transfigured universe. The artist's centuries-old struggle to wrest things from their nature and subdue them to that divine faculty of man whose name was beauty was now diverted to wresting them once again from their nature and subjecting them to that no less divine faculty known as art. No longer made to tell a story, the world seen by the artist was transmuted into painting; the apples of a still life were not glorified apples but glorified color. And the crucial discovery was made that, in order to become painting, the universe seen by the artist had to become a private one, created by himself.

Had Raphael's guardian *daemon* explained (not shown) to him what, in the fullness of time, Van Gogh was going to attempt, Raphael, I imagine, would have perfectly understood the interest this venture might have for Van Gogh himself. But he would certainly have wondered what interest it could have for others. Yet, just as it had been discovered that such things as dramatic line and tragic color actually exist, so it was now discovered that the reduction of all things visible to a private plastic universe seemed to engender a force akin to that of styles, and that (for all those in whose eyes art had a value) it had a value of the same order. Thus the artist's will to annex the world replaced the will to transfigure it, and the infinite variety of forms, hitherto made to converge on religious faith or beauty, now converged on the individual.

So now it was the artist as an individual who took part in the now unending quest, and it was recognized—unequivocally at last—that art is a series of creations couched in a language peculiar to itself; that Cézanne's translucent watercolors sound the same grave bell-notes as Masaccio's frescoes. And now, after an easy if inglorious demise that lingered over fifty years, descriptive art was to have a spectacular resurrection, and find its proper medium: the cinema.

Once the era of discoveries in the technique of representation came to an end, painting began to cast about, with almost feverish eagerness, for a means of rendering movement. Movement alone, it seemed, could now impart to art that power of carrying conviction which had hitherto been implemented by each successive discovery. But movement called for more than a change in methods of portrayal; what with its gestures like those of drowning men Baroque was straining after was not a new treatment of the picture but a picture *sequence*. It is not surprising that an art so much obsessed with theatrical effect, all gestures and emotion, should end up in the motion picture.

RUBENS: ABRAHAM'S SACRIFICE

The photograph had proved its usefulness for passports and the like. But in its attempt to represent life, photography (which within thirty years evolved from Byzantine immobility to a frenzied Baroque) inevitably came up against all the old problems of the painter, one by one. And where the latter halted, it, too, had to halt. With the added handicap that it had no scope for fiction; it could record a dancer's leap, but it could not show the Crusaders entering Jerusalem. But the desire for descriptive pictures, from those of the saints' faces to great historical scenes, has always been focused as much on what people have never seen as on that with which they are familiar.

The attempt to capture movement, which had lasted for four centuries, was held up at the same point in photography as in painting, and the cinema, though it could record movement, merely substituted mobile for unmoving gesticulation. If the great drive towards representation which came to a standstill in Baroque was to continue, the camera had to become independent as regards the scene portrayed.

The problem did not concern the movement of a character within a picture, but the possibility of varying the planes. (The planes change when the camera is moved; it is their sequence that constitutes "cutting." At present the average duration of each is ten seconds.) The problem was not solved mechanically—by tinkering with the camera—but artistically, by the invention of "cutting."

When the motion picture was merely a device for showing figures in movement it was no more (and no less) an art than gramophone recording or ordinary photography. Within a defined space, that of a real or imagined stage, actors performed a vaudeville or drama, and the camera merely recorded their performance. The birth of the cinema as a means of expression dated from the abolition of that narrowly defined space; from the time when the producer had the notion of recording a succession of brief shots (instead of photographing a play continuously), of sometimes having the camera brought near the objective so as to enlarge the figures on the screen, or else moved back; and, above all, of replacing the limitations of the theater by a wide field of vision, the area shown

1950 PHOTOGRAPHY: THE DANCER

on the screen, into which and from which the players made their entries and exits, and which the producer *chose*, instead of having it imposed on him. The means of reproduction in the cinema is the moving photograph, but its means of expression is the sequence of planes.

The story goes that Griffith, when directing one of his early films, was so much struck by the beauty of a girl at a certain moment of the action that he had the cameraman take a series of shots of her, coming closer and closer each time, and then intercalated her face in the appropriate contexts. Thus the close-up was invented. This story illustrates the manner in which one of the great pioneers of filmcraft applied his

genius to its problems, seeking less to operate on the actor (by making him play differently, for instance) than to modify the relations between him and the spectator (by increasing the dimensions of his face). It is interesting to note that when this bold innovation of cutting a body at the waistline changed the whole course of the motion picture, commercial photographers, even the least advanced, had long given up the habit of taking their sitters full length, and were taking them half length, or their faces only. For when the camera and the field were static, the shooting of two characters half-length would have necessitated making the whole picture in this manner; the change came with the discovery of variable planes and "cutting."

Thus the cinema acquired the status of an art only when the director, thanks to this use of different planes, was emancipated from the limitations of the theatre. Henceforth it could choose the significant shots and co-ordinate them, thus remedying its silence by selectivity, and —ceasing to be a record of stage plays—become the ideal medium for pictorializing the anecdote.

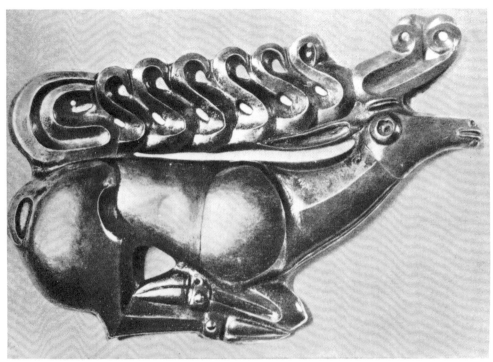

ART OF THE STEPPES (5th CENTURY B.C.). KOSTROMSKAIA, KUBAN. HORSE

DEGAS: HORSE

The divorce of painting from the anecdote had taken place fifty years before this happened. And the cinema confirmed this separation. The suggestion of movement, as found in Degas' "snap-shots" and in the abstractions of Scythian plaques, had taken the place of the representation of movement in the plastic arts. The long-standing feud between purely pictorial expression and the delineation of the world (on which academic art had thrived) now became pointless. The cinema took over the illustrative values which were the artist's when painting was the handmaid of representation, make-believe and emotional appeal, as it took over the methods and glamour of the stage, the cult of beauty

and facial expression. Dimly, across the mists of time, we seem to glimpse a rough-cast mask, chanting and swaying to the slow rhythm of a ritual dance, when today before our eyes there looms in close-up some immense, contorted face, muttering across the shadows it submerges.

SUMERIAN MASK (3rd MILLENNIUM B.C.)

The liberation of art from narrative assured that mastery of the visible world which every great painter was henceforth to exercise. Never before in the history of art had one and the same impulse given rise to works so diverse as those of Daumier and Manet; of Renoir, Monet, Rodin and Cézanne; of Gauguin, Van Gogh and Seurat; of Rouault, Matisse, Braque and Picasso. And this very diversity served to throw light on many other forms of art, from such resuscitated artists as Piero della Francesca and Vermeer to the Romanesque frescoes

and to Crete; just as, from Polynesian art to the great periods of China and India, it is throwing light on the long record of successive conquests that make art history. Michelangelo had a collection of antiques, and Rembrandt (as he used to say) of coats-of-mail and rags-and-tatters; in Picasso's studio—whence day after day he looses on the world those strange works in which the conflict between the artist and life's forms moves to a climax—the show-cases look like a miniature museum of "barbarian" art. This multifariousness of forms in modern individualist art has made it easier for us to accept the infinite variety of the past, each style of which as it emerges, suggests to us an individual artist, at long last resuscitated. The Masters of Villeneuve and Nouans, Grünewald, El Greco, Georges de Latour, Uccello, Masaccio, Tura, Le Nain, Chardin, Goya and Daumier have been either hailed as revelations or promoted to the front rank; while a host of other arts have come to the fore: from Pheidias to the *Koré of Euthydikos*, then the Cretans; from the Assyrians to Babylon; then, yet further back, to the Sumerians. And all are seemingly united by virtue of the metamorphosis they undergo in this new realm of art which has replaced that of beauty; as though our excavations were revealing to us not so much the world's past as our own future.

Not that these works on entering our Museum without Walls will disclaim history—as did the classical works when they entered the official museums of the recent past. Rather, they still link up with history, though precariously (the link is sometimes snapped); their metamorphosis, though infusing new life into history as well, does not affect it to the same extent as it affects the works of art themselves. And while we have come to know cultures other than those which built up the European tradition, this knowledge has not modified our general outlook to the same extent as the works of art have affected our sensibility. It is in terms of a world-wide order that we are sorting out, tentatively as yet, the successive resuscitations of the whole world's past that are filling the first Museum without Walls. We have seen how greatly our efforts to elucidate this order (associated with the discovery that the values of art and those of culture do not necessarily coincide) have modified our attitude towards Greece; our notions of the life and history of art, indeed our notions of art itself, have changed still more, now that the significance of ancient statuary is being appraised in terms of the ancient world as a whole; and now that the struggles of dying Rome against the hordes of barbarism are being replaced in our memories by those of dead Delphi against the East, India and China, and the non-Romanized barbarian world. With the result that a large share of our art heritage is now derived from peoples whose idea of art was quite other than ours, and even from peoples to whom the very idea of art meant nothing.

GREEK ART: THE APOLLO OF THE TIBER (DETAIL)

PART TWO

THE METAMORPHOSES OF APOLLO

BURGUNDIAN ART (6th CENTURY): BELT-BUCKLE

When Caesar died, all that remained of what in Greece had spelt the liberation of Man was pictures made to please the eye, or to gratify pride. The nineteenth century thought to see the decadence of these forms—following the Empire's decay—in Gallo-Roman art, the so-called retrograde art of the West. But the tireless inventory of world art on which our century has embarked (incomplete though it still is) shows that this retrogression covered the whole ancient world: Gaul, Spain, Egypt, Syria, Arabia, Bactria, Gandhara. Indeed this supposedly debased type of art is an art form as widespread and significant as that which, beginning at the Acropolis of Delphi, lasted until the days of Constantine. Ancient art had won more victories than any conqueror and united Caesar's empire with Alexander's. Once the man of the classical age was overwhelmed, the great wave of retrogression swept the world, from Gallia Narbonensis to Transoxiana.

We have seen that notion of retrograde art revived ("revived," since from the sixteenth century to the eighteenth, all medieval art was considered retrograde) with reference to works which give the impression of being clumsy copies of the works of a culture that had passed away or was in process of dissolution. True, incompetence is not always present where in the seventeenth century its presence was inferred; yet, while we may assent (though not without qualifications) to the generalization that great artists always do what they set out to do, dare we say as much of every sculptor? Seen in time's perspective,

PALESTINIAN ART (5th CENTURY?)

not a few works that in their day passed for the acme of craftsmanship have come to look almost primitive. It is obvious that clumsy forms exist; but not that they are botched attempts at something better. Rather, they are signs, and often bear traces of the simple gestures which went to their making. Thus the noses of clay figures in the past and the faces children make today with breadcrumbs are the result of squeezing with the fingers; likewise the naïve complexity of the "little men" drawn by youngsters—a head of sorts, two thick strokes for legs, two more for arms, and thin ones for the fingers—are of the same order as the spots or holes which indicate the eyes in the clay figures. The seventeenth century read this "childishness" into arts that differed from its own, because it believed that arts had a childhood, and because it knew nothing of the art of children. But who today would read childishness into Romanesque art? There are clumsy artists, but there is no such thing as a clumsy style.

The extreme form of the retrograde copy is obviously the sign. But this has rarely survived; with the result that we never come across an *ensemble* of signs as opposed to the *ensemble* of a style. The fact that the material in which the sign was made was often perishable has told against its survival. Thus, while an Egyptian statue involved the use of granite, the sign was often made in lines of chalk or charcoal. Once the sign came to be engraved or incised, this meant that it was on the point of changing. Roman forms which seemed to tend towards the sign were adjusted to the forms brought in by the barbarian invasions; the figures on Burgundian sword-belts look more akin to fetishes than to the conventional signs of, for example, gypsies. Thus a retrograde art is, in effect, an art in which forms that have been inherited, but drained of their original significance, are more perceptible in it than the new forms that are being built up. In this sense Gallo-Roman art was "retrograde" so long as its Roman elements were more noticeable than those which later built up Romanesque; but if all it stood for were the death throes of Roman art, there would exist no real Gallo-Roman art, but only Gallo-Roman curios. For an art lives on what it brings in, not on what it discards. The notion of a regression may be valid as regards the march of history, but not as regards art *qua* art; an art which breaks up into ideograms is regressive, an art which is progressing towards a new style is not—and it is obvious that Romanesque is not a mere decadent form of the art of classical Antiquity.

More clearly than many better known arts of savage races, the art of the Celts illustrates the evolution of a stylized form, sometimes towards a retrogression, sometimes towards a new significance. Photographic enlargement has won for Celtic coins a place in art from which their small dimensions, even their character, seemed hitherto to bar them. (After the photograph reproducing an original, came the cinema

which has no original; in the case of these coins the original is merely the source of the enlargement.) Though it is hard to trace the interrelations between these forms, which ranged from England to Transylvania, we can study to advantage the metamorphoses which, during several centuries, were imposed on the coins of antiquity. In some cases they moved from portrayal to the sign; in others from humanistic expression to barbarian expression. And all these coins have one point of departure: the stater minted by Philip II of Macedonia.

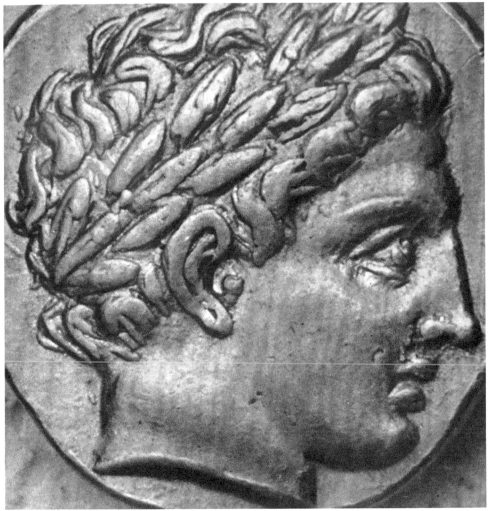

STATER OF PHILIP II (CA. 350 B.C.)

GALLIC "IMITATION" OF A RHODA COIN

The *Hermes* on the Macedonian coin becomes more and more transformed, the further the new coins are from the Mediterranean. Thus in Gaul the "imitations" of the Hermes are completely different from the prototype; even in Rhoda (Catalonia) we find traces of the style of the reliefs of the Second Iron Age (just as we see a certain angularity, more or less pronounced, persisting through so many types of Chinese art). The makers of these coins built up the profile with small, separately modeled, globules of metal; this *pastillage* differed from the Sumerian *pastillage*, and, in some coins which imitate those of Rhoda, reaches a high level of expressive art. Doubtless the procedure here is of a glyptic order; nevertheless, once we become familiar with these figures, they lose the qualities which seem to assimilate them to Sumerian seals or engraved stones. With the Osismii of Armorica and in Jersey

OSISMII (BRITTANY): GOLD COIN

PARISII

we find that these coins—by way of how many intermediate stages?—
have broken wholly with their origins and acquired a style of their
own without the least reminiscence of the stater coined by Philip.

In a later phase the relief became less pronounced, but the drawing
still relied on binding masses with thick outlines. The faces on the coins
of the Parisii look as if they were chalked in on a dark background, but
here, too, the outlines enclose masses like those of the earlier profiles.
These masses can easily be reconstituted; the two balls at the end of the
spurlike mouth belong to them. Sometimes attrition (or the coin-molder
himself) has flattened the planes building up the face, which in coalescing
acquire a swirling movement reminding us of Baroque.

At its opposite pole this art raises what were originally sunken
passages into relief, but retains the intricate unity of volumes which
characterizes these Celtic coins. We have only vestiges here to whet
our imagination; yet surely those early artists who for the Macedonian

CARNUTES (ETAMPES)

CORIOSOLITES (NORTH OF FRANCE)

Hermes substituted that harmony of forms to which the coins of the Osismii so splendidly testify were of the race of men we call Great Masters. Hair, nose and lips are in relief in the coins of the Osismii and Coriosolites; but the eyelids, too, were ridges in the former, whereas in the latter they are hollows; similarly the eye has become a hollow instead of protruding. Most noteworthy of all, the cheek is almost flat and less prominent than the forehead. The lower part of the face has become purely abstract and another abstract passage joins the nose with what began as a lock of hair. We find as much diversity in these coin-makers at their best as in Romanesque sculpture.

Did these men, one wonders, alter the Mediterranean coins because they did not grasp their meaning, or was it not, rather, because that meaning did not interest them? They replace a charioteer's cloak by a buckler, partly no doubt because the cloak is effaced on the original, but also because they prefer to engrave a buckler; next, they replace the buckler by a winged face. When they substitute a sun for an ear, need we assume they failed to notice that a head has ears? Likewise the man-headed horse, so widespread at the time, is not due to an error of interpretation. Rarely have artists displayed to better advantage than on these small engraved surfaces a happy gift of clothing the latent framework of a style with whatever living forms specially took their fancy. Thus the curved patch of a lion on the coins of Marseilles became one of a squid; loosed from the neck, the pearl necklace we see on classical coins scattered into the little "prehistoric" blobs of the Armorican coins. A list of these successive mutations would, no doubt, be helpful—but can we not guess already what it would have to tell us? From "degeneration" to "degeneration" the head of Hermes on the stater of Philip II disintegrated; but it so happened that this disintegration culminated in—a lion's head.

TRANSYLVANIA (RUMANIA)

From one end of Europe to the other the "barbarians" set to reconstructing the Hermes on their own lines—until they succeeded in so doing, or the face disappeared altogether.

In the latter case, the result was a startling modernism. The engraver was no less obsessed by the circular surface he was about to pattern with abstract lines than is a modern artist by the rectangle of

SOMME DISTRICT

his canvas. The forms of the Atrebates, whose abstractions were still governed by a feeling for movement akin to that of André Masson, were replaced in England and the Somme region by static compositions; static, yet in their lay-out almost frenzied—which is all the more surprising in that the art of making coins is not an art of solitude (nor, for that matter, is Negro art). Here the numismatist may see merely signs; not so the sculptor. No longer have we here an eye and there a nose disseminated on the surface; instead, we have that menacing sickle and, below, a concave ring balancing the convex boss.

AQUITAINE

One of the motifs that most often figure on the reverse of these coins is the winged horse. As regards the horse, civilized and barbaric races had more in common than as regarding Man; both Vercingetorix and Alexander were—amongst other things—cavalry generals. In Aquitania the horse became a geometrical figure, but freely and variously treated; sometimes its curve is regulated by the animal's hind leg and the head of its rider (who has replaced the wing), while the body of the latter and the horse's tail are straight lines, and the mane is built up with the little globules characteristic of this art. In the coin of the Lemovices, the horse

REVERSE OF STATER OF PHILIP II

is in keeping with its fantastic rider; we find it again amongst the Parisii, *minus* its rider and the wings, and here its form has split asunder into arabesques—those of an almost purely ornamental art resembling that of Persian pottery.

But we have nothing of the East here. Nor of the Steppes. The art of the latter (sometimes akin to that of Altamira) shows us armored animals closely locked in combat; this interlocking, as obligatory for the artist as was the frontal posture in Egypt, musculature in Assyria, and free movement in Greece, is here replaced by a dislocation of forms. Even when the Armorican coins lost their sinewy structure, and when in the Dordogne (home of caveman art) the engravers seem harking back, across the chaos of prehistory, to the totemic boar, each of the lines looks like a split-off bone. Everywhere the horse breaks up into fragments, as does the human face, and, like it, ends up as a disjointed ideogram.

LEMOVICES (HAUTE-VIENNE): COIN (DETAIL)

The difference between these compositions and the sign is all the more apparent when we contrast them with the coins of certain tribes (notably the Veliocasses) which were mere signs and nothing more. Barbaric expressionism, more pronounced in the Armorican coins than in the "hammer gods" of ancient Gaul, and more vehement even than that of the heads of Roquepertuse and Antremont, has died out of them (assuming that the Veliocasses ever practiced it); and the characteristics of the compositions of the Somme region are also absent. Indeed the lines in these ideograms are more of the nature of inscriptions than arranged in terms of any preconceived design. The best Armorican and English figures take to pieces their classical prototypes with a view to recombining them in new patterns; whereas the ideogram does not indicate a face at all: only two tresses, a headband, a nose, an eye. Indeed, did we not know its origin, we should be unable to decipher it; the ear, for instance, has become a sun! Here we have not a metamorphosis but total retrogression, and in this art, as in so many others, this triumph of the sign is a sign of death.

Can so distinctive a style have emerged merely as a sort of by-product in the process of minting these coins? We find traces of it in some Gothic statuettes in metal (no wood carving of the period has survived). In any case its figures clearly show the triumph of the "barbarian" creative impulse over the Macedonian Hermes, and illustrate, in the world-wide break-up of the forms of antiquity from Elché to Lung-Mên, which of their elements underwent a metamorphosis, and which passed out of existence.

The art of the great retrogression made less headway in places where the Roman civilization was falling to pieces than in those in which it was being transformed. The carvers of the tombs at Arles and those of the Gandhara schist were alike feeling their way towards creating the same squat figures; and what sculptor would accept a theory that

VELIOCASSES (BASSE-SEINE)

GALLO-ROMAN ART (ARLES): THE GOOD SHEPHERD

craftsmen capable of making such figures and of imposing such unity of style would have been incapable of making more faithful copies, had they so desired? The clumsiness of copyists can destroy a style, but it cannot create a new one; and even the least expert craftsman has little difficulty in reproducing proportions correctly. True, the rendering of movement needs to be learnt; and this is probably the reason why this art has been so much misunderstood. But these "retrograde" sculptors did not dispense with movement alone; they also omitted to round off planes, and surely the smoothing down of sharp edges was not beyond their competence. When they fell to replacing the folds of Greco-Roman drapery by heavy, parallel, often hollowed-out folds, and

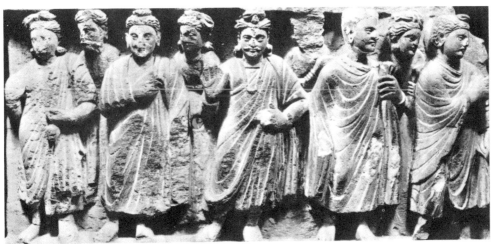

GANDHARA (2nd CENTURY): BODHISATTVA

145

when they gradually rediscovered symbolic representation (as it had been practiced for three thousand years, before being eclipsed during the six centuries of Greco-Roman supremacy), they acted thus because the Roman and Alexandrian concept of Man was passing away. Indeed, from Byzantium to Bactria, the dying Empire regarded the Aphrodites and Venuses much as we regard the wax busts in hairdressers' windows. They were not ignored; but unacceptable.

The art of this period is styled "popular." We must not be misled by the suggestion of naïveté that the word has nowadays. The People's Art, as Michelet called it, the art of those whom the Gospel calls "the poor in spirit," it is the art of that pregnant poverty which, in a sudden sublimation, gives rise to religions and revolutions. It emerges in transitional periods when an art, grown aristocratic and pagan, gives birth in its death throes to a religious, even theocratic art; Romanesque, too, has been called popular. Owing to a long tradition and a continuity of culture, Greek art had become aristocratic. But in periods of general upheaval art repudiates tradition—and what this art repudiated was the legacy of Greek culture. And consequently the artist, as Greece conceived him, ceased to exist. So long as his task had been to perpetuate a style, technical qualifications were expected of him. But what was the point of learning anatomy and academic drawing, when all that they ultimately stood for had become valueless? It is only in a culture of a special type that art calls for this kind of proficiency.

True, these craftsmen of the Retrogression, like all craftsmen, copied; but not the antique. On the contrary, they copied what the creators of barbarian and Buddhist forms, turn by turn, forced upon the art of Antiquity, as elsewhere they copied what the Byzantines forced upon their art: sunken instead of projecting folds of drapery, in Asia lowered eyes, at Byzantium the idioms of the East. But though all craftsmanship is linked up with a past, creative art is given its direction by the future, and illuminated for us by what that future brings to it; its life-story is the life-story of its forward-looking works. Thus we shall see these works imparting its significance to the new world that is in the making, and destroying for its benefit the world of the past. For genius is inseparable from that which gives it birth as is a conflagration from that which it consumes.

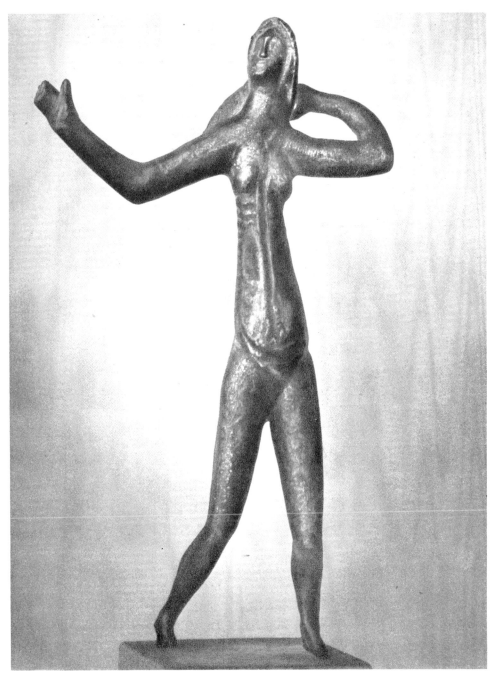

GALLO-ROMAN ART: VENUS ANADYOMENE

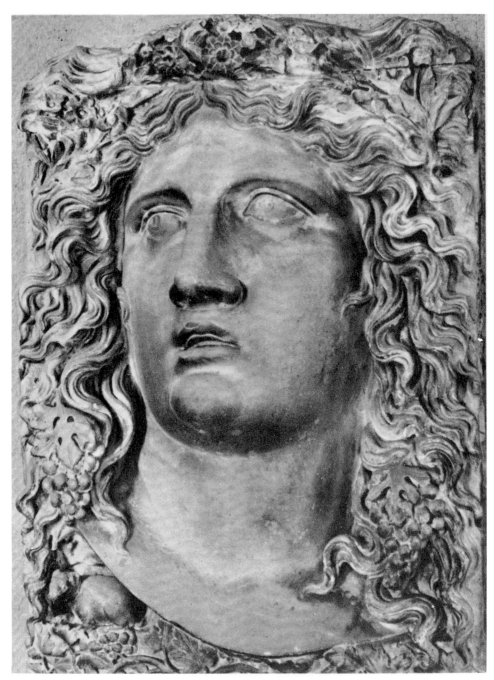

HELLENISTIC ART: THE SUN

II Whereas at Byzantium and in Europe during the great invasions the forms of antiquity were to encounter Christ and the barbarians, it was Buddha they encountered in the Macedonian kingdoms of the East.

The Greek soul and the Buddhist of that period were not without a common language; for though Asiatic, Buddhism is not oriental. The languorous grace of its kneeling women, with the white roses of Kashmir and Gandhara drooping between their clasped hands in a gesture of meek adoration, had nothing of the oriental's groveling before a fear-compelling Presence. While Greece bade Man confront destiny on equal terms, Buddhism aspired to show him, at least, a way of escape from destiny. It aimed at liberating Man from action no less than from the cycle of rebirths, from the tyranny of his desires no less than from that of the cosmos; the one permissible emotion was a pity forlorn as the world—two homeless children clasping hands in a dead city, loud with the tedium of apes and the heavy flight of peacocks. Reincarnation—unknown to primitive India—had steeped all things in its eternity. Buddhist philosophy was more closely associated with the Vedas than the nineteenth century supposed, but the sense of destiny in ancient India had weighed so heavily (how fervent was Buddha's monition to "escape from the wheel!") that it now seemed as though the sermon in the Deer Park were making the bleak immensity of the steppes break into flower, and shedding pity on the world. The forms of Greece revealed to Central Asia another way of liberation. But liberation with the Greeks was as Protean as man; and when, after the times of Alexander, it assumed a less clean-cut form, it became by the same token more accessible to Asia. By the time the Apollo of Olympia had reached the Pamirs he had been transformed into a sungod. The *Princes* of the schists may suggest a Greek Baroque; actually they pertain to a Hellenistic art that has been stiffened up. For the liberation Buddhism stood for was as narrow and rigorous as its one-way Path; always in art the absolute takes the color of the emotions leading up to it. The features of a Buddhist statue tell of a deliverance, and the face of man set free, if there be only one path to freedom, is the likeness of his Saviour.

Hellenism and Buddhism had common enemies in Brahmanism and in that medley of local primitive religions which India as a whole seems to have influenced but little. Preached under the auspices of the Indian King Asoka, Buddhism enjoyed the patronage of the Greek King Menander and the Indo-Scythian King Kanishka. But the Greco-Buddhist art we know best belongs to a period five centuries later than Alexander. In the earlier, obscure period Hellenistic statues seem to have come into contact with effigies of a "popular" order; probably these effigies, which had been in vogue for two centuries at the foot of the Pamir highlands when at last the Buddha's evangel reached that remote region, were the only full-fledged forms it encountered there.

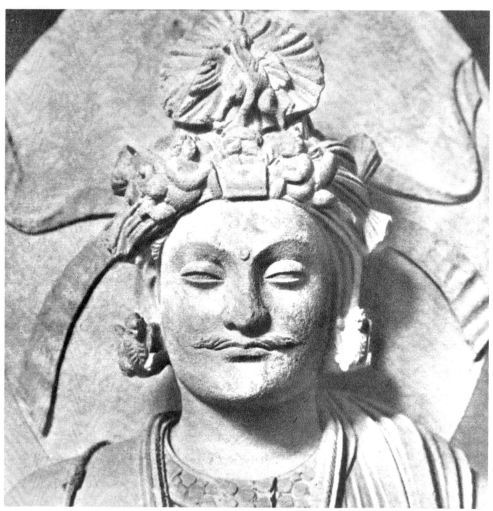

SHAHBAZGARHI: BODHISATTVA. SCHIST

We know nothing of this encounter. The Greek kingdoms of Central Asia having been cut off from the Hellenistic world by the Parthian conquests (though not severed from its culture—they were like a South Africa severed from Great Britain), Alexandrian forms, which had held their ground without difficulty until the days of Menander, continued to hold it no less effectively under the Indo-Scythian monarchies (the Kushan overlordship notwithstanding). If they always have the air of being a transformation of some Indian or Bactrian art, this is because they shaped themselves in Central Asia, and perhaps

because we forget how relatively late was the coming of Buddhism to this region. No doubt, at certain periods, they profoundly modified indigenous forms. But to begin with and oftener than not it was they that were transformed. Indeed, until they reached the Ganges and China, the Alexandrian forms acted rather as a leaven than as the basic stuff of art. Romanesque art is a conquest of Byzantium by the West, not *vice versa;* likewise the art that came from Greece did not overwhelm the local, Indian arts, but was itself transmuted into Buddhist art.

Moreover Buddhism did not find its path more speedily than Christendom was to find its own. This art, which was developing alongside that of the subtlest sculptors of animals the world has known, in the reign of a king who had trees planted on the roadsides "so as to rest men and beasts," practically ignored animals. (So, for that matter, did Franciscan art.) Rather, it set out to portray the Sage, hitherto represented by means of symbols as was the Christ of the Catacombs. It seems to have begun with the style of the earliest schists: processional scenes like those of Arles, which culminated in Byzantine immobility and that hieratic parallelism of planes and bodies in which the seething vitality of the Panathenaic festivals drained itself away, from the Atlantic to the Indus. It has much in it of that ponderous art of the Indian jewelers, which brings to mind those garlands of tuberoses worn by the temple priests; sometimes, too, it is endowed with exquisite poetic feeling—for nowhere is the swansong of dying Greece more poignant than in those Pamir backlands whence India looks out upon the Tartar deserts, as in the far South she confronts the junks of Malaya. It is a somewhat rudimentary art, as is everywhere defunctive Greco-Roman: in Provence no less than in Palmyra. And suddenly we come upon a head which might be that of the blackstone god of Heliogabalus. And likenesses of the conquerors with curly, sleeked moustaches.

Next came the art of the stucco-painters, which lasted over several centuries, intermingling (no exact dates can be assigned) primitive or retrograde works with mass-produced copies; occasional reminiscences of Iranian art with others of Flavian art or Chinese portraits. Thus into these desert havens came mixed cargoes of to-be museum pieces.

The earliest Buddhas of Afghanistan are copies of Apollo, to which are added the conventional signs: the mark on the forehead symbolizing the third eye, and the "mount of wisdom" on the top of the head. Apollo's face itself was a sign, as Hermes Kriophoros was to become at Rome a sign of the Good Shepherd, that is, of Christ. Being ethical rather than metaphysical religions, and based on life-stories far more precise than those of Osiris, Zeus or Vishnu, Christianity and Buddhism were bound to portray individuals, Jesus and Siddhartha; but also to portray that which made them Christ and Buddha. As a makeshift it was permissible to use Apollo and the Good Shepherd as symbols; but there was no question of making likenesses of them. A new style, *their*

THE BUDDHIST APOLLO

own, was needed to express the divine quality in each.

Greece had always been averse from abstract signs; thus, to begin with, the sculptors who drew their inspiration from her were naturally led to represent supreme wisdom in the guise of supreme beauty. But neither the spirit of Buddhism nor its clergy could tolerate for long the indomitable freedom implicit in Greek forms, or the suggestions of sensual pleasure Asia tended to add to them. Thus while a motionless parallelism of bodies replaced the free movement of the Hellenic dance, Buddha's outward aspect was altered; his garment was brought into line with monastic robes and no longer modeled on the Mediterranean toga. Above all, sculpture was called on to relinquish that assertion of man's freedom proclaimed so triumphantly in the arts of Greece; and to approximate more and more (as also happened, later, in Gaul and in Byzantium) the trance-bound style of the Eternal. In the early phase the Greek spirit had brought to Buddhism its genius for portrayal, breathed life (for the first time, it would seem) into scenes from the life of the Sage, and replaced by his bodily presence the vacant throne which until then had symbolized the Illumination. But now the convent had replaced the palace and works of sculpture were no longer shown in public places but only within sacred precincts where the sole gestures the visitor allowed himself were ritual, almost priestly. And soon the sculptors took to assigning a fixed symbolical gesture to each incident of the Buddha's life. Even when the Buddha

himself is being portrayed we find hints of that early aversion for the "likeness," manifested in the vacant throne of the Illumination, now replaced by the *Illuminato* himself. Art no longer catered for the moods of everyday life, but for those rare moments when, in contact with a mediating Presence, men have glimpses of the meaning of the universe. In any Buddhist convent Greek art would have looked even less in keeping than on Mount Athos or at the Grande Chartreuse. For now the artists' quest was for the lines of silence, keyed to the solitary hours of meditation.

The history of Buddhist art is primarily that of the conquest of immobility. Christendom is dominated by the tragic picture of an execution; Buddhism by the tranquil picture of

GANDHARA (4th CENTURY?): MONK

a meditation. Thus, throughout the centuries of the "high" periods of Buddhist art, we find a gradual lowering of the eyelids, a tightening of the drawing of the face that seems, as it were, to seal it fast upon the Buddha's musings. Hence, too, the closer and closer wrapping of the mantle round the body, and the increasing abstractness of the body itself. The classical, especially the Alexandrian nude always suggested movement; the Buddhist nude is not merely motionless, but exempt from movement.

Thus the gesture was the first to go. For a while the Apollonian heads were left alone, because they were *signs;* often, indeed, intruders in that motionless, meditative world, they give the impression of having been grafted on to bodies to which they do not properly belong. However, in time Apollo came to be regarded with disfavor, and the artists

GANDHARA (4th CENTURY): BUDDHA

sought to set up against his forms a new incarnation of their liberating power. Though the classical line seemed still intact, there was now a tendency to use sharp ridges instead of rounded-off planes. But the volumes of the faces of Gandhara were too different from the architectural volumes of primitive Greece to permit Apollo's face, however far the hardening was pushed, to revert to the Auriga's. The line that took the place of the elusive, flowing line of Greece was put not to the service of architecture, but (to begin with) of pure calligraphy. The eye in the Bamyan frescoes seems to be composed of those flourishes known as penstrokes. Whether racial in origin or not, the nose that replaces the Greek nose is that whose line best harmonizes with the linked brackets into which so many a mouth has been converted

This calligraphy was not a chance development. At Byzantium, a new calligraphy, angular in this case, was introduced, while in the West the illuminators of the Merovingian manuscripts invented yet another, gradually softened down into the fragile grace of Adhemar de Chabannes. And no sooner was Romanesque set free from the austerity of Autun and Cluny than it acquired something of the florid line of Catalonia. The calligraphy of Gandhara ended in Indian painting, which was closely bound up with the dance; its curves became more and more assimilated to those movements of the nautch which lurk behind the art of Ajanta, as ritual gesture underlies Byzantine art. Thus, too, the rippling line of Villard de Hennecourt and French alabaster

DRAWING FROM THE ALBUM OF VILLARD DE HENNECOURT (13th CENTURY)

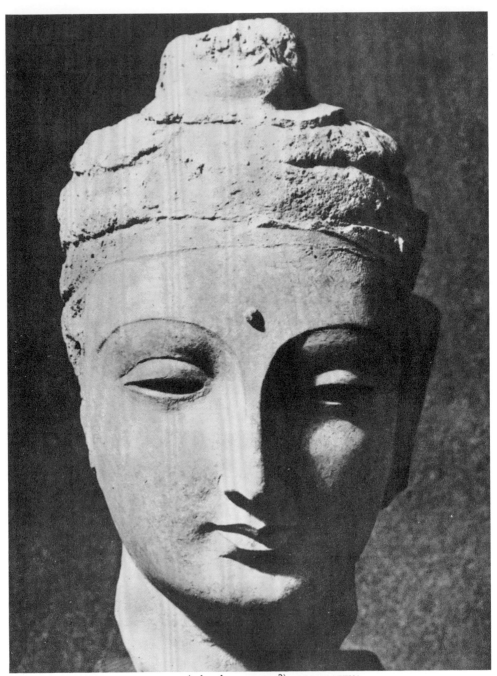

GANDHARA (4th-5th CENTURY?): BODHISATTVA

work worked its way into the dainty ivories of the period, before being submerged in the bold calligraphy of Gothic flutings.

Every art, indeed, develops its own calligraphy, which is taken over in its large-scale works though it may not always be in keeping with them. Just as the monumental styles of Byzantium and Western Europe developed on parallel lines to a calligraphy which synchronized with their progress (though actually it had no direct effect on this), so into the eclectic style of Gandhara there entered forms, sometimes perhaps deriving from the Iranian hinterland, which seconded Greco - Buddhist art in the struggle it was waging against the forms of Greece. Incisive drawing and modeling assumed the functions that the "touch" was to have in modern painting. Though sharp edges reappeared, the planes of the cheeks still were modeled; but the lips and eyelids, delicately wrought though they were, seem to have been cut out with a knife (like those of the *Lady of Elché* and those of Romanesque heads).

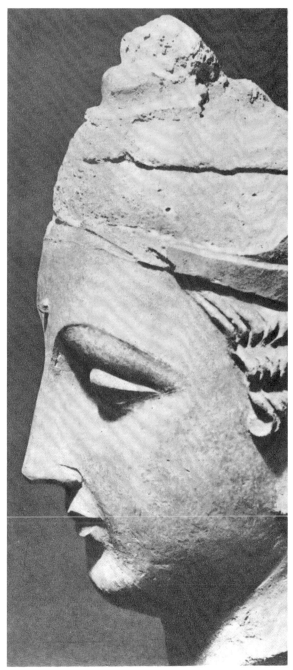

PROFILE OF THE BODHISATTVA OF THE OPPOSITE PAGE

157

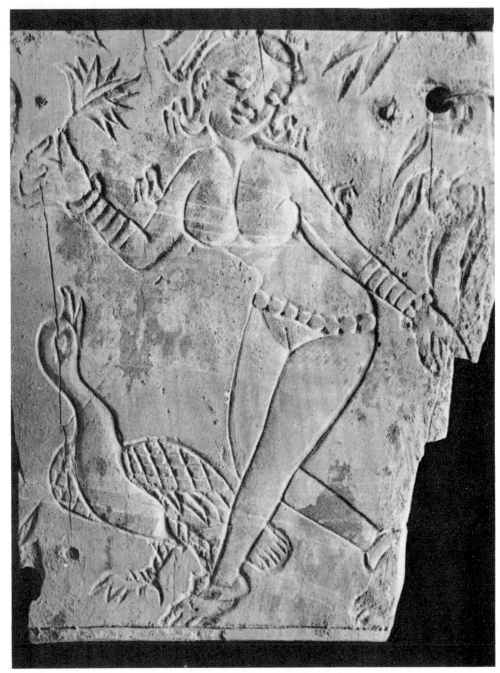

BEGRAM (AFGHANISTAN, 2nd-3rd CENTURY): IVORY

When our medieval art arose the highly developed forms of antiquity had come in contact with that primitive culture, at once agricultural and war-like, upon which the Christianized barbarians were thrusting their crosses. In Asia the same classical forms were encountering the culture illustrated by the *Milindapanha*, that famous debate between Greek philosophers and Buddhist theologians convened by the Indo-Greek King Menander. Here in Europe were plows and battles-axes; there, in Asia, docile congregations bending their tall yellow lilies before the Holy One. Though the steppes were perilously near, these oases had lost neither their glasswork nor their ivories,

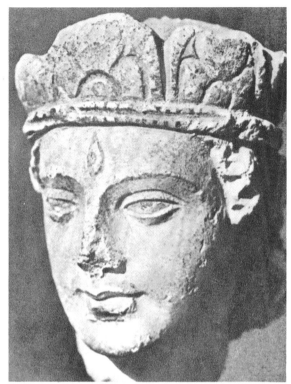

"GOTHICO-BUDDHIST" ART (4th CENTURY?)

neither their jewelry nor their ceremonial. In these high valleys Hellenistic art came into contact, not with the Merovingians and their tortures, but with supreme refinement. It was an Indo-Scythian King, Kanishka, who presided over the Fourth Buddhist Council. The replacement of blue schist by a soft material, stucco, had both good reasons and significant results. In all the lands where the spirit of compassion had won the day, bringing to living faces a smile that Buddhist art was soon to make its own, the so-called humanist forms were enlisted in the service of this humbly triumphant pity, now that they had prepared the way for its coming. The humanism they served took various forms. In western Europe they seemed to sponsor both Gothic gentleness and ecclesiastical pomp; none of the Masters of Rheims, however, was a Pheidias or a Lysippus, nor were Giotto and Michelangelo. The term "Gothico-Buddhist" as applied to some of the eastern works of art of the period is apt enough, in so far as it distinguishes them from the early schist carving and the Apollonian figures; but, actually, they are not so much Gothic as Renascent. Even in such as seem to come nearest the *Smiling Angel* of Rheims, the planes

THE SMILING ANGEL OF RHEIMS (13th CENTURY)

GANDHARA (4th CENTURY): BUDDHIST HEAD

are as different from those of the *Angel* as from those of Praxiteles; we need but compare the eyes, and even the mouths. What these smiles have in common is an all-embracing tenderness in which Greek idealization, now imbued with pity, might seem to link up with Gothic, were it possible to conceive of a Gothic which, out of all the Christian iconography, portrayed the angels only.

The reason why the life-story of Gandharan art has special interest for the sculptor lies precisely in this fact that, by-passing the intermediate stages of Romanesque and Gothic, it came into line with our Renaissance. It discovered repose, but not hieratic immobility, and moved on from the Antique to Giotto by way of Nicola Pisano, without any Middle Ages, and neither hell nor the supramundane played any part in the transition. Setting out to express the highest wisdom through the Sage's face, Buddhism compelled each of its artists to extract some aspect of deliverance from the chaos of appearances; its stylization aimed at making the visible world a *décor* of serenity—as Egyptian stylization had made it a *décor* of eternity.

GUPTA ART (5th CENTURY)

Thus in the East the art of Gandhara superseded Hellenistic art, following in whose footsteps it set forth on its long pilgrimage, to India and China—and to its death.

In the fifth century in India it called forth the great Gupta figures. And called them forth against itself. Though it is in those of its figures which have rid themselves of Hellenistic elements that the art of Gandhara makes good, a real fusion between Buddhism and the

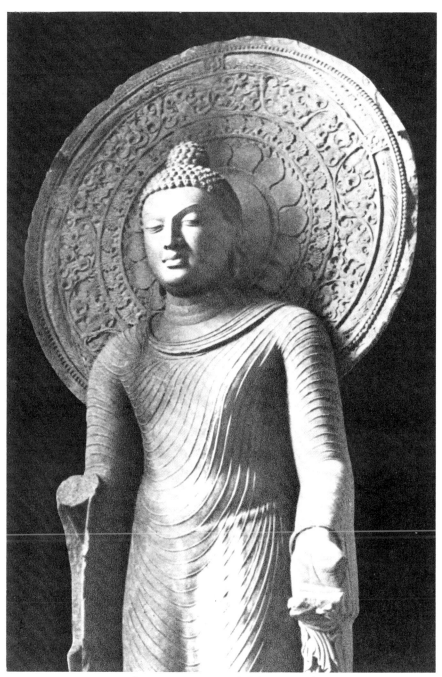

GUPTA ART (MATHURA, INDIA, 5th-6th CENTURY): BUDDHA

THE MAHESAMURTI OF ELEPHANTA (8th-9th CENTURY)

Greek spirit had taken place in this strongly hellenized region of the East. At Mathura it encountered the Buddhism of the Ganges. But it was not Gandharan art that took effect by way of the Gupta statues; nor yet was it merely taken over by eternal India and incorporated in her art. The Mathura Buddha is neither a figure of Sanchi nor one of Amaravati; indeed, it is hardly Indian at all, but neither is it Hellenistic. Here we seem to find the art of Gandhara operating on forms that existed before its coming; acting like a leaven. Just as Buddhism endowed Brahman-ism with a universality to which the latter laid no claim, so this art conjured up from India figures that India had never known before. On its return from its exodus Buddhism called on the Indian artists to evolve a figure so much simplified and stripped of foreign accretions that the whole Buddhist world could see itself in it. The Hellenistic venture had run its course, and now, until the come-back of Brahmanism, the Buddha belonged to India alone.

But soon an Indian sculptor was to make the Mahesamurti of Elephanta.

It was not through the Indian seaports but by way of the desert oases that Greco-Buddhist art was to spread to China. And before its glory had dwindled and died under the sands and the blue poppies of the Pamirs, it had already reached Yun Kang and Lung-Mên.

Obviously belonging to it is that gigantic Lung-Mên Buddha which seems to have called forth from the ageless Chinese mountains the whole company of statues encircling it. But what is the origin of their Roman-esque rigidity? No doubt the North has a way of robbing Greek forms of their happy unconstraint—that of a growing plant, an athlete, a woman bathing—and of subjecting them to the discipline of stone; doubtless, too, it knew nothing of the Sassanian reliefs carved in the rock-face. But did Tibet or the Pamir uplands produce nothing comparable to these cathedrals of solitude? These pilgrim statues, which after long roaming across the wastes of Gobi, reached the Pacific seaboard seem to have been suddenly transmuted by the Enlightenment. Thus an authen-tically religious art took root in China, as distinct as Romanesque from the hieratic art of the ancient East. It was now on earth that the drama of Man was being enacted—as though the Star of Bethlehem had changed for ever the fate-fraught firmament of the Chaldeans.

True, the humanism (ruthless on occasion) of China had taken over Buddhism without exposing it, as it was exposed in India, to the constant threat of a metaphysical reaction which would nullify its message, even its cosmic pity. China had manifested an incomparable sense of style; the magical geometry of the Ts'in period had curbed effectively the exuberance of the Indian arts. Whether submissive or in revolt, the Indian always feels himself part of the cosmos; whereas even the earliest Chinese works imply, if not man's mastery of his environment, at least

his independence, and always show him playing truant from the hard
school of destiny. (It is a far cry indeed from the *Dances of Death* to
the painting of the Sung period.) All great Chinese art aspires to the
condition of ideograms, but ideograms charged with sensibility. In
Yun Kang art at its purest allusion takes the place of affirmation, and
the essential of all that is non-essential. Under the Wei dynasty the
eyes were treated in a wholly new manner. Nor have we here

WEI ART (LATE 5th CENTURY): BUDDHA

WEI ART: BODHISATTVA

the languid convolutions of Indian calligraphy, but vigorous brushstrokes, and in the very firmness of its drawing this art achieves a spirituality only found elsewhere in the subtle modeling of the Khmer heads (whose eyes are sometimes treated in the same manner). But this spirituality is always conditioned by architecture, and it was this fusion of a genius for ellipse with a feeling for the monumental that gave rise on the cliffs of the Shansi to some of the noblest figures men have ever carved.

This "feeling for the monumental" invites some interesting speculations. Our pier-statues, we are told, stem from the pillar —from which the Gothic statue subsequently broke free. Had the elongations we find in the stelae and the figures, hewn in the rock-face, of the Wei period likewise an architectural origin? What, then, was the factor in common between our cathedrals and these eastern cliffs, both of which were carved by nameless believers? Here the artist has succeeded in conveying, no longer the rigidity of death, but that of immortality. Here, too, the massiveness of the Chaldean granite monoliths and the Ibero-Phoenician statues has reappeared, but endowed with spiritual overtones. And despite the rich ornamentation of his headdress and that constricting his garments (as the Gothic fluting constricts that of Christ), the Wei Buddha seems to be

gazing out, between his lowered eyelids, on a universe in which the horsemen of the Acropolis, emptied of concern, are plunging into the netherworld of shades.

How can we fail to see in this great adventure of the mind and soul, which put forth from the havens of the vast Asiatic desert, the reflux of that which had begun on the Acropolis of Delphi? Even though we may question, despite the reverence so many centuries have paid to Greece, the values she made known to the world, one thing is sure: she transformed the artist's attitude to life now that even the gods, driven into the background, were forced to admit man's primacy, and, boldly confronting them, she brought to an end three millennia of human servitude. But time brought its revenge and throughout those lands where he had set up effigies of his victory under the bright southern sun, man was thrust back into his nothingness by a veritable frenzy of self-abasement, in which the pitiless glare of the desert made common cause with the god-haunted darkness of the hermit's cavern. Challenging the sensuality of dying Hellas and the inglorious death-pangs of the Roman world, religious art was now to reconquer, from Spain to the Pacific, its regal prerogative of ministering to the Eternal; and far less by any relapse into primitive clumsiness than with a fervor of iconoclasm. Meanwhile China, too, was replacing that yielding feminine smile which had prevailed along the Ionian seaboard, by something sterner, hewn in the cliff-side: the lonely smile of the men of silence.

The history of this great venture is not that of the survival of the Hellenistic forms, but, rather, that of their death. When, in the oases, these forms encountered weak values, they merely fell to pieces; but when, in India and China, they encountered the grandiose conceptions of the universe sponsored by Indian and Chinese Buddhism, they underwent a metamorphosis. Rarely has art history shown more clearly that the "problem of influences," which bulks so large in our modern approach to art, is invariably misstated. The Hellenistic forms in the Gandhara region were forms from which art deliberately broke free, and the same is true of the Greco-Buddhist forms in India and China. This conflict (which, in lands where Hellenistic art was indigenous, was more or less concealed) is at last becoming evident. Though no doubt a continuity of a kind can be traced from the *Koré of Euthydikos* to Lung-Mên, it is not a continuity of influence, but one of metamorphosis in the exact sense of the term; the part played by Hellenistic art in Asia was not that of a model, but that of a chrysalis.

Wherever Greco-Buddhist influence actively persisted—that is to say, wherever it did not undergo a metamorphosis—we find art wasting away in a sort of slow consumption. Until the seventh century, and even later, it lingered on in the great Asiatic desert, in towns half buried in the sand, reverting to its ancient calligraphy and mingling this in its frescoes with the calligraphies of Iran, India and China. At Tomchuk in the

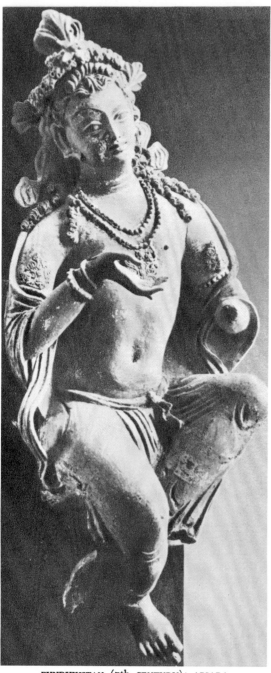

Kashgar region, its sculpture, despite the Chinese cast of the faces, does not belong to Chinese art, but has harked back to the jewelry-laden figures of its *Princes*. Some figurines, however, belonging to its last phase were discovered at Fundukistan, west of Kabul; here the natives extracted from their bed of clay-dust not only fragments of ivory boxes, but fishes in polychrome glass and, here and there, a horse's skull with the Tartar bit intact. Here the world of flowers implicit in Hellenistic art blossoms forth luxuriantly—a world that still exists today on the Ganges as at Samarkand. Even the hands which have been dug up from these sultry sands have the pale curves of lilies. Here too the human form, in later days to implement the divagations of Baroque, served as a pretext for that thoroughly anti-Gothic style, the "orchidaceous style," which underlies all Asiatic art, from the luxuriance of India to the ornate majesty of the T'ang period. It is a system of lines which is not the closed system of the medieval angles in the West and that of Wei art, nor even the system, no less closed, of our classical arts; but a free play of arabesques in which the human body becomes a tulip, fingers

THE HAND OF APSARA

are elongated and melt into the air like the flying forms of Baroque.

The arabesque is thus incorporated in as it were a slow-motion picture of a Cambodian dance, that ballet which Asia never wholly forgets. In the very century during which Buddhism was to find its highest emotional expression in Chinese art, it seems to lose all natural emotion in this art and acquires a curiously de-sexualized sensuality. If their ornamentation be disregarded, these torsos remind one of that least "alive" of flowers, the arum lily. Almost a thousand years of sculpture lie buried in this lonely fastness of the East; where the dreams of the sculptors of Alexander, Menander and Kanishka are redeemed from their Sèvres-like prettiness only by the patina of the years.

Then—as at Palmyra, in Gupta art and presently in Byzantium—there reappeared in China one of the most effective devices for spiritualizing faces: the drawing of thick rims around the mouth and eyes. This

was now to spread across Asia—to Yun Kang, Lung-Mên, Japan, Cambodia and Java— and to outlast fourteen centuries; that device which, when Egypt had forgotten it, made its reappearance far back in Macedonian Asia, where "the green-bronze horsemen of the mighty causeways" were in their death throes, and it was not to disappear until the eighteenth century. Then in the fullness of time the great adventure of Buddhist art came to an end, and the Siamese pagodas drowsing below the endless tinkling of their bells, lost forever, with the coming of their new East India Company *décor*, the last metamorphosis of Apollo.

SIAM (LOPHBURI): BUDDHA

CHINA (SUY DYNASTY, CA. 600 A.D.): BODHISATTVA

III At Byzantium and in Christian Rome the new forms that were arising did not come up against a strongly entrenched past as was the case in India and China; what they encountered was an East no longer garrisoned with the legions.

However, the metamorphosis of the art of Antiquity into Byzantine art becomes intelligible only if we cease to see in the Eastern Roman Empire the decadence of the Western. True, the last of the Paleologi cut a paltry figure if we compare them to Augustus, but not so Basil II *vis-à-vis* Honorius. And the Byzantine guardian angels of the dead kept a centuries-long vigil over the reeds of Ravenna and the Roman catacombs, while the gilded henchmen of Pope and Antipope fought their endless battle. Byzantium, the only existing world-power in ¦the fifth century, lasted a thousand years; longer than Rome.

At the time when Roman power was at its zenith the austere probity of the Republic had passed away. Neither Cæsar nor Augustus was a model of virtue. Nor were their successors. For many centuries the history of European ethics was written to the order of the Church, which was far more interested in blazoning the vices of its persecutors than in decrying Cincinnatus. Viewed by Plutarch's worthies, would Messalina's world have seemed less corrupt than Theophano's? The Church was ready enough to assimilate the schismatic courts of Byzantium to the monstrous imperium over which the twelve Caesars exercised their dying sway, but the break-up of a great military empire had no more reason to sponsor the other-worldly formalism of the mosaics and ikons than the sensuous appeal of the Alexandrian figures. We can perceive the qualities that some figures in the Catacombs have in common with those of Palmyra, the Fayum and Byzantium (in its early period); what sapped the Roman spirit on the Bosphorus was neither world chaos nor sensuality; it was the influence of the East.

Women were veiled at the court of Byzantium as at that of the Sassanids, and the pomp and ceremony of the Porphyrogeniti gave no surprise to the Persian envoys. Indeed a Darius *redivivus* might well have thanked Basil II for having called him back to life and banished from the earth the very memories of Pheidias and Brutus. Once more in tombs were to be found swords with turquoise-studded hilts, and no longer the rusted blades, forged in one piece and tempered side by side with plowshares, that the past had known. This combination of cruelty and luxury, so different from the clarity and ease of Greece, this proliferation of the police officers indispensable to tyrants, and the use of cunning as a substitute for authority (excepting the supreme authority)—all this mortuary *décor* so congenitally Ottoman was but another gleam on that ever-resurgent wave whose name is God.

Had Islam painted ikons of its own, how intelligible Byzantine art would be!

Early Christendom began by taking over the forms it found ready made in Rome. Thus Hermes Criophoros became Christ; obviously the "ram-carrying" deity was more suitable for this than Jupiter or Cæsar. But this new language of eternal life was bound up with death, which seemed to be replacing the imperial effigy on each deserted pedestal: that Asiatic death, at last triumphant, which was now regarded as the supreme solution of life's mystery. When a great wave of calamity—and charity —engulfed the Roman world, the childish figures of the Empire still found a place on the walls of churches; several centuries were to pass before Christ ceased being a shepherd of Arcady, and even Rome

CHRISTIAN-ROMAN ART: THE GOOD SHEPHERD

acquired the Christian accent only when she rediscovered the ancient, buried voices of the dawn of Christianity, by way of the Catacombs and cemeteries.

This art of crypts and coffins was a *canto jondo*, like the songs the Spanish improvise on the spur of the moment; thus it never settled down into a style. Was this because Roman painting kept its old prestige? Little though we know about it, we can judge from its most admired works (the same is true of the sculpture of the period) that it aimed at a form of portrayal at once impressive and ornate. But what could such pretentious figures mean to the slaves who gathered underground to worship, or for that matter to the patrician ladies listlessly dragging themselves to the austere banquets that were all impoverished Rome could now afford? Those Praying Women hastily drawn on ill-lit walls, those dead women on the sarcophagi, no more tried to vie with

CATACOMB OF DOMITILLA (2nd CENTURY): THE GOOD SHEPHERD (?)

the statues lording it in the empty sunlit squares than did the faltering hymn of a crucified girl with the crushing majesty of the Colosseum.

That deeply moving quality of the paintings in the Catacombs is not due to their artistic value but to their speaking with the halting accents of Man making his first, timid answer to the thunders of Sinaï. When we enter the subterranean galleries and the little candle, tied to the end of a broomstick by a monk in everyday attire, lights up for us the first inscriptions, how can we fail to respond to that call arising from the depths? It is the same age-old voice we hear as we thread our way between the rocks in the Font-de-Gaume cavern and come on the timeworn shapes of the bison wavering in the lamplight as if they were their shadows. In the art of the Catacombs that elemental magic of an age for which man's death was not yet man's concern is lacking; but there is something added: the voice of a Revelation, the remission of man's sins. Yet how stumbling is the answer given by these humble, furtive figures to that august voice! Above ground, along the plain of the Campagna, stretch avenues of cypresses in dark recession, while

the sun still pounds on his anvil the red gold that shimmered in the air when Anthony's ship set sail towards his "Egypt"; but underground the myriad dead, the martyrs and the Revelation that was to triumph over the Empire have left us but a few pathetic figures—and poor imitations of the *décor* of Nero's villa.

It is primarily the inexpertness, the poverty of their art, that gives the Catacombs their specifically Christian accent. One would like to read a meaning into this poverty, and try to glimpse behind the graffiti of Good Shepherds the tragic, almost primitive figure whose copy they might be; actually, however, the figures on the sarcophagi, the Praying Women and the Good Shepherd derive from Flavian figures. It was unconsciously that sometimes they discarded the signs of the imperial style; oftener than not they took them over. And in this underworld of tombs that Rome-inspired *Autumn* toys with the dying Empire.

AUTUMN (CA. 240)

In any case the Shepherds, Praying Women and even the Lord's Supper sometimes belong to the same type of art as the bread broken at that Supper, the fishes, the pathetically uncouth crosses. Gradually, however, as the calligraphy developed, the forms of Antiquity tended, under the influence of its minor arts, to be rejected; for when the Christian painters were mere decorators in a humble way, the models with which they were most familiar were not the statues. But though this calligraphy is rudimentary in some respects and in this sense a *décor*, it is not decorative; its very poverty gives it a curious starkness, which does duty for a style. Some of those Praying Women seem on the brink of voicing the divine love encompassing them in death's long night; and here and there some figures seem to weave a filigree of somber lines among these humble folk, forlorn as imprisoned children. But how were they to portray the holiest figures of all? Obviously the painters' diffidence was aided by the fact that their Good Shepherds, even the most realistic, were (like the *graffiti*) treated as *signs*, not likenesses. Afterwards, when the Good Shepherd ceased to be a symbol and the woman and child became, frankly, the Madonna, new methods of expression were attempted. To begin with, the continuity of the arabesque was broken up—as it always is when an old order is dying orgiastically, in a welter of carnage and catastrophe. Egypt had introduced a thin, continuous line; the Euphrates (on occasion) hieratic convolutions; Greece, her smile and her triumphant draperies. Then, a later development, came those volutes and spirals, winding their way in grooves, which served both to adorn imperial armor and to add a tenuous grace to Alexandrian nudes. But there had been no precedent, outside Asia, for that arabesque which, in Rome and in Syria, crept into copies of the Greek masterpieces, and proliferated like ivy over the mutilated busts. It was this arabesque which in the Western Empire had expressed man's confidence in himself at a time when he was vaunting his strength instead of giving play to his genius; when the Emperor was taking the place of the Auriga. But when the world went underground, and the Christians of the Catacombs walked in terror of the ghost of Cæsar that was said to haunt the sewers of Rome, those raggedly drawn yet august Praying Women were alone in bodying forth an art of hallowed gloom. And a tragic art like this has no place for the arabesque.

Roman forms had been far more theatrical than the Greek; perhaps they stood for the only wholly effective "theater" in a culture whose stage performances relied so much on the mask. Indeed, the few great Roman paintings that have come down to us, and all Roman statuary, illustrate Seneca far better than the performance of any of his tragedies can have done. But the vast reflux now setting in was to replace the stage play by the Mass within the Church and the mystery play in front of it. No longer do we find an assertion, virile

CATACOMB OF PRISCILLA (3rd CENTURY): THE VIRGIN

at first, then feebly bombastic, of Man's prerogative; no longer does he call in question all that baffles him—the challenge Greece had launched. Far otherwise, Man himself is arraigned by powers that transcend, or crush, him.

At Byzantium this breaking-up of the line was destined to become involved (especially in the ivories) with the growing heaviness of Constantinian art; at first, however, it took an independent course. Doubtless the *Christ with Four Saints and the Apostles* in the Catacomb of Domitilla owes more to engraving than to sculpture. It is well known that all

CATACOMB OF DOMITILLA: CHRIST WITH FOUR SAINTS AND THE APOSTLES (CA. 340)

180

this art came to acquire a Byzantine accent, and we can trace easily enough each successive stage of its surrender to Byzantine influences. Nevertheless the life story of Roman art during this period is far from being composed solely of the factors that transformed it into Byzantine art; sometimes, too, it held its own against the East. Before Byzantium brought its weight to bear on the art of Rome, there had been several attempts, fervent if indecisive, to replace the Roman idealization of the material world by some truly Christian form of expression. Obviously the lines that had served to express Mars or Venus were the devil's, and, though it had yet to be discovered which were Christ's, there was always the resource of ex-

GILT-GLASS PORTRAIT (CA. 320)

orcising those diabolic lines by the use of angular, jagged brushstrokes such as the classical artist never used. This new broken line was not yet the scythe-shaped notch adopted by the Byzantines. That unknown man who painted the *Virgin* in the Catacomb of Priscilla was perhaps the first Christian artist.

But Rome retained her inveterate fondness for the portrait, and the gilt-glass portraits in the cemeteries kept to her tradition of photographic likeness. Soon, however, the awareness of eternal life was to impart a new accent to the individual face, as the proximity of the corpse was to do in the Fayum. (We can hardly imagine the *Poetess* of Pompeii painted on a winding-sheet.) Some of the Praying Women became portraits sublimated by the fixity and enlarging of the eyes. And once the angular linework was combined with this other-worldly gaze, the Christian style came into being.

BAS-RELIEF OF THE ARCH OF CONSTANTINE

Meanwhile, at a distance from Rome, an art akin to this seemed to be evolving. This was at Palmyra and in the Fayum, where the Roman forms came in contact with the Orient, as Greek forms had come in contact with Asia at the foot of the Pamirs. No doubt the Roman forms had been becoming less and less stable, and Rome did not need Byzantium to make her forget the art of Trajan. The basic elements of the Arch of Constantine and his colossal statue were already in a style directly opposed to what we call the Roman style. What was petrifying Roman figures was not yet Christianity, but the creeping paralysis of Rome herself. The Cæsarian gesture was dead and the artists' problem was not the finding of a new gesture to replace it, but one of somehow breathing life into the inert.

There may well have been other Palmyras, but, if so, they are unknown to us. The Palmyra we know was a desert port of call, but a military one; it was in this oasis that the Romans recruited the Arab cavalry they so often needed in Syria. This much-belittled art which in so many ways adumbrates Byzantine lasted nearly as long as French Romanesque. (How easy it is to imagine a history of art in which the Renaissance would be treated merely as a fleeting humanistic episode!) In it the spirit of the Ibero-Phoenician statues—notwithstanding the

many differences between Palmyran stelae and *The Lady of Elché*—seems to petrify the Greek dance; likewise funerary figures take the place of nudes. The rising curve which the smile once gave the lips becomes a drooping one; gesture is replaced by the immobility of the eternal. But eternity had yet to find its *style*.

There is realism in this art (the iris of the eye is engraved on the stone), and there is that preoccupation with the portrait which Roman art *in extremis* bequeathed to the Catacombs, to the Fayum, to Syria and the minor figures of Gandhara. These tombstone portraits, full of a yearning to escape life by refusing to depict it, and replacing light veils with heavy drapery and diadems, seem to aspire towards a composition in which death

PALMYRA (2nd-4th CENTURY): FUNERARY FIGURE

tells out in every line. We must not forget that this art, like Gandharan art, is only very slightly "historical," that is to say, its forms do not follow each other chronologically; some roughly made figures being contemporary with the most finished ones. In it we find side by side an Ingres and a Delacroix fraternizing in an atmosphere of death perhaps and of the desert, certainly of numinous awe. Thus in the *Amith* we seem to see the effort of the sculptor to petrify a figure that obstinately retains its life; he stylizes it as deliberately as a Greek would have embellished it. And one of his near contemporaries pushed this stylization still farther, achieving a majesty the Empire had never attained, when he carved what is perhaps the only head truly befitting "the grandeur that was Rome"; while another artist

PALMYRA (2nd-4th CENTURY): AMITH

PALMYRA (2nd-4th CENTURY): "THE GRANDEUR THAT WAS ROME..."

PALMYRA (2nd-4th CENTURY): FUNERARY FIGURE

hardened and elongated the face till it calls to mind Byzantium—also recalled in the form he gives the hands, the weight of the jewelry and garments which reveal the Sassanid influence latent in both these towns; instinctively we attribute to Zenobia the gestures of Theodora.

Thus over the dying empire the gods were resuming their indomitable sway, and what was dying with the empire was pagan art. Those smiling faces of Attica and Alexandria, those resolute faces of the Capitol, were as out of keeping with the desert, the forests and the Catacombs—with that oriental night-world of blood and doom-fraught stars—as Plutarch was with Saint Augustine. For art was now seeking to break away from the human as obstinately as in Greece it had sought to attain the human. Smiles and movement disappeared; whatever moves —all that is fleeting—was no longer deemed worthy of the sculptor's art. The monstrous, elemental forms dear to the Orient and the nomads were reappearing; yet neither the unmoving, nor the inhuman was to be transmuted into the eternal without a struggle. Gallo-Roman art felt its way cautiously towards a break with Rome, while that of pre-Islamic Arabia, from the Druse country to Petra and perhaps to Sheba, abolished the Roman face with a frenzy soon to be that of the iconoclasts; replacing the nose by a trapezoid, and the mouth by a straight line. Why assume that the Zadkine before his time who carved such faces was incapable of making the nose less flat and of giving the lips their natural curves? The technique of realism

DRUSE ART (6th CENTURY?): HEAD

was no more unknown to him than it is to modern artists; but like them he rejected it, though for different reasons. And in his wake, in the rocky valleys of Gandhara, that far-flung venture was in progress which was to carry Greco-Roman forms eastwards to the Pacific.

Did the various arts of this "retrogression" which extended over half the world contain the makings of their own Romanesque? South of the Mediterranean all indigenous sculpture was obliterated by Islam. Persia alone stood out against the conqueror and retained some part of her genius. Islam converted into abstract decorative patterns that teeming dissolution of forms which, at times, found its

COPTIC ART (POST-PHARAONIC PERIOD): HORUS ON HORSEBACK

most telling expression in Egypt, in Coptic art, and buried alive that
incipient art which promised to do as much for painting as Palmyra did
for sculpture—an underground art which might indeed have expressed the
spirit of Christianity as well as did the Catacombs: the art of the Fayum.

The Fayum, too, is a cemetery in which the great rub shoulders
with the humblest. Its artisans cared nothing for art or for posterity;
they buried their pictures in the coffins. We may disregard their antlike
industry, since our museums have gathered much that outdoes it; but
we should not forget that this art, like all collective arts whose practi-
tioners are anonymous, was directed to a lofty end: that of combining

the individual face with death's distinctive presence. The Fayum invented for itself neither the portrait, which it inherited from Rome, nor the likeness of death, always familiar in Egypt. But the Roman portrait was the opposite of a funerary image; the figures in Etruscan tombs had told of a different kind of eternity, and now that death was gradually taking possession of Rome, the marble portrait was about to change its nature. In Rome the painted portrait, a poor relation of the bust, had been painted "after life." (The little portraits on gilt glass often remind us of the photographs one sometimes sees on French graves.) But behind the Fayum figures, whoever the artisans that made them, lay an immense ambition; that oldest land of death, which clasped in its embrace the living and the mummies, was once more bidding these forms of death confer on mortals their eternity.

Never, assuredly, had any great nation been so persistently and thoroughly deprived of style as were the Romans. By this I mean not merely that they imported their forms, but also that they never had the genius which enabled Iran and Japan to endow the forms that each in turn took over with permanence and quality. The taste of Augustan Rome (it is quite wrong to say that the Victor Emmanuel monument in present-day Rome is not Roman in spirit) was on a par with that of the Second Empire in France; and its temperament very different from that suggested by the Museum of Antiquities at Naples.

A false belief that this museum gives a sort of cross-section of antique painting has played no small part in shaping our opinion of the art of ancient Rome. Yet suppose Deauville were buried under ashes today and, two thousand years hence, excavations brought it back to light, the impression given of our Western painting would be queer indeed! The most recent excavations at Pompeii, thanks to which we can see its shop-signs and decorative compositions *in situ*, show that this painting was a commercialized art for popular consumption. Those crude figures *à la* Magnasco (which remind us of our Regency decorations) would probably, could they be compared with the superficial yet brilliant art we vaguely glimpse behind them, seem as tawdry as do copies of Timomachus—or reproductions of *Monna Lisa* on our calendars—when confronted with the originals.

One major Roman work of art is extant whose calligraphy, if not that of a master—and even if we assume it to be only a copy of some much earlier Greek work—is an artist's, and which casts into the shade the banal craftsmanship of the big figures that have been dug up no less than the charming craftsmanship of the small ones; and this is the series of paintings in the "Villa of the Mysteries." At first sight one tends to get a false impression of the relationship between the figures and their red backgrounds; it looks as if we had here a conventional device of the house-decorator of the period, for setting off figures—and no doubt such red backgrounds were suitable enough for the painted and polished

POMPEII. VILLA OF THE MYSTERIES (CA. 50 B.C.): TERRIFIED WOMAN (DETAIL)

statues of Antiquity. But it may well be something quite different: a quest of that escape from reality which was more effectively achieved by the gold backgrounds of the Middle Ages and the black backgrounds of Goya's engravings. Here technique, style and spirit tend to put a distance between the spectator and the scene portrayed; we seem to be watching a stage performance from which the spectator is as much separated as from a scene done in relief. Moreover this art, despite some obvious differences, is affiliated to sculpture. True, neither the naked women, nor that *Terrified Woman* who seems to be launching

POMPEII. VILLA OF THE MYSTERIES: THE VISITATION (DETAIL)

POMPEII. VILLA OF THE MYSTERIES: KNEELING WOMAN (DETAIL OF THE "UNVEILING")

her veil upon the wind, resemble Roman statues; yet their *spaceless* masses, though not imitating bas-reliefs (the value of the backgrounds, equal at least to that of the figures, in the original rules that out), have a very similar effect. The use of the word "masses" here may be questioned; for a mass implies surrounding Space. If we compare these figures to Piero della Francesca's, for instance, we are struck by the fact that they have no weight; the ground is their limit, and only that. To give them if not relief—at which the artist does not aim, or a third dimension—of which he is ignorant, at least an accent other than that of two-dimensional painting, the painter falls back sometimes on a schematized lay-out, at once "Ingresque" and rudimentary, as in the kneeling figure crouching above the veil that hides the phallus (curiously like the amusing parodies of Ingres that Cézanne painted at Le Jas de Bouffan); sometimes, also, on an elaborate style of drawing, at a very far remove from the trivialities in the Naples Museum and the woman in the *Visitation*. In short, these figures, especially when isolated from their contexts, give us an idea of one of the manners of painting practiced by the authentic artists of classical Antiquity.

Rome stood for that alone which *is;* for the factual. Which explains why this realistic picture of the Dionysiac Mysteries seems so surprising to those of us for whom the terms "Mystery" and "Dionysus" have a meaning. If the gulf between the Roman portrait and those that came later is so vast, the reason is that Rome had no future in any field of art; her mysteries were unveiled, like symbols, on bare walls, her portraits are "artistic" photographs! Even when Rome managed to give them life, she put no soul into them; for she had none. A dogged continuity she had—but so have the sciences. Her portraiture, on which Rome set such store, was that of faces separated from the universe. What efforts she put forth in her paintings, realistic mosaics, gilt-glass portraits, to represent the individual personality! And yet, despite these efforts, that personality had no *value.* When, after having recorded the personal appearance of great men, or conquerors, the portrait came to record that of the ordinary citizen, it still fastened only on personal peculiarities, investing them, as best it could, with conventional dignity. The busts that clutter up Italian galleries differ from or resemble each other like numbers on a catalogue, not like living men. A Roman face could no more be an intimation of a soul or an incarnation of a god than a Roman figure could convey its presence in Space or link up with the cosmos; for empires, in art, are but poor substitutes for a cosmos.

Nevertheless pagan Rome showed an unflinching fidelity to the directive ideas behind these forms. It was by means of style that the Egypt of the Pharaohs had given life to its fantastic figures; victorious Rome took them to pieces and reassembled them in her own manner, making, with a realistic jackal's head affixed to a realistic man's body, or a lioness's head on a woman's body, ingenuous but highly effective *collages.* Whereas Egypt had been style incarnate; her age-long wrestling with those very forms in which style was most conspicuously lacking is one of the most signifiant episodes in the whole history of art.

The Fayum portraits were painted on little wooden tablets which the shroud held to the dead man's face. Their art is not, whatever has been said, that of the masks of Antinoë, for in it the manipulation of the pigment, relations between colors, and sometimes the individual brushstroke play a decisive part; but all are expressions of that same impulse which gave rise to the figures painted on the bottoms of the sarcophagi.

For a long time these had carried more significance than the figures embossed on the lids. Lacking relief, they can justly be described as paintings, whereas the carvings on the outside of the sarcophagi stand in the same relation to sculpture proper as does the ornamental work on modern furniture. If sometimes we fail to see this, it is only in cases where the effigy has lost its color. When abandoning the Egyptian tradition they replace it with the tawdriness of the third century, these lids seem cheap to a degree! One might almost think that all the

Mediterranean gods had forgathered in these oases, there to lay to rest a motley company of gilt and candy-stick figurines. Nevertheless, the same figures, when rendered in the flat on the bottom of the coffin, have a quite different style. We know well how the process of decay can endow even the tawdriest colors with a certain beauty, and perhaps it is better not to try to conjure up what these figures must have looked like when freshly painted, but one thing is certain: those patches of salmon-pink and ashen blue, edged or intersected by black lines in a curiously restless, ornate calligraphy, must always have produced a different effect from that produced by the same colors lacquered on the gilt chocolate-box surface of the lids. There is no mistaking their accent; if it be that of creations doomed to the grave, it is none the less that of creations. We seem to feel in them Egypt's last efforts to drag down with her into the Kingdom of the Dead which she had served so faithfully all that she could still call her own, from the Euphrates to the Tiber.

Instead of rendering the likeness of the dead person by an elaborately built-up style, these paintings have the febrile intensity of the abstractions of the Syrian East. The Fayum portraits, however, are *not* abstract, and in them the living person is not merely the raw material of Death. Basically they are Roman portraits (no more than that, when the artist is a poor one), and at first they had the rather naïve harmony and unambitiousness of these. Whenever it aspired to being a work of art the Roman portrait took the form of sculpture; paintings were mere ef-

figies, produced by a technical process, like most modern photographs. Soon, however, the Fayum artists began to aim at something different from the Roman conception of the portrait. The busts, in interpreting the individual, had changed him into a Roman; now he was to be changed into a dead man—not a corpse, but something which was only just beginning to be called a "soul."

Some previous styles had been bound up with the feeling of death, and in Fayum art this feeling was seeking for its form, which Rome had withdrawn from it and never given back. In the process of transforming the Latin portrait the new art discovered that the portrait (under Roman influence) had totally lost contact with the other world. What was it that the Fayum asked of its portraits, sometimes painted on the winding-sheet itself? To give the dead man's face eternity. The Egypt of the Pharaohs had accomplished this by means of a style which translated all forms into an hieratic language, a style deriving naturally from a religion that permeated the whole of life. Now, however, the positive sense of death conditioned by an after-life was being replaced by its negative: the sense of *that which is not life*, of that gray limbo to which gods, demons and the dead had long been relegated indiscriminately. This is why Christian art was akin to these portraits in so far as Christianity was a negation of the pagan world, and why it broke away from them once it became an affirmation. Man is oftener led to sponsor an after-life he thinks he knows than one he knows he does not know.

THE FAYUM. PORTRAIT (ROMAN PERIOD)

From that limbo come some of the forms of expression which most appeal to our modern sensibility. Schematic structure, to begin with; superfluous details were ruled out as being associated with realism (and realism could express the living man or the corpse, but not the dead), or else with an exuberant idealization, irreconcilable with the awe inspired by the world of the unseen. Next came the employment of a range of colors often passing from white to brown by way of various ochres (a color-scheme sometimes adopted by Derain). Next—and this struck deeper than our modern scientific use of divisionist color—expression in terms of pure colors. Figures in which the white-and-ochre harmony is not employed keep to the Syrian gamut, the pinks and blues of Dura-Europos, deepening them sometimes to aubergine purple, or purplish red. These colors persisted in Coptic art, even when (deliberately, it would seem) it took to reducing to geometrical patterns the pensive gravity of the Fayum art and the emotionalism of the sarcophagus paintings. Lastly, in studying the work or anyhow the masterpieces of these craftsmen, we cannot but be struck by the peculiar stiffness of the figures, which seems to owe less to the rigidity of the dead body than to their disdain for the futile agitation of the living. The bodies are immobile, but so is eternity; not without reason did Egypt have recourse to basalt for her statues. No doubt this stiffness gives a suggestion of clumsy workmanship, but it derives also from the "frontalism" of all Egyptian statuary; indeed it is less a matter of rigidity than of the schematization mentioned above, which is one of the few equivalents in painting (prior to Romanesque) of the great anti-humanistic schools of sculpture. The painted tablets of the Fayum differ considerably from the ornamental art of Palmyra, and their broad planes owe nothing to the pre-Byzantine, perhaps Parthian, accents of the Syrian desert. But we feel them somehow allied to sculpture; they reject alike the legacy of the phalanx and that of the legion (despite Palmyra's military associations), and likewise go beyond mere imitation in their likenesses. Moreover, this art has learned the secret of a gaze that is neither the expression of a fleeting moment, nor the dazed stare of a Byzantine figure,

THE FAYUM. PORTRAIT (DETAIL)

FAYUM PORTRAIT
(AFTER RESTORATION BY THE LOUVRE)

THE FAYUM. PORTRAIT (LATE PERIOD)

but often has a glimmer of eternal life, spanning the gulf between the dead man and the world beyond the grave.

Did this art perish because it consigned its works to coffins? True, other arts had done this, but it was the first to work exclusively for the tomb. Though man's feeling for the other-worldly often has recourse to solitude, solitude does not foster its development; rather, it is nourished by communion, to which the church is more propitious than the cemetery. This fellowship among men was Christian Rome's vocation, and now her art found in the mosaic its most suitable medium of expression, so much so that all previous mosaics strike us now as merely decorative. Popular as was the miniature in those early days (chiefly because, forming part of a manuscript, it was easily transportable), it soon led up to the mosaic, in which during the fourth century enamel came to replace marble, and which surpassed the miniature as, subsequently, the Romanesque tympana were to surpass it. The apse of SS. Cosmas and Damian, with its deep-toned echoes of the Testaments, is no mere enlargement of a miniature. Meanwhile the fresco was the poor man's mosaic; nevertheless, if the mosaic (begetter of the stained-glass window) so long predominated in Christian art, this was not due to its parade of affluence but to its peculiar aptness for suggesting the divine.

197

ANTIOCH (5th CENTURY): THE SEASONS: WINTER

Thus we need not attribute the hieratic quality of the early Christian figures merely to a technical tradition they took over. Even the *Seasons* at Antioch which, while showing strong oriental influences, clearly derive from pagan art, are hieratic, and the drawing of some pagan mosaics had been as free as the drawing of Matisse.

ROMAN MOSAIC

Then art history shifted to Byzantium, where what the Fayum had foreshadowed found fruition. But how vigorously Rome still defended herself, even when the shadows were closing in upon her! For it was then that the great apse of St. Cosmas triumphantly arose. The spirit of this mosaic is that of the Old Testament, but its monumental design is different from that which was being perfected on the Bosphorus. The reason why this work is little known is that not only its texture and dimensions, but also, and especially, its curving surface fare so badly in reproduction. But while St. Pudentiana conjures up thoughts of Assisi, here we have intimations of the Carmine; who else was to achieve such stupendous masses, such dramatic architecture, before Masaccio?

Within four centuries the face of Europe had been transformed, and with it changed the world whose expression painting claimed as its domain. For early Christendom the Gospels had been inseparable from the sombre postscript added by Paul; Christianity had not meant the coming of love alone, but that of the voice of the Eternal, into a civilization in which the last surviving vestiges of the Eternal were the pompous statues of victorious generals. As probably was Greece before her, Rome was unaware that forms and colors can express the tragic *by their own specific qualities.* In sculpture as in painting all the *Dying Gauls* (works, moreover, of a late period) gave expression to tragedy only by illustrating it. But the styles of Byzantium and the Middle Ages, and some others after them, made it clear that the tragic has its own appropriate styles—a fact that was unknown to classical antiquity. Whenever its line did not tend towards idealization, it retained a puerile regularity—and how much of this was needed to make of Pasiphaë that figure in the Vatican Museum!

Color, too, remained that of an art as yet unclouded by the tragic. The earliest Christian arts were international, but even the East had made Rome familiar with bright colors (and in fact was thriving on them)—the dominant hue of the Dura frescoes is pink. At Santa Maria Antica, the *Crucifixion,* with its background of sombre violet attuned to the drawing of Christ's form, is violently in conflict with those traces of pink and blue with which the monks (who probably hailed from Cappadocia) seem to be trying to perpetuate nostalgically, amongst the pines and wild roses of the Aventine, the fragile charm of Asia Minor.

PASIPHAE: ANTIQUE FRESCO

SS. COSMAS AND DAMIAN, ROME (CA. 530): DETAIL

(Also many leading works of Romanesque painting, the St. Savin frescoes for example, show that the artists making them had no notion of the dramatic possibilities of color in itself.) We may be sure it was not due to chance that brown was used so often by the Catacomb artists for their signs; but the humble pathos of these works was inadequate for expressing the tragic sense of life. By its rejection of the relatively naturalistic methods of Rome, Christian art, when it sought to make its figures step forth from the wall, not with a view to another kind of illusionism but to creating a feeling of mystery (a paradoxical ambition that was, later, brilliantly realized by the stained-glass window), gave fleeting glimpses of the possibilities of a color-language. From St. Pudentiana onwards, however, color plays a part regarding which no mistake is possible and which is not limited to dramatic expression. At St. Cosmas it is the intense darkness of the recesses of the cupola that, balancing the heavy masses of the figures, frees them from the aspect of a bas-relief. The blues and whites of the ornamental compositions, the brown and gold which in San Apollinare, at Ravenna, hark back to the decorative tradition belong to another realm of art. That of color was explored in the little scenes at Santa Maria Maggiore; in St. Pudentiana it had achieved its balance and its plain-song in monumental composition; at St. Cosmas, abandoning simpler forms of harmony, an orchestration based on contrasts that maintained and amplified it, as flying buttresses were to shore up, ever higher, the naves of the cathedrals. Surely El Greco felt a thrill of joy when he set eyes on the red of those clouds billowing around Christ against a starry background whose azure darkens and deepens little by little into the profound blue of the Roman night. In this superb mosaic were intimations of a whole new art coming to birth, and art history, when it now withdrew from Rome, left there the first great painter of the West.

MOSAIC OF THE APSE OF SS COSMAS AND DAMIAN

THE CHRIST OF THE APSE

203

MONREALE, SICILY (13th CENTURY): CHRIST PANTOCRATOR

Thereafter, Byzantium reigned alone. That age which was discovering the sublimity of tears showed not a single weeping face, and the New Testament, though it was shaking the world to its foundations, left no other traces of its passage on the walls than the august faces of the Old. Man, who came into his royal own at Salamis, was once again becoming a mere fleeting shadow. Hercules may have been the one true god of

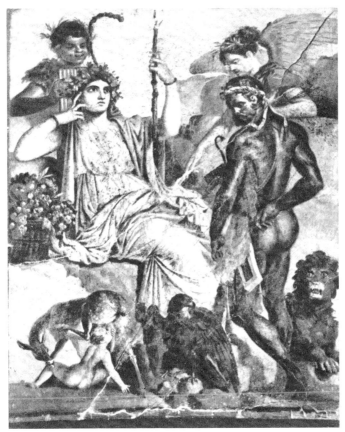

POMPEII. HERCULES FINDING TELEPHUS

Rome, but his conversion into something worthier than the pugilist of the *Telephus* fresco would have called for some gleam of the Lernean marshes or Deianira's pyre reflected on his face. But henceforth no such gleam was to light a hero's face, and the sole reason men had for painting sanctified faces was that these might bear witness to the eternal Presence which fills the god-haunted East. That so-called "clumsiness"

which Taine found in Byzantine art usually resulted from an attempt to expunge all traces of the human from the last art of antiquity.

Some recent discoveries tend to suggest that, before the Byzantine style settled into its final form, there was a phase of vacillation between Man and God, such as we see in the style of St. Cosmas. Indeed some of the St. Sophia figures, in which Christ is still a man, recall Chartres far more than Daphni. But, once man had been devalued, why go on portraying him? Now that the Victories standing on ships' prows had lost all meaning, they became archangels haunting the dusk of the basilicas; thus at last the Catacombs had won the day. Often the little Byzantine church standing above its crypt like a cross upon a tomb seems hardly more than an upcrop from some vast underworld of death. For nearly a thousand years the two oldest dynasties of the Orient reigned conjointly at Byzantium: gold and the eternal. Gold predominated whenever the eternal weakened; Boccacio had in mind that tyranny of gold when he thanked Giotto for at last ushering in "the art of the intelligence." The "eternal" to which Byzantium aspired and which sometimes took the lead, whether it was expressed by the *Christ* whose huge face fills the Monreale cupola, by the little Torcello *Madonna*, or by the Prophets who thronged the crypts of the Bosphorus as the statues thronged the public squares of Rome, ended up by banning all but superhuman faces.

As much genius was needed to obliterate Man at Byzantium as had been needed to discover him on the Acropolis. For the suppression of movement and the nude was not enough; the soul is immaterial. The one thing that could "devalorize" the human was what had "devalorized" it at Palmyra and in Gandhara, as in China: a *style*.

As in Buddhist art, so in the Christian art now following its destined course, scenes of real life played a negligible part; indeed the Christian artist seemed more bent on picturing eyes in which a god is mirrored, and the Buddhist on closing men's eyes to the outside world, than on rendering visual experience. Remarkable in this Byzantine art is the persistence of earlier forms, the strangely tenacious hold of pagan antiquity on figures that with all the fervor of their persecuted souls rejected it. The artist's slow ascent Godwards was on his knees as he climbed the steps of the Holy Way, and a momentous dialogue ensued between the age when Christian art was launching its appeal (to which as yet no form responded) and the artists' effort to impose forms of a new revelation on a past which had ceased to give them a response. Since the religion that found expression at Byzantium is almost ours, it is easy for us to perceive how its style aimed persistently at creating a world conditioned by the values of the men who were discovering it. What the Byzantine artist actually saw mattered not at all; for that

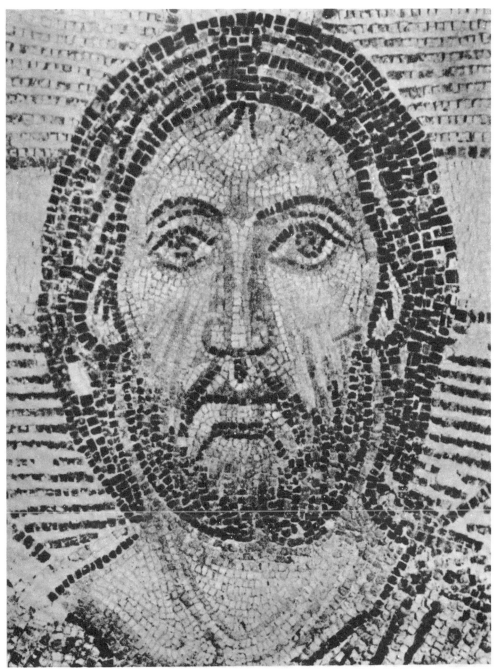

SANTA SOPHIA (9th CENTURY): CHRIST IN GLORY (DETAIL)

matter, our academic art has given us a likeness of Theodora quite different from that of the Ravenna mosaicists. What they depicted was neither what they saw, nor a dramatic scene; it was a superb negation.

Like so many oriental styles, theirs arose from a passionate desire to represent that which, rationally speaking, cannot be represented; to depict the superhuman through the human. Not the world but that which, in this world or beyond it, is worthy of depiction. No doubt other arts, if only of a popular order, flourished at Byzantium; for there is no great style, even though it be bound up with Man as was Greek art, that has not timid rivals in its minor contemporaries. So firmly rooted in the Slav world was the notion that all art worthy of the name involves stylization, that stylized forms, half Byzantine and half Persian, are to be found even on lacquer boxes, and Slav pastry-molds made in 1910 look like medieval wood-carvings. The Russian revolution, however, by aligning side by side the effigies of "Christ Scorned" collected from the Northern Provinces, has revealed to us (behind the Orthodox stylization) an art as different from that of the ikons as are Breton "Calvaries" from the art of Fontainebleau, their contemporary. A minor, or popular, art usually employs perishable materials—but already we are beginning to unearth specimens of Byzantium's Tanagras.

NORTH RUSSIAN ART (17th CENTURY): CHRIST SCORNED

Nothing better brings out the significance of the major Byzantine forms than the capitals carved in the Holy Land by a sculptor (probably a native of Poitou), in which he took over the faces of the Prophets of the Eastern Empire, treating them as if they were real portraits, and thus transforming those enigmatic visages, which seem to be launching an eternal question across the twilight of the Bosphorus, into delicately wrought faces with wavy beards. Neither the sculptor's talent nor the promptings of his Romanesque soul could prevent the lapse of those august figures into the human, and thus they lost their thaumaturgic powers. The Bagdad court had adapted itself more readily to the Byzantine plain-song, so easily acclimatized to those litanies declaring that "there is no other God but God." But it was not at home in that world of foliage and animals which Romanesque incorporated in its clean-cut strapwork. The basic incompatibility which severs Moissac from Byzantium (as it severed papal doctrine from Michael Cerularius) lies in the fact that the Byzantine style, as the West saw it, was not the expression of a supreme value but merely a form of decoration. Its physical apparatus (shadows, gold, majestic aloofness) being rejected and its true purport not being understood, it was by way of becoming what those Nazareth capitals show us: a variant of the goldsmith's art,

NAZARETH (13th CENTURY): RESURRECTION OF TABITHA

SENLIS (13th CENTURY): HEAD

NAZARETH (13th CENTURY): HEAD

charged sometimes with emotion. Was there not in the Byzantine temperament, molded as it was by the City and the Sea, and with which Venice was so well to harmonize, something fundamentally unsuited to the spacious countrysides whence arose the Romanesque churches, and to the forests, vanquished perhaps, yet secretly so near akin to them? The East knew almost nothing of the barn, which lies at the origin of Romanesque architecture; but timber, flouted by the marble of the two Empires, is never far distant from medieval stonecraft. Byzantine art was bound up with refinement. It had gradually discarded sculpture in the round, and replaced it by reliefs, mosaics, ikons; by scenic effects and spectral forms. Whereas the West, from its earliest figures down to Rheims and Naumburg, was to evoke the smiling Virgins and pensive donatrices of the Autun pediment, just as Umbria and Tuscany conjured up from the underworld of early Christendom those unquiet, trembling figures which they transmuted into divine effigies.

Roman painters had made their figures tell out against a neutral background like that of the classical stage-play. The semblance of a wall, a patch of landscape (as in the Timomachus copies) and a hint of perspective compose backdrops in front of which the figures show up like statues. Christian art makes this background even more abstract, but amalgamates it with the figures, which seem to sink into it like foundering ships. It rediscovers darkness; rekindles the desert stars in the night sky above the *Flight into Egypt*. In Byzantium, as in St. Cosmas' Church, the dark, leaden blues of the backgrounds of frescoes and mosaics tend not only to suggest the tragic aspect of the universe, but also to pen the figures within a closed world, wresting them from their independence in much the same way as Christianity wrested from the Empire the life of individual man, so as to link it up with Christian destiny, with the serpent and with Golgotha. For Christianity claims to be the Truth; not Reality. To Christian eyes the life that the Romans saw as real was no *true* life. Thus, if the true life was to be portrayed, it must break free from the real. The task of the Christian artist was to represent, not this world, but a world supernal; a scene was worthy of portrayal only in so far as it partook of that other world. Hence the gold backgrounds, which create neither a real surface nor real distance, but another universe; hence, too, a style of which we can make nothing so long as we read into it any attempt at realism; for it is always an effort towards transfiguration. A transfiguration not of the figures only; Byzantium aimed at expressing the whole world as a mystery. Its palace, politics, and diplomacy, like its religion, kept that time-old craving for secrecy (and subterfuge) so characteristic of the East. Superficial indeed would be an art portraying emperors and queens, did it confine itself to a mere display of pomp; but this was only, so to speak, the small change of the art of the great mystery, the secular accessories of an art which made haste to annex them to the sacrosanct—as is evident when we compare the bust of any

TORCELLO (12th CENTURY): CUPOLA

Roman Empress with Theodora's portrait, the St. Pudentiana *Virgin*, the *St. Agnes* in Rome, or the Torcello *Madonna*. All that vast incantation which is Byzantine art is manifested in the last-named figure, standing aloof in the recess of the dark cupola, so that none may intrude on its colloquy with destiny. Under the Madonna are aligned saints and prophets, and below these, again, the congregation in prayer. On high looms that elemental Eastern night, which turns the firmament into an unmeaning drift of stars and the earth into a futile shadow-play of armies battling with the void—unless these passing shows be mirrored on the meditative visage of a god.

Western Christian art was to give the Madonna what at first Byzantine art denied her: her quality of the Mother, first beside the manger, then beside the Cross. And it likewise discarded all that was making her the feminine expression of the Prophet. For the Prophet dominated Byzantium, as he was never to cease dominating the Orthodox world. He is not the Hebrew prophet, a man of holy wrath and an historic background; already he is the typical Slav prophet, the Illuminate, the Man of Truth and the Man of God. All the rankling anguish of Dostoevsky lurks in the shadows beneath those ikon-like figures of Zossima, of Prince Muishkin and Aliosha; as Byzantium's murderers and its tortured, blinded victims lurk in the teeming darkness beneath similar figures—similar, but more ardent, less compassionate. In answering Aliosha's accusers, Dostoevsky sounds a last echo, faltering yet sublime, of that voice which silenced the accusers of the Woman taken in Adultery. The spirit of Byzantium is all a fixed resolve to escape from the mirage of appearances and an aspiration towards a Nirvana in which, however, man attains God instead of submerging his personality in the Absolute. In Dostoevski's novels, as in our Middle Ages, this was to take the form of charity. In the West the prophets were to become saints; whereas in Byzantium the saints had become prophets.

That is why Christ, so different from the saints in Rome, tends, in Byzantium, to be so much like the prophets; He is the supreme Prophet. From the paralysis of the last imperial statue onwards to the Torcello *Madonna* and the Monreale *Christ*, the Renaissance of the West—the conversion of the free man and the hero into the Man of God—was following its appointed course. Art was no longer called on to represent that Holy Figure; rather, its aim was to create a world appropriate to Him, His setting—as music might create it. During the centuries in which, from the Black Sea to the Atlantic, kings blinded their conquered rivals, there arose great hieratic figures that peremptorily lowered men's eyelids lest the allurements of the visible should continue to distract them from the supreme mysteries. And just as Apollo had become the Buddha, Jupiter became the Pantocrator. Was, then, the Cross destined to do no more than bring back to the world the lost arts of Egypt and Babylon? In any case, the Eternal was, once again, invested with a style.

BYZANTIUM (9th CENTURY): HEAD

ROMAN ART: AUGUSTUS

IV The relations between the Western world and the figures of classical antiquity were of another order.

While to the Roman mind all that gave a man value lay in his mastery over a selected field of his personality—courage, intelligence, decision—and while every Roman virtue was a form of steadfastness, the Christian, even when capable of dying a martyr's death, knew himself for a sinner and in constant peril from the outside world; because the devil was its "prince." To his mind, Grace lay behind all forms of steadfastness. All Roman portraits—whether of emperors or divine beings, of heroes, vestals or barbarians—were primarily character studies; in contrast with them our medieval figures (no longer inspired symbols as in Byzantium) are biographies. A classical face, even if it be not a god's face, may bear the stamp of any experience—except life. If we contrast it with a Gothic saint, we realize that neither Caesar, Jupiter, nor Mercury, ever lived; confronted with any prophet whomsoever, Roman patricians have the shut-in faces of prematurely aged children. The features of each Christian were stamped with his personal imprint of original sin; for while wisdom and fortitude had one form only, the forms of holiness and sin are diverse as human nature. Each Christian's face bears the marks of a great tragedy, and the finest Gothic mouths seem like scars that life has made.

Moreover the appearance given an ancient deity had only the slightest connection with his or her personality. Mercury looks little more of a rascal than Apollo; Pallas and Persephone might be sisters, and to carve a Venus after Juno was a very different matter from carving a St. Anne after Mary Magdalen. Gods without life-stories, mere animated shadows in which, like blood that has for years lain stagnant, are dimly throbbing intimations of divinity or the stirrings of a will —Jupiter is Jupiter, and not Danae's lover. Whether or not murder has given the dark cast of the underworld to their lives, all these faces assert the same complacent triumph. The Athenian spectator watching *Oedipus* saw a servitude no longer his; the fresh blood flowing from the last quarry of the monstrous gods of old. But the Christian of the West bore his own destiny, the most imperious of all, within himself, and it was to his inmost heart that Christ's hand, wounded ever anew by man's very nature, brought at once remorse and pity, now that each Christian's destiny was of his own making.

It was the individualization of destiny, this involuntary or unwitting imprint of his private drama on every man's face, that prevented Western art from becoming like Byzantine mosaics always transcendent, or like Buddhist sculpture obsessed with unity. Another reason why Christian works of art have this strong individualism is that Christendom is founded on specific events. The life of Venus was conditioned by her nature, the Virgin's by the Annunciation. The story of the life of Zeus is not a gospel, and classical mythology has no Sermon on the Mount

ROMAN ART: AGRIPPA

RHEIMS (13th CENTURY): ST. JOHN THE BAPTIST

or Crucifixion; that is why it has no message to men. Each great Christian event is unique, the Incarnation will never be repeated. The Greek gods were shown carrying the attributes of their respective functions; the Virgin carries the Child, and Christ the cross.

Hitherto a painted or carved personage had always conveyed his feelings, like an actor in a dumb-show play, by *symbolical* gestures. In Egypt, Greece, Assyria, China, India and Mexico art had known two forms of expression: abstraction and symbolism. All mankind had until now used one language, that of gesture, and the various races had differed chiefly in the renderings of their silence—for Jupiter reigns quite otherwise than the Buddha dreams. All these portrayals had in fact been a system of signs—as in the Chinese theatre the lifting of the leg signifies mounting on horseback (but also as friends embrace to demonstrate affection). The early cinema gave us a good idea of the way such conventions could be used effectively; its gestures, whether stylized or everyday, always had a logical basis.

Christendom had been led to portray many emotions flouted before its coming. Though Assyrian art depicted tortures, it had been indifferent to the victims' suffering. The style of one of the Mother-Goddesses worshiped on the banks of the Euphrates would have ill become the Madonna. And what previous art had been called on to depict a woman gazing at her crucified son? Christianity's supreme discovery in the field of art was that the portrayal of *any woman whatsoever* as the Madonna had a stronger emotive value than a would-be exal-

LE LIGET (12th CENTURY): CRUCIFIXION

tation of the role to superhuman heights by means of idealization or symbolism. In the Chartres Nativity we see Mary drawing the Child's swaddling-clothes aside with her forefinger. Actually these "snapshots" of a fleeting gesture or expression were not late innovations; those moving gestures which we see in many Depositions from the Cross, with Joseph of Arimathea supporting Christ's body while Mary holds His hand and fondles it, are so far from being an invention of the Trecento that they can be seen even in the somewhat stylized frescoes at Le Liget, Saint-Savin and Montmorillon. The scene was rendered abstractly at first, then gradually "came alive." A reason why men understand their experience so little is that they usually apprehend it by way of logic; they rationalize it. Art sometimes has recourse to a symbolical rendering of emotions that we know (a method involving logic); but sometimes to an irrational, vividly compulsive expression of feelings that we all can recognize (as when Giotto shows Mary watching the Ascension with an expression not of ecstasy but of sorrow). The Gothic rendering of scenes bears much the same relation to previous renderings as does the modern novel to the long narrative poem.

Doubtless the use of masks accounts in part for the emphatic gestures and ornate presentation of every scene which make all classical art seem like one long stage performance. Asia, too, where the stage play aspired to be a rite, was obsessed by the mask. Until the great age of Christian art the mask prevailed everywhere; even in Roman portraits, where the face either betrays no feelings or proudly masters them. Then again, classical painting and sculpture had recorded joy, sensuality and anger; whereas Chartres and Rheims are all for meditation, gentleness and charity. Whatever relates to the senses may be expressed by the shaping of the body or its movements, sensuous appeal by the molding of the breasts, joy by the free rhythm of the dance, though the faces may be left quite abstract; it is with the face alone that finer emotions are conveyed. Thus in classical statuary the mobile elements of the face (eyes and mouth) count for little; whereas Christian statuary pays particular and passionate attention to these. When in the course of visiting a chronologically arranged museum we enter the first Gothic room, we seem to be meeting living men for the first time. When an Asiatic sees our medieval art, his first impression is one of shamelessness; far more than any Greek nude it shocks him. For Gothic art is man *unmasked*. Nothing attenuates the effect of nudity so much as the depersonalization of the face, a fact that the Renaissance artists were quick to grasp.

The saints had shown themselves on earth. Associated with handicrafts and localities, they were far from being mere chrysalids, shells out of which would come the butterfly of a wisdom perfect and unique; rather, they were witness-bearers to a holiness whose forms were as manifold as nature's. The saintliness of the saint is measured not

by his capacity for overcoming human nature or discarding it, but by his sublimation of the human, while accepting it. He is a mediator in the realm of forms (as in so many others), a light whereby the dim people of the field and furrow are revealed to us. To this advance from the abstract to the particular is due the anomaly of so-called medieval realism; those realistic sculptors made it their life's work to portray definite persons—Christ, the Madonna and the Saints—whom they had never seen.

TAVANT (12th CENTURY): CHRIST

Imaginative as, under these circumstances, it had to be (since they had never seen them), it was a realism of sorts; for the sculptors were not expected to *invent* Christ's face, as the pagan artists had invented those of Zeus and Osiris, but to recapture it. Christ crucified had existed and the sculptor did not aim at making his crucifix finer than other crucifixes, but more like Christ; he did not picture himself as creating, but as drawing a step nearer to the truth. And how remain unmoved when we conjure up a picture of those early craftsmen who, greatly daring, were the first to evoke with trembling hands the face of their Redeemer? When the spirit of the West had vanished from the world, Byzantium had rediscovered the sacrosanct: those haunting faces which the first small, anguished crucifix transformed into abstractions. The haggard intensity of some Tavant figures was the first faltering speech of the Christian artist, beginning to address himself not to the Creator or the Eternal but to the humble carpenter whose agony had persisted throughout the centuries during which men slept. How could an Egyptian, an Assyrian or a Buddhist have shown his god nailed to a cross, without ruining his style? And, seen from the angle of Greek sculpture, Prometheus bound had been merely a clandestine hero.

Medieval art was the portrayal of scenes, for the most part dramatic or tragic. No doubt the theory that it was first to represent such scenes is largely due to the disappearance of the paintings of antiquity; painting, everywhere, is more "representative" than sculpture. True, Timomachus'

ROMAN COPY OF TIMOMACHUS: MEDEA

223

Medea, gripping her sword as she watches the children she is about to murder at their play, is theatrical enough, but, like the same Medea in a Renaissance painting or one by Ingres, she expresses no emotions. Just as in ancient art the "story" always tends towards the theatre, so in Christian art it tends towards the mystery-play. Even in periods when he was unmolested, the Christian martyr-to-be seems branded by the death which is to give his life significance. And also it imparts significance to him who contemplates a picture of that life, since martyrdom is a bearing-witness, not an accident; while Medea's predicament and Niobe's tears concern them alone, the Virgin's sorrow concerns all mankind. Christianity did not originate the dramatic scene; what it originated was the spectator's participation in it.

The style of antiquity, being a rhetorical expression of the world, meant nothing to the Christian. It often implied the precedence of the sculptor over the scene he carved, the primacy of the act of portrayal over the thing portrayed. The style of the *Laocoön* would become pointless, not to say unthinkable, if Laocoön had died for the sculptor, whose genius well may make a deeper impression on us than does the agony he depicts, because the latter concerns him only as an artist. But no genius can be as emotive as a picture of Christ's death for a man who believes that Christ died to save him. For the Gothic sculptor to emerge, the classical sculptor had first to disappear. He was to reappear—but now in the service of Christ—when the Crucifixion came to mean primarily to him a promise of redemption.

Gallo-Roman art was not the progenitor of Romanesque, which signified the opposite of what the former signified and was separated from it by four centuries. Generally speaking, it is a pagan art, even when it fancies itself otherwise. A pagan art of dying gods, in which the paganism of the past is petering out into superstitions leading nowhere, and in which all that survives of the lore of the primeval forest is some shadowy elves. It seems less disposed to perpetuate the Roman order than to escape it, taking cover from it behind its rags of stone. Such few towns as did not wholly disappear when, after the invasions, the forests of the Druids resumed their primeval sway were not in the least like the "free towns" that came later—they were more like big Negro kraals. France, which was to be the most thickly populated land of Europe, was an Abyssinia without a capital. Outside the monasteries only one art obtained, and it took the place of Gallo-Roman. It is less familiar to us than the latter, since little of it except its funerary figures has survived. Most of these simply reverted to the sign; the sculptors produced their effigies as mechanically as they re-cut on tombs the names of long-forgotten worthies. A few, however, have a significance which seems to derive from some ethnical tradition, but for the understanding of which much research work will be needed. It is suggestive that after

a lapse of seven hundred years we find the pattern of the Celtic "eye-coin" reappearing in Merovingian gold pence. And other, obscurer forms recurred now and again, up to the Gothic age.

Gallo - Roman had been a colonial art; the characteristics of the Roman style persisted in those provinces which had been thoroughly latinized, while in other areas they were commercialized for popular consumption in replicas adjusted to the taste of the tribes of ancient Gaul. When, after their five hundred years' eclipse, the towns reappeared, they found not only the Roman monuments still standing but also (since meanwhile Byzantium had arisen) Byzantine forms in the monasteries, and in the older graveyards the figures of the forest, which were not merely those carved on

MEROVINGIAN GOLD COIN

the Merovingian sarcophagi. Now a barbarian art can keep alive only in the environment of the barbarism it expresses; Negro art is dying of its contacts with European forms, however inferior these may be. In the Tibetan monasteries the parquets, smooth as mirrors, on which once were painted the Buddhist images that reached perfection in Bengal many centuries ago, now reflect, alongside the vastness of the snowfields, a motley horde of popular fetishes, tawdry streamers fluttering in the icy wind, or bulls' skulls hung on dead trees. In Europe, as in Tibet, there were two distinct kinds of forms, two cultures akin but different. When Europe "clad herself in a white robe of churches," she stripped off the rags and hides of the dark ages; the resurrection of the towns, the determination of the religious Orders to use Christian forms

GALLO-ROMAN ART: CAPITAL OF VERECOURT (VOSGES)

for the edification of the masses (Byzantine art attracted the believers into the church, whereas the Romanesque tympanum cried out its message to the crowds in the marketplace), and that fellowship of men *in action* inculcated by the Roman church (which, while accepting the medieval caste system, was alone in transcending it)—all alike conspired to wrest the Byzantine forms from the crypt, to bring them up into the light, and to force on them a metamorphosis which enabled Christian art to unite men in their daily lives, in the here-and-now.

The true nature of Romanesque art eludes us so long as we regard it as a legacy of Byzantium. It is neither a less skillful, nor a more successful form of Byzantine art. Nor does it owe anything to the Irish or Carlovingian miniature, or to the reliquaries of Spain and the Rhine-

land, to the tangled animal carvings of the Great Invasions, or the prows of
drakkars and Iranian silks—with which various European peoples, one
after the other, sought to replace the lessons of Byzantium.

Byzantium *was* the East, but there was much of the East in the
West of those days, both as to influences and to kinship. Thus our
European "strap-work man" is akin to the Kufi inscriptions, the bearded
man in our miniatures to the bearded man in Abassid miniatures, the
concentric Burgundian volute is Byzantine, but the Byzantine volute
is also that of Bagdad. It was in breaking away from this vast
common background that Romanesque art set itself up against the
East. Since the plastic script of Byzantium was that of the Western
Church (just as Latin was its language), it was necessary to conform to
it, in externals. But its spirit was another matter; the West had never
assimilated this as did the Slavs. Thus, only if in assessing the forms
which influenced Romanesque style, we take account not only of what
was retained but also of what was done away with, can the way in which
it was built up be ascertained. In the first phase there was a tendency
to bring together such forms as enabled the artist to isolate God from
man and to adorn the abstract world in which this solitary God had his
being: prows of drakkars and Sassanian brocades, Germanic animals
and Irish miniatures. In the last-named the ornament is no longer

PROW OF A VIKING SHIP

227

subordinated to the human figure but the human figure to the ornament; the Centaurs and Victories which had replaced the bull-men of Assyria and effigies of Anubis were succeeded by the "strap-work man." This polymorphous art mingled the forms of the townless man, those of the Armoricans and those of the tribes which had poured into the Empire in the wake of the invaders, with the jetsam of prehistory, giving a fraternal welcome to all alike. The result was the barbarian abstraction, which Islam was to civilize without destroying it. From Byzantine art the barbarian artists took over its mannerisms, but not its visions of transcendence. And the insertion of the face of Christ within the sinuous strap-work of the nomads did not suffice to christianize it.

But, before the year one thousand, there had emerged in France, in Spain and in the Rhineland certain tendencies towards humanization very different from the Byzantine formalism; this is evident in some seemingly decorative figures in the Gellona Prayer Book. Romanesque sensibility was bound up with this new development; for in the Romanesque style there was much besides those elements of barbarism to which it owed not only its carapace-like structure but also its passion for decoration—happily kept within bounds by its subordination to architecture. What Romanesque led up to was not a new Irish, Sassanian or Byzantine art; its offspring was Gothic art. And Romanesque means far more than the totality of artifacts produced during the Romanesque period. If we set aside the products of its craftsmen, we see that the forms which exclude the humanizing element, great as are their merits in certain cases, are *sterile*. Thus the two female figures (styled *The Signs of the Zodiac*) at Toulouse, though undoubtedly a work of art, have no progeniture; it is not at St. Sernin's but at Moissac that we find an art teeming with the future. Despite the perfection of the figures at St. Paul-de-Dax, they engender nothing; for fecundity we must

GELLONA PRAYER BOOK (8th CENTURY)

turn to Hildesheim. The creative genius of Romanesque, like that of all other arts, resided in the new elements it brought in, not in what it copied; we have learnt what the werese first by studying Romanesque as a whole, and then by studying Gothic art, to which it led. It did not "tend" either to carve gargoyles like Scandinavian dragons or to perpetuate the style of the Visigothic belt-buckles; nor can any "influence" it underwent account for the genius of Gislebert of Autun, or that of some anonymous Rhenish artists, or that of the Masters of the Royal Portal at Chartres. Its tendency was, rather, to give the Byzantine "Elders" the idiom of those at Moissac, and to the "Kiss of Judas" the accent it has at Saint-Nectaire. None of the forms which presided at the birth of Romanesque sought to remake its past; all these forms—whether barbarian, oriental, deriving from the age-old folklore of the peasantry or even from that of classical antiquity on the shores of the Mediterranean—make common cause against the enemy of all alike : Byzantium.

MOISSAC (CA. 1115): ELDERS OF THE APOCALYPSE

230

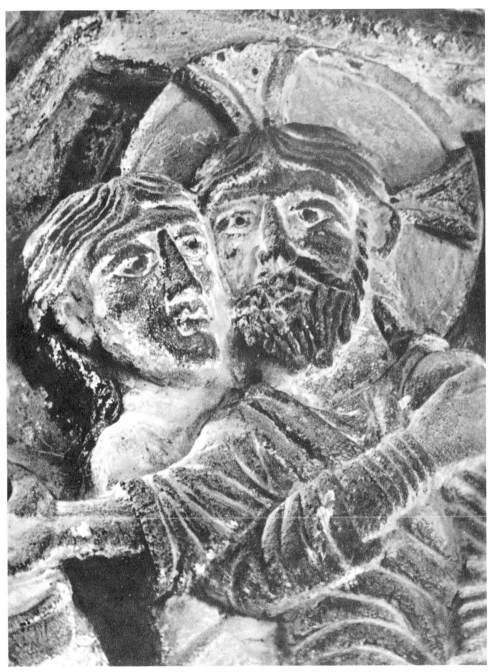

SAINT-NECTAIRE (12th CENTURY): THE KISS OF JUDAS

Ornamental though it be, every great Romanesque figure, as compared with its Byzantine next-of-kin, is *humanized;* though essentially religious, it is no longer esoteric. And as time went on it was even less estranged from the world of men; it is because so many of the heads are broken off that the great tympanum at Vézelay looks more Byzantine than the other tympana which have not been mutilated; as becomes particularly clear if we compare a photograph of it with that of an authentically Byzantine work. We have only to isolate a group of the Autun heads to see how little Byzantine was the sculptor Gislebert.

GISLEBERT D'AUTUN (CA. 1130): TYMPANUM OF AUTUN CATHEDRAL (DETAIL)

AUTUN (CA. 1180): ST. PETER

SOUILLAC (12th CENTURY): CHURCH PILLAR (DETAIL)

Hence the futility of seeking to trace the origin of Romanesque in any Germanic or Byzantine forms of art; these did not quicken its life and were united with it only in their common death. It is possible that the sculptor who worked at Souillac took his lay-out from Aquitanian or Spanish miniatures; but his *art* is quite different from theirs. Indeed the influence of miniatures of this kind on the great Romanesque works of art was little more than iconographic. They had no more direct bearing on the genius of the sculptors than picture postcards on Utrillo's art. Romanesque is neither a synthesis nor a consequence of forms that it took over; no more than was the art of Mathura and that of Lung-Mên—and no more than a fire is a combination of the sticks that feed it.

The figures which, for want of a better name, we describe as popular (or folk) persisted during the period of the full flowering of Romanesque, just as in the seventeenth century the Breton "Calvaries" and Saints kept to a pseudo-Gothic style. The primitive sculpture of Europe (and the "primitive" periods, when the first spark of art was kindled in the

BIBLE OF ST. MARTIAL (10th CENTURY): DETAIL

darkness of unknowing, have been steadily pushed back during the last hundred years) is revealed in these figures, and it is beginning to find its way into our Museum without Walls. These figures elude art history all the more because they do not tend (so far as we can judge at present) towards the expression of any obviously selected aspect of Man. In transforming them, Romanesque art rescued them from the sporadic and the accidental, and incorporated them in its massive unity. And in so doing christianized them—though even on the capitals of church pillars these figures have the aggressive heathenism of fetishes, very different from the staid Roman allegory. Hence comes the curiously ambiguous effect of the *Pietà* at Payerne. And several of the Moissac "Elders" look like heathen figures—converted.

PRE-ROMANESQUE ART: CAPITAL (PAYERNE, SWITZERLAND)

CAPITAL FROM POITIERS CHURCH

In some Romanesque heads, even the later ones (at St. Denis, for example), these elementary forms still lurk behind the orderly lay-out of Romanesque. Indeed, even after the sculptor has imposed the Romanesque idiom on them, how strikingly that elemental life persists! And in cases where an indifferent sculptor fails to impose this idiom, how readily he harks back to those early forms! Yet like the forest they were being steadily pushed back, and they were soon to find a last refuge in its depths, now that art had become one long, un-flagging effort to make each form reveal its latent intimation of Christ's presence everywhere. It is because Joseph in the well prefigures Christ in the tomb, and because the Queen of Sheba's visit foreshadows that of the Magi to the Child, that Romanesque sculptors impart that special accent to the faces of Joseph and of Balkis. In art, life's starting-point is always to be found in the meaning the artist reads into it, and when these sculptors singled out among the biblical legends those which have a prophetic bearing, the reason was not a mere desire to edify. All art centered on that brief life of Christ and found its inspiration in whatever had associations with the tragedy on which man's hope is founded. So as to take effect on what lies deepest in the human heart, all life was made to link up with that Life, until from symbol to symbol, from analogy to analogy, Christ's arms embraced the whole world like the shadow of the Cross, like the communion on the faces of the statues. At Moissac, Autun and Vézelay He still dominates the tympanum by his size, by his position, and by the fascination He seems to exercise on every line;

ROMANESQUE EYE

but above all because He incarnates the meaning of the prophets, of the living and the dead surrounding Him and gazing on Him.

As against Byzantine art Romanesque pertains to the New Testament, and as against Gothic to the Old. It leads on towards Rheims as God towards Jesus; as the Vézelay *Christ in Glory* towards the Preacher Christ at Amiens and the dead Christ of the *Pietàs*. The more the Christ becomes Jesus, the more He merges into the composition. The Romanesque eye began as a sphere inset between the eyelids, a sign; the mouth was a sign for two lips; the head as a whole was merely a supreme sign. In the Gothic eye, however, we find more than a sign; rather, the purposive shadow of an eyelid, a speaking glance. Henceforth art is called on to express emotion by selecting that which in man himself is already charged with expression—and which, transcending form, can link up with Christ. Early Romanesque centers on the head, and Gothic on the face; a Romanesque body is merely a sign bidding man overcome the strange predicament of his life on earth, and what the artist wrings from him is a testimony of God's transcendence. Soon, however, the sculptor replaced the sign of two parted lips by something that had hitherto been practically ignored: the expressive line between them. Gothic, indeed, began with tears.... Starting from the earliest composition in which the Presence of the Mediator had been made manifest, the Gothic sculptor aimed at making every line on every face bear witness to it; and throughout the Christian world Gothic, like Romanesque at its outset, became an Incarnation.

GOTHIC EYE

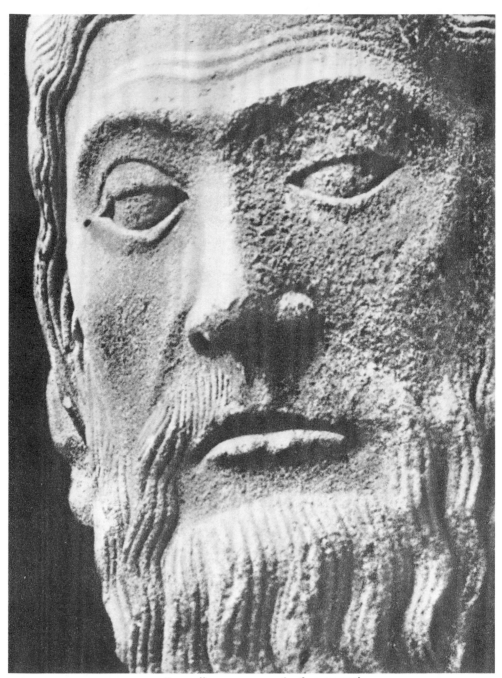

THE "DAVID" OF CHARTRES (12th CENTURY)

Seldom is a Gothic head more beautiful than when broken.

The Incarnation was also a gradual deliverance. Nearly all the Rheims forms are forms set free from sin no less than from the Byzantine tyranny of the abstract; they depict God present in His creatures, no longer in august aloofness. Thirteenth-century man discovered simultaneously his inner order and its paradigm in the outside world. For the cathedrals arose at the same time as the French royalty; Christ the King, crowning the Madonna, takes His place beside the Crucified. Sorrow by sorrow, into the communion of saints to which each saint brings his meed of charity, the *mater dolorosa*, whose all-consoling shadow is ever lengthening across Europe, introduces woman. Most cathedrals of the time were dedicated to her; the theme of her coronation became ever more prominent, while He who crowns her is less and less the Lord, more and more the King.

Thus, on the brows of God's Son, who came down to die a criminal's death on the Cross, a kingly crown (in the Middle Ages there is nothing abstract about his crown) replaces the crown of thorns. This dominant figure of the new Christendom is all the surer of its triumph since, to the thinking of many sculptors, it is soon to be reincarnated; indeed, for those of Rheims, it is already incarnate; the mightiest monarch in Europe is Saint Louis. Gone are the days of the Moissac Christ, a Romanesque Pantocrator. For the first time Christian man is making his peace with the outside world. That crowned head which sculptors now carve on cathedral porches, that face in which for the first time power, compassion and justice are united, is the face that in their dreams they might assign to the King of France.

The royal *motif*, whether that of the Buddha still a prince, or that of Christ the King, always encourages a flowering of linear designs. But the Prince Siddhartha lies behind all Buddhist art, as behind the life of the Buddha himself; whereas Christ the King was not born in the Catacombs. He is no chrysalis but a full-fledged, consummated being. In the Rheims *Coronation* not one line of the face of Christ is "antique."

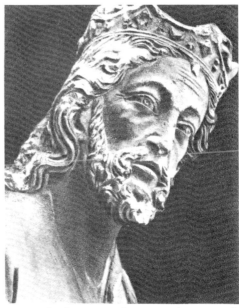

RHEIMS (13th CENTURY): CHRIST (SEE P. 242)

241

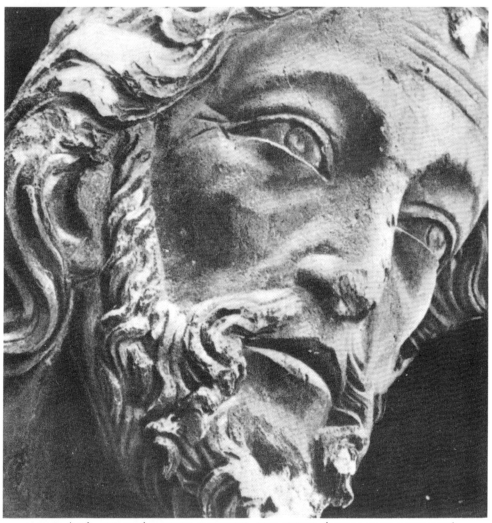

RHEIMS (13th CENTURY): CHRIST CROWNING THE VIRGIN (FIGURE NOW DESTROYED)

The furrowed forehead, the eyebrows slanting towards the temples, the sensitive nose, the crow's feet *above* the corners of the eyes, the build-up of the face in clean-cut planes, the hollows below the cheek bones, the almost parallel eyelids (with the drooping curve of the lower) matching the mouth, whose corners have the same downward movement—everything in this head is Gothic; and yet, none the less, in some obscure, indefinable way it links up with the antique. If we cover up the crown with a finger, we are, to our surprise, reminded of—Michelangelo.

Starting off from abstract or symbolical forms (the Christs on Romanesque tympana, the animals symbolizing the Evangelists), art was now progressing, by way of the saints, towards the widest possible diversity and discarding the abstract in proportion as it humanized it; was passing on from St. Mark's lion to St. Mark himself—unlike the art of antiquity, which had never humanized the abstraction of its sacred figures by giving them individuality. Greece moved on from abstract to idealized figures without an intermediate stage of portraiture. Gothic Christianity, on the contrary, idealizes *only* the individual; compared with any Minerva or Juno of Antiquity, even the queenliest of Madonnas is a real woman. From the emperor made god, art was turning to God made man and Christ made King. But, if Christianity thus fostered infinite possibilities of expressing the individual man or woman, this was not because it set any special value on the personality, but because it valued everyone; none but God could judge a soul. Those Plutarchian faces of Roman art, even the faces of individuals, always conformed to the Roman pattern; whereas faith can assume the form of every Christian's face. The essential man, for the Christian, was not to be evaluated by his eminence, his functions or his destiny; but by his soul.

While throughout Christendom the Church and, to a lesser degree in France, the monarchy were resuscitating an ordered world, apotheosis was gradually taking the place of incarnation and the concept of Christ the King (though not replacing that of Christ the Crucified) was lightening the impact of the tragedy on which humanity is founded.

Nevertheless, it had become no easier to portray divine beings without risk of sacrilege. The Christ at Vézelay, as at Autun and Moissac, looming large in the center of a microcosm, was Christ by definition; but this Gothic Christ, involved in narrative scenes and closely surrounded by figures that were becoming more individual as time advanced—how was His divine nature to be made apparent to the senses? He could move ever farther from symbols and transcendence, becoming more and more incarnate; yet He remained and must remain the Son of God. The fervent, though unconscious, desire of the style that now emerged was somehow to reconcile these two natures. The idealization of a face imparts to the features, which express the emotion the artist wishes to convey, the maximum prominence compatible with the harmony of the face as a whole. (Its converse, the caricature, illustrates this *per contra*.) This idealization is wrapped up with a sense of man's inner order; since the dawn of Christianity most of the great idealizations in the art of Europe have been either Catholic or imperial. Christian idealization was an expression of the order and harmony that the Church was attempting, not without tragic mishaps, to implant in man and in his way of life. In art, the fact of not conceiving the world as being a neatly ordered cosmos consists less in viewing it

as mere chaos than as the scene of a dramatic conflict. The Jesuits' conflict with Protestantism was a revival of the quarrel between Thomas Aquinas and Augustine. The Church brings order to man in so far as it integrates, or sublimates, the drama of existence. The art of St. Louis' time, whether manifested in the work of the Master of the *Angels*, in that of the sculptor of the *Christ*, or in the *Visitation*, was the art of the great cathedrals and the *Summa Theologica* and imbued with the spirit of Innocent III and St. Bernard: almost, one might say, an art of "peace on earth." For it synchronizes with the first setback of the devil. And as though the forms of the ancient world had been lurking in his shadow, they reappeared when he retreated. True, it once was thought these forms were his, but that view has long since been exploded; the devil I have in mind, the metaphysical or saturnine spirit of the remote Asiatic past, had nothing at all to do with the harmless nudes of antiquity, its dancers, its settings, whether sunlit or hermetic. The Christian might treat the nude as diabolic, because he was tempted by it; but it did not tempt the Greeks. It was not lust that reigned over their gay populace of statues, it was Aphrodite.

With the devil disappeared the mainstay of his power: man's sense of haunting fear. For now the forms of fear, and the style of fear, were things of the past. The wild roses of Senlis were invoking that gracious *Virgin* of Rheims, of whom the Byzantines with their cult of a huge, inaccessible God would have so fiercely disapproved. The wheel had turned full circle and the smile was coming back into its own, winning admittance to the City of God.

Once again sharp ridges were to disappear, draperies and gestures to grow supple. And that art of smoothly modeled planes, of supple garments and gestures that had flourished in the past was to become once more a language. The Gothic artists felt they could understand its message, and though it was not imitated, it was put to use in the struggle with Byzantium and even Romanesque magniloquence much as, at a much earlier day, it had served to combat Egypt and Babylon. This language had sometimes been man's most favored means of defending himself against the unseen forces that destroy him and also against those transcending him. But now it sought to voice the concord between man and what transcends him, the last act of the Incarnation.

We can be sure that the art of antiquity was not unknown at Rheims; there are classical precedents for the way the Master of the *Visitation* treated drapery. And the beard of the prophet beside the Queen of Sheba (though the planes of the face are Gothic) has the same small corkscrew curls we find in Roman bronzes. In the *Visitation* the artist began by imposing folds of the antique pattern on a Gothic garment. But the poise and gestures of the two figures are pure Gothic. The folds in the Virgin's costume, the modeling of the lips, the decorative

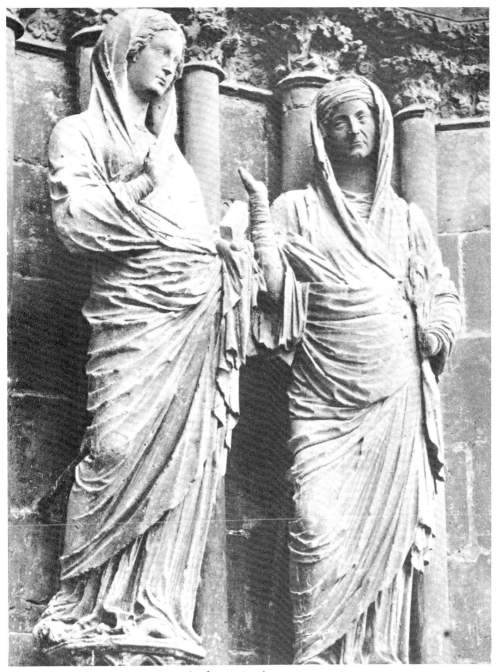

RHEIMS (13th CENTURY): THE VISITATION

RHEIMS (13th CENTURY): THE VIRGIN OF THE VISITATION

curve of the chin, the oval face—all these are classical; but not so the slight quiver of her nostrils. This detail clearly demonstrates the artist's intent to humanize her, since, carving as he did directly in the stone, he was bound to pass through the stage of the straight nose we find in classical statues, before reaching the sensitive line of the Virgin's. Nor is there anything classical in that hollow in the nape of the neck or, above all, in the forward movement of the forehead. It is the angle between forehead and nose—replacing the parallelism of antiquity—which makes the Virgin lose her look of a Patrician lady when we walk around her. Thus the nose is no longer the axis on which the face is built;

246

RHEIMS (13th CENTURY): THE VIRGIN OF THE VISITATION

BAMBERG (13th CENTURY): ST. ELIZABETH

and, despite the Roman globe-like rendering of the eyes, the gaze is suggested by the perpendicular mass of the forehead. All that this French profile takes over from antiquity is what the Master of the *Coronation* achieved by the broadness of his drawing, and the Master of the *Angels* in his smile: a method of de-personalization. Here Roman form is employed much as fetish structure is employed by Picasso; or as certain naïve near-contemporary artists made use of the Romanesque frescoes. For when man had made his peace with God and once again order reigned in the world, the sculptors found in the art of antiquity a means of expression ready to their hand.

RHEIMS (13th CENTURY): ST. ELIZABETH

If we turn East to Bamberg, where this reconciliation was less complete, we find that its *Virgin* gives an impression of being much earlier than the Rheims *Virgin*, from which, nevertheless, it derived. Gazing with eyes still misted by fears of hell, above that miraculously apt fracture which makes her face the very effigy of Gothic death, the *St. Elizabeth* of Bamberg seems to contemplate her "prototype" of Rheims across an abyss of time.

At Rheims we often come across forms anticipating the Italians'. Unknown to Greek and Roman art alike, they can be seen in many great cathedrals: on the Amiens portals, in the bas-reliefs of Paris—in

249

NOTRE DAME, PARIS: JOB (12th-13th CENTURY)

those minor works whose function liberated them from architecture and which, thus, were so often in advance of the large-scale sculpture. The medieval sculptor freed himself sooner from his sense of fear than from the influence of the pillar. A style which was common to three great French cathedrals of the period, and echoes of which are found throughout the West, cannot be held to be accidental; this style is bound up with the calendar, the seasons and months, with human toil, with the elemental freedom which hymns its triumph on the gable of the great portal of Rheims. Surely that little angel holds in his closed hand —with Ronsard's roses—the most vital message of the sculpture of Rheims: that when seemingly it looks back to Caesar, actually it is pointing the way to Lorenzo the Magnificent; for the style of its *St. Elizabeth* is far less that of the *Great Vestal* than that of Donatello.

Donatello, moreover, sheds light on the relationship between medieval art and the forms of antiquity, much as the supreme work of a great master throws light on his earlier ones. Gothic and even Romanesque always had two kinds of calligraphy: the first being that of the monumental style, ranging from the pillar to extreme purity of line; the second being the scroll-work technique we find in many miniatures, in tapestry and stained-glass figures—an art of slender necks and curling hair. The former points forward to Giotto and recalls Olympia; while the latter, under the hands of a great sculptor, transforms its serried linework into a pattern of flowing curves, idealizes by its feeling for the sublime, and points the way to Donatello; and thence to Michelangelo and to Baroque. The former haunts the thoughts of Maillol; the latter those of Rodin. These two forms of art underwent like changes wherever the voices of hell were muffled and Man made his peace with God. Protestantism proceeded straight from Gothic to Baroque, and the one great Catholic country that did not shake off the threat of hellfire—Spain—has no classical sculpture in the French meaning of the term.

Before the reliefs of the Trajan column and the buried statues could come back into view, man needed to efface the last vestige of his solitude. So long as the great movement towards a reconciliation of man with God —and of both of them with the world—had not taken effect, none of the Rheims discoveries was possible; men did not need anatomy, but theology. To restore to life that slumbering populace of ancient statues, all that was required was the dawn of the first smile upon the first medieval figure.

BOCKHORST, WESTPHALIA (12th CENTURY): CRUCIFIX

V How timid was that smile! Behind the Greek smile, Buddhism's meditative smile, this brief Gothic smile, and the warm humanity of Italy lay untold ages of the inhuman. And now it fell to the Trecento to find out, for sorrow, what the smile means for happiness.

On that lofty plane where man's noblest creations congregate, Giotto's *Crucifixion* is the sad brother of Rheims' happy *Angel*. The Romanesque Christ had been a Man of Sorrows, as was to be the *Christ in Prayer;* as against Giotto's Christ they look like tortured Vikings, grandiose abstractions made by barbarian artists. What is there in

GIOTTO: CRUCIFIXION (DETAIL)

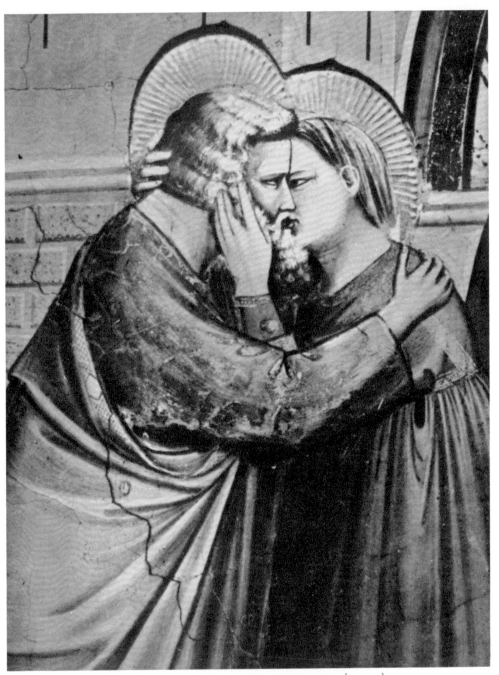

GIOTTO: THE MEETING AT THE GOLDEN GATE (DETAIL)

common between such gruesomeness and Mary's hands fondling her Son's pierced feet, like two little animals asleep?

Giotto renewed the liberation that had been cut short at Rheims. True, he began in the Byzantine style (from which the eyes of his figures were never to escape completely), but he was less concerned with its effects of other-worldliness than with retaining its volumes—while transforming them. This quest of the three-dimensional, which led him to model the prophets in his early work, persisted until its culmination in the figures of Joachim and the *Presentation*.

By the use of a preliminary design, at once schematized and wavering, of which after the retouching only a hint remains, he gives the impression of breaking away from Byzantium. (Of this the noblemen in *St. Francis revered by a Simple Man* are an instance—whether or not Giotto was its sole painter.) But from his Prophets onwards to the bishop in *St. Francis renouncing his Possessions* it is from three-dimensional volume that he derives his strikingly personal accent. In these works relative depth is not attained by the use of perspective or tone values. Whereas Roman and Northern painters secured this effect by, as it were, hollowing-out the canvas, Giotto embosses his. With the result that, as compared with all earlier painting—Romanesque frescoes, miniatures, Byzantine panels—his frescoes look like bas-reliefs; we need only look at reproductions of them upside-down to see how near

GIOTTO: THE RESURRECTION OF LAZARUS (DETAIL REPRODUCED UPSIDE DOWN)

GIOTTO: THE ANGEL OF THE UFFIZI MADONNA

they come to sculpture. Not only had the statuary of the Saint Louis period given rise to those elongated, rather heavy profiles and the thick-set bodies which were to become characteristic of the school of Giotto; not only does Giotto's drawing seem to retain that predilection for showing forms in silhouette, which he shares with sculptors, but his whole plastic world is essentially a sculptor's world.

When his frescoes have not been altered by retouchings, we can see how much his genius is bound up with this feeling for just poise and verticality; his best works show us standing figures, or at least (like those in *Joachim's Dream*) in definitely statuesque attitudes. Such of them as lie outside the world of sculpture (the prostrate woman in the *Lazarus*, for instance) are handled with less assurance. The harmony of faces, bodies and the fresco itself takes strongest effect in those compositions in which the sculptural lay-out is most pronounced—as in the *Golden Gate*, the *Visitation* and the *Flight into Egypt* (in which Mary is *not* bending forward on the ass). Just as we feel even in reading a Greek tragedy that the true faces of the characters are stone masks, so Giotto's angels make us think of statues. Indeed we need only take a panoramic view of Flemish painting, or even of fifteenth-century Italian painting, to realize how much nearer is Giotto's art to

PISA (PRIOR TO GIOTTO): ANGEL

NOTRE DAME, PARIS (13th CENTURY): THE PRESENTATION IN THE TEMPLE (DETAIL)

the Paris *Coronation of the Virgin* than to the work of any painter, and that the bishop in the first *St. Francis renouncing his Possessions* and the Saint in the *Dream* are Gothic statues recast in terms of fresco. Similarly the *Presentation in the Temple* at Padua seems a consecration of the sculptured *Presentation* in Notre Dame of Paris.

The successive influences of antiquity on the styles of painting were those of antique sculpture, and in the same way the discovery of medieval (and subsequently, African) sculpture deflected the course of modern painting before it began to take effect on modern sculpture. The three Magi figuring at the nativity of Italian painting were Cavallini,

258

GIOTTO: THE PRESENTATION IN THE TEMPLE (DETAIL)

Giotto and Orcagna—and all three, in reality, were "sculptors."

The link between Giotto and Gothic sculpture does not stem from any influence but from his method of portrayal. And this was something more than a mere supersession of the Byzantine way of viewing the world or the introduction of a greater flexibility. Actually there never was a Byzantine way of seeing, only a Byzantine style, and in 1300, despite the seeming intermediation of Romanesque, this style and the Gothic were diametrically opposed. From the Christ of St. Sophia to the Daphni Pantocrator, Byzantine art had been drifting farther and farther from Man. Though in the Kahrieh Djami church (contemporary with Assisi) it refined its style and even seemed to be humanizing

it, it was not towards Tuscan but towards Persian art that Byzantine art was tending. Its roots lay always in the East. Despite structural changes, the gestures of the figures remained symbolical; as they were in St. Mark's and at Daphni. How could the sculpture then known in Italy (statues, imported ivories, relics of antiquity) have been reconciled with what was known of this Byzantine painting?

True, during several periods painting and sculpture did not develop on lines as parallel as we are apt to think; twelfth-century painting has little in common with the sculpture in the cathedrals, nor is there any statuary corresponding to the art of Velazquez and Rembrandt, or any painting corresponding to Michelangelo's statues—except his own. The gulf between painting and sculpture in the Florence Giotto knew as a young man was as wide as that between Seurat and Rodin. Once a Gothic sculpture, compelling enough to make it clear that the Byzantine style was not the only style suitable for the expression of the sacrosanct, came to prevail in Tuscany, the emotive drive of Gothic found a new outlet in painting also. When in Giotto's *Crucifixion* we see St. John fiercely crushing his fists against his eyelids, or the holy women upholding the limbs of the dead Saviour, or the monks clasping St. Francis' hand in his death agony; when we see figures interlocking their fingers, not to

pray but to express pity; when, in the *Meeting at the Golden Gate*, we see Anna touching Joachim's cheek in a caress light as a snowflake, we are witnessing the dawn of a kind of expression that no painting had yet compassed (though it had existed for a century in northern sculpture). Psychology was replacing the symbol, and painting in its turn discovering that one of the most effective methods of suggesting an emotion is to picture its expression. The face of Giotto's Christ stands in the same relation to that of a Byzantine Christ as his artistic procedure stands to that of the Neo-Hellenes. In abandoning the symbolic gesture, he would actually have invented Gothic, had it not already been in existence.

The Franciscan element in his mental make-up encouraged him on this path—though we must be chary of taking his "legend" on trust. Franciscanism was introducing all that was apt to disintegrate man, but Giotto was quite as near to St. Thomas Aquinas as to St. Francis of Assisi. The Church's struggle to rebuild a Christian order out of all that threatened it most accounts to some extent for the massiveness of all Western creation, that tendency (prevailing from Sparta to the United States) to "build big," Colosseum-wise, which Asiatics regard as typical of our genius. Roman order was needed to prevent Franciscanism from lapsing into Buddhism; Giotto sides with Rome, and perhaps in him the Franciscan *motif* tends more to conceal its true nature than to disclose it.

The driving force of St. Francis' teachings lay in their humanization of grief and their treatment of sorrow not only as a link between man and God, with Christ as mediator, but also as a fraternal bond between all men. But God's world seen through Franciscan eyes was even more inspiring than the Saint's own life, and what is most nobly Franciscan in Giotto's work is not any one of his renderings of the Saint's face, but that kiss in the *Golden Gate*. Never is he greater than when the long, dramatic course of Christianity is summed up in his art and, in his frescoes, the new evangel of his age evokes lingering echoes of St. Augustine. As much as in his gift for breathing life into his figures—which probably has never been surpassed—his greatness lies in the way in which he stamps the divine faces with the presage of their destiny: Christs for whom a Judas ever lies in wait, Virgins already wearing the dark cast of the *Pietàs*. Into Mary's face he instils something of that supreme pathos which we find in the sufferings of little children; each of her gestures seems an intimation of the deepest of all sorrows. By grace of this vast compassion embracing every aspect of a tragic destiny charged with supreme significance, he is Christianity incarnate.

What counts most for us in St. Francis is not those tales of his preaching to the birds but the fact that (more effectively than all the homilies of that period) he forced men to see that real tears flowed on the face of the Crucified. Little does it matter if Giotto learnt the technique

of certain Gothic gestures by seeing this or that ivory carving; his vision of the world of holiness was Gothic in its soul, its gaze, its tears. We do not think of him as a painter of angels according to Cavallini's methods. His way of seeing does not conflict with that of the cathedral sculptors, but carries it further. Not only does he take over their sense of the dramatic—how many a Giotto Virgin resembles those earliest, as yet unsmiling, Gothic Virgins!—but he even retains certain incidental figures of the bas-reliefs, the mocker in *Christ Scorned*, for instance.

But he alters their gestures. He is the first, so far as painting is concerned, to use the sweeping gesture without making it look theatrical. He changes the drapery, too. For though he does no more than deepen the emotion of Gothic art, he wholly transforms its **calligraphy**. He destroys the break in the line (soon to become fluting) by which we promptly recognize any work of the late Gothic period. He it was who originated that elongated curve (lasting for nearly four centuries) which was to develop into the arabesque—and which, in their turn, Rembrandt and Goya were to destroy by means of another break.

At Chartres, at Strasbourg and in Paris, sculpture had known this curve, but merely as applied to isolated figures; Giotto was the first to systematize it.

For its transmutation into frescoes his world of bas-reliefs had somehow to overcome the relative independence maintained by every figure in the Gothic scene, as by every statue in the church porches. At first subservient to architecture, medieval statuary had gradually emancipated many individual figures; but this independence, suitable enough for pillar-statues, was carried over into the group scenes, where each figure often seems almost wantonly isolated from those around it. Thus the "dialogue" between the Virgin and St. Elizabeth, at Rheims, is very different from Giotto's, and even in the high relief of the Paris *Coronation*, where the figures are not porch statues, they stand out singly against an abstract background, gold like that of the frescoes. Although Gothic expression is not theatrical, it has this in common with the theater, that its figures are extremely conscious of the spectator. Giotto's characters, however, telling out against a background of the "new" architecture, or of rocks that are still Byzantine, are clearly interdependent, *looking at each other*. We need only compare his *Nativity*, in which the Virgin's whole body is turned towards the Child who is gazing at her, with the Paris *Nativity*, in which no one is looking at anyone; or the arrangement of his *Presentation in the Temple* with the same scene in Paris, where the persons accompanying the Virgin are looking not at the priest but away, towards the spectator. Giotto applies his genius for stagecraft to making each scene self-coherent; St. Elizabeth's hands are slipped under the Virgin's arm and the Child in the *Presentation* does not stretch His towards the priest who is greeting Him, but towards the Virgin whom He is leaving.

GIOTTO
THE KISS OF JUDAS (DETAIL)

GIOTTO: THE NATIVITY (DETAIL)

Nevertheless, though freeing his figures from the isolation everywhere imposed on them in the cathedrals, Giotto none the less subjects them to an ideal and inflexible architectural discipline, akin to that of his Campanile and that pensive, laurel-crowned figure inevitably conjured up when we think of Florence. As contrasted with his grave intensity, Northern Gothic looks grandiose but often grotesque, almost unkempt in its luxuriance. It was Giotto who inaugurated what came to be known to European art as "composition." He also invented the frame: for the first time an imaginary window delimiting the scene makes its appearance. In replacing symbolical gesture by the expression of psychological and dramatic situations, he soon discovered that these called for a rendering on several planes. And in achieving this he not only definitely broke with Byzantium, but went far beyond all Gothic precedent. The mighty current that had flowed from Chartres to

GIOTTO: THE VISITATION (DETAIL)

Rheims now pursued its course from Rheims to Assisi, rather than from Rheims to Rouen. Though his linear system is that of the bas-relief and his walls seem embossed, the color relations Giotto sets up between the different planes—though not creating the depth of distance. which was to appear only much later—imposed not a mere change but a thorough transformation on the sculptural lay-out of the forms. It needed a great sculptor to design those frescoes, but a great painter was needed to ensure that they should not be sculptures. He is at once the last great master-craftsman and the first artist. And his use of the "frame" was a first safeguard against the risk of disintegration to which an art on the verge of discovering space is bound to be exposed.

This innovation was not, strictly speaking, a matter of technique; and it is no more an improvement on what preceded it than psychological expression is an improvement on symbolical expression. What it did was to change the relations between the spectator and the picture. True, the mosaic had had a frame, but its object was more to divide up a narrative than to delimit a scene. The over-all gold background of the frescoes unified the wall on which the figures took part in an unmoving pageant, like those in the miniatures on the "blank" pages of manuscripts. Hitherto there had been scenes isolated as were the groups of statuary in front of which the spectator passed, as he passed alongside the cathedral walls; as, in an earlier age, he had walked past the Panathenaic frieze or that of the *Archers* in Darius' palace—and as human lives make their brief passage through the vistas of eternity. Giotto did not paint exactly what the eye perceives—for our field of vision is almost always vaguely defined—but what the eye believes it sees, and thus he associates the spectator with the biblical scenes in a manner all the more direct because his gaze is drawn into the spatial recession suggested by the frame. (Where, as in the Scrovegni Chapel, the frame is omitted, Giotto's art undergoes a curious change.) Thus all the resources of his art were directed towards modifying the nature of the spectator's participation in the scene portrayed.

Psychological portrayal, once it breaks loose from sculpture, involves the rendering of space; the Giottos with gold backgrounds are not the works of a different painter, but another kind of painting, which, however, leads directly on to Padua. Duccio seems to have had an inkling of this, but he never dared to paint Christ as a man amongst other men. By lavishing gold on Christ alone and segregating him (and, by the same token, the picture) from the human, he retained the Byzantine transcendence. He discovered, also, those celestial blues which harmonize so well with his Christ aloof from all things human; as the Byzantines had discovered for certain ikons those harmonies in black and purple which make them seem like dirges for a dying world.

Thus every panel at Assisi and Padua implies an ordered lay-out that neither tympanum nor stained-glass window had permitted.

CHARTRES: ST. MODESTA

At Padua, panels matching those of the side walls isolate the *Annunciation* from the *Visitation* and contrast with the dispersed, still Gothic, composition of the *Last Judgment* on the front wall. (At Rheims the carvings on the back wall of the façade, where they are not hampered by architectural exigencies, show that this artist, too, glimpsed the possibilities of such a lay-out.) But it was not the Gothic handling of *scenes* that prepared the way for Giotto's innovation, for each sector of the tympanum is linked to what surrounds it or comes above it; it was, rather, the *St. Modesta* at Chartres, the *Church* and *Synagogue* at Strasbourg. Giotto's genius lay in his incorporation of these great and hitherto isolated figures in a formal system as strict as that of Romanesque **art**.

His conception of man estranged him from both Romanesque unity and from Gothic discursiveness. In the teeming profusion of the North all things were made to converge on the Gothic Christ, heir to the huge Romanesque Christ exalted above the infinite diversity of created beings. As in the *God* at Chartres, within whose shadow rises Adam of whom He is dreaming while He creates the birds, Giotto merged that all-embracing shadow into the ultimate, last-created form. Posted on high above the Gothic multitude (as was the Pantocrator above the Byzantine populace), the saints had played the part of intercessors between Christ and the tangled forest of souls. Giotto's

figures, too, were intercessors, but they interceded far more between Man and God than between God and Man. That theme of Man reconciled with God, which made its appearance in the art of the period of Saint Louis, reappeared in Giotto's art, and for the same reasons, and his biblical figures extend their promise of redemption even to the humblest of mankind. But nothing of the individual man remains in any of his personages; instead of the divine seal which Gothic had stamped on every face there now was an idealized portrayal by grace of which every face shared in the luster of the divine. The new feeling of Christian fellowship (of which Franciscanism was but the most striking evidence) was leading men back —if only for a happy moment—to the world of peace and good will, of Gothic at its apogee. As represented in Northern Europe or in Spain a biblical character was often a transcendent or a forlorn figure, whereas Giotto shows him as a sage; in his art man has regained the old self-mastery of the Roman, but without his pride. Giotto was perhaps the first Western artist whose faith gave every Christian his due of majesty.

Though his forms owed little to Byzantium—whose art allotted majesty to God alone—Giotto took over the Byzantine view that art's function is to create a world, if not superhuman, at least free from many human traits. From his death, down to the day when the Carmine frescoes sponsored the rediscovery of his genius, the freedom-bringing figures he had introduced into the Christian world were repeated time and again on Tuscan churches (as Byzantine

STRASBOURG: THE SYNAGOGUE

forms once had been). It seemed as though the new gospel were utilized by painters solely for changing as it were the alphabet of art. But when he reconciled Gothic love with Byzantine reverence, he did this by upholding the honor of man's estate. His noblest figures were a worthier court of that *Beau Dieu* who at Amiens is surrounded only by a retinue of groveling henchmen. For the individual man in Gothic art seems always to have the taint of sin, and of this there is no trace in the faces at Padua.

This conception of "the honor of being a man" was to traverse all later Italian art like the muffled, persistent sound of a subterranean river. With Masaccio and Piero della Francesca (less clearly with Uccello and Andrea del Castagna)—whenever, in short, early Renaissance art cuts free from the brilliant practitioners who were always threatening it, and whenever it refuses to subordinate the artist to the spectator and merely to seek to charm—this basic *leitmotiv* will be found recurring, a linked echo of Chartres and of Dorian genius. Whenever the ebullient art of Italy looked back towards Rome, it was from these men it retrieved its tradition of austerity; as though the Empire had needed the coming of Tuscan art to body forth its world of bronze, and as though art were ever, in respect of power and glory, either a prophecy or a remembrance of the past. It is in Michelangelo's loftiest works that we hear for the last time an echo of that deep-toned voice which, amplifying the message of St. Louis, was wafted, as on a migration of great birds, by the stately figures of Masaccio.

MASACCIO: THE TRIBUTE MONEY (DETAIL)

That is why we hear so much about "antiquity" in appraisals of Giotto. But what antiquity is meant? Such Roman remains as he knew spoke for an art utterly unlike his: that of the theatrical toga and the carvings on imperial breastplates. The lines of Roman drapery were as broken as those of Gothic, but in a different manner. We need only picture how odd would be the effect were even the most insignificant figure on the Trajan column inserted in a Giotto fresco.... No, the only "antique" art he recalls is that of Olympia and Delphi, which he perpetuated without having ever set eyes on it. As in the work of the masters of archaic Greece, so in Giotto's we see man launching his challenge at whatever aspects of the gods have kept their *terror antiquus* and, a small, timidly heroic figure with the curling locks of youth, championing the cause of those who still are cowering in the shadow of the sacrosanct. The first gleam of a daybreak which, after a brief eclipse, was to usher in the dawn of a new world.

Even assuming that he saw some such statue as the *St. Peter* of the Catacombs, could he have elicited from it the *Meeting at the Golden Gate* or the *Visitation*? Of all that was ancient Rome not a single statue or bas-relief makes its presence felt in his work. The straight-nosed profiles (termed "Roman" though actually little characteristic of Roman statues) in the *Nativity* and in so many of his haloed faces, are much more like those we find on medals, than those of the statues.

Nicola Pisano, too, made majesty his aim, as we can see in *The Presentation in the Temple* (in the Baptistery of Pisa). Moreover, his figures are not mere copies. Yet, though he employs those of the

NICOLA PISANO: THE PRESENTATION

ancient sarcophagi, and sometimes dramatizes them, he does not subject them to a metamorphosis. What makes Giotto's art so unequivocally Christian, and so unlike that of pagan antiquity, is the inner life revealed by the faces of all his personages. A metamorphosis of Byzantine painting in terms of Gothic sculpture, this art is no less a metamorphosis of Gothic sculpture in terms of the new Christianity, which was to end up by destroying it. In taking over this sculpture he did not impose on it the antique mask, but reduced it in the crucible of his art, extracting its majestic purity and purging away the dross. Not as a precursor of Fra Angelico but in virtue of his being Piero della Francesca's master did Giotto create a style which, no less than the Greek, was to captivate the West.

That ferment of ideas—now bloody, now serene—which we name the Renaissance developed between two phases of Christianity. The Italy that was coming to birth was not to be a land of agnostic coteries; it was the court of Julius II. In fact it is impossible to understand Italian art, and Giotto's to begin with, if we read into the plastic genius of the Renaissance any anti-Christian bias. The Christian humanism which took its rise in thirteenth-century France and had to struggle through a century and more of blood to keep itself afloat, reappeared in fourteenth-century Tuscany, was submerged by naturalism, reappeared again at the beginning of the fifteenth century (with Donatello and Masaccio) and ended its long pilgrimage in Bramante's Vatican—this humanism is really a passing phase of Christian thought, much as was the faith of the Crusades, or even Orthodoxy and Protestantism. Even Raphael did not think himself less Christian than Rembrandt claimed to be. Italy used Roman pillars as ornaments for her basilicas, not as battering-rams to destroy the temples of the gods. From the tentative essays of Rheims onwards to the forthrightness of Rome, antique form is a pillar pressed into the service of the basilica, another witness to the great reconciliation. The Renaissance was "antiquarian" only in the way that Montaigne was a pagan; all that it really has in common with the birth of art in Hellas is perhaps that it, too, was a challenge to the Scheme of Things. But always within the pale of the Christian faith. Thus Van Gogh utilized Japanese flat color; the Fauves utilized Byzantine or primitive forms; Picasso employs those of fetishes. But all alike are far from being dominated by these forms, and farther still from the world these forms meant to their inventors. Donatello was hardly less independent in his attitude to the world of the Empire than is Picasso in his towards the world of the African Negro. Were the forms of antiquity better adapted to the new-found hope of concord between God and Man than Negro forms are to our modern individualism and, above all, its spiritual unease? The reason why the myths of Greece obsessed Renaissance artists was not merely, or chiefly, that classical

sculpture seemed to supply them with the technique and means of representation of which they were so eagerly in quest; it was, rather, the fact that for Jacopo della Quercia, Donatello and Michelangelo the forms they so passionately admired were by the same token dead forms which it was now their duty to recall to life. That defunctive splendor graven on the flanks of the triumphal arches was soulless, but they felt they could endow it with a soul. All that multitude of ruins had lain bound from birth by some tremendous spell and was waiting for the coming of the Fairy Prince. Thus we can picture Michelangelo gazing at the Trajan Column; and with what emotion must he, who knew so well how to body forth a smile, a living look, or the dark cast of sorrow, have watched emerging from the excavations the figures which were to owe to him a second lease of life! On the one hand we have the company of the dead, and on the other the liberator who, as he feasts his eyes on them, feels the divine creative impulse surging up within him—and which of these is the master?

He began, at the age of twenty, by copying these shells of death, but soon he was to recall them only with a view to transfiguring them —and utterly to consume them in the fire of his genius when in the shadow of his Prophets, he rediscovered hell. At about the same time Leonardo and Raphael rediscovered the Greek smile and grafted it upon the Roman face, which had almost wholly ignored it. Just as the Master of Rheims had simultaneously lit on marble statues and glimpsed the possibility of transforming them, breathing a soul into some Vestal so as to make of her a St. Elizabeth, in the same way the sixteenth-century artists who brought about this metamorphosis chose to regard it as a homage to the past. Is the Rondanini *Pietà* nearer to any classical statue than a Byzantine bas-relief to one of Persepolis? When at last the battle-cries of the Sargon Palace fell silent and Persia was set free from Assyria, the treasure-hoards of ancient Iran, re-emerging among the Sassanids, were to show the way for which it had been groping to Byzantine art, and the vultures on the new Towers of Silence were to see, across the flames of the relit sacred fires, Eastern Christendom grow petrified in the age-old forms of the eternal Orient.

So far as art history is concerned, the Renaissance "made" antiquity no less than antiquity "made" the Renaissance. When Florence was in her decline the cycle that had started with the death of the imperial forms ended in Rome, after the lapse of over a thousand years, not with a return to antiquity but with its metamorphosis. And throughout that period, even in the centuries of barbarism, even in the golden age of Florence or that of the Sistine—or, for that matter, even in the Seleucid and Sassanian epochs—never do we find an epoch-making form built up without a struggle with another form; not one problem of the artist's vision but is conditioned by the past.

Never has a Giotto acquired his genius by naïvely sketching his sheep. As deliberately as Byzantium wrested from the figures of Imperial Rome the immobility of the Torcello *Virgin*, Europe wrested from Byzantine majesty the tenuous smile that was to make an end of it. Like the Sassanian renaissance, like all rebirths, the Italian Renaissance made haste to modify the forms which it had taken for its models, because they supplied it with the means of overcoming its immediate predecessors, and of working out the destiny of Christian art. Thus all those statues of Bacchus, Venus, Cupid and the rest were constrained to end up in the *Pietà Palestrina*—and in Rembrandt's portraits. And while nineteenth-century art and our modern art are shedding their characteristic light on this resuscitation, and while the Mediterranean past is being made plain to us in the light of our discovery of the whole world's past, the Renaissance is discarding the trappings of "antiquity" (in which it once was travestied) under the watchful eyes, in bitumen and alabaster, of the Sumerian statues and the enigmatic smile of the *Koré of Euthydikos* arisen from the grave.

Little does it matter whether a Byzantine painter was capable or not of drawing like Pheidias; to his mind such drawing was as irrelevant as to a modern painter's is the exact imitation of nature. A style which creates sacred figures does not involve a special way of seeing figures which lack sanctity; the painter's eye is at the service of the sacred, not *vice versa*. The medieval fluting (at the close of the Middle Ages, while drapery was fluted, the planes of the face were smoothly modeled) is a calligraphy of Faith; the Renaissance arabesque is one of beauty. The modern "distortion" (whose purport is less obvious) seems to be placed as strictly at the service of the individual—though not, perhaps, at his alone—as the Christian arts were placed at God's. Style, which like architecture is a language, is not necessarily the most effective means of expressing what it represents; thus Sung wash-drawings are not the most effective means of rendering landscape, nor has Cubism any special aptitude for depicting guitars and harlequins. Painting centers much less on seeing the "real world," than on making of it another world; all things visible serve style, and style serves man and his gods.

Thus, for us, a style no longer means a set of characteristics common to the works of a given school or period, an outcome or adornment of the artist's vision of the world; rather, we see it as the supreme object of the artist's activity, of which living forms are but the raw material. And so, to the question, "What is art?" we answer: "That whereby forms are transmuted into style."

At this point begins the psychology of the creative process.

PART THREE

THE CREATIVE PROCESS

I The notion that all great styles are the expression of different and incompatible ways of viewing the world—that, for instance, a Chinese sees "through Chinese eyes" just as he speaks Chinese—has become singularly unconvincing now that Chinese and Japanese painters (who rendered figures and landscapes in an Asiatic style so long as European art was unknown in Asia) are going to school with our great artists, discarding Chinese perspective in favor of ours (or of none at all), and seem to see from the Montparnasse angle far more than from the Sung. And does an African peasant seen through a Negro sculptor's eyes *really* assume the form of a fetish?

This mistaken idea that man's visual habits are determined by geography has been carried a stage farther, and extended to include history, too. Obviously there is less risk in speaking of the Gothic man or the Babylonian—and, as a corollary, of the Gothic or the Babylonian way of seeing—than in applying the same criteria to the Chinese and their way of seeing; for those early periods no check is possible. Thus our "Gothic man" is simply an embodiment of what the Gothic period has bequeathed to us: its values. In asserting the existence of this "Gothic man" we are simply asserting that the *form* of a civilization shapes the human element to such an extent that a Gothic plowman must have been more like St. Bernard than a plowman of today.

We are too prone to associate the ruling taste of a people and a period with their way of seeing the world; actually these are quite distinct. The innumerable admirers of Detaille's *Le Rêve* did not "see" the soldiers of the Third Republic as he did; Bretons do not "see" themselves as figures in their wayside "Calvaries." A Ghent merchant probably found pleasure in imagining that his wife resembled a Van Eyck *Virgin;* it is unlikely that a burgher of Chartres ever saw his as a pier-statue. We are too ready to use the verb "to see" in these contexts as meaning "to imagine" in the form of a work of art. All imagining of this order associates the real form with some form that has been built up already, whether by the Byzantine mosaics, by Raphael, by picture-postcards or by the cinema. But plain "seeing" is another matter. The hunter does not see the forest in the sense in which the artist sees it; he is as impervious to the artist's vision as is the artist to the hunter's point of view. The fact of being a clarinet-maker does not involve a special manner of appreciating music. True, between a Chinese house, a Chinese article of daily use and a Chinese painting there is a family likeness real enough to foster the illusion that members of that race view the world in a special way: that a Chinese sees a landscape in terms of the Chinese style. Yet though their junks and horned houses are akin, a Chinese fisherman who knows nothing about painting does not see the waves patterned in the "Chinese-junk" style; he sees them as a fisherman—that is to say, as a fishing-ground. For while the sight of a

man who is interested in art, whether deeply or slightly, is often conditioned by this interest, that of the man uninterested in art is conditioned by what he does or wants to do.

To the eyes of the artist things are primarily what they may come to be within that privileged domain where they "put on immortality" —but where, for that very reason, they lose some of their attributes: real depth in painting, real movement in sculpture. For every art purporting to represent involves a process of *reduction*. The painter reduces form to the two dimensions of his canvas; the sculptor reduces every movement, potential or portrayed, to immobility. This reduction is the beginning of art. For though we can imagine a still life carved and painted so as to look exactly like its model, we cannot conceive of its being a work of art. Imitation apples in an imitation bowl are not a true work of sculpture. This reduction (which functions indirectly in purely imaginative painting and in Moslem abstractionism) is no less necessary when the painter is aiming at unlikeness than when he aims at life-likeness. The loftiest of abstract arts, that of China, wrung out of chaos patterns so impressive that, after thousands of years,

CHINESE ART (3rd MILLENNIUM?): PAINTED TERRA-COTTA VASE

CHINESE ART (14th-12th CENTURY B.C.): RITUAL URN

we find them still persisting in Chinese forms. But they owe nothing to the artist's way of seeing, and when this makes its presence felt in the bronze vases, reduction, too, is present. That is why the colors of polychrome sculpture so rarely imitate those of reality; why everyone feels that waxworks (the only forms, in our time, that are completely naturalistic) have nothing to do with art; and also why it may well be that if, after a few centuries have passed, their faces are partially destroyed, they will have the same place in art as those mediocre antiques in the Alaoui Museum, which were salvaged from a sunken ship and to which the corrosive action of the sea has imparted a curiously intriguing style; or that Palermo helmet, the effectiveness of whose warrior figures owes so much to the poisoned oysters stuck to them.

ANTIQUE. ALAOUI MUSEUM, BARDO, TUNISIA

Of how men saw the world in the ages of antiquity, those of the Mesopotamian cultures, and even in the Middle Ages, we know exactly nothing. But we do know that, the less they know of art, the more our contemporaries of every race appreciate the photograph; and we know, too, that the cinema, whenever it tells a story, gratifies the wishful fancies of the whole world. If the difference between the artist's vision of the world and the non-artist's is not one of intensity but one of kind, this is due to the latter's being conditioned by life itself, whereas for even the feeblest painter pictures are the stuff his private world is made of.

An artist is not necessarily more sensitive than an art-lover, and is often less so than a young girl; but his sensitivity is of a different order. To be romantic is not to be a novelist, to indulge in day dreams is not to be a poet, and the greatest artists are not women. Just as a musician loves music and not nightingales, and a poet poems and not sunsets, a painter is not primarily a man who is thrilled by figures and landscapes. He is essentially one who loves pictures.

However, artist and non-artist often meet on the common, if debatable, ground of the emotions. The non-artist is not so much indifferent to the arts as convinced that they are the means of expressing emotions; the man who has no real taste for music likes sentimental songs or military marches, the man who is bored by poetry enjoys magazine stories, and the man who does not care for painting likes photographs of film stars, Detaille's *Le Rêve*, or pictures of cats in baskets. Every art that appeals to the masses is an expression of some feeling: sentimental yearning, sadness or gaiety, patriotism and, above all, love. That is why certain masterpieces of religious art in which expression is given both to love and to a sense of man's liberation (or of his dependence) appealed so strongly and immediately to so vast a public. But, needless to say, an artist supremely gifted for quickening emotion is not necessarily sensitive, and the most sensitive man in the world is not necessarily an artist.

Those to whom art as such means nothing see it as a means of recording life's poignant moments, or of conjuring them up in the imagination. Thus they tend to confuse story-telling with the novel, representation with painting. (Which is why politics and religion, working in this field, find it so easy to make the most fantastic notions appear plausible.) Most men would have no more ideas about painting, sculpture and literature than they have about architecture (which to their eyes, as painting often does, seems merely decoration on the grand scale), were it not that sometimes they have fleeting intimations of that "something behind everything" on which all religions are founded; when gazing, for example, into the vastness of the night, or when they are confronted by a birth, a death, or even a certain face. Ignorance may partly explain the masses' dislike for modern art, but there is also a vague distaste for something in it which they feel to be a betrayal.

Many men suspect that there exists a truly great art beyond the pictures giving them immediate pleasure, but they always think of it as being religious, even if the religion in question be a cult of revolution or of victory. While it is undeniable that the greatest arts give rise to emotions of a lofty order, it is not true that, in order to do this, they are bound to represent subjects which would generate these emotions in real life. The feelings aroused by watching a bull being killed in the arena have nothing in common with those the picture of a bullfight evokes in us, even if the picture be by Goya. And if it so happens that an artist immortalizes some supreme moment, he does not do this by reproducing it, but because he subjects it to a metamorphosis. A glorious sunset, in painting, is not a beautiful sunset, but a great painter's sunset; just as a fine portrait is not necessarily the portrait of a beautiful face. There is more of Pascal's "great darkness" in some of Rembrandt's faces than in all the night-pieces.

The non-artist believes the painter's sight to be keener than his own and hence capable of agreeably stimulating his visual responses (this is his attitude to impressionist and Japanese art); or trained to single out exceptional scenes, which the artist proceeds to reproduce with photographic exactitude; or else allied with a capacity for imaginative idealization. These three views derive from a conception of the artist's function which prevailed from the Renaissance onwards to Impressionism. Medieval art, regarded as a system of forms, seems as outlandish as Negro or Mayan art to the non-artist, and the surprising presence of reproductions of certain Gothic statues on our calendars is chiefly due to their sentimental appeal.

The man-in-the-street's way of seeing is at once synthetic and incoherent, like memory. But who can seriously think that the difference between Benjamin Constant's reveries and *Adolphe* is only one of degree? The non-artist's vision, wandering when its object is widespread (an "unframed" vision), and becoming tense yet imprecise when its object is a striking scene, only achieves exact focus when directed towards some *act*. The painter's vision acquires precision in the same way; but, for him, that act is painting.

We do well to bear in mind that we never look at an eye as a thing-in-itself; hardly anyone of us knows the color of the iris in the eyes of even his close friends. For us the eye is essentially a look: only for the oculist and the painter is the eye something, intrinsically. Nothing is less unbiased than human sight. The first act, whether conscious or not, of the painter (and indeed all artists) is to change the function of objects. If we can conceive of a novelist, a poet or a philosopher who never writes a line, this is because the raw material of their art—words—is language, and the function of language is not limited to catering for literature and philosophy. But it is as impossible to conceive of a

painter without paintings as of a musician without music. A painter is a man who makes paintings, as a musician is a man who composes music, and a painter's vision is what serves him for painting, just as a sportsman's serves him for shooting.

"When Lenin," a garage-keeper at Cassis once told me, "was giving lectures to the Russian *émigrés* during the 1914 war, he gave one here. I should mention I hadn't run up the garage in those days, I had only the bar and the big public room. Then one day a Shell inspector came this way and saw at once that it was just the place for a service-station, so he had that pump installed. That's why I built my garage. Just before that we had a painter stopping here; Renoir, his name was. He was working on a big canvas and I thought I'd have a look at it. It showed some naked women bathing at a quite different place. He didn't seem to be looking at anything in particular, and he was only tinkering with one little corner of the picture." The blue of the sea had become that of the stream in *Les Lavandières*. Thus trees plunge their roots into the depths of the earth, to draw up the moisture which nourishes the green of their leaves. Renoir was making use of the visible world to fertilize his painting, as he had done, fifty years earlier, to break free from Courbet's. The painter's vision was less a way of looking at the sea than the incorporation of the blue depths borrowed from the sea's immensity into the world he was building up within himself.

The artist has "an eye," but not when he is fifteen; and how long it takes a writer to learn to write with the sound of his own voice! The greatest painters' supreme vision is that of the last Renoirs, the last Titians, Hals' last works—recalling the inner voice heard by deaf Beethoven: that vision of the mind's eye, whose light endures when the body's eyes are failing.

II One of the reasons why the artist's way of seeing differs so greatly from that of the ordinary man is that it has been conditioned, from the start, by the paintings and statues he has seen; by the world of art. It is a revealing fact that, when explaining how his vocation came to him, every great artist traces it back to the emotion he experienced at his contact with some specific work of art: a writer to the reading of a poem or a novel (or perhaps a visit to the theater); a musician to a concert he attended; a painter to a painting he once saw. Never do we hear of a man who, out of the blue so to speak, feels a compulsion to "express" some scene or startling incident. "I, *too*, will be a painter!" That cry might be the impassioned prelude of all vocations. An old story goes that Cimabue was struck with admiration when he saw the shepherd-boy, Giotto, sketching sheep. But, in the true biographies, it is never the sheep that inspire a Giotto with the love of painting; but, rather, his first sight of the paintings of a man like Cimabue. What makes the artist is that in his youth he was more deeply moved by his visual experience of works of art than by that of the things they represent—and perhaps of Nature as a whole.

No painter has ever progressed directly from his drawings as a child to the work of his maturity. Artists do not stem from their childhood, but from their conflict with the achievements of their predecessors; not from their own formless world, but from their struggle with the forms which others have imposed on life In their youth Michelangelo, El Greco and Rembrandt imitated; so did Raphael, Velazquez and Goya; Delacroix, Manet and Cézanne—the list is endless. Whenever we have records enabling us to trace the origins of a painter's, a sculptor's, any artist's vocation, we trace it not to a sudden vision or uprush of emotion (suddenly given form), but to the vision, the passionate emotion, or the serenity, of another artist. During periods when all previous works are disdained, genius languishes; no man can build on the void, and a civilization that breaks with the style at its disposal soon finds itself empty-handed. It was only by transforming Apollo's face, stage by stage, that Buddhism, though strong enough to transform the whole life of Asia, found a suitable face for its Founder. For, however vital the truth he wishes to enounce, an artist, if he has but this at his command, finds himself speechless.

Few indeed have been the voices addressing human sorrow in a language it could really understand; but it seems that no sooner did they make themselves heard than multitudes were found to listen. The fascination of Christianity in its early days owed nothing to promises of Heaven; fewer scenes of Paradise than Crosses are to be found in the first Christian paintings. The message of Christianity was founded on that which stood in greatest need of it: on suffering. For the world of antiquity suffering consisted doubtless in that appalling sense of loneliness which still pervades those parts of Asia whence Buddhism has disappeared.

Rome must have been much like the large Chinese towns at the break-up of the empire, whose miserable populaces, forlorn amidst the utter indifference of all around, and consumed by an aimless, meaningless sorrow, endured through thirty years of leprosy, syphilis or tuberculosis, their dumb bewilderment at being on earth. Job on his dunghill —but without his God. The West, that dares not pass by human suffering without shutting its eyes, has lost the power of realizing that something was even more needful than the promise of a next world to the beggar, the outcast, the cripple and the slave: deliverance from life's futility and from a load of sorrow borne in solitude. Early Christianity won the day in Rome because it told the slave-woman, daughter of a slave, watching her slave child dying in vain, as it had been born in vain: "Jesus, the Son of God, died in agony on Golgotha so that you should not have to face this agony of yours, alone." Nevertheless, the victims cast to the beasts of the arena because they preferred a martyr's death to the absurd—and thereafter the great multitude of Christians— were for many centuries unable to express their God save in the forms created by their murderers.

Thus both Christendom and Buddhism were blind at first; and it would seem as if, with each great Revelation, a sort of catalepsy comes over art, and revolutions can see themselves only through the eyes of their slain enemies.

We have no means of knowing how a great artist, who had never seen a work of art, but only the forms of nature, would develop. (This problem of first causes is not peculiar to art.) As regards the drawings, if any, of the

SUSA (BEFORE 3200 B.C.): IBEX VASE

pithecanthropes, our ideas are obviously nebulous. Going back to the origins of the oldest cultures, we seem to find in the expressive sign (e.g., the statuettes of Sumer, the Cyclades, Mohenjo Daro) and geometric figures and patterns, records of man's first ventures into the world of art. Nevertheless, the great skill displayed in some of these decorative forms often makes us suspect the existence of another, yet earlier, culture behind the culture, seemingly arisen out of chaos, which such art reveals. But the art of a civilization in its inception —this much we know—never proceeded from man to God (though the correct outlines of human forms could quite easily be obtained by tracing their shadows, and the technique of making casts was an early discovery); on the contrary, all such arts began with the sacred, the divine, before turning towards Man. Delving into the past, our quest for primitivism has reached the threshold of the prehistoric. Yet what painter, when he sees an Altamira bison, fails to realize that this is a highly developed style? And the rock paintings of Rhodesia, also

MAGDALENIAN ART (ALTAMIRA): BISON

MAGDALENIAN ART OR EARLIER (LASCAUX): BULL

PREHISTORIC ART (RHODESIA): HUNTING SCENE

prehistoric, vouch for conventions quite as strict as the Byzantine. Always, however far we travel back in time, we surmise other forms behind the forms that captivate us. The figures in the Lascaux grottos (and many others), too large to have been drawn straight off and so oddly placed that the artist must have worked on them lying flat or bent backwards almost double, were almost certainly "enlargements"; in any case they were not impromptu or instinctive creations— nor were they copied from models the artist had before his eyes.

It is above all in the arts of representation that we are apt to infer a direct connection between the artist and a model. A composer seems less likely to have become one out of a love for nightingales than a painter to have become a painter out of a love for landscapes. It is especially in painting, sculpture and literature that we seem to see an instinctive expression of the artist's or the writer's sensibility; because we assume that the function of these arts is to *represent*. And also because —before they have known anything of works of art—children draw.

Yet we feel that, though a child is often artistic, he is not an artist. For his gift controls him; not he his gift. His procedure is different in kind from the artist's, since the artist treasures up his acquired knowledge—and this would never enter the child's head. The child substitutes the miracle for craftsmanship. A miracle rendered easier by the fact that in making his picture the child gives little thought to possible

spectators; painting above all for himself, he is not trying to impose his "art" on others. Thus inevitably he stands outside art history, though our appreciation of his work does not. Yet, just as we have come to describe as Gothic not merely a style common to all Gothic works, but also the sum-total of these works (somehow felt as being a living entity), so children's art is coming to be regarded by us as a style. A style, however, that is different from that of the Gothic or Sumerian super-artists, since it cannot develop, and resembles the work of an instinctive, hit-or-miss artist whom we might personify as "Childhood."

Still, all of us can feel the difference when, after visiting a show of children's drawings, we move on to an art gallery; we have quitted an "art" that is all surrender to the world and are witnessing an attempt to take possession of it. And at once we realize how the mere fact of being a man means "possessing," and that here, as in so many cases, the attainment of manhood implies a mastery of one's resources.

Children's works are often fascinating because in the best of them, as in art, the pressure of the world is lifted. But the child stands to the artist as Kim, conqueror of cities in his dreams, to Tamerlane; when he wakes, the dream-empire has vanished. The charm of the child's

CHILD ART (DOREEN BRIDGES, 11 YEARS): THE CAT

productions comes of their being foreign to his will; once his will intervenes, it ruins them. We may expect anything of the child, except awareness and mastery; the gap between his pictures and conscious works of art is like that between his metaphors and Baudelaire. The art of childhood dies with childhood. Between Greco's early drawings and his Venetian canvases the difference is not one of proficiency; in the interim he had seen the Venetian masters.

CHILD ART (PAUL MIDDLETON, 8 YEARS): SPRING

Children's art, however, is not the only one suggesting that the artist wants to depict what he sees. Naïve and folk art, too, suggest this. But folk art has its traditions, no less strict than those of academic art. Often, too, it is the language of one particular artist and addressed to a special public; Georgin could have engraved, not to say painted, academic battlepieces, had he wished to. We can easily understand why this art does not set out to vie with that of the museum; but why should it not try (like naïve art) for illusionist effects on its own lines? It refuses to do anything of the kind, and its artists persist in representing what they will never see. When, abandoning saints, they turn to depicting some legendary town, they do not trouble themselves with its perspective, all they want is to convey its glamour. Now that their work has been studied with some care, it has become obvious that there is

THEODOLINA, Reine des Amazones.

FOLK ART OF LORRAINE (BETWEEN 1820 AND 1830)

no point in trying to discover what is "imitated" by a style which rejects the real with a quite Byzantine fervor, and whose primary concern is to evoke a world of the imagination the characters of the Golden Legend, the Queen of the Amazons, the homes of Cadet Rousselle and Puss-in-Boots' castle.

The forms of naïve art likewise obey a tradition which it would be rash to ascribe to naïvety alone. Even in the mid-twentieth century they hardly dare to dispense with the up-curled moustache. True, a Sunday painter would make a poor copy of the *Monna Lisa*; but merely because of his being more interested in his mother's face, his little suburban garden, things he sees in everyday life. Often he takes for his models color-prints, not those of Epinal but pictures in magazines. Naïve art is sentimental, but a sentimental art is not necessarily instinctive. Is it due to mere accident that the naïve artist continues to paint figures resembling not so much waxwork dummies as mannequins? The painters at our country fairs know well what subjects are expected of them—ranging from the "Crocodile River" to soldiers and weddings, from Jules Verne to Déroulède—and what style these call for. We need only compare these French naïve works with those of Persia and China, or with the figures Islam is now beginning to tolerate in its Mediterranean seaports. To appreciate the limits set to instinct in the work of popular artists, we need but compare the

NAÏVE PERSIAN ART (EARLY 20th CENTURY)

289

SLAV FOLK ART (ORTHODOX): 19th CENTURY

SLAV FOLK ART (CATHOLIC): 19th CENTURY

figures made by Catholic Slavs with those of Orthodox Slavs; only sixty miles—but two schools of painting differing from time immemorial—separate a Pole from a Russian even more than from a Breton. And naïve Russian art resembles that of the ikons, not that of the Douanier Rousseau.

HENRI ROUSSEAU: SKETCH FOR "THE AVENUE"

In this connection let us consider the Douanier's art. Did he paint, in all innocence, just what he saw? His sketches are available, and in them that meticulous attention to detail which we associate with him is absent. Inexpert or not (or, rather, on occasion inexpert), the style of his major works is as pertinaciously worked-up as was Van Eyck's. To perceive that the *Snake Charmer, Parc Montsouris* and *Summer* are elaborately constructed works (though this elaboration is not of any traditional order), we need only rid ourselves of the preconception that naïvety is creative *in itself*, and study them between, for instance, any truly naïve picture and Uccello's *Story of the Host.* "People have said," the Douanier wrote in 1910, "that my art does not belong to this age. Surely you will understand that at this stage I cannot change my manner,

HENRI ROUSSEAU: SUMMER (DETAIL)

293

SÉRAPHINE LOUIS: FLOWERS. THE TREE OF PARADISE

which is the result of long years of persistent work." His sketches are composed of patches. Though certainly there was in Rousseau the stuff of a naïve painter, he built up his true style on this very naïvety—leaf by leaf.

He seems to derive from nothing; yet, if he "competes" with the naïve painting of the Second Empire, he does so in the sense that Tintoretto competes with Titian. He loves that painting, imitates it, makes it his starting-off point; then swerves away and, though never quite abandoning it, strikes out in his own direction. While his early works are saturated by its influence, the *Snake Charmer* belongs to another realm of art. Further removed than Rousseau was from the main stream of art history, some other naïve painters, Séraphine for example, seem really to stand outside Time in their art; they have that very rare gift of seeming to continue and at the same time to enrich an art of childhood. But the act of seeing counts for as little with them as in children's paintings; it is obvious that flowers serve Séraphine for her pictures, and not her pictures for the representation of flowers.

The mistaken impression that artistic expression and visual experience necessarily concur was fostered by the most widespread form of art: the portrait. Christendom which in its early days indulged in portraiture, then gave it up, then reverted to it, attached so much importance to the soul as to ascribe some to its outward form; still the Gothic painters did not treat the Virgin in quite the same way as they depicted donors. And what value could likeness have had in a land like

India, imbued with the doctrine of metempsychosis? The individualism of Christianity, and later of the Renaissance, upheld the prestige of the portrait from the fifteenth to the nineteenth century; and due perhaps to this prestige is the odd legend of Chardin's being ever in quest of "lifelikeness" in his peaches, and Corot's aspiring to the same quality in his landscapes.

This notion that one of art's chief functions is complete resemblance to life, taken so long for granted in Western Europe, would have much surprised a Byzantine, for whom art, on the contrary, implied an elimination of the personal, an escape from the human situation to the Eternal; for whom a portrait was more a symbol than a likeness. And would have surprised still more a Chinese, for whom mere resemblance lay outside the range of art and came under the category of signs. Thus in China, after a man had been buried, a painter called on the family and submitted to them his album, in which were drawn various types of noses, eyes, mouths and profiles; he then proceeded to paint the "portrait" of the dead man, whom he had never seen. In any case these painters no more regarded themselves as artists than do our itinerant photographers. The likeness which a Chinese aimed at was that of whatever a face, an animal, a landscape or a flower might *signify*. The fact that art means a kind of representation quite distinct from the real was as obvious to him (if for other reasons) as it had been to the sculptors at Babylon, Ellora, Lung-Mên and Palenque. In short, likeness, for him, had nothing to do with art; it belonged to identification.

The cult of lifelikeness was fostered over a long period by the deference great artists paid to Nature, their assertions that they were her faithful servants. When Goya mentioned Nature as being one of his three masters he obviously meant, "Details I have observed supply their accents to *ensembles* I conjure up in my imagination"; this is the novelist's procedure, too. Certain masters, however, seem really to have been mastered by the thing seen, and even claimed that this submission contributed to their talent. Such artists often belong to a special human type, that of Chardin and Corot; and they are the least romantic men imaginable. Should we say "bourgeois"? I doubt if humility is a bourgeois virtue and that shy, good-hearted artist, Corot, seems more like Fra Angelico than like Ingres. Whereas Chardin's seeming humility involved not so much subservience to the model as its destruction in the interests of his picture. He used to say that "one paints with emotions, not with colors," but with his emotions he painted—peaches! The boy in *The Sketcher* is no more emotive than the still life with a pitcher and that marvelous blue of the carpet on which he is playing owes but little to the real. Chardin's *Housewife* might be a first-class Braque, dressed-up just enough to take in the spectator. For Chardin is no eighteenth-century *petit maître*,

more sensitive than his coevals; he is, like Corot a *simplifier*, discreet but unflinching. His quietly compelling mastery ended for ever the still lifes of the Dutch school, made his contemporaries- look like decorators, and in France, from Watteau's death down to the Revolution, there was nothing that we can set up against his art.

Corot's case is similar. He revered nature, yet who, around 1850, was less subservient to nature? Daumier was to reduce it to "accents," but Daumier was a painter of the human. Corot makes of the landscape a radiant still life; his *Narni Bridge, Lake of Garda* and *Woman in Pink* are, like *The Housewife*, dressed-up Braques. He preferred nature to the museum, but his paintings to nature. And his style, like Chardin's, tells of a long conflict with nature (which he was apt to confound with the pleasure of visits to the country). "One never feels sure," he once wrote, "about what one does out of doors." His genius does not reside in his sensibility (alert as a Parisian sparrow) but in his subordination of the subject to the picture—which caused it to be said of him that he was incapable of finishing his works. The masterpieces of this devotee of nature passed for rough sketches—which indeed they often were. By "nature" he meant all that set him free from the theatrical.

The comparison of a picture by Vermeer, Chardin or Corot with what its represents, its counterpart in the real world, can be revealing. Let us imagine *The Housewife* become a *tableau vivant*. When in our mind's eye we contrast the "real" jug and bread with those in the picture, the former stand out much more sharply; the passage becomes a long recession, while the girl in the background loses her abstract quality; to keep the color of the bucket and cistern we have to conjure up the golden haze of a summer afternoon. If we set to clothing the housewife herself in any specific material (Chardin's famous "textures," even when he paints fruit, are essentially the stuff of painting, not of reality), she would promptly become a figure straight out of a waxworks exhibition. In fact—and this is true of all Chardin's major works—the things he paints, once they become real, lose their essential harmony. His choice fell on a simple pitcher not a ewer, a bucket and not a goblet, and his lemon-peel did not take the form of a volute; for the use of humble objects and extreme simplicity enabled the presence of the artist to make itself felt all the more strongly. Like *Las Meninas* his best pictures present the world as a farrago of raw materials waiting for a master's brush to give them order.

A reason why the painter's humility vis-à-vis what he sees, insisted on by Corot—Corot who discovered the secret of treating the face, on occasion, in the manner of a still life (and who, pointing his pipe at a man who was looking over his shoulder and had enquired where was the tree that he was painting, replied, "Behind me!")—does not surprise us more is that in his art, as in Chardin's, we find an admirable accuracy of tone. In a painter this has less analogy than might be supposed with

CHARDIN
THE HOUSEWIFE (DETAIL)

the "accurate intonation" of an actor (which may be phonographic). It resembles more the accurate tone given by a novelist to a long speech by one of his characters, which is always an equivalence, not a mere shorthand record. Thus while some of Corot's pictures, even the finest, give an impression of being extraordinarily "true to nature," though no doubt the picture resembles the landscape it depicts, the landscape does not resemble the picture. When we look at the Saint-Ange château, the bridge at Mantes, Sens Cathedral, or conjure up in our mind's eye the valley in the *Souvenir d'Italie* and the Narni Bridge, we can see at once that in the pictures of these places there is a harmony different

COROT: SOUVENIR D'ITALIE (DETAIL)

in kind from theirs or from that of any existing landscape. That is why Corot needed to "finish the picture at home." When we look at the real Sens Cathedral and at the same time at a good reproduction of the picture, we find that the real cathedral has the garish disharmony of photographs in colors. Seemingly Corot keeps to the relations that the various elements of the landscape have between themselves; actually he adds one that they have not, and this it is that makes the picture—the harmony between its elements. The unemphatic drawing of his paintings (unlike that of his etchings which is remarkably bold) tends to conceal the fact that, so as to attain this harmony, he imposes on his subject-matter a transformation as thorough-going as Poussin's when he adjusts an Italian scene to one of his compositions. Like Chardin and Vermeer he transcribes nature but is far from being subservient to it, and our age, which has promoted these painters to the front rank, has been quick to discern in their work, not realism, but the first gleams of modern art.

All great painters, Grünewald no less than Velazquez, Goya no less than Chardin, stand for a unity (not always of the same kind) based on the relations of colors between themselves; and this becomes strikingly apparent when we compare their own work with that of their imitators. This was Corot's unity—and his sketches are not less true to life than the finished canvases. Thus the Young Girl who was the model for Vermeer's famous picture was undoubtedly like this portrait—but in the same way as Marie Champmeslé resembled Phèdre.

The French open-air school, in defense of their methods, not only declared that traditional landscape suffered from the perversive influence of the studio, but also claimed the artist's right to see in his own way. And, in fact, late nineteenth-century art strikes us as the acme of individualism; looking at the works of Van Gogh, Gauguin or Seurat, we completely forget the "official" theories of Impressionism. Yet it was in conjunction with these theories that the artist's declaration of liberty took effect. So much so that submission to reality (formerly, and again to be, a bourgeois value) became a criterion of value for the artist, too, but always provided that the reality in question was a private one, achieved by the artist himself.

Almost always until now this deference to nature had won the spectator's approval. Now all that was changed; firstly, because the spectator, continuing to insist on "finished" pictures, resented a way of seeing so obviously unlike his; and especially because the Impressionists, far from courting the spectator's approval, repudiated it. But, now Impressionism is of the past, we can see that a landscape by Monet is no more true to life than one by Corot; it is at once more emotive and less finely wrought, far less governed by the artist's sight (whatever Monet may have said about this), and far more subservient to a flamboyant, somewhat hollow calligraphy, used by the painter for making the world

so tenuous that he could bring his art to bear on it more weightily. This relentless impact of the individual does not lead to a tyranny of the impression but to one of the artist himself; not to a resurgence of the Sung landscape, but to Van Gogh, the Fauves and, ultimately, to Braque and Picasso. The vision of even the most orthodox Impressionists (like that of other painters) was not a submission to "reality" but a means. Byzantine painters did not see men in the semblance of ikons, nor does Braque see fruit-dishes in fragments.

All types of realism are submissions to reality no less questionable than was the alleged fidelity of the Impressionists. The connection between Courbet and his ideology of realism is no closer than that between Van Gogh and the impressionist ideology. In Courbet's time realism was determined by the subject; the fire in his picture of that name is realistic enough (we are shown the firemen!); not so the *Burning of Troy*. Even so *The Fire* takes more after Rembrandt and the backdrop than after reality. When, on occasion, Courbet fails to superimpose his private universe on a scene and forsakes the sombre, deeply thought-out

COURBET: WOMAN IN A HAMMOCK

COURBET: THE FIRE (DETAIL)

harmonies of the *Funeral*, the *Studio* and the *Fire*, in favor of the convention of *The Woman in a Hammock* or the "objectivity" of the *Portrait of Proud'hon*, his genius gains little by the change.

It is hard to overestimate the debt that Flemish realism owes to Brueghel's peasant extraction. Today we realize that while he made common cause with the humanists (he was "ignorant" in the same way as Rabelais) and his painting is an outstanding expression of the cosmic spirit of the Renaissance, peasants were the builders of his *Towers of Babel!* And that Spanish realism—from its dwarfs to its crucifixions—what is it but one long indictment of the human situation? And Goya? Viewing art as an embellishment of the real, traditional aesthetics assumed that those who ruled out this embellishment could but replace it by total submission to appearances. But there had been no submission of this kind in a great artist's refusal to idealize when painting a Virgin or a donor; rather, it meant that so-called realistic methods were being employed by him to introduce this Virgin, or donor, into a private universe, distinct from the real.

Assumed to find its natural sphere in observation of the proletariat, realism dallied for a while with Bosch's devils. It sponsored now character study, now meticulous accuracy; now the individual and the singular, now the will to play on natural feelings; now Chardin's masterful humility (as against moribund classicism), now Romanticism against Neo-Classicism; now early Italianism against Byzantium, and even Gothic against Romanesque. Strange alliances, indeed—but all become intelligible if we bear in mind that realism, in so far as it claims to express "reality," takes as its province that very chaos which it is art's function to redress; and that there is no absolute style of realism, there are only realistic deflections of pre-existing styles. Thus every realistic movement in art has been a form of polemics, an attack on the idealism preceding it. "Realism," Courbet once said, "is at bottom the *negation* of the ideal." Again and again—during the last days of Rome, of Gothic, of the Great Chinese period, of Romanticism—realism seems to offer a great style *in extremis* its last chance of survival. All art, it seems, begins as a struggle to vanquish chaos with the aid of the abstract or the holy; never does it begin by representation of the individual. Whereas all realism is founded on the individual and its attitude to the art preceding it is plain to see; *qua* art, all realism is a *readjustment*.

One way of seeing, however, seems to be wholly dependent on the model: that of the camera. No art previous to his seems to have any influence on the photographer; moreover, he is less necessarily a man who likes others' photographs than the painter is a man who likes paintings.

This, of course, on the assumption that our photographer does not trouble his head about art.

PHOTOGRAPH BY ADOLPHE BRAUN IN 1860

For, actually, the earliest photography derived from painting; the "primitive" photograph was a sham still life, a sham landscape, portrait or *genre* piece. Nor did the early cinema stem from life, but from the knockabout music-hall turn and the stage play. When after twenty years of dumb-show it solved its major problem by finding its voice (not, like the theater, its drama), the invention of the talking film did not throw it back on life, but (for some years at least) on the theater.

From the outset photography was called on to face the problems of style and representation. The photographer had no trouble at all in doing justice to the statue or the apple facing his camera, like a still life; but why "take" them at all, why photograph a table from in front and in full light? No sooner did he begin to "pose" his still life—no sooner did he take to *composition*—than he came up against the painter's time-old problems. Composition became "centering"; idealization and character a matter of lighting (according as the light is "soft" or "hard" a face conveys a different personality); motion, the snapshot. Photography thus became subject to an *isolated* reality; a "slice of life" made significant by its isolation—by the destruction of the surrounding world's autonomy.

Once the cinema realized that it could become art only by ordering the sequence of such chosen glimpses in a special manner, it began to go to school with the masters of Venetian Baroque. And once photography and the motion picture had become arts, the style of each cameraman, each producer, began to differentiate itself from the style of other cameramen, other producers.

Perhaps the specific character of art would have been sooner recognized (Constable, Goya, Delacroix, Daumier and many others were well aware of it), had not literary romanticism—Romanesque in comparison with the Flaubertian prose that was to follow—indulged in a realistic handling of tragic themes. By employing the raw material of reality—or, rather, selected elements of it—this nineteenth-century romanticism aspired to imparting the maximum intensity to its poetic effects, and hailed as its precursors the Gothic masters.

It was the late Gothics that our romantics had in mind. Théophile Gautier regretted "not having had time to visit the Cathedral, when passing through Chartres." After duly admiring the picturesqueness of machicolations and the like, they proceeded to build up the myth of the "great medieval crafts-man" (the myth that has been built up round the Douanier Rousseau is its modern incarnation): that is to say, of genius as a direct expression of more or less naïve emotion.

This myth was linked up with that of the popular artist, who was held to be inspired by instinct; the sculptors' anonymity and an imperfect knowledge of the historical background of their work—all the cathedrals were lumped together indiscriminately—helped to foster this belief. It was fostered also by the term "Gothic" which suggested quite as much the wood carvings on the altarpieces and even articles of furniture as the sculpture of the Masters of Chartres and Naumburg. Yet the *Beau Dieu* at Amiens with its hieratic planes, the *Creation of Adam* at Chartres and the Naumburg *Uta* pointed the way towards Masaccio far more than towards the innumerable wooden statuettes of the period. Though a style involving teamwork, Gothic in its creative moments was no more the product of

ST. MARTIN (ZEITLARN, 1480)

NAUMBURG (13th CENTURY): UTA

collective handicraft than would be the style of the Renaissance, which also employed teams of craftsmen, had the names of its great artists not come down to us.

Thus the "man of sensibility" was now replaced by the religious-minded craftsman of the past—both being preferably carpenters, like St. Joseph. The noblest works of this craftsman, who carved with pious fidelity what he naïvely saw or passionately imagined, were held to be the product of inspiration. The inspiration of innocence—Beethoven's shock of hair and, later, Verlaine's beard, the love of a hind or that of a lion—but always (to the romantic's thinking) it was love that fecundated art. That term "craftsman" implied humility and intuition far more than technique; from which it followed that Fra Angelico was a great painter because he was a saint and the Master of Chartres owed everything to his purity of heart. And both owed their genius to the fact that they were fervent copyists of God's works. Thus presumably paintings by St. Francis of Assisi, had he painted, would have been superior to Giotto's!

This great mythical craftsman was regarded as a product of the highest epochs of religious culture; but actually an age of faith, a world in which the gods are very near and real, creates between the artist and his themes a relationship that has less to do with craftsmanship than with magic. The humility of the Moissac or Yun Kang sculptors is not the modesty of a doll-maker; the state of mind of that Christian sculptor who was the first to force upon an effigy in stone the expression of an inner life was far nearer that of a monk preaching a crusade or withdrawal from the world than that of a carver of picturesque ornaments. The fact that a Hebrew prophet is not an Academician does not convert him into a public scribe.

True, the Naumburg sculptors did not regard themselves as artists in the modern meaning of the term; but that meaning is far from covering all the art we know. Now that we have learnt to admire so-called primitive works, we recognize that style finds some of its most vigorous expressions in forms that are foreign to the highest cultures. This is to some extent an optical illusion due to the fact that we are often as much impressed by the schematic lay-out of the most elementary art as by that of the most highly perfected art. But the matter is not so simple as that; there is little doubt that the Altamira bison, the Castellon and Rhodesian hunters are consciously elaborated works; as are Scythian plaques, the prows of drakkars and Armorican coins—and this is no less true of many African masks and ancestors and Oceanian figures. Can it be thought that all the various styles from the bisons to the cathedrals whose sequences, connecting links and ramifications we know or can surmise—can it be that these styles were always created by inspired individuals? We feel that somehow the greatest works forgather in

a domain as yet uncharted; but the common measure between the outstanding works of the Middle Ages, the great epochs that ensued and the decadent, popular and barbarian arts is more than an uprush of emotion touched with genius—even if modernized by the appellation of the instinct or the subconscious.

Indeed, when applied to art, these terms are highly unreliable. They lump together what the artist does without aiming at it and what he does unwittingly—his triumphs over the dark powers beleaguering him and his capitulations to them, his quest of a subtle, slowly matured perfection and his spontaneous ecstasies. (Incidentally, our interpretations of this dark hinterland are greatly rationalized; perhaps before this century is out we shall find surer sources of illumination.) Though great artists tend to explain their genius in terms of the values of their age, they are far from being unaware that it is something wholly personal; Rodin was always talking about "nature," but when he carved his *Balzac*, sculpture was his sole concern. It is a mistake to confuse that obsessive vulture which Freud claims to detect in *Saint Anne* (and of whose presence he suggests that Leonardo was unaware) with the rendering of distance in the *Monna Lisa*, on which the artist expended so much thought. During many centuries artists regarded the language of painting as a form of "mystery"; no artist ever painted a fresco or a tempera panel with the careless rapture of a child doing a water-color sketch. No doubt we cannot analyse the sudden crystallization of genius as we are trying to analyse the creative process; but are we any better able to analyse it in the case of the mathematician or physicist, who also has his inspired moments? The unconscious element behind invention, which comes when least expected—when the wall against which the inventor has been pushing suddenly gives way—has nothing in common with the age-old heritage bequeathed to us by myths and legends. The latter is one of art's ferments; the former, the victory of an obsession. Every invention, whether a Max Ernst picture or the quantum theory, is an *answer*. Analysis, conjunctions of ideas do not give rise to invention, they release it, and even so release it only after a sort of siege; similarly artistic creation does not spring from a surrender to the unconscious but from an ability to "tap" and canalize it. That the Masters of Chartres and equally Cézanne and Van Gogh were in no way unconscious of what they were doing is proved not only by what they say but by their works. Like other men, and no more than they, the artist is conscious of the human tide bearing him up, but he is also conscious of the control he exercises on it, even if that control be only of its forms and colors. When instinctive artists arise in any human group, it means that they had the creative instinct to begin with.

Shall we say that in the fetishes, as in Celtic coins, there is *an element* of instinctive expression? But it is also present in Michelangelo, in Rembrandt and the metopes of the Parthenon. Some hold the view

that the coins and the fetishes were the expression of instinct *alone*. But, since it is obviously not the case that the best sculptor of some terrifying god is the most terror-stricken member of the tribe, what is it that gives his style its power? Either he is copying previous forms (in which case it is their inventor who concerns us), or else he is inventing them; but why, if guided solely by his instinct, should he always keep in touch with an earlier style? Timid indeed must have been the instinct which prevented the Polynesians from carving a single "Negro" statue! Or is it that Polynesian soil makes Polynesian art sprout automatically, like the breadfruit-trees? And barbarian soil, barbarian coins? How marvelous must be the "unconscious" of New Ireland which gives rise to fetishes as intricate as games of patience, and that of the Osismii which combines a system of bars and globules with swelling arabesques, amplifying these adventures coin by coin till they link up with the abstract art of today! Such an "unconscious" would have to be no longer individual but racial or regional, and its alleged freedom would gradually shade off into complete determinism.'

The truth is that the continuity we find in the arts of savages hardly fits in with any notion of an instinctive art, in which we should expect to find at least as much diversity as in the art of children. For each of these savage arts tries to maintain, or even to intensify, with a Byzantine fidelity to the past, the art preceding it, on which (when not purely and simply copying earlier works) it is as obviously dependent as Van Gogh on Millet. Almost all the modeled skulls of the New Hebrides come from one small island (Toman); it is only on the periphery of the Archipelago that its strident colors mingle with the ochres, blacks and whites of the art of New Guinea.

Quite obviously consciousness plays a smaller part in the *life* of a designer of Armorican coins and in that of an Oceanian sculptor than in that of a Pheidias; but can we be so sure that it plays a proportionately smaller part in his *art*? Obviously the consciousness of an artist, his mentality, has nothing to do with a gift for building theories of art. The kings of the Balubas refrained from having their effigies made when there were no "good sculptors" available. Who, then, were these "good sculptors?" To discern the limits of the part played by instinct in the art of an Oceanian, a graver of Armorican coins, a medieval artist, a Douanier Rousseau, we need only to view their works amongst those preceding them and in their chronological order. There are elements of instinct, chance and play in Sumerian terracottas as in the black basalt figurines of Lagash; but not the same elements. Undoubtedly a great artist gives rein to his instinct—but only after he has mastered it; that illusion of the omnipotence of emotion in art, which arose with the resuscitation of Gothic, reappears whenever we are confronted and conquered by an art whose figures do not fit in with any aesthetic theory of beauty or of the imitation of nature.

The belief that the plastic arts transcribe the artist's visual experience, and the collateral belief that they are expressions of an instinctual drive, are not theories in the ordinary sense; they are persistent illusions which, disappearing and reappearing through the ages, take effect on the artists themselves at certain periods—though in their interpretations rather than in their creations. Thus while Corot declared Nature to be his mistress, Rodin made the same assertion still more vehemently; but what he really meant by "Nature" was what he took from her.

Often the medieval master-craftsman did not himself ply the chisel. A remark once made by Renoir puts this in an amusing way. "As far as I can make out," he said, "there was one fellow with a hammer and a chisel hammering away at a statue for all he was worth and another fellow in a corner just looking on and doing nothing! And the one who looked on, so they tell me, was the sculptor." That was doubtless so, and we can hardly be asked to credit a theory of an unconscious working by proxy in such cases. Actually those "naïve copyists of what they had before their eyes" of whom we have heard so much studied all the new forms, from reliquaries to ivory carvings and miniatures, with much more attention than they gave to the farmyard animals they saw every day. Giotto was a shepherd but the sheep he painted were **very queer sheep** indeed! Much of Rheims is plain to see at Bamberg and Naumburg; of Senlis at Chartres, Rheims, Mantes and Laon. Like the escarpments of a mountain range, the great Italian painters seem to take their purchase on each other. The most extreme realists stem, according to their period, from romantic or idealist masters, even from the more impressive forms of architecture. Goya's path led through Bayeu; the Impressionists' through traditional painting and Manet; Michelangelo's through Donatello; Rembrandt's through Lastmann and Elsheimer; El Greco's through Bassano's studio—and precocity means an ability to copy at an early age. The fact that not a single artist became a landscape painter until, first, he had gradually and laboriously pruned away the figures from his landscapes has much to tell us as to the alleged subjection of the artist to nature and the limitations of his surrender to direct visual experience or to spontaneous emotion. The man of genius has nothing to do with nature, apart from what he takes from nature and makes his own. Whether the artist is aware or unaware of this, whether his picture is carefully thought out beforehand or instinct plays a major part, what a work of art reveals is neither a visual experience, nor emotion, if style be lacking. Even a Rembrandt, a Piero della Francesca or a Michelangelo is not, at the dawn of his career, a man who sees more vividly than others the infinite diversity of things; he is a youth enraptured by certain paintings which he carries about with him everywhere behind his eyelids and which suffice to divert his gaze from the world of appearances.

No doubt those artists far remoter from us than the Gothic masters, the bronze-workers of the Steppes, treated as outcasts by reason of their professional dealing with fire and weapons (just as the butcher and the sacrificer, men of blood, were outcast)—no doubt these men had a

ART OF THE STEPPES: ANIMALS FIGHTING (FIRST CENTURY?)

ART OF THE STEPPES: ANIMALS FIGHTING (FIRST CENTURY?)

conception of themselves very different from Rodin's of himself; yet did this conception have any influence on their refusal to copy traditional scenes of the slaughter of wild beasts and their insistence on creating new ones? The first Buddhist sculptor who dared to close Buddha's eyes, the first medieval sculptor who dared to depict the Virgin weeping —and all who dared to reject the evidence of their senses—have a place beside Pheidias and Michelangelo, their compeers (and not beside their imitators), in our art museums and in our memories. I name that man an artist who *creates* forms, be he an ambassador like Rubens, an image-maker like Gislebert of Autun, an *ignotus* like the Master of Chartres, an illuminator like Limbourg, a king's friend and court official like Velazquez, a *rentier* like Cézanne, a man possessed like Van Gogh or a vagabond like Gauguin; and I call that man an artisan who *reproduces* forms, however great may be the charm or sophistication of his craftsmanship. How many arts have been discovered since we have learnt to isolate them from the productions of the handicrafts that grew up around them! The indistinguishable herd of Gallo-Romans are not to be confused with that unknown man who carved the Poitiers capital, or the band of craftsmen responsible for the Palmyra tombs with that one unknown artist who foreshadowed Byzantium, or the artisans who carved the blue Gandhara schist with the masters of the great Buddhist figures and the prophets of the Wei period, or the servile

followers of the Byzantine canon with him who made the mosaics of St. Luke's in Phocis. It would be as inept as likening to Poussin Raphael's imitators or the seventeenth-century decorators. The fact that our conception of the artist was something quite unknown in the Middle Ages (and for many thousand years before) and that a genius like Van Eyck was commissioned to design set pieces and to paint coffers, does not affect the fact that painters and sculptors, when possessed of genius, transfigured the art they had inherited, and the creative joy of the man who *invented* the Moissac *Christ*, the Chartres *Kings* and the *Uta* was different in kind from the satisfaction felt by the cabinet maker who had just completed a perfect chest. Though a serf, a serf-artist is none the less an artist. And when even the least sophisticated sculptor of the High Middle Ages (like the contemporary painter haunted by art's long history) invented a system of forms, he did not accomplish this by freeing his art from subservience to nature or to his personal emotions, but as a result of his conflict with a previous type of art. Thus at Chartres as in Egypt, at Florence as in Babylon, art was begotten of life upon an art preceding it.

III That is why every artist starts off with the pastiche. And this pastiche, into which sometimes genius furtively insinuates itself (like the humble figure at a garret window in some Flemish paintings), is certainly an attempt at participation, but not participation in life itself. The fact that it is not the sight of a supremely beautiful woman, but the sight of a supremely beautiful painting that launches a painter on his career does not diminish the emotion behind his creative impulse; for, like all deep emotions, the emotion roused by art craves to make itself eternal. Practiced with ritual fervor, imitation is a familiar instrument of magic, and a painter needs but recall his first paintings, or a poet his first poems, to realize that they served him as a means of participating, not in the world of men, but in that of art, and what he asked of them was less a conquest of the world of reality, an escape from it, or even an expression of it, than a sense of fellowship with brother artists. It was Courbet, the realist, who entitled certain pictures in his first exhibition *Florentine Pastiche, Dutch Pastiche* and the like.

As most of us have realized, art is not a mere embellishment of life; nevertheless, having so long regarded it as such, the average European is still too apt to confuse the vocation of an artist with the activities of the jeweler. We all know that other worlds besides the real world exist, but nothing is gained by relegating them indiscriminately to a dream world, where the word "dream" expresses at once the vagaries of sleep and satisfaction of desire. The world of art is fantastic in the sense that its elements are not those of reality; but its fantasy is intrinsic and fundamental, quite other than the wayward imaginings of the daydream, and present no less in Velazquez and Titian than in Bosch or Goya; no less in Keats than in Shakespeare. We need only recall the admiration and the other less definable emotions conjured up in us by the first great poem we encountered; they stemmed from a revelation, not from any reasoned judgment. It is significant that a young man, swept off his feet by a stage play, cannot decide if he wishes to become an actor or a poet. The world of art is not an idealized world but *another world;* thus every artist feels himself akin to the musical composer.

In his *Baalam* of 1626 Rembrandt did not set out to represent life but to speak the language of his master, Lastmann; for him the love of painting meant the possession, by painting it, of that plastic world which fascinated him, just as the young Greco sought to possess, by imitating it, the world of the Venetians. Every artist builds up his personality on these early imitations; the painter advances from one world of forms to another world of forms, as the writer from one world of words to another, and the composer from derivative music to his own. When Rouault mentioned certain influences in an early canvas, Degas replied: "And have you ever seen anyone born by his unaided efforts?"

REMBRANDT: THE PROPHET BALAAM

PIETER LASTMANN: MANOAH AND THE ANGEL (DRAWING)

The pastiche is not necessarily one of a single master; it sometimes combines a teacher with one or more masters (Rembrandt in his extreme youth combined Lastmann with Elsheimer); sometimes these masters are relatively different, sometimes akin (in his early Italian canvases El Greco owed more to Venetian art than to Bassano). Occasionally a style is imitated as a whole, and, it may be, something even less than a style—the prevailing taste of a period, the sparkling intricacies of

ELSHEIMER: THE FLIGHT INTO EGYPT

Florentine composition, the tapestry effects of the Venetians, the Expressionism of German Gothic in its last phase, the limpid color of the Impressionists, the geometry of Cubism. The Munich exhibition which, after nearly twenty years of Hitlerian aesthetic, brought together self-taught artists under the style of "The Free Painters," gave the impression of being, as a whole, a pastiche of the School of Paris, though actually no individual French master was imitated by these painters.

Whether an artist begins to paint, write, or compose early or late in life, and however effective his first works may be, always behind them lies the studio, the cathedral, the museum, the library or the concert-hall. Inasmuch as painting, though representing or suggesting three dimensions, is limited to two, any painting of a landscape is bound to approximate more closely to any other painting of a landscape than to the actual scene depicted in it. Thus the young painter has not to make a choice between his personal "vision" and his master or masters, but between certain canvases and certain other canvases. Did he not derive his vision from some other painter or painters, he would have to invent the art of painting for himself.

One of the reasons why we fail to recognize the driving force of

315

previous art behind each work of art is that for many centuries it has been assumed that there exists a styleless, photographic kind of drawing (though we know now that even a photograph has its share of style), which serves as the basis of works possessing style, that style being something added. This I call the fallacy of a "neutral style."

Its origin is the idea that a living model can be copied without interpretation or any self-expression; actually no such literal copy has ever been made. Even in drawing this notion can be applied only to a small range of subjects: to a standing horse seen in profile, for instance, but not to a galloping horse. This theory owes much to the silhouette, and underlying it is the assumption that the basic neutral style would be a bare outline. But any such method, if strictly followed, would not lead to any form of art, but would stand in the same relation to drawing as an art as the commercial or official style of writing stands to literature.

Expression through the medium of color was confused over a long period with the representation of color; told to paint a red curtain, an art student after blocking-in the outline covers the surface thus enclosed with any red he has to hand; just as in an industrial draftsman's office metal surfaces are shown in a symbolical blue. That red, too, is in no sense expressive; but, like the symbolical blue, *a sign*. Painting recognizes no neutral forms, though it recognizes signs—the forms that an artist discovers for himself and those already discovered by other artists. A neutral style no more exists than does a neutral language; styleless pictures no more exist than do wordless thoughts. Thus the teaching of the plastic arts (apart from mere training of the hand) is nothing more than the teaching of the significant elements in a style or several styles (thus, in our own, perspective is one of these elements). Academic drawing is a rationalized style—what theosophy is to religions or Esperanto to a living tongue. The art school does not teach students to copy "nature"; but only the work of masters. Though the life-stories of great painters show us pastiches as being the starting point of their art, none tells of a transition from the art school to genius without a conflict with some previous genius. Any more than the history of art can show us a style born directly from nature, and not from a conflict with another style.

Thus the artist is born prisoner of a style—which, however, ensures his freedom from the world of appearances. But even so, we are often told, he certainly chose his masters.

This is one of those "logical illusions" so frequent in the comedy of the human understanding. That word "choice" suggests a weighing-up of comparable significances and qualities: the attitude of a buyer at a shop-counter. But have we forgotten the first contacts of our early

youth with genius? We never deliberately *chose* anything; we had successive, or simultaneous, enthusiasms, often quite incompatible with each other. What young poet ever *chose* between Baudelaire and Jean Aicard (or even Théophile Gautier)? What novelist between Dostoevski and Dumas (or even Dickens)? What painter between Delacroix and Cormon (or even Decamps)? What musician between Mozart and Donizetti (or even Mendelssohn)? Tristan did not choose between Isolde and the lady beside her. Every young man's heart is a graveyard in which are inscribed the names of a thousand dead artists but whose only actual denizens are a few mighty, often antagonistic, ghosts. Permanent survival is reserved to a few great immortal figures, and men do not "choose" them; for they do not allure, they exercise an irresistible fascination.

Love is not born of consecrated eminence; nor is our love of the great works of art. And, incidentally, we still are far from having discovered the sum total of these works; we are far from appreciating the music of other parts of the world, in all its richness, at a first hearing. True, we are quick to feel at home with a new Rembrandt, but a newly found Byzantine work is slow in extricating itself from the farrago whence it has emerged. And, lastly, one sees only what one looks at; in the twelfth century, men looked at the classical bas-reliefs very perfunctorily. The sensibility of a young artist is tempered by history, which made its choice before he came on the scene—primarily by its eliminations.

The relationship between the artist and art is of the order of a vocation. And the religious vocation, when authentic, is not felt as the result of a choice, but as an answer to God's call. The painter may spend his time choosing and preferring (as he thinks), but once his attitude to art takes a definitive form much of the freedom has gone out of it.

An artist's vocation almost always dates from adolescence and usually pivots on the art of his own time. Neither for Michelangelo nor for Raphael was the art of antiquity a starting-off point; nor even for David, who began as an eighteenth-century *petit maître*. The artist needs "living" forbears though, in periods held by their painters to be decadent, these are not always his immediate predecessors, but the last great outstanding figures. For at a certain moment of history a picture or a statue speaks a language it will never speak again: the language of its birth. Varied as was the life-story of the Parcae from their Parthenon days to their journey's end in London, none has ever heard again the message they gave men on the Acropolis. The *Smiling Angel* of Rheims is a statue whose "stiffness" increased with every century; but at its birth it was a smile incarnate, a face that had suddenly come alive—like all faces sponsoring a discovery in the field of the lifelike. Only after we had seen color films did we become conscious of the

monochrome of the early cinema; when they were a novelty, the hieratic photographs of our ancestors seemed the last possible word in realism. But the compelling effect of great works of art (though not always immediate) is not limited to innovations in the field of representation; it is inherent in all forms of true creation. It was not when they set eyes on Flemish art even at its most realistic, or on Italy's freest, airiest forms, that the crowd hailed the living figure and bore it aloft in triumph; it was when they set eyes on a certain Cimabue.

CIMABUE: MADONNA (DETAIL: ANGEL)

Since the visible world is never merely something to be reproduced, a painter can only copy another painter—or else blaze new trails. In the field of representation he seeks for what has not yet been portrayed (a new subject, movement, light); in the realm of creation, what has not yet been created. In either case he is bound to make discoveries, whether he be a Raphael or a Rembrandt, and the note he strikes is such that those who hear it for the first time often recognize in it (as did the creator) a proclamation of the artist's conquest of the world. It is exceptional that Cimabue's *Madonna* should have been borne in triumph *by the crowd*, but every artist of genius, so long as his discoveries retain their pungency, is secretly borne in triumph by artists. In the realm of modern art Cézanne is still a king. The reason why the great artist builds his genius up on the achievement of his immediate predecessors is doubtless that the leaven of discovery had not been exhausted in their art. From Cézanne's death to Renoir's, every true painter felt himself nearer to them than to Delacroix; the admiration they inspired in him had an immediacy that was lacking to their fore-runners in the art museum; their art was *alive*. Though paintings and statues make Pheidias more present to us than Caesar, Rembrandt than Louis XIV—as Shakespeare means more to us than Elizabeth and Bach than Frederick II—there lies between a living art and the art museum something of the gulf that yawns between our lives today and history. As in music and literature, so in painting a living lesser art affects us more strongly than a great art, dead.

The previous work which gives the start to every artist's vocation has usually so violent an impact that we see not only the style that has fascinated him, but the subjects, too, incorporated in the pastiche. That a thirteenth-century sculptor should want to make a *Virgin* seems self-evident; but it is less of a foregone conclusion that we should discover in far-away Japan the landscapes of Aix and Cagnes, the Harlequins that Picasso inherited from Cézanne and the guitar he brought from Barcelona. And that *motif* of a lion savaging his prey which, from Mesopotamia down to the art of the Steppes, persisted through at least three cultures—how could it have owed its permanence to a religion it so long outlived? This continuance through so many centuries of a so small number of most-favored subjects is striking evidence of the blind infatuation of every painter in his early phase. In all the vast diversity of things young artists once seemed to see nothing except a comely youth, a Virgin, some mythological scenes or Venetian fêtes, just as today the young artist sees Harlequins and apples everywhere. For what he sees is not a diversity of objects asking to be painted, but those only which the style attached to them has segregated from reality.

The man whom painting affects solely as a form of representation is not the artist but the non-artist. But the man who is profoundly moved by Rembrandt's *Flayed Ox*, by Piero della Francesca's *Adoration*

of the Shepherds, by Van Gogh's *Vincent's House*—does this man see merely scenes, however striking and well executed, in these paintings? Just as a certain sequence of chords can abruptly make one aware of the world of music, thus a certain compelling balance of colors and lines comes as a revelation to one who realizes that here is a magic casement opening on another world. Not necessarily a supernal world, or a glorified one; but a world different in kind from that of reality.

For thence it is that art is born: from the lure of the elusive, the inapprehensible, and a refusal to copy appearances; from a desire to wrest forms from the real world to which man is subject and to make them enter into a world of which he is the ruler. The artist knows that his domination is at best precarious, that its progress will be limited, yet he is conscious—passionately at first, then as the experience repeats itself, with diminishing intensity—of embarking on a vast adventure. The primordial impulse may have been no more than a craving to paint. Yet, whatever are the gifts revealed in his first attempts and whatever form his apprenticeship may take, he knows that he is starting a journey towards an unknown land, that this first stage of it has no importance, and that he is "bound to get somewhere."

Art has its impotents and its impostors—if fewer than in the field of love. As in the case of love its nature is often confused with the pleasure it may give; but, like love, it is not itself a pleasure but a passion, and involves a break-away from the world's values in favor of a value of its own, obsessive and all-powerful. The artist has need of others who share his passion and he can live fully only in their company. He is like Donatello who, as a legend tells us, struggled to prolong his death agony, so that his friends might have time to replace the tawdry crucifix on his breast with one of Brunelleschi's.

Like every conversion, the discovery of art is a rupture of an earlier relationship between man and the world, and it has the far-reaching intensity of what psychologists call "affects." Creators and connoisseurs, all those for whom art exists (in other words, who are as responsive to the forms it creates as to the most emotive mortal forms) share a faith in an immanent power peculiar to man. They devalorize reality, just as the Christian faith—and indeed every religious system—devalorizes it. Also, like the Christians, they devalorize it by their faith in a privileged estate, and a hope that man (and not chaos) contains within him the source of his eternity.

This immanent power of art can be equated to the fact that most works of the past usually affect us *through their styles*. The tenacious but mistaken belief that art is a means of representation and copies nature in nature's style and not in one of its own, and the equally mistaken belief that a "neutral" style exists—both of which beliefs were fostered by the long supremacy of the art of antiquity—gave rise to the view that styles are, as it were, successive varieties of ornament added to

an immutable substratum, adjuncts and nothing more. Yet it is clear that the woman's body at Pergamum is prisoned within the Hellenistic arabesque, as was the Roman bust within the conventions of the Roman theater. After that great moment of art history when for the first time man arose, rejoicing in his strength, in the straight folds of the Auriga, then in the parallel lines of the Panathenaic frieze and the horsemen of the Acropolis, the "classical" sculptors replaced the hieratic line of Egyptian statuary by their broad shell-like curves and a facile majesty reminiscent of the trophy. Thus we see that what once ranked as absolute beauty now strikes us as the style, followed by the stylization, of the classical age. Both, like those of Byzantium, are the expression of a particular interpretation of the world—an interpretation calling for a special way of seeing before being enriched by it. When

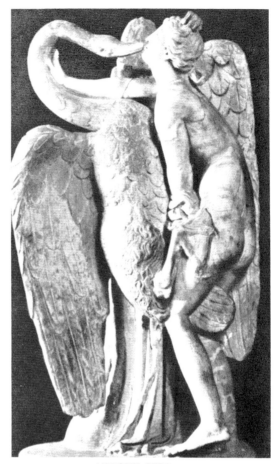

ANTIQUE: LEDA

Claude Lorrain took sunset as his theme, what he saw in it was not so much the intrusion of the fleeting moment into the classical landscape as a perfect expression, in Time, of the embellished world he was aspiring to create; his sunset is not a fleeting moment but an ideal aspect of the universe like certain stormy skies of the Venetians, a transcendent hour standing to ordinary daylight as an idealized face stands to its ordinary aspect. For him it was not a model to be copied, but an accompaniment; as mist is to the lay-out of the Sung landscapists, and as is the schematic death's-head to so many Pre-Columbian figures. A style is not merely an idiom or mannerism; it becomes these only when, ceasing to be a conquest, it settles down into a convention. The tastes of a period are mannerisms which follow those of styles or may exist without them; but Romanesque was not a medieval "modern style," it illustrated

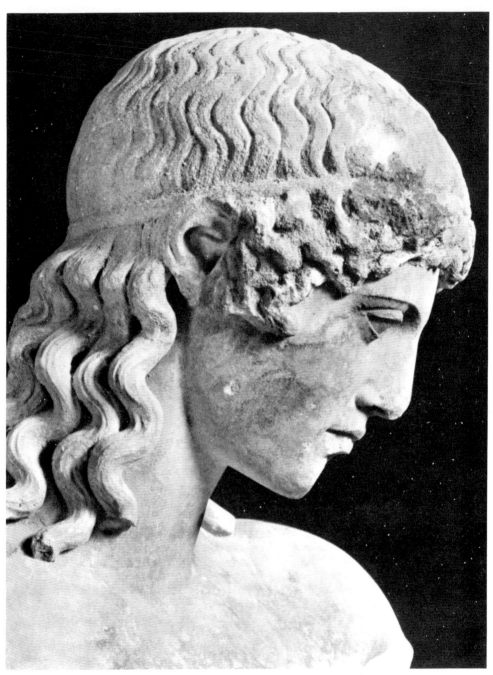

THE APOLLO OF THE TIBER (5th CENTURY B.C.)

a special attitude towards the cosmos; indeed every true style is the scaling-down to our human perspective of that eternal flux on whose mysterious rhythms we are borne ineluctably, in a never-ceasing drift of stars. Apollo, Prometheus—or Saturn; Aphrodite, or Ishtar; a resurrection of the flesh, or the Dance of Death. Once the Dance of Death becomes more than an allegory, it throws light on Northern Europe of the fifteenth century in the same way as the Panathenaic frieze throws light on the Acropolis. It has its own idiom, its own color. (Only imagine a Dance of Death treated in the style of Raphael, Fragonard or Renoir!) Its dancing throng points the way towards the *Christ in Prayer*, in the same sense that the processions of ancient Greece converged on the *Auriga* and the *"Apollo of the Tiber."*

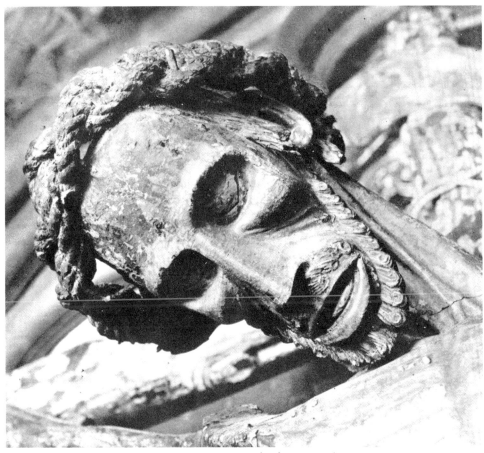

CHRIST IN PRAYER (15th CENTURY)

Whatever the artist himself may say on the matter, never does he let himself be mastered by the outside world; always he subdues it to something he puts in its stead. Indeed this will to transform is inherent in his artistic personality. They are simpletons, those "theoreticians of the fruit-bowl" as we may call them, who refuse to see that the still life is a product not of primitive cultures but of advanced cultures; that our painters are not painters of fruit but of those modern still lifes, which follow each other like so many ikons, truculent or timid as the case may be. Thus, too, portraits, during those periods when the face was not yet treated as a still life, qualified as works of art in so far as they revealed or magnified what began where the mere reproduction of features ended. Our attitude towards an object varies according to the function we assign to it; wood can mean a tree, a fetish or a plank. The depiction of living forms begins not so much with the artist's submission to his model as with his domination of the model—with the expressive sign. Thus the sexual triangles imposed on the bodies of Cretan and Mesopotamian statuettes symbolize fecundity but do not represent it. For the visible world is not only a profusion of forms, it is a profusion of significances; yet as a whole it signifies nothing, for it signifies everything. Life is stronger than man by reason of its multiplicity and total independence of his will, and because what we regard both as chaos and as fatality are implicit in it; but, taken individually, each form of life is weaker than man, since no living form in itself *signifies* life. We may be sure that the ancient Egyptian's feeling of oneness with eternity was indicated less by his features and demeanor than by the statues that have come down to us. And though the world is stronger than man, the significance of the world is as strong as the world itself; a mason at work on Notre-Dame could, as a living, moving being, defy the sculptor's art—yet, though he was alive, he was not "Gothic."

Thus styles are *significations*, they impose a *meaning* on visual experience; though often we find them conflicting with each other, passing away and superseded, always we see them replacing the uncharted scheme of things by the coherence they enforce on all they "represent." However complex, however lawless an art may claim to be—even the art of a Van Gogh or a Rimbaud—it stands for unity as against the chaos of appearances; and when time has passed and it has borne fruit, this becomes apparent. Every style, in fact, creates its own universe by selecting and incorporating such elements of reality as enable the artist to focus the shape of things on some essential part of man.

The *Last Judgment* might be taken as a symbol of this significance implicit in all styles. In the Florentine "Christs" that Michelangelo had carved before this, there had not been a hint of that strange colossal figure whose maledictory gesture consigns to the outer darkness those wretched sinners wrested from the brief darkness of the tomb. When in one of his last works (in the Cathedral of Orvieto) Fra Angelico

MICHELANGELO: THE LAST JUDGMENT (DETAIL: CHRIST)

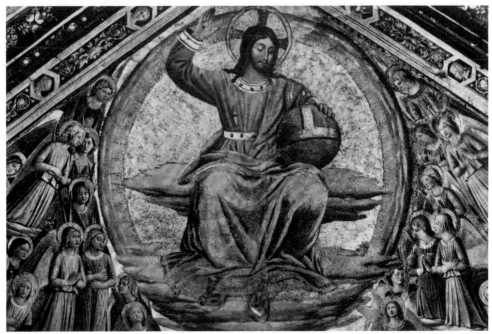

had portrayed that gesture, it was still charged with benediction and seemed to be directed towards the attendant angels. Its transformation is one of the most significant transformations in the whole history of art. In Michelangelo's fresco the Damned press forward towards that implacable Judge against whom crouches the Virgin of Pity; everything —even the light enveloping Christ's Herculean torso, twice as large as that accepted by the conventions of the day—conspires to make the surging throng of the Valley of Jehoshaphat resemble the triumphal progress of an *imperator*. If there be little of Jesus in the central figure, it is surely God incarnate.

How small a part, indeed, is played by Jesus in the Bible of the Sistine! The whole ceiling announced his coming, yet when at length He appears above the altar (almost thirty years later) a change has intervened. In this heroic threnody, unique in the world's art, there is no trace of the quivering movement Rembrandt's compassion imparts to the open hands of his Christ and even to the menacing hands of his prophets; for Rembrandt sponsors the whole Bible. Whereas in Michelangelo's vision of the last end of the human adventure what account is taken of the Incarnation? His all-conquering Messiah was not born in a stable, was never mocked and buffeted, succored no travelers on the Way to Emmaus, nor was He crucified between two

thieves. Remote indeed is that divine humility which He shared with the saints who now escort Him, like a terrified bodyguard! The trumpets of Apocalypse have sounded, every wall has fallen, the immemorial lights twinkling on earth above the Christchild's crib have been put out, and with them the Star in the East—and Giotto's genius. Those friendly, understanding beasts beside the crib are now mere insensate animals. The incarnation has become an ordeal fraught with terrors and a time of humiliation.

Gothic Judgment Days—at Rheims and Bourges, for instance—had often been resurrections; Michelangelo's is a doomsday. His trembling saints are not the Blessed, and the composition of his fresco is not so much integrated around Christ (like Tintoretto's *Paradise*) as skilfully disintegrated by the great void down which are cataracting —without filling it— the Damned. The compelling influence exerted then and still exercised by Michelangelo's great work has been attributed to the nudes that figure in it; indeed the multitude of naked bodies caused offense and three popes gave orders for the destruction of *The Last Judgment*. This seems surprising when we remember that the Church tolerated the nude under certain circumstances: before the Fall and after death—Eve and the resuscitated bodies. This was the judicious answer given by the Inquisition of Venice when, summoned before them to justify his "profane" treatment of *The Last Supper*, Veronese fell back on the authority of Michelangelo to justify his harmless dogs. Surprising, too, is the fact that, during two centuries, charges of indecency were leveled against *The Last Judgment* (which had been bowdlerized into decorum a month before the artist's death); it was feared that this throng of burly Titans might evoke ribald comments from a populace that was being edified by Bernini's statues. Yet it is surely obvious that *The Last Judgment* is one of the world's least sensuous works of art. The truth is that Michelangelo's detractors, though unconscious of the true reasons for their antipathy, were not mistaken when they saw in this fresco a hostile work.

For these nudes are not idealized, they are magnified. Evil, for Michelangelo, is not a "deficiency," the negative of virtue, and his hell is not made of mud. The human dust that eddies in the whirlwind of the *Judgment* still forms part of the huge shadow cast by Lucifer; this is the Last Day, and also the last end of Satan, henceforth entombed forever in the kingdom of the dead. This Michelangelo expressed in terms of an art that foreshadowed Milton and Hugo in his last phase; and it was by way of man that he expressed it. But Michelangelo's "man" in this fresco (in which he no more says the last word of his art than Shakespeare does of his, in *Macbeth*) is quite other than Raphael's "man," who has made his peace with the universe; he is in the toils of a dilemma, a mystery without solution. Raphael's man is saved by the New Testament, Michelangelo's aggrandized by the Old; his significance

SIGNORELLI: THE RESURRECTION (DETAIL)

is heightened, he is forced into becoming the loftiest expression of his own tragedy, an echo of the drama of the universe. He is of heroic stature, not in so far as he dominates his situation, but in so far as he embodies in himself its harrowing grandeur. Art for Michelangelo is a means of revelation; he gives his own likeness to the hideous, ravaged visage St. Bartholomew displays, not to Christ, but to the spectator. Nothing brings out more clearly the new significance that genius can impose on a set theme than a comparison of the Gothic irony of Signorelli's skeletons with those deep organ-notes which in the lower portion of the fresco stress the polyphonic majesty of Michelangelo's vision: Death contemplated by Man, whose gaze neither the panic-stricken crowd nor the celestial Judge can avert from the fascination exercised by that inexorable face.

MICHELANGELO: MAN AND DEATH (DETAIL OF THE LAST JUDGMENT)

A Judge, nevertheless, such as had never before been seen, in whom not only the face but the significance of Christ was changed, and, as a result, the significance of the faces around Him. Though these nudes are so much like those on the Sistine ceiling and these faces like those of the Prophets, they acquire another meaning, because they follow the coming of Christ instead of announcing it. We can hardly conceive of this Judge in Israel figuring in *The Damned* of Signorelli with its devils with pointed wings and its knights borrowed from the Golden Legend; nor can we see how the nudes in the cathedrals or even the poor human herd of Orvieto could have been grouped around Him. Gothic nudes are men stripped of their garments—one can almost see them shivering with cold—and even in the Romanesque art of Autun the Damned have the look of punished children. Michelangelo's Damned are convulsed but not cowed by their terror, and that shattering gesture which casts them forth has come, by way of Angelico, from the remotest past; it is the same gesture as that which overwhelmed the revolting angels.

The fall of Satan and his host was to figure in front of *The Last Judgment*. But it was not needed; it was there already. Michelangelo expunged from Christendom a legendary lore that had held its ground for many centuries; his Christ is not a vanquisher of dragons but of men, men likewise of heroic stature by reason of their very damnation, a surging mass of Promethean rebels, suffering but unsubdued. What those who saw them were perturbed by in these nudes—petrified, like the woman in *The Deluge*, despite their writhings—was not their sensuality, for they had none (indeed Signorelli had gone further in this direction), but the epic note imparted to the doctrine of Augustine. "Man is so foully soiled by sin that his very love, were it not for grace, would befoul God Himself." Here in his estrangement from God, his reprobation, man attains sublimity; he is ennobled, not saved. When the fresco was unveiled the Pope, we are told, fell on his knees and prayed. At the same moment, very likely, Luther was thinking out his message. . . . Only one hope of salvation from the *Judgment* remained, and that was grace.

The effects of this new presentation of Christ were far-reaching; all subsequent portrayals of Him bear traces of it. Indeed these forms, under the name of Baroque, spread all over Europe. But though they involved a break-up of the forms on which, to begin with, Michelangelo had relied; though they ignored Donatello and Verrocchio no less than the lessons of Ghirlandaio's frescoes, and though the peremptory arm of Christ effaced the arm suavely portrayed by Fra Angelico—they kept the spacious settings of the earlier art. Although Michelangelo's genius had wholly transformed the Gothic treatment of the large-scale scene, Tintoretto's sumptuous vision retained not a little of it, but his color gave it a very different accent and transmuted Gothic emotivity

MICHELANGELO: THE WOMAN OF "THE DELUGE"

into the chromatic splendors of the *Paradise* in the Doge's Palace. Then (after the dazzling but puerile *Last Judgment* of Rubens) there came a time when the Sistine *Dies Irae* confronted a Roman public so completely estranged from the voice of Augustine that they could not even hear it, and presently when the ruined Palace had come to mean no more than an obsolete *décor* to men who feasted their eyes on the luxuriance of Jesuit art, the Hebrew prophets, denizens of the Amsterdam ghetto, were to conjure up a new meaning of the world in the pregnant dusk of Rembrandt's studio.

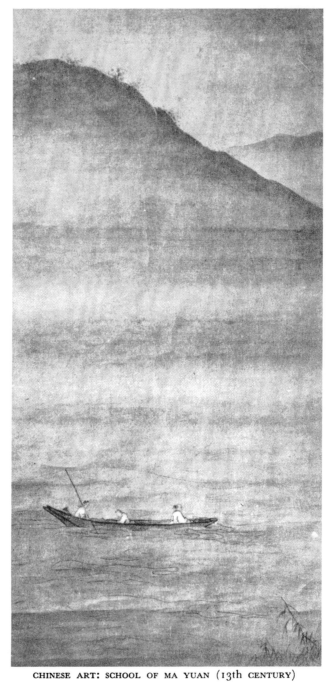

CHINESE ART: SCHOOL OF MA YUAN (13th CENTURY)

CLAUDE MONET: THE SEINE NEAR VERNON

Now that we are no longer blinded by that "lifelike" representation so tenaciously and successfully sought after during a few centuries of Mediterranean art, and now that our retrospect on art covers several thousand years, we are coming to perceive that while representation may be accessory to a style, style is never a means of representation. The impressionism of the Sung artists aimed at suggesting by a subtle use of the ephemeral that eternity in which man is swallowed up, as his gaze loses itself in the mist that blurs the landscape. It is an art of the moment, but of an eternal moment; whereas our modern Impressionists, in their concentration on the fleeting moment, aimed at giving individual man his maximum importance—and may not this have been a happy device of painting to enable Renoir to win his freedom and Matisse to fulfil himself? We see Christian art gathering all the dead branches it lays hands on into a single burning bush and Gandhara imprinting the cast of Buddhism on the faces of classical antiquity, just

as Michelangelo sublimates them into his Christ, and Rembrandt illuminates with his vision of Christ even the faces of the beggar and the woman sweeping the floor. Every great style of the past impresses us as being a special interpretation of the world, but this collective conquest is obviously a sum total of the individual conquests that have gone to its making. Always these are victories over forms, achieved by means of forms, they are not the allegorical expression of some ideology. *The Last Judgment* was the outcome of a meditation on figures, and not a declaration of faith. Once we realize how all-important is the significance of styles, we understand why every artist of genius—whether like Gauguin and Cézanne he makes himself a recluse, or like Van Gogh a missionary, or like young Tintoretto exhibits his canvases in a booth on the Rialto—becomes a transformer of the meaning of the world, which he masters by reducing it to forms he has selected or invented, just as the philosopher reduces it to concepts and the physicist to laws. And he attains this mastery not through his visual experience of the world itself, but by a victory over one of the forms of an immediate predecessor that he has taken over and transmuted in the crucible of genius.

IV The non-artist imagines that the artist's procedure is the same as his would be, were he to try his hand at making a work of art; only the artist has a better technical equipment. But the non-artist does not really "proceed" at all, because what he produces is at best a memory, a sign or a story; never a work of art. Obviously a remembrance of love is not a poem, a deposition given in court is not a novel, a family miniature is not a picture.

The poet is haunted by a voice with which his words must harmonize; the novelist is so strongly ruled by certain initial conceptions that they sometimes completely change his story (to which, however, they have not given rise). Sculptors and painters try to adapt lines, masses and colors to an architectonic (or destructive) schema that fully reveals itself only in their output viewed in its entirety. A poor poet would he be who never heard that inner voice; a poor novelist, for whom the novel was no more than a tale! That trumpet-call in the shadow of the Coliseum by which we recognize Corneille at his best, that palm tree in whose likeness Racine's lines deploy their graceful curves—never do Corneille and Racine forget their loyalty to these. Those words, "*La fille de Minos et de Pasiphaë*," are not a piece of biographical information. For Victor Hugo those obsessive rhymes in -*ombre* echoing the surge and thunder of the sea, serve as an orchestration; we can feel the words seeking to fit themselves into this pattern, far more than its being adjusted to their meaning. The lines of mere enumeration, of proper nouns—such lines as "*Tout reposait dans Ur et dans Jérima-deth*"—are upcrops as it were of the underlying patterns, on which are based the various kinds of pastiche, inspired, ironical, involuntary or merely plagiaristic. The novelist, who seems much more subservient to reality than the poet (and the same is sometimes true of the painter), also employs "schemas" or procedures of this order. First of all there is the "lighting"—which prompted Flaubert to remark that *Salammbô* was a purple novel and *Madame Bovary* puce-colored; which led Stendhal to make Parma the scene of his *Chartreuse*, with Correggio in mind and perhaps violets as well. Then, again, we have the choice the author makes of what is to constitute the scene or setting and what is to remain in narrative: the lay-out of those porches where a Balzac or a Dostoevsky seems, as it were, to lie in wait for his characters as destiny lies in wait for men. In the first draft of *The Idiot* the murderer was not Rogozhin but the prince. The character was destined to be radically changed, and the plot changed too, but neither the scene nor its significance was changed. Dostoevsky does not care a jot whether the flint hits the steel or the steel the flint, so long as the spark is there.

The presence of these underlying patterns or schemas is particularly noticeable in sculpture and painting, because the artist's evolution brings them into prominence. The doors which Dostoevski tries to unbar in *Poor People*, Balzac in *La Peau de Chagrin* and Stendhal in *Armance* open the

CELTIC COIN (MARSEILLES)

way to *The Karamazovs, Les Illusions perdues* and *La Chartreuse de Parme;* though less obviously than Cézanne's *La Maison du Pendu* points the way to *L'Estaque*, the El Grecos of Venice to those of Spain, and Michelangelo's *David* to the *Pensieroso.* The masterworks seem to hover in superimpression above those preceding them, and the Gothic element in Romanesque would be harder to detect did not Gothic art reveal it to us.

These schemas acquire greater definition in the successive phases of the artist's output as a whole. When those of several great artists have proved themselves so effective as to give rise to a style, the programs of individual artists are adjusted to this style—until new modalities

CELTIC COIN (MARSEILLES)

emerge and it becomes obsolete. Those vast collective modalities of art which developed from Autun to Rouen, from the Greek archaics to Praxiteles, from Manet and Cézanne to our contemporary artists, are akin to those which brought about the transformation of the Macedonian stater into Celtic coins. It is clear that when on the coins of Marseilles the primitive squid was transformed into a lion, the graver did not merely wish to substitute one surface for another. The lion has retained something of the shape of the squid, whose whiplash curve has turned into the crouching form of the lion about to spring. The open jaws attempt without success to adjust themselves to the thonglike body; but

RUBENS' "SCHEMA" (NEGATIVE OF DETAIL OF ABRAHAM'S SACRIFICE)

at least they succeed in freeing themselves from the Mesopotamian structural pattern. Here, as elsewhere, we find a latent schema acting like a nervous system seeking to enflesh itself.

The less the artist aims at illusionist realism, the more clearly emerges his ideal schema. That of Botticelli, of El Greco or of Goya is plain to see. Those conveying movement come out most clearly; though they seem to belong essentially to Baroque (Tintoretto, Rubens), we also find them in the art of the Steppes. Van Gogh's began as a rugged simplification, associated with dark tones; it was in his later phase that he took to that swirling movement, like seaweed lifted and let fall by the rising tide, which we find in his cypresses and sunflowers, and to those wrought-iron brushstrokes which sometimes seem to fray the canvas like bones piercing the skin. Klee's schema involves a tenuous, clean-cut line telling out against an uneven background, the line of the *graffiti;* Corot's, Chardin's and Vermeer's a simplified color harmony shot through with light; Rembrandt's the single sunbeam lighting up the room where his philosophers confabulate or muse; Piero's and Cézanne's an architectural lay-out. In fact each great artist has his own favorite procedure, and the same holds good for color. Oriental art has its distinctive color scheme, and that of medieval Europe was quite different from the color scheme deriving from our conquest of the third dimension. Modern art, too, whether impressionist or not, has its own colors and Matisse's color scheme seems often to determine his design. What is the idea behind these procedures? They certainly make no concessions to "the real," and each vouches for a latent but fanatical resolve to break with the art that gave it birth. "No man on whom a good fairy has not bestowed at birth the spirit of Divine Discontent with all existing things will ever discover anything new." While primarily defining the Romantic, Wagner's remark throws light on the formative period of every great artist—provided we remember to include works of art amongst "all existing things." For a Sumerian artist as for Raphael art began by a break with the past; this rupture is not art, but no art can emerge without it.

It is obvious that the masters who imposed on Byzantium its first distinctive accent did not begin by thinking up an abstraction—the Byzantine style—to which they proceeded to adjust their art and whose lead was blindly followed by their successors. The truth was of another order; these artists were acutely conscious of the discrepancy between the forms of antiquity and the Christian world, and what they aimed at destroying was, above all, the *style* inherent in those earlier works. For the Byzantine artist the world hierarchy these implied was rooted in a lie, and they set out to transform it, not by any submission to the living forms around them but by selecting some of these and subjecting them to a purposeful distortion, charged with new intimations. Thus, for example, they perceived that majesty is better incarnated in a face that

BYZANTINE ART (LATE 4th CENTURY): THE SHIELD OF THEODOSIUS (DETAIL)

God has marked with suffering than in that of a great actor playing
the part of an emperor. They achieved their purpose by developing
a style in which an hieratic quality reminiscent of Sumerian and Syrian
art imposed order on the paralyzed confusion of forms that still retained
their pagan aspect. But the true Byzantine style emerged only when the
emotive line of Sinai and the Fayum had acquired a sickle-shaped
calligraphy as far removed from the spirit of Sassanian art as from that
of classical antiquity—a script that at once orientalized and christianized
its motifs. It is clear that representation played no part in the formation

of this art, for it does not aim at any sort of realism; rather, we feel behind it, like an abstract pattern, the schematic transposition which preceded and gave rise to it, before it crystallized into a style that, in the East as in the West, became as it were the sign-manual of Byzantium.

Though the break with the past without which the personal schema cannot come into being and which is the starting-off point of the life's work of all great artists implies dissatisfaction, it is not necessarily an indictment; Giotto, Rubens and Chardin reacted against the forms preceding them, but not against the world at large. Whether rebellious or acquiescent, every great artist stands for a metamorphosis, but sometimes it occurs to him that, to vary Shakespeare, "there is more nobility, more happiness on earth, Horatio, than is dreamt of in your art galleries." Thus, while Goya sought to wrench its mask of hypocrisy from the world he lived in, Giotto sought to remove its mask of suffering.

The bold repudiation by our modern painters of the art in favor with the public of their day has led us to regard art as being essentially one of the loftiest arraignments of the scheme of things. From the Villeneuve *Pietà* down to Van Gogh (as from Villon to Rimbaud and Dostoevski) that Promethean dirge whose tones resounded at their fullest in the work of Michelangelo and Rembrandt has been making itself heard in art until, in our time, it seems to voice the cry of Europe in her death throes. Yet, though the great individualistic venture abounds in votaries of solitude, this self-imposed isolation does not always spell detachment. There were those who rebelled less against life in general than against certain distressing aspects of their age, or against what they regarded as an unworthy expression of Man; those to whom it seemed that the mask imposed on human suffering was the lie of lies and must be torn away—and such men were no less antagonistic to the forms which had given birth to their art than were those who denounced the world at large. These men I speak of belonged to the school of gentle accusers—who sometimes aspire to be redeemers. We tend to associate in our minds their successors with that period of general decay in which the "antique" and all those for whom during two centuries it had been catering foundered in an inglorious death. But what of the lineage of the Masters of the Acropolis and Rheims, what of Masaccio, Piero and Raphael? What of Rubens, Titian, Fragonard, Renoir, Vermeer, Chardin, Corot and Braque? These artists did not blame the works from which they took their rise for being untruthful, but for being inadequate or impure. Vermeer did not resemble Poussin, still less Rubens, yet the harmonious world of the two first-named artists was brought into being by a process similar to that which led up to Rubens' brilliant orchestrations. Sometimes these painters give us an impression—which, however, does not stand up to close examination of their works—of having "perfected" the art of their forerunners. Yet the art of each has quite as good a claim to rank as a "conquest" as has

the art of any of the great tragic painters—only it is less aggressive, its conquest less apparent. Titian repudiated Bellini, yet fulfilled him, as El Greco was to step-up Titian's art to a poignant intensity. El Greco's truth—stripping the world of its pomps and vanities to give it back its soul—was other than that of the Acropolis sculptor who stripped it of its soul to give it its freedom; nevertheless, these truths, reconciled in the fraternity of death, bear joint fruit in those passionate transfigurations which link up Grünewald and Van Gogh with the Theban sculptors.

The reason why we are often at a loss to understand the workings of the creative process is chiefly that our present-day conception of the artist, *qua* artist, is curiously indefinite. In the seventeenth century the position was clear; the great artist was necessarily one who produced "high art." Then the Romantics adopted Rembrandt as the symbol of the art they wished to substitute for Raphael's. During the last half of the nineteenth century ideas of what is meant by genius were somewhat vague; hence our contemporary efforts to elicit from the correspondence and memoirs of artists the secret of the creative process. But while the correspondence may express the man, it never expresses the artist. It was Signor Buonarroti who wrote the letters and Michelangelo who carved the figures in the Medici Chapel; it was M. Cézanne who wrote his letters and Cézanne who painted the *Château Noir*. Van Gogh's correspondence brings out his nobility, it does not explain his genius.

Romanticism has bequeathed to us a conception of the artist in which his function as "interpreter of the great mystery" bulks large, and it is on this sort of tribal witch-doctor that the man least sensitive to art lavishes the respect he would not dream of bestowing on the decorator. This conception invests the man himself with the genius implicit in his works and assumes that he has mastered life with the same compelling power.

This conception links up with that of the universal-mindedness of the Renaissance, whose symbol is Leonardo, and implies that there were certain men whose wide knowledge, combined with quite exceptional intelligence, endowed them with powers in other fields equivalent to those they displayed in their art. Yet Leonardo, whose painting evidences an intelligence that none has equaled and whose drawing, first of its kind in Europe, gives us (like the drawing of the Chinese and Japanese painters) the impression of having no limits to its possibilities, regarded as his supreme works the equestrian statue of Francesco Sforza, *The Last Supper* and *The Battle of Anghiari*. The first he did not succeed in casting, the second was badly damaged by an improvement he thought he was making in the technique of the fresco, and the third was quite destroyed by this supposed improvement. He was seriously handicapped—especially in his dealings with the Pope—by his ignorance of Latin, a language which this man who knew so many things never

troubled to learn. Even his way of living seems undistinguished when we compare it with that of Rubens or Wagner, or with the haunted solitude of a Rembrandt or a Van Gogh.

What expression can we ask of a painter's genius outside his art? Van Gogh's life was as tragic as his painting, but, though tragic, it does not command admiration. Was it to be expected he would write letters we can admire as much as we admire *The Crows*? Or that he should write Rimbaud's poems? Even Michelangelo's poems are not to be compared with the Medici tombs. True, in Van Gogh's case his affection for his brother and the knowledge of painting possessed by Theo impart to the artist's letters a poignancy enhanced by the dark glamour of incipient madness. Whereas, regarding Cézanne's letters, all we can say is that they are not the letters of a man capable of painting as he painted. Hence the conclusion: *"Cézanne est un œil"*—purely and simply.

Sainte-Beuve's criticism of Stendhal seems to have been based on this argument. "But I knew that Monsieur Beyle quite well, and you will never convince me that a trifler like him can have written masterpieces." It remained to be seen whether it was "that Monsieur Beyle" or Stendhal who wrote *La Chartreuse de Parme*. (A pity Sainte-Beuve never knew "that little fellow Proust"! Still, he did know Balzac.) Men do not find goodness of heart, nor saintliness, nor genius in their cradles, so they have to acquire them. And the dissimilarity between Stendhal and M. Beyle, between Michelangelo and Signor Buonarroti, between Paul Cézanne and M. Cézanne may well be due to the fact that these three gentlemen had never to solve the same problems that Michelangelo, Cézanne and Stendhal set out to solve.

When M. Beyle met Sainte-Beuve he merely tried to entertain, to puzzle or to charm him. When Stendhal wrote *Le Rouge et le Noir*, he did nothing of the sort; he forbade M. Beyle the expression of any thing that was not the fine flower of his intelligence and sensibility. In short, he filtered M. Beyle; he ruled out his lapses. Had he put as much energy into playing a part, he would doubtless have made good on the stage, and what if he had devoted himself to acquiring that spiritual invulnerability which is the apanage of great religious thinkers? But those paths were not for him, he was more gifted for literature. And if he proved himself a genius in this field it was solely because he subordinated M. Beyle to a loftier part of his personality (we can hardly conceive of a religious-minded man without God, a hero without honor or a sage without wisdom) and by attaching no importance to the opinion of others. True, M. Beyle was Stendhal, but a Stendhal *minus* the books and *plus* his human failings. The former, doubtless, took trouble with the women he wished to charm, the latter concerned himself with the means of his creation, not with the resistance of the women he wished to create; when these women seemed to resist him, it was a part of himself that he was grappling with. When, however, the

special problems with which—owing to the fact that human experience can be expressed in words—the novelist has to cope do not arise (as in the case of painting and music), that which differentiates the artist from the ordinary person becomes clear; he has not the same opponent to contend with. The ordinary man puts up a struggle against all that is not himself, whereas it is against himself, in a limited but all-essential field, that the artist has to battle.

This explains his divided personality. When Cézanne spoke of himself as "a failure," it was not, I think, that he had any qualms about his painting, but that—on that particular day— he could not believe that M. Cézanne was fit to hold a candle to Poussin. As for M. Poussin, the man, Cézanne never gave a thought to him. Moreover there were occasions when dramatically the master arose in his strength and startled some tactless visitor who had been pestering a mild and modest old man, with the unlooked-for remark: "Let me tell you, I am the greatest painter of this age!" Every true artist regards himself, alternately or simultaneously, as what he is and also as a failure. For the feeling of superiority is mingled in every man with one of inferiority, if not always in the same manner. Cézanne's proud assertion, Nietzsche's "I am the leading authority in Europe on the subject of decadence," and Baudelaire's retort to Ludovic Halévy "But *I* was writing in those days!" when the latter had been disparaging the writers of the 'forties—these were very different from the "I'm a fine fellow!" of the ordinary self-satisfied man. Gauguin, too, referred to himself as "a failure," yet he was fully conscious of his value as an artist; he wrote thus not because he felt any doubts about the picture he was painting, but when he looked at his rotting limb. At such moments it was not his art that was defeated; it was the opinion others had of him that got the upper hand. As he lay dying in that lonely hut in the Marquesas he knew in his heart of hearts, the despondent letters he wrote to Monfreid notwithstanding, that his death would make an end of his body only, not of his life's work.

Apart from a small group of artists, Gauguin's contemporaries were all the less capable of understanding his greatness because the processes that go to the making of a genius were quite other than those they supposed. But, for that matter, no community can understand these processes, though sometimes they admire their results. What exactly are the conditions that go to shape a genius? A man who is destined to become a great painter begins by discovering that he is more responsive to a special world, the world of art, than to the worlp he shares with other men. He feels a compelling impulse to paint, though he is well aware that his first work doubtless will be bad and there is no knowing what the future has in store. After an early phase of the pastiche, during which he usually copies near-contemporary masters, he becomes aware of a discrepancy between the nature of the art he is imitating and the art which one day will be his. He has

glimpses of a new approach, a program that will free him from his immediate masters, often with the aid of the masters of an earlier age. Once he has mastered one by one his color, drawing, and means of execution —once what was an approach has developed into a style—a new plastic interpretation of the world has come into being, and, as the painter grows older, he modifies it still farther and intensifies it. Though it is not the whole of artistic creation, this process almost always enters into it, and each of its successive operations involves a metamorphosis of forms —a fact which until quite recently was overlooked completely. Thus the view of Gauguin's contemporaries (a view shared by most Western cultural groups) was that genius derived from humble fidelity to nature, from the artist's accurate response to visual experience, from his technical proficiency or a gift for dramatic presentation. These conceptions of genius were not the consequence of any aesthetic doctrine or a theory that another theory might have ousted; they stemmed from basic illusions similar to those we have seen operating in respect of the artist's vision. For whereas the aesthetician joins issue with other aestheticians, the artist has to contend with prevailing sentiments, of an order hardly touched on in aesthetics, and these sentiments are modified only by vast changes in the outlook of successive cultures. Also, we find that cultural groups understand more readily a symbolical expression of their values than the expression of their underlying significance. Though the Florentines and the Romans (the popes included) admired Michelangelo, they showed much indulgence for inferior painters. Then, again, the notion of art as representation—especially representation of the imaginary—fostered a confusion of ideas, often injurious though sometimes helpful to the artist. Now that representation and this confusion of ideas have gone by the board, the average magazine-reader sees in Picasso a modernistic decorator or admires him much as he admires Einstein. Thus every social group regards painters as brilliant copyists of nature, as prophets, as aesthetes or as decorators—as anything in fact but what they really are.

During the last fifty years the artists themselves have been only too prone to speak of their art as if they were house-painters. No doubt it is absurd to speak of painting without speaking of colors, but it is hardly less so to speak of it in terms of color only. While ready to admit that his art is a language of a special kind, not needing to be translated into any other, the painter professes to be unaware that what it expresses, if indirectly, is human greatness under a special aspect. But he knows quite well that true painting is not merely an agreeable or striking arrangement of lines and colors any more than poetry is merely a felicitous arrangement of words. The nameless presences of the sculptor who carved the effigy of Gudea and the master of the Villeneuve *Pietà* haunt his waking hours. Once attention is focused on his painting the human frailties of the great painter are thrust out of mind

—for his art would not survive insistence on them. Do M. Cézanne's letters read like those of a *petit bourgeois*? What we mean by a *petit bourgeois* is a man who is always thinking of his personal advantage—but Cézanne sacrificed everything to his art; a man who is swayed by petty interests and has no truck with anything that transcends him—but Cézanne's whole life was consecrated to his painting, and his painting reached out to a host of things transcending him. If all of us imposed on our lives the virtues that such artists practiced in their art, great would be the wonder of the gods!

Granted—yet the fact remains that Cézanne did not speak of painting as we would wish him to have spoken of it. Actually he hardly spoke of it at all. He threw off a few aphorisms, grumbles about the *métier*, mentions of what he was painting at the moment—but never a considered opinion. In fact no great painter has ever talked as we would like him to talk.

Painters, Leonardo no less than Cézanne, have always known in their heart of hearts that painting is—just painting. But never perhaps until the present day has painting openly claimed to be no more than painting. Artists of the past rarely felt called on to expound what was *specific* in their art; if they wrote at all, it was about technique, procedures, sometimes aesthetics. But aesthetics is, or was, concerned with abstractions—with ideologies—not with painting. As late as 1876 Fromentin felt he must excuse himself for using the word "values"! When the painter took to writing he had no choice but to use the vocabulary of the critic or the aesthetician, a vocabulary that was not his own and often struck him as inapt, if not misleading. Thus he was led to express himself in aphorisms, usually tending to justify his methods and sometimes, up to a point, enlightening. "Sincerity," wrote Manet (often more happily inspired), "gives works of art a quality which makes them seem like a challenge or a protest, though actually all the artist wanted was to paint his impression." That was written thirteen years after *Olympia*—was *Olympia*, one wonders, an "impression"? Obsessed by that word "realization," Cézanne seems deliberately to court misunderstanding. He paints the Montagne Sainte-Victoire again and again not because he does not find his picture sufficiently "true to life" but because at certain moments the mountain conjures up new color schemes, implementing a fuller "realization"; it is not the mountain he wants to "realize" but the picture.

Yet it was Cézanne who said: "There is a logic of colors, and it is with this alone, and not with the logic of the brain, that the painter should conform." This clumsy phrase, but one of the boldest and sincerest a painter has ever uttered (for the artist is by nature secretive and likes to mystify), explains why every painter of genius feels that trying to write about his art is completely futile. His vocation and his quarrel with the past are not the result of looking at the world or reading

346

CÉZANNE: MONTAGNE SAINTE-VICTOIRE

books, but of looking at pictures. He does not necessarily want to change the world, nor does he seek to justify God's ways to man; he wants to challenge existing pictures with pictures that do not yet exist. His mental activity is limited to a specific field (how to change that yellow; with what color to render that light effect so as to harmonize it with the picture as a whole, since light can be expressed in painting by means of colors only, not excluding black—and so forth). His genius finds its means of expression in that field alone, whether he elects to paint seapieces or a *Way to Golgotha*. Thus, when Paul Cézanne wants to speak he imposes silence on M. Cézanne whose fatuous remarks get on his nerves, and he says with his picture what words could only falsify.

Cézanne knew better than I what I have just written. Giving form to the unconscious does not involve unconscious action on the artist's part. Though it means nothing to those who are indifferent to art (as religious experience means nothing to the agnostic), artistic activity, far from being haphazard, is governed by strict laws which,

though at some points they impinge on everyday experience, are independent of it; indeed no work of art is the expression, instinctive or inspired, of any such experience.

Thus, though M. Cézanne may have dealings with the outside world —and if for M. Cézanne we substitute Señor Goya or M. Van Gogh these dealings are of no amiable order—the painters Cézanne, Goya and Van Gogh have dealings solely with a "filtered" world. "The thing is to paint as if no other painter had ever existed," Cézanne said —and forthwith paid another visit to the Louvre! The forms he took over, like those taken over by his great predecessors whom he confronted with them, were not always the same, but they were always called for, in the sense that they were responses. Egyptian sculptors observed cats with more interest than did the Greek sculptors, who never portrayed them. A Byzantine sculptor decided to paint St. John the Baptist before looking at the faces of the passers-by with a view to painting them, and when he did look at them he had his St. John in mind. Leonardo did not paint with a view to portraying faces bathed in the evening glow, but he noted for future reference that the light of evening imparts to faces a special kind of beauty. Corot set up his easel in front of the Nerval ponds or the Mantes bridge, not in front of factories, and when the conventional landscape-painter decides to paint a landscape which strikes him as "pretty," he is deferring to a convention prior to his painting.

Far from studying the visible world with a view to subjecting himself to it, the true artist studies the world with a view to "filtering" it. His first filter, once he has got past the stage of the pastiche, is the schema or preconceived system, which simultaneously, if rather roughly, filters both the world of visual experience and the pastiche itself. At first the collective and inherited schema (which gave rise to the lion on the coins of Marseilles, the convolutions of the animals on Scythian plaques, the carapace-like figures of late Romanesque art), and then the personal schema (which led to Tintoretto's first stridencies, to the first stairway under which Rembrandt placed a philosopher in the light falling from a dormer window, and the first Gothic accent in El Greco's art). This schema acts like a sieve, keeping back what belongs to it amongst the forms of the art museum and those of nature likewise. It assimilates these elements and elaborates them, under the influence of a creative impulse upon which deliberate selection has only a superficial effect. However, the final sifting process retains but few of them. For the schema becomes style only when it has segregated a coherent, *personal* whole. Often the artist has to expel his masters from his canvases, step by step; sometimes their hold on him remains so strong that he has as it were to insinuate himself into odd corners of his picture. Thus he gives glimpses of his personality in marginal details or in backgrounds until the day when he finds himself, becomes alive to his discoveries and isolates them. Thereafter it is across these discoveries that he filters

RHEIMS (13th CENTURY): THE LAST JUDGMENT (DETAIL)

living forms, and a true personal style emerges. Sometimes death intervenes between the discovery and the world it was evoking. The sculptor who made certain women in the Rheims *Last Judgment* might well have been capable of adding that note of poignant innocence peculiarly his to the simple plainsong of the *St. Modesta* and *The Synagogue*. It may happen, too, that the artist, blind to his discovery, lets his genius slip

by, as others let their chance of happiness slip by them. Many anonymous canvases in our art museums owe their life to such discoveries and the passing centuries have focused ever more light on these passages, while dimming out the parts without survival value. Here the filter has not come into play; we do not find the happily inspired passage developing into a whole picture—whereas in the masterworks of great artists we almost always find that details of the pictures of their youth have blossomed out into whole pictures. Thus, though we are often told that all Fauve pictures have a family likeness, the fact is that a Derain of the Fauve period also resembles Derain's future work and a Vlaminck of that period points to the later Vlaminck.

A happy fluke is but an accidental masterpiece and style, unless it be more than a casual encounter, does not justify a claim to genius; for it must be patiently, persistently, sought for and steadily built up. Genius thrives on what it *annexes*, not on what it merely encounters. Thus that amazing Signorelli at the Louvre had no sequel in Signorelli's art—but Rembrandt's birds are always brown. The natural world is rich in suggestions—of color, line and the form he "is after"—to the artist who seeks for these in nature; provided that he seeks for them not in view of a synthesis of diverse elements but as great wellsprings, with their accumulated waters, seek the course they are to follow as a river. Under these conditions the part played by living forms can be immense; Delacroix's vast "dictionary" emerges out of limbo When Delacroix spoke of Nature as a dictionary he meant that her elements were incoherent (or, more accurately, that the way in which they are assembled, their syntax, is not that of art); it is the artist's task to pick out amongst them what he requires. The cleavage with the past which leads him to seek to surpass or to destroy the works from which he took his start, and that schema thanks to which the break takes place, serve to elicit forms from the chaotic profusion of the visible. But, though he extracts from this profusion whatever serves him for modifying his earlier works, he succeeds in this only because he uses those earlier works as taking-off points. To climb, he builds his stairway step by step, and imposes order on the world through the very process of creation. It was, doubtless, when he noticed that a meditative look comes over a face when the eyelids are lowered that a Buddhist sculptor was moved to impart that look of meditation to a Greek statue by closing its eyes; but if he noticed the expressive value of those closing eyes, it was because he was instinctively seeking amongst all living forms for some means of metamorphosing the Greek face. In fact the reason why the artist studies living forms so intently is that he is trying to discover, in their infinite variety, elements that will enable him to impose a metamorphosis on the forms already possessed by art—such as eyes that can be closed. There is a rich hoard in the cavern of the world, but if the artist is to find the treasure he must bring his own lamp with him.

SIGNORELLI: THE BIRTH OF ST. JOHN THE BAPTIST (DETAIL)

It was because the candid sensuality of the Greek figure offended the Buddhist sculptor and because he was seeking for that as yet unknown expression of himself which came, later, to be named serenity, that he discovered the meaning of those lowered eyelids. While both Rembrandt and Claude Lorrain found in sunset a congenial means of expression, Claude found his in a cloudless sky, and Rembrandt in a stormy sky cleft by a sudden gleam of light; and these two skies are as different as the two languages of art that sponsored them. Ingres advised his pupils to isolate and then depict the elements of ideal beauty, and to prove their talent by welding them into an harmonious whole; thus a perfect armless body called for a perfect arm—which must not be a creation of the imagination. The student's first duty was to "filter" the visible world in terms of the ideal of classical beauty; then in terms of what was needed to complete his work in progress. The artist looks at the world through the hole left by the unfinished section of his jigsaw puzzle. For the classical ideal of beauty we may substitute some other value—but it is always through this hole that the artist looks, much as a man who has lost his key looks around him for some implement with which to break open his door.

Those dainty cockle-shell whorls in the hair of antique statuary, the rippling locks of the Gandharan Buddha and Christ's twisted coil at Rheims are not in themselves significant; but their carved or painted volutes serve as its means of expression for an art that attracts them like a magnet drawing up iron filings mixed in a heap of dust. Egypt and Byzantium, where the human predicament was expressed by gestures very different from those of Rome and those of the seventeenth century, required a different kind of line. Like a rhythm that has not yet found the melody to go with it and like the schema of a great artist during his first, tentative phase, they cast about for forms and scenes of a special, transcendental nature. That strange array of sleep-walkers which Egyptian art conjures up before us conveys a craving for eternity no less effectively than the Assyrian hordes of warriors and wild beasts express the spirit of combat. Yet it was neither the wild beast (which Barye also carved), nor the warrior (painted by Horace Vernet, too) that expressed Assyria's torture-haunted soul; this was expressed by the Assyrian *style*—and that style found a better vehicle in the forms of lions, executioners, and the like, than in those of women.

Just as Athens discovered the artistic value of a perfect breast, so the barbarian artist discovered the hawk's beak, the claw, the horn, the fang, the skull, the death's-head grin. Whereas Greece brought into the world the radiant dawn of the smile, Mexico concentrated on the death's head, which was to become the Aztec hatchet. That generalized interpretation of the world which we call a style begins by giving the artist's way of looking at the world a special trend, which in the end he supersedes. Thus everywhere we find the creative artist using the

forms of nature, not as models, but with a view to quickening or completing his own forms, and for him the visible world is no more than the most copious repertory of suggestions available. "If I wanted to paint battle pieces, "Renoir said, "I'd always be looking at flowers; for a battle piece to be good, it must look like a flower piece."

No doubt when he goes for a walk in the country Braque often takes his latest still life under his arm, but this is not because he wants to check up on its truth to life, but because the countryside may suggest to him color relations that will improve the picture. (A country walk in the opposite direction to Corot's, who always "went home to finish off" his landscapes.) The story goes that one day when Cézanne was picnicking in the country with some friends and a collector, the latter suddenly realized that he had dropped his overcoat somewhere on the way. Cézanne raked the landscape with his gaze, then exclaimed: "I'll swear that black over there doesn't belong to nature!" Sure enough, it was the overcoat. "So now we know how Goya gets his black," he remarked with a smile in which no doubt there was a glint of irony. But the blue of *Les Lavandières* is certainly in nature—and so are the lobsters' claws which Bosch gives his devils. It is on reality that the painter's eyes open, and are shut. When the human face has become estranged from the faces of the gods, the artists slowly discover new gods—and often enough discover them on men's faces.

In some of Corot's landscapes we find something seemingly foreign to painting, and almost indefinable; it is as if in that calm morning light a memory of childhood had found expression, and it sets us dreaming of some far-away, immemorial Arcadia. No doubt Corot was extremely sensitive to such golden moments; but obviously, to enjoy them, he needed only to go for a walk in the forest. But he did more than enjoy them, he painted them, and this was because they roused in him a creatively *fertile* emotion. They were not merely what are called "good subjects," they were sources of exaltation—that creative thrill felt by the artist when he sets eyes on certain landscapes, certain figures, rich in intimations. Even the painter who claims to be a fervent devotee of Nature does not exclaim, when looking at a picture, "What a delightful scene!" but, when looking at a landscape on which his choice has fallen, "What a delightful picture!" Cézanne did not love the Montagne Sainte-Victoire as a mountaineer might love it, nor yet as a mere observer. That eternal *youngness* of mornings in the Ile-de-France and that shimmer—like the long, murmurous cadences of the Odyssey—in the Provençal air cannot be imitated; they must be conquered. A latent harmony between a certain scene, a certain moment and some elements less easy to define set Corot and Cézanne in as it were a state of grace; the ideal "subject," whether it be a stone, the Château Noir, or the Passion, is that "subject" which gives a painter the most vehement desire to paint.

The homelier poetry of familiar objects played this part for Chardin; the languid afternoon light for certain minor Dutch painters; sunset for Claude Lorrain; darkness teeming with august forms for Rembrandt; torchlight or lamplight for Georges de Latour. These hypersensitive moods of the great artist are not due to chance; the artist is always looking out for them. Perhaps, indeed, what we call inspiration can be traced to its source. There is a certain type of far-eastern scene —a straggling row of huts, a monstrous temple, huddled on the bank of some huge, lugubrious river—which seems ever to fan Conrad's talent into flame; an Indian atmosphere that does the same for Kipling; a furtive stir of figures in darkness or the dusk (a setting akin to Rembrandt's) that does the like for Dostoevski. Then there are Stendhal's high places, Shakespeare's skulls and ghosts, Leonardo's youths, Goya's tortured victims. For some reason the smell of apples helped Schumann to compose, yet apples obviously played no part in his music, into which we should have been more inclined to read an obsession with darkness, had he had one. Corot's painting was influenced in the same way by the morning light, which, however, he embodied in it. The picture is a means for "fixing" the emotion, and the emotion for the creation of the picture. If the artist is on the look-out for these stimulating visual experiences, it is in order to put them to the service of his art. All the same these stimuli are not indispensable. Corot did not integrate his genius at Mortefontaine, but by painting models who meant so little to him that he made of them not portraits but "figures."

What had Ingres in mind when he said that "only the masters of antiquity can teach us how to see"? That the artist looks at what he most admires? But the objects of his admiration often belong to the realm of the imaginary—whether gods or women or even landscapes. Egypt had no exclusive preference for cataleptic monsters, Islam for ornamental foliage, or Delacroix for historical scenes; nor are dishes of fruit the modern painter's substitute for angels. "Nature" has undergone a steady transformation, progressing from Poussin's classically composed scenes, by way of Turner's dazzling effects, to the landscape pure and simple, then to the landscape as a starting-off point. In fact Nature has come to figure more and more in painting as the painter's prestige and autonomy have increased, and it is for the greater glory of the artist, not that of the gardener, that it has won an ever larger place in the art museum. Thus those interminable discussions of such questions as "Has or has not Rembrandt's *Flayed Ox* the same value as his *Homer*?" stem from a confusion of ideas. We all agree that the portrait of a captain is not necessarily superior to one of a lieutenant, and it is equally true that Rembrandt painted his flayed ox in the same way as he painted Homer—and that some of our moderns would paint Homer on the lines of a flayed ox. When Rembrandt, equaling as he does the greatest modern painters, transfigured a butcher's stall or the lowliest face, the

reason was that whatever lent itself to this transfiguration stimulated his genius—of which, however, the *Supper at Emmaus* and *Homer,* too, may well be a more direct expression than would be a still life. Thus there is no point in trying to decide whether a subject has a value *per se,* but it is well for us to know that Giotto set more store on his *Visitation* than on *Justice,* Rembrandt on *Homer* and the *Supper at Emmaus* than on the *Flayed Ox* or the *Haunch of Meat,* and Michelangelo on *Night* than on his *Bacchus;* whereas Chardin set more store on a housewife than on *Fêtes galantes,* Manet on a lemon than on mythological scenes, Renoir on flowers than on battles, and Cézanne on the Montagne Sainte-Victoire and his apples than on anything else whatever. Like Cézanne's pipe-racks, like those surprising bouquets in El Greco's pictures, Rembrandt's Christ pervades, if latently, all Rembrandt's œuvre. Whether he depicts gods, monsters, heroes or apples, the artist begins by painting what enables those whom he admires to assert their mastery and then paints what enables him to assert his own; as for the world of men, he asks of it only what will fill out the lacunae of his private world.

It would seem that one day Tintoretto when musing on the art of painting, perhaps as it was exemplified in Titian's works, had a sensation that something was lacking. Not that he thought it was not Christian enough, or not dramatic enough—merely to make it more Christian or dramatic would take him nowhere. For forms are not a *rational* expression of values any more than music is. We see at once that Fra Angelico's celestial colors breathe the very spirit of Christianity, but though the Christian feeling in those of the Villeneuve *Pietà* is no less evident, they come as a surprise—it needed a painter of genius to discover them. Thus, too, the obvious expression of joy is the smile, which indeed symbolizes it; nevertheless Pheidias expressed joy not by the smile but by the rhythm of the Panathenaic procession. Nor, until the Venetians had shown the way, was it easy to imagine how a landscape could be voluptuous. Even the significant expressions of faces were often happy *trouvailles* and their efficacy in painting (as in the novel or on the stage) is often due to some quite unpredictable form of representation. It is not a matter of logic; most of Stendhal's mistakes when he talks of painting are due to his cult of logic. Even in that ultra-emotional art of the cinema pictures have been made in which the producer, when he wishes to express grief, replaces tears by a look of dazed despair. To do duty for the extra arm he needed for carrying big loads, man did not invent an extra arm, but the wheel of the wheelbarrow; thus when the artist wishes to "express" the world, he discovers and employs a system of *significant equivalences,* which a few years or centuries later comes to be taken for granted. Tintoretto discovered one by one the means of effecting the metamorphoses he was aiming at (as Balzac discovered those which enabled him to advance from Walter Scott to *Le Père Goriot*); that is to

say the means of imposing his personal schema on those of other artists. But all he thought, when contemplating the Titians he had so much admired, was "No!" An emphatic "No," since for every painter of genius there exists a truth, his very own, in painting.

The artist is far from being the man he feigns to be when he quits his easel and goes to the café, and in this respect he resembles the priest who goes to play at bowls when the service is over. His truth does not belong to the realm of the demonstrable; it is a matter of faith. If asked "Why do you paint in this way?" he can only answer "Because it is the right way." And that "rightness" may not be perceived till many years have passed. We do well to remember El Greco's remark when he visited the Sistine Chapel: "Michelangelo was an excellent man; a pity that he did not know how to paint." (Yet he had copied Michelangelo!) And Velazquez' remark when he looked at Raphael's work: "I don't like it at all." And another remark of Velazquez, this time à propos of Titian: "He has invented *everything*!" The great painter is a prophet as regards his art, but he fulfils his prophecy himself, by painting. The truth that was Van Gogh's was for him a plastic absolute towards which he constantly aspired; for us his truth is what his pictures signify as an *ensemble*. The truth of the classical painter is a concept of perfection and it is not the truth of the world of visual experience nor that of the artist's vision, but the truth of painting *qua* painting. Little did Gauguin care if the Tahiti beach was pink or not; or Rembrandt whether the sky above Golgotha was really that of *The Three Crosses*; or the Master of Chartres whether the Kings of Judah were really like his statues; or the Sumerian sculptors whether Sumerian women were like their effigies of Fertility. Indeed for many artists the most self-evident reality is merely an appearance, a mask, a lure and, as compared with the noble aspirations of the soul which only the highest art can satisfy, an earthbound solace of the eyes.

What was Hals aiming at when he painted *The Governors of the Haarlem Almshouse*? Psychological expression? But we should be very wrong if we confused mere "character study" with the passionate resentment that lay behind that canvas. Hals aimed at making a canvas that would "kill" all others; his own, to begin with. The impression that Hals has here renounced the glowing colors of his earlier palette is misleading; behind *The Governors of the Almshouse* glow the *Archers* like an unseen conflagration just below the rim of the night-sky. In his wrestlings with the angel of his past his one desire is, like Van Gogh's in *The Crows*, to outdo himself, to go yet farther. What genius but is fascinated by that Ultima Thule, with its challenge that makes Time falter? Can he but achieve that *ne plus ultra* of painting, this pauper who has just been granted "three barrowsful of peat per annum," this beggar who knows that his models will see no more in his ruthless brushstrokes than the tremblings of a senile hand, will have avenged

FRANS HALS: THE GOVERNORS OF THE ALMSHOUSE (DETAIL)

FRANS HALS: THE GOVERNORS OF THE ALMSHOUSE

himself on the all-powerful yet despicable world that sits to him as an act of charity—by forcing on it immortality!

In the case of many moderns from Goya down to Rouault this "truth" of which we have spoken is not merely obvious; it sums them up. Yet was it less of a summing-up for Rembrandt, whom it brought to destitution; for El Greco, who countered Philip II's rejection of his *St. Maurice* by pushing his style still farther; or for Michelangelo who boldly snubbed the Pope; or for Uccello who persisted on his lonely way, undaunted by the Florentine masterpieces? When the Governors of the Almshouse commissioned him to paint their portraits Hals knew all the tricks of painting that would enable him to keep the wolf from the door. He was over eighty, and very soon a debit note was to figure in the daybook of the Haarlem Municipality: "On account of a "hole" in the Great Church for Mr. Frans Hals, twenty guilders." But all his life he had painted with a stubborn independence that heeded nothing but the truth that was in him; he was impervious alike to poverty and wealth, anguish and peace of mind. A truth that was inexpressible in any language but its own language of forms; that truth which is no less self-assured in successful than in "pariah" art, for we find it in Poussin as in

Van Gogh, in Racine the courtier as in Rimbaud the vagabond or Villon the footpad. It engenders, in the case of Goya, monsters; in that of Rubens, the portraits of his children.

This truth sets out to convince, by an outspoken affirmation. Even the sculptor of the Acropolis passionately affirmed his interrogation of the scheme of things. We must not let ourselves be misled by the self-imposed isolation of the moderns, their submission to adversity; retreat into the desert and martyrdom have always been the prophet's lot. For the glory of God, no doubt. But of *what* God, in this connection? Not nature, but painting. For the artist, painting is a world apart, in which ecstasy and the absolute commingle, like a love now crossed, now satisfied, and in this realm of art the universe is brought into harmony with the painter. Though it is evident that neither El Greco, nor Hals in his last phase, nor Goya sought to conjure up a world that was "rectified" like that of the Greek sculptors, their painting bodies forth a universe of which they are the masters. Hals incorporates in his private universe the "Governors" who form part of that outside world which has brought him so much suffering; Goya (by means of his style, not by mere portrayal) incorporates in his universe the evil spirits haunting him. Confronting *his* "Governors," Hals feels no qualms; vis-à-vis his Christs, El Greco is the Christian he fain would be; so long as he is painting Saturn, Goya is free—as, *per contra*, Fra Angelico was free once he had expelled all traces of the devil from his pictures. Truth for the artist is his painting, which frees him from his disharmony with the outside world and with his masters.

Though his vocation has come to him under the aegis of another's genius, it gives him hopes of future freedom, if also an awareness of his present servitude. Hardly has he broken away from the passionately servile copy than he sets about incorporating the master's schema. But he soon understands that interpreting the world in another man's language also involves servitude, of a kind peculiar to the artist: a submission to certain forms and to a given style. If he is to win through to his artistic freedom, he must break away from his master's style. Thus it is against a style that every genius has to struggle, from the early days when he is dimly conscious of a personal schema, an approach peculiar to himself, until he attains and voices the truth that is in him. Cézanne's architecturally ordered composition did not stem from dissatisfaction with nature as he saw it, but from his dissatisfaction with tradition. For every great artist's achievement of a style synchronizes with the achievement of his freedom, of which that style is at once the sole proof and the sole instrument. What differentiates the man of genius from the man of talent, the craftsman and the dilettante is not the intensity of his responses to what he sees, nor only that of his responses to others' works of art; it is the fact that he alone, amongst all those whom these works of art delight, must seek, by the same token, to destroy them.

V Thus we can see how far the master is from being regarded as a model. That word "school" in which the idea of training is yoked uneasily to the idea of a line of research followed up in common by several artists (sometimes it means that Giulio Romano was a disciple of Raphael, sometimes that Gauguin and Van Gogh were friends) suggests that artistic creation follows a process quite different from the one we discover when studying the life-work of great artists. This is due to the classical aesthetic prevailing at the time when there was believed to be an absolute beauty which could be attained by sitting at the feet of the great masters and learning their methods. Before this period there had been only the workshops (*bottegas*), and the idea of "teaching art"—not a particular branch of art and a needful minimum of technical procedures—arose only when the eclecticism of Bologna took the place of the particularism of the *bottegas;* when painting had come to the end of its discoveries in the field of representation.

Sometimes it happens that in a much-favored period, cultural evolution and a sudden change of values may lead several artists to strike out simultaneously in new directions. When this happens, some individual discoveries are pooled, there is a give-and-take of a complex order (as is the case today with the technical discoveries of film-producers). The schools which then arise have an air of Romanticism, not at all that of our evening art classes. It is obvious that Tintoretto, Jacopo Bassano, El Greco, Schiavone and Veronese are not imitators of Titian who failed to attain his genius; of El Greco's companions all that can be said is that they did not make so conspicuous a break as his with the past. By the Venetian School we mean all those painters who at the beginning of the sixteenth century decided that a picture must be more than a drawing with colors added to it, and they achieved their end by using certain procedures different from those of Leonardo; the Venetian School was much more than a graduate class of Titian's pupils.

No painter worthy of him was shaped by Michelangelo, Rembrandt or Goya, and Leonardo's teaching, extraordinarily skillful though it seems to have been, gave the world only artists of the second rank. When Raphael's brief life ended he had no less than fifty "disciples"; nothing remains of them. In the style of decorative art prevailing in Venice some have thought to see the heritage of Titian. It is this style (combined with the effect of repeated coats of varnish) that creates an illusive kinship between the harmonies of Giorgione (and Titian himself) and Tintoretto's strident or poetic color, the dazzling coruscations of the art of Veronese. Certainly, had it not been for Titian, this style would not have arisen. Nevertheless, it owes less to him than is commonly believed, and more than is admitted to other painters. When a tapestry-like fresco of the period is discovered, bearing no artist's name, is it of Titian we think automatically? All the minor paintings of the great Venetians keep to this style of decoration, which tends to mask

their genius rather than to bring it out. The thick contour-lines characteristic of the decorative figures is employed very differently in the big compositions. In our Museum without Walls the miscellany of large canvases (often of a decorative nature) in the Academy of Venice is replaced by a single room containing nine pictures: on the first wall Titian's *Shepherd and Nymph* and *Pietà*, and Giorgione's *Tempest;* on the second, Tintoretto's *St. Augustine healing the Plague-stricken* and the Vienna *Flagellation;* on the third, the brightest Veronese and the most complex Bassano; on the fourth (to the exclusion of the Spanish canvases), El Greco' *St. Maurice* and the London *Christ driving the Traders from the Temple.* These pictures can give us a truer idea of what the "school" of Venice really was—and perhaps tell us much about what painting really is. Also if in an adjoining room we added Rubens' *Philopoemen* and Velazquez' *Venus* we would, perhaps, understand still better that the genius of Titian and Tintoretto did not consist in their common talent for adorning rooms and that their fraternity was in many respects more like hostility; the San Rocco *Crucifixion* has no more affinity with Titian's *Pietà* than the *Burial of Count Orgaz* with Bassano's *Adoration of the Shepherds.*

In his last phase Titian, who lived to a great age, followed up paths at which he had merely glanced in earlier days. Painters were not called on to rediscover what he had discovered (of far-reaching consequence, since he destroyed the classical supremacy of line); but they sometimes harked back to the original sources of his discoveries—to Bellini and especially to Giorgione—though the lessons they drew thence were not always the same. It was the younger men who relied on him most directly, but to all alike, if to each in his own kind, Titian's art brought a liberation; the living artist freed their hands as classical antiquity had freed those of the men of the Roman Renaissance. Once given his freedom, each of them answered the same call with his own voice. For we must remember that schools can exist without having leaders; the School of Paris has none, and Manet, though he opened the way to a new freedom, was not the master of Renoir or Degas or even Monet. Like that of Paris, the schools of Venice and Florence were concerted movements of attack on moribund significances.

Thus every great school is the response of a brilliantly endowed generation to a changed outlook on the world, the discovery of a new significance—as is proved by the fact that along with each school there emerges a "period" taste and, to some extent, a way of living congenial to it. The School of Paris functions today as both a school and an arbiter of taste. Such tastes bring out the difference between a mere disciple and an heir, between an Aart de Gelder and a Tintoretto; the former clings to the past and tries to perpetuate it, while the latter is inspired by the world that is coming to birth; the former seeks to implement his master's message by resembling him, the latter by *not* resembling him. The break that Tintoretto (at San Rocco) made with Titian

TITIAN: PIETA OF THE ACCADEMIA, VENICE (DETAIL: THE VIRGIN)

TINTORETTO: ADORATION OF THE MAGI (DETAIL: THE VIRGIN)

may not be so spectacular as Titian's break-away from Bellini, yet it was of the same order.

Schools, in the sense in which we have been using the term, are often confused with great painters' studios. Art history is concerned with the sequence of the former, not of the latter; for the schools give the masters their true successors, whereas the studios produce imitators. From the time of the art of decoration by way of which the Tuscans of the Trecento perpetuated Giotto's forms (as Byzantine forms had been perpetuated over many centuries) up to the days of the London version of *The Virgin of the Rocks*, almost entirely painted by de Predis, those who worked in a great artist's studio were essentially craftsmen. When our art experts use the term *œuvre d'atelier*, they mean a work done in the master's studio under his direct supervision, to which sometimes he has added the finishing touches (we have a modern parallel in color reproductions sponsored by the painter). Studio training involves the utmost fidelity to the master and produces the replica, whereas the school leads to a break with the master and its product is new masters.

The reason why studios and schools tend to be confused together is that over a long period they overlapped and intermingled. Thus the "workyards" of the cathedral sculptors were schools inasmuch as we perceive in them the styles of different masters and their supersessions by new styles; but they were also *ateliers* or studios in the older meaning of the term. The artists worked in teams and the amateur painter (as

SCHOOL OF FRA ANGELICO: THE ARRESTING OF CHRIST (DETAIL)

SCHOOL OF FRA ANGELICO: THE ANNUNCIATION (DETAIL)

we would call him) was necessarily rare in days when each artist had to manufacture his own colors and technical procedures were more or less closely guarded secrets. Botticelli, who while admiring Filippo Lippi aimed at surpassing him, began, as a matter of course, by entering his studio. Artists who are united by a bond of deeply felt emotions, sharing the same dissatisfactions and dreams of better things tend, especially when living and working together, to form a school. How many frescoes formerly attributed to Fra Angelico were actually painted by his pupils! At the Convent of San Marco we can distinguish the master's hand from the craftsman's; it is less easy to decide what is Fra Angelico's in some *œuvres d'atelier* whose execution he supervised, with the result that the attribution to him of certain works as famous as *The Flight into Egypt* has been (quite legitimately) questioned, and that of *The Annunciation*, though its value is not questioned, withdrawn from him. During periods when artists are anonymous the "inspired" pastiche

FRA ANGELICO: ST. DOMINIC

may go far—indeed if the master himself has superintended its making, the line of demarcation between it and original works is often hard to trace; yet it is never a Jordaens who paints a *Helena Fourment* or a Lucas *The Shootings of May Third*—or a de Predis a *Monna Lisa*.

Undoubtedly an *œuvre d'atelier* may command no less admiration than a work by a master; as is the case when we know little, or nothing at all, about the master in question, and the style itself plays the part of a creative personality. (Perhaps we would admire Aeschylus less were we acquainted with his precursors.) We do not admire a fine work of a high period as a mere feat of skill, but as being an original creation; if an epigone is to strike us as a great artist, he must be alone in revealing to us the significance he has usurped. But whatever our admiration of the follower, it cannot survive discovery of the work of the true creator; thus the prestige of the great Assyrian bulls has sadly dwindled with the discovery of Sumerian figures which relegate those once-famous bulls to the level of the statues on the Place de la Concorde.

Great schools are collective schisms, like nascent religions or, more accurately, heresies. The prophet finds disciples amongst those who were waiting for a prophet; he transforms their dissatisfaction into action or into contemplation, just as certain masters reveal to other great artists their right to freedom, and sometimes set their feet on the path that leads to it. The pundits of academicism and the studio will not hear of a break with the past and, when they see signs of one, they fulminate. Eclectic though it sometimes is, the academy always claims to sponsor some vanished art, one around which a myth has deliberately been built up; thus Pheidias was never so much praised as during the period when not a single statue by him had been discovered. But though Annibale Carracci doubted if it were possible to equal the genius of Apelles, whose work was known uniquely by the descriptions given of it by classical writers, he had no doubt that Raphael and Titian could be "improved on." In his view the elements of a style were not *organically* knit together, and art history was a record of technical advances. And presently classical aesthetic—like all anti-historical aesthetic—was to imply that the pastiche, if carried to perfection, might rank as a form of genius (though this raised awkward problems, since it involved reference to an original). Anyhow it was not positively denied that a brilliant seventeenth-century sculptor might be able to turn out an *Apollo* superior to the Belvedere *Apollo*. In our forefathers' time the historical factor bulked little in deciding whether preference should be given to an Old Master such as Michelangelo, or to Girardon. When Largillière saw *The Skate* and *The Buffet* he said to Chardin: "Those Dutchmen were great masters, I quite agree. Well, now let's have a look at *your* pictures." "But," Chardin replied, "those are my pictures." "Ah, yes?" And, quite unabashed, Largillière continued his inspection, approved of

Chardin's standing for the Academy, and when the time came voted in his favor. Recognizing that the *Portrait of M. Bertin* made by his pupil Amaury Duval was faithful to the original, Ingres actually consented to sign it. But we cannot accept his signature. We admire a Greek archaic work, a Khmer head or a pier-statue only if we believe them to be authentic. A ring on the foot of one of the Parthenay *Kings* showed that the figure was a forgery; would it have become genuine for us again, had that foot been amputated? We do not object to a picture's changing its maker (several Latours were ascribed to Le Nain, several Vermeers to other Dutchmen), but we will not tolerate its changing its period; we do not mind a Rembrandt looking modern, but resent a modern picture looking like a Rembrandt. We are ready to proclaim that we would not admire *The Three Crosses* less, were it anonymous. Anonymous, perhaps, but what if the etching—less obviously the work of a genius—were a forgery?

There is a curious ambiguity in our attitude towards artistic creation, but it is not the theoretician who throws light on it; it is the forger.

VERMEER: THE GEOGRAPHER (DETAIL)

No modern forger can hold a candle to Van Meegeren, and that famous *Supper at Emmaus* is well worth studying piecemeal. Let us begin with the disciple on the right. Here we have the portrait of a portrait, that of *The Geographer* and *The Astronomer* (the painter himself?) treated in Vermeer's technique but also in that of a Caravaggio school (the "Pensionante de Saraceni," for example). The disciple on the left forms a mere patch in the composition and may perhaps owe something to the *Soldier* in the Frick Collection. To copy the still-life portion was almost as easy as copying the dottings on the bread or Vermeer's monogram. There is no model for the figure of Christ in the work of Vermeer, who only portrayed Him once, at the close

of his adolescence, in the Edinburgh *Martha and Mary* (assuming, as is not certain, that this is by Vermeer). Thus here the forger had a relatively free field and it is difficult to judge how "faithful" he was in his infidelity. The woman is taken over, rather clumsily, from *The Procuress*. The color of the other figures is obtained by the procedure commonly used by counterfeiters in the field of sculpture. They try to strike the right note by amplifying some detail of their victim's work. Here, noticing as we all do, the very frequent association of blue and yellow in Vermeer's work, and having hit on exactly the right pigment for the former, Van Meegeren employs this blue-and-yellow color-scheme as the basis of his picture, remakes a costume with that of the *Young Girl*, another with her turban, adds a pitcher,

VAN MEEGEREN: THE SUPPER AT EMMAUS (FORGED VERMEER)

and adjusts the secondary tones—those of the woman excepted—to this color harmony. The most vulnerable and "tricky" element in Van Meegeren's enterprise was the drawing, and he turned the difficulty by his color, reducing his "Vermeer" to that special color harmony which is the first thing we think of when this artist's name is mentioned, and offering us, so to speak, a symbolical Vermeer. But it was a subtly modernized Vermeer, and this is why the picture appealed to a wider public than Vermeer had ever reached, triumphed over Rembrandt in the "Four Centuries of Painting" Exhibition, and was reproduced on calendars. The color given the woman must have led even the most uncritical observer to assume either that this figure was an afterthought (or had been entirely repainted) or else to attribute to Vermeer the prescience of an art as yet unborn; just as Ossian's poems would have been indeed prophetic in this sense, Mac-

CARAVAGGIO (?): THE SUPPER AT EMMAUS

pherson's obviously were not. Here, too, Van Meegeren was definitely taking risks. The composition is that of Caravaggio's *Supper at Emmaus*, but "centered" as a photographer would say; that is to say, it has squeezed into a smaller frame. The result is that the frame cuts short the figures adjoining it, depriving them of the air which would otherwise have enveloped them. Which alone should have aroused suspicions, for this procedure does not belong to seventeenth-century art; and it, again, would have been "prophetic"—had it not been a fraud.

During his trial Van Meegeren put forth a bold but futile plea; he claimed to rank beside Vermeer in his own right, and when confronted by his *The Child Jesus and the Doctors*, which he had not yet camouflaged, the experts were startled at discovering the face of a film star doing duty for that of Christ.

But the ordinary forger does not aspire to vie with the painter of genius he is counterfeiting; he tries to imitate his manner, or, when dealing with a period of anonymity, his style. And it is this latter which affects us so compellingly that all that bears its stamp passes as art. The Parthenay *Kings* were forgeries but they did not lack style, and for a work to have style, it is enough for it to have struck deep roots in the past. As regards mutilations and especially the patina of time, only when these are really due to chance and age do they appeal to us; though the patinas laid on by Chinese forgers are highly skillful imitations, once we know them to be false, our interest ceases. Verdigrised bronzes charm us because in them the work of time is not less visible than that

VAN MEEGEREN: JESUS AND THE DOCTORS (DETAIL)

of art; they have undergone a metamorphosis due to oxydization. A famous counterfeiter had the idea of weaving would-be medieval tapestries whose designs were a patchwork of authentic fragments: he filled the museums with them, then, on the point of being unmasked, committed suicide. Who could have impugned the Gothic style of these remarkable concoctions? In every line they belonged to the Gothic style—but to Gothic style alone, not to Gothic art.

It might seem that the *Supper at Emmaus* could anyhow claim a place beside some panel of a minor Dutch artist, as much influenced by his master as Van Meegeren was "influenced" by Vermeer. But that is out of the question: Van Meegeren's picture is *dead*.

Moreover the *Supper at Emmaus* is not less dead in the eyes of the academic artist than in those of the abstract modernist. Yet seemingly we are here confronted by a dilemma: if this picture is worthy of admiration, how can it be less so simply because we now know it was painted not by Vermeer but by Van Meegeren? And if it is not admirable how came it to be so much admired?

None of the modern theories of art takes into account our attitude towards the forgery; none, indeed, has the relative coherency of the classical approach to this problem. The feeling given us by a skillful forgery is not so much contempt (the bust in which Bode thought to see a work by Leonardo is far from being despicable); it is a sort of *malaise*.

One reason for this is that our idea of art, whether we wish it or not, is bound up with history; sometimes, too, with geography, when the historical factor does not come into play. A bogus Polynesian wood-carving is not less dead for a connoisseur of Polynesian art than is a bogus Raphael for a connoisseur of academic art. We wish a work of art to be the expression of *the man who made it*. So indeed does the accomplished forger; the night-club art of Van Meegeren was not given "the Vermeer look," whereas the bogus Vermeers have come to look like genuine Van Meegerens. That *Supper at Emmaus* was, shall we say, the expression of a ghost. The work of art which we call "success-ful' "—a feat of artistry—achieves significance only in a culture in which it stands for an essential value (and the *Supper* is not a success in this sense); its whole point goes once it is segregated from the classical aesthetic whence it took its rise. Rembrandt's and Van Gogh's greatest works are far more than "successes"; in fact that term could apply only to the rectification of a master in pursuance of a recognized aesthetic or some form of eclecticism, and if one tried to rectify Rembrandt one would risk turning out work like Bonnat's. We have already indicated, with regard to sketches, the confusion that arises from the idea that they might have been perfected; the only admirable sketches are those which would be weakened or completely altered by being finished; indeed they are not "finishable." Like Rembrandt, Cézanne deepened his art in terms of the basic principles of that art and no

other; if there were any question of rivalry with other artists, it was a rivalry on the plane of genius, he was not taking part in a competition governed by set rules. The notion that an absolute perfection, triumphant over time, exists—and it is to this that the artist aspires—is very different from the notion that he seeks to "rectify," guided by his reason or his taste, an art that has not found itself harmoniously; nevertheless the two notions are interrelated, the first serving to justify the second. Today the cult of classical tradition has come to mean a nostalgic yearning for that serene and spacious art which reappears in several styles—not necessarily midway in their courses: in Van Eyck's *Adam*, for example—and gives us an immediate impression of the artist's complete mastery of his medium. Whereas the imitator of classical art pins his faith to a continuity of forms, the true classical masters sponsor a continuity of conquest, each advancing on lines appropriate to his personal genius. Thus they discover forms which only *afterwards* are found to be perpetuating a tradition. Even a sincere desire to keep to the forms that tradition has consecrated does not overpower the artist's personality; Ingres' drawings are no more like Raphael's than the Valpinçon *Baigneuse* is like the Farnesina *Galatea*. The spirit of continuity always operates through metamorphoses, the idea of perfecting any previous art form is completely foreign to it. Raphael is not a perfected Perugino; he is Raphael.

Never has a great artist made himself the equal of another great artist by deliberately modifying his art, by imposing a thought-out stylization on what was initially an emotive drive, or *vice versa*. "The thing is to combine the movement and the shadows of the Venetians with Raphael's drawing"—thus the Carracci. Did they propose to portray Venetian figures by some other kind of drawing? The movement of the figures is inseparable from the Venetian linework, and the true heirs of the Venetians were men who gave little or no thought to "improving on" them: Rubens, Velazquez, Rembrandt. In the last analysis this idea of "perfecting" means a rectification like that of the anthologist. But the anthologist who makes cuts in *Booz endormi* did not begin by writing it; nor did Victor Hugo cut it. The life of genius is an organic whole like that of a plant or a human body.

All this we can feel, though we rarely stop to analyze it. We ask of a genius that he should be a creator of forms. There is no question of giving the palm to this man or to that; Giorgione's genius does not diminish our admiration of Titian's, and we know that only the work of art itself can tell us if it stands for mere pastiche or fraternity of inspiration. Many of the world's greatest artists were not so squeamish about the actual execution of their works as we have come to be (with our fetish-worship of "the master's hand"); Leonardo saw no objection to having the London *Virgin of the Rocks* painted by de Predis, Verrocchio to having Leonardo paint the Angel in his *Baptism*, Raphael to employing

DE PREDIS: PANEL OF THE VIRGIN OF THE ROCKS

others to paint several passages in *The School of Athens*.... But Leonardo made haste to break free from Verrocchio. He knew that his genius lay in his capacity for inventing forms and if someone had insisted on reminding him that *The Virgin of the Rocks* was de Predis' work, would simply have replied, "Look at the others." What damns *The Supper at Emmaus* (and would damn it equally even if the painter had made a bigger success of it) is essentially that its forms do not represent a conquest of anything, there is no invention behind them. Supposing, however, Van Meegeren had faked-up to look like an ancient work a picture that was at once unlike the work of any known master and not a mere anticipation of some later art (an impossible feat, most probably), that picture would have impressed us far more than *The Supper at Emmaus*. We expect the work of art to be an expression of the man who makes it, because genius means neither fidelity to appearances nor a new combination of old forms; the original work of genius, whether classical or not, is an *invention*.

And in this matter of invention the time factor cannot be ruled out. True, the history of art records many "parallel inventions,"

CARAVAGGIO: ST. JEROME

and the metamorphosis of forms they sponsor is sometimes all the subtler for the fact that the painter has retained many elements of his predecessors' procedures, if not of their art. But he employs them *for other ends* and alters their significance. This, perhaps the most revealing phase of creation, is perhaps also the easiest to analyze.

It well may be that there exists no more striking illustration of this process than the transformation of Caravaggio's red-and-black pictures into the night-pieces of Georges de Latour.

Caravaggio's renown was at its height when Latour became acquainted with his art—which was to affect the whole of Western Europe. If an artist's influence is to be assessed by the extent to which his themes and colors are taken over by another, rarely has there been

an influence so great as Caravaggio's on Latour. Latour took over from him his card-players, his musicians, his mirror, his Magdalen, his St. Francis, his Crowning with Thorns (which became the "Christ of Pity"), his St. Jerome, his way of playing off red drapery against dark backgrounds, and sometimes even his particular shade of red; also he employed a very similar lighting. Yet, despite all these borrowings, he ended up with an art almost the antithesis of Caravaggio's.

In Caravaggio we have a rebel far more in earnest than Cellini; his realism was, for him, a gospel. He believed that he could impart more veracity to New Testament figures by giving them the faces of his friends than by idealizing them. True, Gothic painters and sculptors had already discovered the expressive power of the individualized face; but Caravaggio, no doubt deliberately, went much farther in this direction and his characters are frankly ordinary people. The reason why he failed in what he aimed at when he gave the old man holding up Christ's body in the *Deposition* and his St. Peter in the *Crucifixion* the aspect of old working men, was that he had to combat, not an emotional abstraction (as did Gothic art when breaking with Romanesque abstraction) but an art of idealization, and merely individualizing figures was not enough to overcome it. We can measure Caravaggio's failure when we compare his robust carpenters with Latour's St. Joseph and, looking but a little ahead, with Rembrandt's Saints. He aimed at breaking away from both idealization and Italian Baroque, but he did not break with either as thoroughly as he supposed. His genius lay elsewhere. The characters in his big

DETAIL OF THE FOLLOWING PAGE

CARAVAGGIO: THE DEPOSITION FROM THE CROSS

CARAVAGGIO: THE MADONNA OF THE OSTLERS: THE VIRGIN

canvases gesticulate; in the *Deposition* the uplifted arms of the woman on the right seem foreign to the picture (some have supposed, but wrongly, that these arms were inserted later); in the *Vocation* St. Matthew is hardly in the same style as the gamblers; St. Anne's face in the *Madonna of the Ostlers* is not a portrait but at once a replica of the Madonna's face aged by the painter's imagination and a traditional Italian face treated realistically.

His art seems to anticipate Courbet's in its handling of color, sumptuous, thickly laid in, but without emphatic brushstrokes; to aspire, far more than Courbet's, to a photographic realism never achieved

CARAVAGGIO: THE MADONNA OF THE OSTLERS: ST. ANNE

in practice; and also to aim at both that still-life realism whose offspring was the chromo, and at an aggressive realism, a passionate—almost, perhaps, Dostoevskian— counterblast to that Baroque idealization whose deeper significance Caravaggio rejected but which he never actually abandoned. It was his feeling for the monumental style that enabled him to create some magnificently simplified figures, inconsistent though these were with his realism, with the Baroque tendencies persisting in his art, and often with his dramatic handling of light; for the lighting alone seemed to him capable of giving his realism the grandeur after which he always hankered. Moreover, his art retained a very

379

MANFREDI: ST. JOHN THE BAPTIST

Italian strain of lyricism, grandiose if turbid, which is illustrated by his *David,* in which Goliath's head is said to be a selfportrait, and was to come out more strongly in those who directly imitated him, finding brilliant expression in Manfredi. In some characteristic works, as in *The Madonna of the Ostlers,* we find an exaltation of the individual as a "character," which he inherited from Mantegna's old women, and which, though typically Italian, was to reappear in most of his Northern imitators. He died at the age of forty-six. Had he lived, would he have succeeded in imposing unity on his art? It was left to Rembrandt to discover that lighting which, wresting humble figures from the darkness, invests them with eternity.

Less than towards Latour this art pointed the way towards Ribera. In Ribera's work there is a harsher but less individualizing realism, a discreeter use of gesture, a less subtle but surer handling of dark colors, a fervid austerity seconded by well-controlled lighting, and by these means Ribera achieved—though at the expense of Caravaggio's sumptuous effects and his genius—the unity his master had perhaps disdained.

RIBERA: ST. JEROME IN PRAYER

GEORGES DE LATOUR: THE NEW-BORN CHILD

When we turn to Latour after Ribera we cannot fail to see how diametrically opposed was the whole outlook of the former to Caravaggio's, despite apparent similarities. Latour never gesticulates, and in an age of frenzied agitation he dispenses with movement. We do not even pause to wonder if he was capable of rendering it well or not; for he simply ignores it. There is nothing of Ribera's histrionics in his art which partakes, rather, of the nature of the Mystery-Play, and has the slow rhythms of a rite. It is unlikely that he knew the work of Piero della Francesca. But the same devotion to style gives his figures that immobility, timeless rather than primitive, which we find in the Nouans *Pietà*, in Uccello, sometimes in Giotto. Whereas in the Baroque gesture the arms are usually spread out far from the body, the gestures of Latour's figures bring them in towards the body—like those expressing meditation or contained emotion. Rarely do the elbows of his figures quit the torso, nor are the fingers of an outstretched hand extended.

The figures placed on the margin of a group seem drawn towards its center as strongly as those in a Baroque picture seem to strain away from it. This might suggest the influence of sculpture; but the sculpture of his day gesticulated like the painting. And Latour's figures, while their effect of weight exceeds that made by Persian "verticalism," are redeemed from heaviness by a curious translucency.

Every great painter has his secret, that is to say the means of expression of which his genius usually avails itself. Latour's color is never subordinated to the model, indeed it conjures up the model. His palette seems always built up around *red*, and it is from red he modulates to gray, from red to yellow ochre, from red to brown or black; only one of his surviving canvases is really multicolored. On the face of it this palette closely resembles Caravaggio's in his various *St. Jeromes* and *St. John the Baptists*. Yet who could attribute Latour's *Prisoner* to the painter of the *St. Jerome* in the Galleria Borghese? No doubt a definite point of contact can be seen in the gamblers of *The Vocation of St. Matthew*,

CARAVAGGIO: THE VOCATION OF ST. MATTHEW

whose novelty, when first revealed to the public, drew so many visitors to the Church of San Luigi in Rome. But there were similar points of contact in pictures whose handling differed greatly from this mural's. Like the Flemish artists Caravaggio laid on his color thickly, whereas the texture of Latour's is almost transparent; the opacity of the former is justified by the strong lighting, the transparence of the latter by its sheen. Caravaggio aims at effects of relief, not so much sculptural as "modern" in their treatment, and prefers to use a thick impasto, which he models; Latour, even when he indulges in warm, rich colors as in his *St. Joseph the Carpenter* (a work exceptional in his output and, oddly enough, recalling Cousin's *Eva Prima Pandora*), does not aim at relief; far otherwise, he avoids it. Only a genius like his could work the miracle of conjuring up a Caravaggio become translucent. His secret was that of rendering, in a seemingly naturalistic treatment of his subject, certain volumes as though they were mere surfaces, *in flat planes*. This is why he has so much in common with our modern artists (and with Giotto) and is so utterly different, *au fond*, from Caravaggio.

Caravaggio was a firm believer in "the real," and the emotional tension of his style at its best comes from the fact that, while his talent bade him cling to the reality before him, his genius urged him to break away from it. The function of his shadowy backgrounds is to exalt his light; of his light to stress that on which it falls; and what it falls on to

CARAVAGGIO: FOLIAGE AND FRUIT

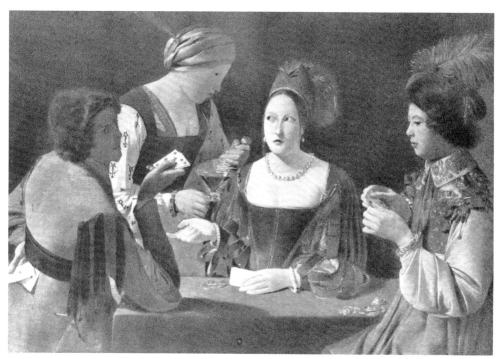

GEORGES DE LATOUR: THE CHEAT

become more real than the real, to accentuate relief, character or a dramatic situation. He began by painting still lifes in which each apple seemed to be trying to be rounder than a sphere, and he achieved a type of painting which sometimes stood to what went before as high relief stands to low relief. Latour's discovery, on the other hand, was that of a surface which, while not excluding three-dimensional volume, often merely suggests it instead of rendering it; which presents a mass *that does not turn upon itself*. We find this surface again and again in Latour's work: in the woman painted side-face in *The Cheat*, the women in *St. Peter's Denial*, the woman on the left in *The New-born Babe*, the man with the moustache in *The Adoration*, the hat in the Stockholm *St. Jerome*, the leg and arm of the Grenoble *St. Jerome*, the women in the background of *St. Sebastian*, though not to the same extent in the calligraphically treated *St. Jerome* in the Louvre (whose attribution to Latour is questionable). We find it again in the faces of the various children holding candles, in the receding, yet almost flat surfaces of the two *Magdalens*, in the child Christ in *St. Joseph the Carpenter*—here it is enough to cover up the face (over-much cleaned) to change the whole style of the picture—and almost everywhere in *The Prisoner*, where the band of red at floor level is a wholly abstract passage. Caravaggio paints

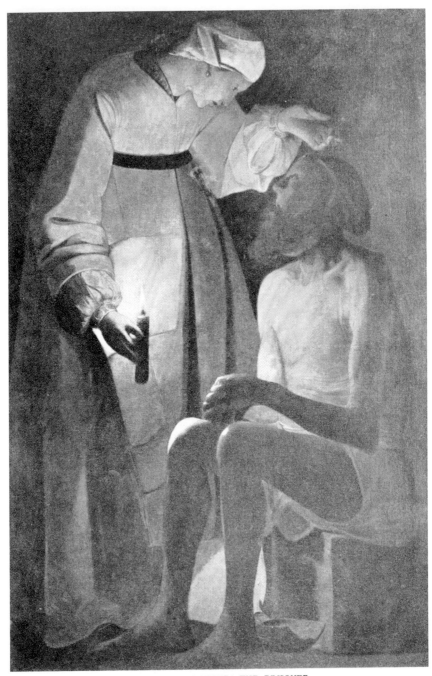

GEORGES DE LATOUR: THE PRISONER

GIOTTO: THE PRESENTATION (DETAIL)

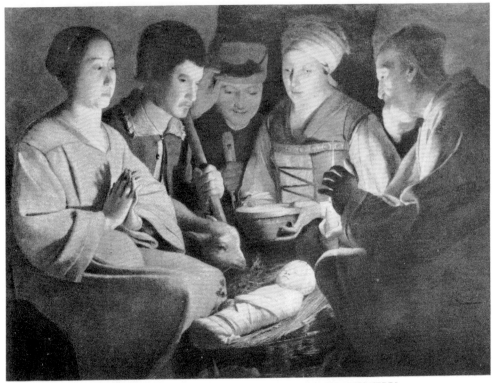

GEORGES DE LATOUR: THE ADORATION OF THE SHEPHERDS

figures in the middle distance (for which he has an aversion) just like the foreground figures; Latour paints them, even if only slightly in retreat, quite differently, with a light, though clean-cut calligraphy, usually in profile—a profile without a trace of modeling. The gray figure of the man with the stick in *The Adoration of the Shepherds*, immediately on the right of the Virgin and above the Child (who looks as if he had been drawn by Fouquet), shows how effectively he can cut free from the real and how he goes about it.

These flat passages adjusted to three-dimensional volume (as they had been, though by other methods, by Giotto and Piero della Francesca and were to be by Cézanne) indicate a very different outlook on painting from that of Caravaggio. We can easily imagine a copy *à la Cézanne*, not to say Cubist, of *The Prisoner*, but not one of *The Deposition*. An amazing art indeed—when we consider the part the lighting plays in it; for it is his handling of light that enables Latour to create planes without relief and modeling.

GEORGES DE LATOUR: ST. JOSEPH THE CARPENTER

Some have said that, like those contemporaries of his who specialized in night-pieces, Latour gave close study to the chemistry of light. But fascinating as is his use of light, it is not, strictly speaking, correct—as we should see if we reconstructed the scenes of his pictures and photographed them. No doubt torches play a large part in his compositions, but has a torch ever diffused that even glow which shows up masses and does not bring out accents? The bodies in *St. Sebastian mourned by St. Irene* cast shadows, but only those the painter requires; and in the foreground of *The Prisoner* there is not a single shadow that is not put there with a purpose. Caravaggio's lighting usually comes from a stray beam of sunshine, often the ray piercing one of those small high-set windows he was so fond of, and it serves both to make his figures come forward from a somber background and to bring out their features. Latour's pale flames serve to unite his figures; his candle is the source of a diffused light (despite the clean-cut rendering of the planes) and this light, far from being realistic, is *timeless* like that of Rembrandt. Great as is the difference between Rembrandt's genius and Latour's, there was much in common in their poetic vision of the world. Neither set out to copy the effects of light, but both artists indicate them with just enough accuracy to secure the spectator's assent, the credibility needed in their evocations. Balzac, too, found that he could convey the fantastic most convincingly by drawing on the real. Moreover such elements of reality as Latour employs are often rendered with remarkable precision—the candlelight, for example, glowing through the fingers of the child Jesus in *The Carpenter*—and his light creates an all-pervasive harmony, an atmosphere of other-worldly calm.

This light "that never was" creates relations which likewise are not wholly real between forms. The difference between Latour's daylight scenes and his night-pieces is far greater than we realize at first sight, even when the colors are akin, and even when the pictures are almost replicas, as in the case of the Stockholm and Grenoble *St. Jeromes*. The difference, it may be said, lies merely in the special lighting of the night-pieces. But are Latour's small sources of illumination intended merely to act as lighting? The light in works by Caravaggio and his school serves primarily to isolate figures from a shadowy background. But Latour does not paint shadowy backgrounds; he paints night itself—that darkness mantling the world in which, since the dawn of time, men have found a respite from the mystery of life. And his figures are not isolated from this darkness; rather they are its very emanation. Sometimes it takes form in a little girl whom he calls an angel, sometimes in wraithlike women, sometimes even in the steady flame of a torch or a small lamp—for even these are ministers of darkness. Latour's world seems enveloped in that vast night brooding on sleeping armies of long-ago, whence the lantern of the night-patrol called forth, step by silent step, unmoving forms. Slowly in that crowded darkness

GEORGES DE LATOUR
SAINT SEBASTIAN MOURNED BY SAINT IRENE

a small light kindles and reveals shepherds gathered round a Child, that Nativity whose humble gleam will spread to the farthest corners of the earth. No other painter, not even Rembrandt, can so well suggest this elemental stillness; Latour alone is the interpreter of the serenity that dwells in the heart of darkness.

In his finest works he invents human forms attuned to that darkness. It is not in sculpture that his art culminates, but in the statue. That the women in *St. Sebastian mourned by St. Irene* and *The Prisoner* look like nightbound statues is due, not to their density or weight, but to their immobility: that of apparitions of the antique world· arisen from the slumbering earth, each a Pallas of compassion.

This is why, though Latour took over so much from Caravaggio, he took from him nothing that went to the making of Caravaggio's genius or his own. It was no more difficult then than it is now to distinguish the various elements which met but rarely fused in Caravaggio's pictures. His so-called monumental figures (which, however, do not make us think of statuary) are quite out of keeping with his realistic figures, and one feels that a disciple with a stronger feeling for harmony might well have sought to achieve unity of style in his own work by eliminating the realistic figures and, if possible, transforming the *Death of the Virgin* into a seventeenth-century Nouans *Pietà*. Caravaggio's disciples, however, while retaining these figures, also retained both realism and gesticulation. One detail in Gentileschi's *San Tiburzio*

GENTILESCHI: SAN TIBURZIO (DETAIL)

GENTILESCHI: SAN TIBURZIO

is admirable; the picture as a whole is not. That curious alloy in Caravaggio's genius—seemingly, indeed, inseparable from his personality—was taken over with all its impurity (but without his genius) by his imitators. Latour did not extract its gold, purging away the dross. Rather, his art filtered Caravaggio's forms, though it was in no sense a "rationalization" of Caravaggio. In *The Magdalen at the Mirror* the color is exactly that of some of Caravaggio's pictures —of, for instance, the Borghese *St. John;* yet the Magdalen is unmistakably Latour, and quite unlike the *St. John.* That line of the woman's profile in *The Cheat,* that of the woman in *The Prisoner* and in the various *Magdalens*—now tracing a sweeping, all embracing curve, and now broad, blunted angles—whose only precedent was the Florenine arabesque (very different, however, because it moves less freely and serves to outline forms); that line which Caravaggio would have loathed as Courbet would have loathed it; that line which fluently adapts itself to trails of smoke and spirals, follows its ineluctable course, annexing and transforming what it can annex, destroying all the rest, and draws its nourishment from things which, seemingly quite foreign to it, serve its turn, as a tree draws nourishment from the leaf-mold at its roots.

393

CARAVAGGIO: THE DEATH OF THE VIRGIN (DETAIL)

Though of all painters' work Caravaggio's appears the least co-
herent, it has a coherency of its own, not to be broken down, whether
by skill or even by genius. Latour took over only its themes, which
he could have dispensed with, and certain color combinations, which
he transformed. He began by isolating a cycle of it (which indeed
holds our interest chiefly thanks to him, for Caravaggio's black-and-red
compositions are not his most rewarding works). What the "symbolic"

GEORGES DE LATOUR: ST. SEBASTIAN MOURNED BY ST. IRENE (DETAIL)

Latour into whom three centuries have crystallized the real Latour might have been expected to take from Caravaggio was surely his broadly and simply rendered figures, such as the weeping woman in the foreground of *The Death of The Virgin* and faces such as that of Mary in this picture. He equaled them, but what did he take from them? Precisely nothing. In the last analysis Latour's secret is all that *separates* the women in the *St. Sebastian* from those in *The Death of the Virgin*.

395

Far from ensuring Caravaggio a place in an unbroken lineage, Latour created a plastic world of his own, without borrowing a single element of that world from Caravaggio, who indeed had not the least inkling of it. True, he employed his colors, forms and a certain kind of light—just as he took colors, forms and a certain kind of light from reality—but in both cases he wholly transformed them. Thus Caravaggio's art, all realism, dramatic effect and sumptuous splendor (also, perhaps, an indictment of the scheme of things), became in Latour's hands a far more delicate art, pensive and crystalline, which weaves a mysterious music, reconciling man with the divine. Nowhere do we see more clearly the operation of that metamorphosis which, like a bloodstream, pulses throughout art's long history. Latour used what he took from Caravaggio as Christian architects used the pillars of pagan Rome: to build churches "for the greater glory of God."

The same path led Poussin to become the Poussin we know, with this difference that his proximate masters were inferior to Caravaggio and those he chose out for himself were greater. We know that he believed in an "art of all time" in which he wished to secure a place. Superseding the styles of illusionist realism, he set out to recapture *style* in its classical, abiding sense and to replace the passing pleasure of the

POUSSIN: L EMPIRE DE FLORE (DETAIL)

POUSSIN: THE ASHES OF PHOCION (DETAIL)

senses by what he named delectation. He realized that Raphael gave
the art of antiquity a new lease of life not with his Roman profiles but
with the least "antique" elements in *The School of Athens*. Thus he
tried to find for painting an equivalent of the antique line; but,
starting from bas-relief, he ended up with landscape. He began, like
Latour, by demolishing the naturalistic style by using flat planes,
abstract passages which determine the lay-out of the picture—those flat
planes to which, from Piero della Francesca onwards, renewers of the
"grand style" have so often had recourse. Such of his pictures as have
been cleaned, especially the *Bacchanal* in the London National Gallery,
show how modern this art which set out to be traditional can look, and
why there once was talk of his "astounding brio." Cautious French
cleaning, which revives above all the highlights, reveals on his misted
canvases all that likens him to Corot rather than what he has in common
with Cézanne. But if we wish to rid his art of the decorative elements
which mask it and to discern the crystallization it stands for, we have
only to confront with the works of his Venetian and Bolognese contem-
poraries his *Bacchanal*, the *Massacre of the Innocents* and the women on the
right in his *Rebecca*, and likewise to confront with any work by Raphael
the rediscovered *Crucifixion* (in which nothing Christian remains), the
Berlin *St. Matthew* and the celestial steeds in *L'Empire de Flore*.

POUSSIN: THE CRUCIFIXION

FILIPPO LIPPI: THE NATIVITY (DETAIL)

Had he belonged to the other race of painters, his "conquest" would have been the same. To all appearances Botticelli took after Filippo Lippi no less than Latour after Caravaggio. To begin with both artists were affected by the prevailing taste of the period: a taste for exquisite decoration, like that of the goldsmith and the miniaturist, which wove ringlets into the arabesque, spangled Minerva's robe with flowers and bathed centaurs, cherubs and trees in the mellow light of a late-summer afternoon. (It was this which led Leonardo to say of Botticelli that "he did not know the first thing about landscape.") Lippi had done more than any other to propagate this taste. The calligraphy due to this curious blend of Christianity, mythology and the technique of the jeweler was shared by all the Florentine masters, but as their *lowest* common measure. As for what was more vital in their art, we need only compare some of Botticelli's and Lippi's later works to see how, under this veneer of decorative effect, the former metamorphosed his teacher. This would have been detected long ago were it not that so many of Lippi's works were painted in collaboration with Fra Diamante and Botticelli's are so often of small dimensions.

Lippi was essentially an ornate Masaccio, lacking his greatness and intent on charm—the famous Florentine grace and that other, frailer and perhaps more Gothic grace which we associate with Baldovinetti. He painted a flounced and furbelowed Salome and inserted in his *St. John Preaching* and *Nativity* those

399

dots and black underlinings which only his addiction to the decorative prevents from seeming modern. He was a refined colorist who took not a little pride in his refinement. The horizontal moldings on the wall in *Herod's Feast* (in the Duomo of Prato) are pink because Salome's dress is pink, and this hue imparts their values to the yellows of the serving-maids and the violet of the figure with the clasped hands. Lippi's far from realistic color might surprise us more were it not put to the service of a glamour so familiar to us, that of Siena. Indeed sometimes we see him as the painter through whom Siena, foundering in a lore of legends, makes her escape towards the glory that was—Florence.

FILIPPO LIPPI: THE MADONNA OF THE UFFIZI

Botticelli stood to Florentine taste as Tintoretto to Venetian taste; he liked it, made no effort to resist it, yet escaped, as Tintoretto did from Venice, one reason being that true art always eludes the nets of contemporary taste. The misconception regarding him would not have become so firmly rooted, had not the earlier, lesser Botticelli owed so much to Lippi's *Madonna* of the Uffizi, had the Pre-Raphaelite movement never been and, above all, had the dimensions of the last Botticellis been those of the *Primavera*. Otherwise it would have been clear that in the multiple scenes (whose composition really consists of several compositions) of the London *Nativity* or *The Miracle of St. Zenobius* there is nothing left of Lippi and we have a painter very different from the one whom Ruskin so much admired, and one who is still awaiting due appreciation. In Botticelli we have a painter who "distorts" almost as much as El Greco and whom his disregard of depth differentiates

BOTTICELLI: THE NATIVITY (DETAIL)

FILIPPO LIPPI: THE NATIVITY (DETAIL). REVERSED PHOTO

BOTTICELLI: THE NATIVITY (DETAIL)

BOTTICELLI: PRIMAVERA (DETAIL)

above all from the masters of Baroque. The torsion he gave his line—no longer with a view to decorative or representational effect, but for its own sake—led up (as did his predilection for figures in flight) to this *Nativity*. It is well worth while to study piecemeal the details of this panel; not only do they throw light on the angels in *The Birth of Venus* and the woman quaintly nibbling a twig in *Primavera*, but they also show that Botticelli's treatment of nude figures (such as his Venus and his "Truth" in *The Calumny of Apelles*) runs counter to the common conception of his art. It is not mere chance that Northern painters have been so much impressed by these nudes; knots of fine-spun lines enwrap their shining smoothness, much as the knotted muscles ripple on some of Michelangelo's seemingly unfinished figures. Lippi, the monk, slept with his nun without a qualm, but Botticelli burnt his early pictures (we must not forget how many of his "pagan" works are

BOTTICELLI: THE MUNICH DEPOSITION (DETAIL)

lost to us for this reason). The kiss given Christ, the Virgin and the near-by figure in the Munich *Deposition* are not only symbols of the last phase of Botticelli's art, but throw light on his early phase; perhaps the Florence awaiting Savonarola, no less than that later Florence trying to forget him, took thought for more than garlands of flowers.

Insects' tools are the limbs with which they are equipped from birth and which they cannot change; but genius puts forth unseen hands which, throughout the artist's working life, are ever changing and enable him to extract from forms, both living forms and those immune from death, the makings, often unlooked-for, of his metamorphosis.

VI This is why the relations between art and history often seem so puzzling; they might seem less so, if we ceased regarding them as uniform and invariably decisive.

"Locomotives have absolutely nothing to do with art," Ingres angrily protested. But they have much to do with the artist who, less than a hundred years after Ingres made that remark, sees civilization imperiled and is acquainted with twenty times as many pictures as were known to the master of the Villa Medici. Though according to the culture in which his lot is cast, the artist may view himself as a Christian first and foremost and only secondarily as a member of his social group, or *vice versa* (and "Monsieur Ingres" as the French painter was always styled has a very different ring from "Raffaello Santi"), he belongs necessarily to his time, for the obvious (yet often disregarded) reason that he cannot belong to any other. To escape from his age he would need not only to will away the contemporary "present" (this he can do by an effort of the imagination) but to change the past as well. It is patent that different civilizations and even great epochs of the same civilization have not the same past, and that their respective pasts bear on them differently. The artist in revolt against his age often tries, not to belong to another age, but not to belong to any. But this is equally impossible. What is really meant by "an art that stands outside Time"? An art that employs for conquering the future the time-proved methods employed by the Masters of the past? But we cannot reduce these methods to any unity of *forms*. We know that Greek art is no more and no less eternal than Gothic art. Is, then, this timeless art one which is somehow related to that spark of the eternal immanent in man? That element may well exist, but our contemporary civilization dares not lay claim to it; it is, rather, struggling to discover it. Civilizations that claimed to possess it possessed it only on their own terms. True, the Parthenon, Chartres Cathedral and the Capitolium of Rome command alike our admiration; yet the eternal element in man is humbler and lies deeper than these dazzling feats of human genius. Moreover, though exceptionally lasting works of art exist, there is no more an eternal style than there is a neutral style. The man who asserts the eternal supremacy of this style or that is obviously trying to place himself outside history (but though he can imagine an art existing outside history, he cannot imagine a period outside time), or else immuring himself in a chosen period, that of the masters he admires. In whose eyes, save perhaps in his own, could the art of Ingres appear to be "of no time and of all time"? Why, even a nude by him, *La Petite Baigneuse* for example, can be dated at the first glance! Who could think it contemporary with Raphael's nudes? Starting out from David and claiming descent from Raphael, Ingres *reverses* the trend of Raphael, who started out from Perugino; since he, Ingres, is consciously an archaist, whereas Raphael was, for his own times, a modernist.

RAPHAEL: GALATEA

INGRES: LA PETITE BAIGNEUSE

David, who did not lack shrewdness, realized from the first—when he set eyes on Ingres' would-be primitive portraits in flat planes—that here was not an ally but an enemy. Ingres thought to give the same responses as Raphael, but he did not give them to the same questions. It may be said that Raphael himself cultivated the "antique." But there was nothing antique about *Baldassare Castiglione,* the portrait Ingres copied with such pious fidelity. "I do not belong, I refuse to belong, to my renegade century." Thus Ingres; but Raphael never dreamt of anyone's wanting to belong to a century other than his own. Inexorably the tidal flux of Time has imposed a metamorphosis on both alike. Valéry cannot be like Racine; he can but equal, or echo him. There is no "dubbing" a style.

The artist seems to us all the more conditioned by his age because artists of cultures that have passed away appear to have been so strongly conditioned by their respective periods. Actually, the perspective in which we see the past fosters a curious illusion as to the historical background of works of art.

Thus Gothic forms loom large in our notion of art history and the vague picture conjured up by the words "The Middle Ages" owes as much to them as to all the rest we know about the period; indeed the whole climate we attribute to the Gothic world derives almost entirely from the Gothic forms that have come down to us. The more remote the period, the more pronounced is this illusion. Hellas as we imagine her—despite our knowledge of her history and despite Greek tragedies —is irrevocably associated with the Greek statues; it was these statues which gave Taine the odd idea that the Greeks were so often naked! Though for the Egyptologist Egyptian art is but one facet of the life of Egypt, everybody else visualizes Egypt as a reflection of Egyptian art. How could Gothic fail to seem to us an expression of the Gothic world, since that world comes to life for most of us by way of Gothic art? After the lapse of centuries the works of the artists of a period (especially if their names are unknown) tend to coalesce into a uniform whole, because of all they signify in common. Yet are the masters of Vézelay and Gislebert d'Autun really so much alike? Is there not as great a difference between the Toulouse sculptors, those of Moissac and Beaulieu and that enigmatic artist coming to the fore under the name of "the Master of Cabestany," as between Matisse, Rouault and Picasso, due allowance made for the individualism of the age we live in?

No doubt our former readiness to accept the historical factor as paramount was due to a distaste for classical aesthetic. Thus the "inspired moment" was spared the discredit attaching to the race and *milieu.* It was agreed that "art expressed values"; but the fact that art as Ingres conceived it is by no means eternal does not warrant the conclusion that values always produce their own art as an apple tree its apples. Piero della Francesca and Andrea del Castagno belong to

ROUSSILLON (12TH CENTURY): DETAIL OF THE TYMPANUM OF CABESTANY

the same moment of Florentine culture, yet they express it in opposite ways; their drawing, their color and the spirit of their art were wholly different. Are the values the artist expresses imposed on him by his period and his training? In that case they would be the values expressed by the previous generation—the very values that creative art destroys. Doubtless when, owing to the combined effects of metamorphosis and the lapse of time, a period of history has coalesced into a whole, it seems to have been expressed by its art, and its art appears to symbolize it; yet the artist cannot ignore the **idiosyncrasies** of what it is his mission to destroy and is thus obliged to take from the forms of the immediate past those which harmonize with the new values that are coming to birth or called for by the future. But no one—least of all the artist—is fully conscious of these values. The painter does not express them as he would express the nature of some distant land he has visited, but, rather, as he would try to express death, were he suffering from some fatal disease. In fact he is not expressing something he has experienced; he is responding to a call.

The notion that great works of art teem with the future (stress being laid on the notion of "promise" this word has acquired) is due to the outlook of our civilization, which tends to regard itself as a conquering civilization; but great works are, in practice, less bound up with the future in this wider sense than with a limited, immediate future. Praxiteles, no less than Olympia, foreshadowed what was going to follow him, but what followed him was a defunctive art. Sometimes, too, such works —*The Lady of Elché* perhaps, the Villeneuve *Pietà* undoubtedly—seem to be more an inspired interpretation of the present than pregnant with the future. Our tendency to confuse the trend of art with the march of history, though often helpful where a style is concerned, can be misleading when we apply it to an artist or a picture. In a general way the evolution of Christian forms keeps step with that of the Christian faith, but the highest forms often steal a march on spiritual evolution; Goya keeps in line with history as regards his themes, but his vision anticipates the European sensibility of a later period. The initial stages of a culture seem to imply that art is always trying to catch up with history; the teachings of Christ and Buddha were obviously anterior to their expression in plastic form—indeed five centuries had to pass before the latter was triumphantly achieved. The Christian style was not built up on the art of the Augustan age but on a Roman art whose disintegration favored the requirements of oriental Christendom. The artist is no more conditioned by a past to whose forms he looks back than by a future whose spirit he bodies forth. Historical events affect him in so far as they suggest or enforce on him a new relationship with the world, and they affect art in so far as they render the forms sponsored by this new relationship visible and significant. The field of enquiry with which we are here concerned is not that of art as the

aesthetician understands it, nor is it merely that of history—and we propose to explore it somewhat farther.

Manet, Cézanne, Renoir and Rodin were contemporaries, and so too, were Fouquet and the Master of the Villeneuve *Pietà*. Thus a period does not involve one kind of expression only, but may call forth a complex of expressions as unpredictable as the individual schema of each artist. The blue of the flag in Delacroix's *Barricade*, appropriate as it is to the Revolution (the flag is put there no less for its blue than the blue is for the flag) expresses something quite different from Rubens' blue; yet who could have foreseen that a leaden-hued blue, displayed above figures in which is something of the Goya touch, would harmonize so aptly with the doom of a luxurious culture and a dawning hope, the promise of a new fraternity? Here we have an example of the seeming *irrationality* of the forms that genius discovers—as when the invention of the wheelbarrow put an end to attempts to reproduce mechanically the action of the human arm. Moreover, in their struggle against the masters who begot them, artists do not always call in the same masters of the past as allies. Goya, David and Füssli, all three answered the summons first of the impending Revolution and then that of the Revolution when its voice was growing faint, but the tones in which they answered were vastly different; the dialogue between each great artist and history is conducted *in his own language*. It may surprise us to find Delacroix, Ingres, Corot, all three Frenchmen

FUSSLI: NIGHTMARE (1782)

and contemporaries, responding in such different manners; the explanation is that they did not break with the same elements of the preceding period, nor for the same reasons—and also because we are victims of the illusion that the artist begins by becoming aware of the significance of the world and then expresses it by way of symbols. But rational symbolism of this sort no more exists than does an art independent of Time. That the significance of the world as seen through Christian eyes was of a tragic order did not necessarily involve the angularity of the Gothic figure once the world was Christianized. The lapse of a few centuries will suffice to bring out Van Gogh's kinship with Renoir (who was horrified by his painting), but not to make a Renoir of Van Gogh. A comparison of minor arts (when they are not merely decorative) with their contemporary major arts makes it clear that great significances are bound to be expressed in different ways; they belong to a realm so rich in intimations that no contemporary forms can wholly symbolize it any more than exhaust its possibilities. Greek and Chinese statues and the terra-cotta figures corresponding to them follow parallel, not convergent lines; the bear cubs in Sumerian children's tombs are quite unlike the hieratic lions. It is because no period can evoke a range of works of art commensurate with its significance that such large, uncharted areas surround even those works which seem most highly charged with significance, and alongside Raphael we have Titian and Michelangelo. The plastic expression of any given period is infinitely subtler than that of its emotions; as for the expression of a culture, we find it only when the culture is coming to birth—and, sometimes, too, once it has died. As *motifs* of the age during which the machine and Europe conquered the world we are given—the dish of apples and the Harlequin!

Thus it is less a question of an art's crystallizing around an historical situation than of the action of history on a creative process continuing through the ages. The artist's break with the forms that were his starting-off point forces him to break with their significance, and since no neutral forms exist (in other words no no-man's-land in which the artist, freed from his masters, can bide his time until he finds himself), his creative process is directed, its orientation being neither unconscious nor deliberate but specific to his personality. In painting his *Last Judgment* Michelangelo was fully aware what he was doing, and not merely illustrating thoughts that happened to cross his mind.

All art is the expression, slowly come by, of the artist's deepest emotions *vis-à-vis* the universe of which he is a part. This may explain why in social groups where religion is a living reality, it permeates even non-religious works of art, and why great non-religious works are produced only in communities which are by way of losing a sense of the divine. It also explains why the link between history and art often seems so tenuous. Though for us every work of the past is bound up with a phase of history (we know the works that followed it), every epoch

is, for itself, the present day and it dies in childbed without having seen the child whom *we*, however, know. For Botticelli the future did not bear the name of Raphael. Our feeling that a change of forms was bound to come and that the course of time forced artists to make this change is tied up with our knowledge of the historical process and of its essential rhythms. Even if the ruptures with the past which give art its vitality are not due solely to this process, they are multiplied and sometimes amplified by the great turning-points in history.

But since, owing to these drastic changes, the works bequeathed by the past are drained of their significance, the artist, too, is deprived of his taking-off point and thus art undergoes a sort of hibernation. For art is more affected by the deep underlying currents than by the tidal waves, and though many such tidal waves, sweeping away both the values of a social order and the social order itself, have marked the course of history, they do not constitute the past, whose rhythm is that of a slow metamorphosis, gradual as that of a man's life and, like it, sporadically broken by illnesses and accidents. Slow as it is, this metamorphosis is practically continuous. From the eleventh to the thirteenth century in France, from the thirteenth to the sixteenth in Italy, the relations between Man and God were all the time being modified; the same has been true, during the last three centuries in France, of the relations between Man and his environment. The proclamation of an heroic standard of morality at the beginning of the seventeenth century, and its devalorization by Jansenism; the era of seeming appeasement accompanying the stabilization of the monarchy and its slow decline; the end of the great age of Christendom; the Enlightenment, man's isolation and his recourse to political and national fraternity, the Revolution, the ascendancy of the Middle Class, the break between art and the social order—all these changes in the life of France followed in close succession between 1600 and 1900. Whereas during the last hundred years the outside world has changed more than man, man changed more than the world he lived in between 1500 and 1800.

Our study of the art of non-historical social groups is beginning to clear up the relation between the artist and history. From the fact that history and the evolution of forms invariably march side by side we are inclined to infer that the art of the ages preceding history was necessarily static. But the disharmony, due to the historical process, between the artist and the forms he has inherited is not the only stimulus to art. Whether or not the material conditions of life changed during the millennia of unrecorded time, it would seem that at least one important aspect of human development, the pre-religious, then took form and, what is more, evolved. Had it been impossible for certain faculties to enrich and remold themselves in that environment, static as it now appears to us, there would have been no evolution of the primitive religions, Egyptian art would never have arisen. It is more reasonable

to assume that an evolution of art—of that of figures, anyhow—took place outside the pale of history (or in the limbo of the semi-historical) than to endorse the curious theory that in regions thousands of miles apart, at different periods, men were visited by the same creative genius, lit on the same style (incidentally, one as highly developed as that of the Steppes and of which the Sumerian animals often look like a decadent progeny) and created those superb reindeers and bison at their first attempt. Civilizations which seem independent of time are not always independent of it to the same extent or in the same way; the Middle Ages did not resemble Egypt, slow rhythms are not the same as immobility. Even in a culture dominated by the eternal, a sculptured figure shares in the time-span of a human life, for, as in other cultures, its first appearance has an immediate and intense appeal, which dwindles with the passing years. If the sculptor creates it solely for ceremonial purposes and if, supposing it is burnt, it is promptly replaced by another made to look like it, this process of dwindling operates more slowly but no less surely. (In any case it rarely happens that races depicting living forms depict them solely for ceremonial purposes.) The mere fact that the Oceanian sculptor—perhaps the prehistoric painter, too— has to vie with a work made by a master-artist and not with the works of craftsmen modifies his forms profoundly, and it is these forms which his successors, whether tribal sorcerers or not, use as their starting points. By its very presence the masterwork invites the craftsman to make a replica, whereas it incites the artist to better it, to develop all its potentialities. For the craftsman-sorcerer merely copies, the artist-sorcerer creates. Whether partial or thorough-going, the will to outdo the past operates in the same manner whenever the artist is confronted with a given form and feels impelled to refashion it in another form. Indeed the creative impulse of the Magdalenian sculptor was not so very different from that of the Chartres sculptors, from that of Michelangelo or Cézanne.

Though this creative process has a place in history, it is independent of history. For, in so far as he is a creator, the artist does not belong to a social group already molded by a culture, but to a culture which he is by way of building up. His creative faculty is not dominated by the age in which his lot is cast; rather it is a link between him and man's age-old creative drive, new cities built on ruins of the old, the dawn of civilization, the discovery of fire.

In giving its trend now to an artist's break with the past, now to his schema, and sometimes even to his technique, history functions perforce through a man's life; Buonarotti is not Michelangelo, but if the former dies Michelangelo will never sculpt again, and if the former has an emotional experience that changes his outlook on the world, the style of Michelangelo will likewise change. After hearing Savonarola preach Botticelli burnt all the pictures of Venus he had in his possession.

The artist "filters" what he sees, but sometimes it so happens that life has "filtered" it in advance. Thus Caravaggio's lawless passions, Goya's illness, the impact of the irremediable on the lives of Hals, Gauguin and Dostoevski modified their art, even perhaps their whole idea of art. But the blows of fate that fell on Goya, Van Gogh and Dostoevski only throw a vivid light on moments of creativity into which ordinarily enter but vague gleams of less poignant and spectacular events. Since every life is a transition from youth to age, life itself obliges man to appraise even his most deeply felt emotions and beliefs in terms of a metamorphosis. Just as the rift between the artist and the period preceding his compels him to modify its forms, and that between him and his masters to alter theirs, so the difference between his present self and the man he was, compels him to change his own forms, too, in the course of his career. On the one hand, his past exerts a steady forward pressure from which he cannot break loose abruptly (thus the airman wanting to change his direction has to describe a more or less extended curve); on the other hand, that past at once brings a saturation and calls for its enrichment (even if the means to this be simplification or a new austerity); lastly and above all, it is the works of his early days which he feels he must transform. Thus the Gauguin of Tahiti amplified the art of the Gauguin of Pont-Aven—not Renoir's pictures. The painting of Titian's old age does not exemplify the intrusion of old age into life or nature or painting in general; it stands for the intrusion of old age into his own painting, and it is neither the forms of Raphael nor the rocks of Cadore but his own forms that are made to undergo a metamorphosis. To suppose that Signor Tiziano Vecellio, if he had never yet held a brush, could have managed by some prodigy of sudden skill, because he was himself and eighty years of age, to paint the Venice *Pietà* would be obviously absurd. Art is always the response to an inner voice and the most accomplished execution cannot stifle the sound of that appeal, since in his gradual ascent the panorama the artist has behind him changes unceasingly as he climbs. In the case of Titian and that of Hals it is not the same man nor the same life's work that old age has affected; since the fabric it is lighting up is not the same, the same holes are not brought into view. Yet, with all their differences, the basic rhythm of life unites in a baffling fraternity Titian as an old man with Goya as an old man, the aged Rembrandt with the old age of Renoir—indeed all western painting seems bathed in the evening glow of their last years.

The true personality of an artist takes form and emerges in his work in ways that vary greatly—according as his art is in harmony with the social order in which his lot is cast, remains outside it, or reacts against it. Goya was a sick man, and Spain a sick country. Van Gogh, too, was a sick man, but neither Holland nor France was ailing in his day. That most crushing of human situations, a sense of the irremediable, may

take many forms. In the thirteenth century it left ways of escape open.
For Villon, Cervantes, Milton, Chopin, Baudelaire, Watteau, Goya and
Van Gogh it took on the pattern of the times in which they lived, as
much as that of their individual destinies. Did we then need the
perspective of so many centuries to discover in the end that Watteau's
illness and Gauguin's gave rise to dreams, and Goya's to the indictment
of a social order; that a believer's sickness points his way to God and an
agnostic's to the Absurd? On Goya that sense of the irremediable
enforced a metamorphosis; but what of its effect on Watteau? Lives,
too, have their "period style." One can hardly imagine a medieval
preacher Christian enough to love—out of charity of heart—an ugly,
diseased prostitute, then consecrating his failing faith to art, then becom-
ing a painter of genius, and finally going mad and killing himself;
yet that was Van Gogh's life-story. Not in all periods do madness,
syphilis and epilepsy quicken art. There are no more any predetermined
forms of happiness or even of the irremediable than there are of the
significance of the world; like history, life does not predetermine forms,
but it calls them forth.

Because history bulks large in our age, we conclude it is also an age
of biography; and so it is—though for less praiseworthy reasons. For the
modern biography, besides catering to the contemporary taste for the
romantic "life-story" (a mixture of gossip and melodrama), often
sponsors as well a rather crude determinism. In the Middle Ages the
painter's very name was unknown; the Renaissance dealt with him as
it did with other celebrities, his art and his private life being kept distinct.
Our modern approach is different; we trace a connection between the
artist's talent and the secrets of his private life. Though no one goes
so far as to assert that Napoleon's tactics in the Campaign of Italy were
influenced by Josephine's infidelity, or that the modification of Clark-
Maxwell's equation was influenced by any personal experience of Ein-
stein, everyone is ready to assume that Goya's intimacy with the Duchess
of Alba reacted strongly on his painting. The present age delights in
unearthing a great man's secrets; for one thing because we like to
temper our admiration and also perhaps because we have a vague hope
of finding a clue to genius in such "revelations."
Leonardo was an illegitimate child, we are told, and obsessed by
a phantasmal vulture. Much erudition has been expended on detecting
the presence of this vulture in the *St. Anne;* yet it throws little light on
the reason why, four hundred years later, we should be obliged to seek
out that elusive emblem. This psychological "discovery" loses much of
its point when we remember that this portion of the picture (in which
the vulture is suggested by a patch of color rather than by the drawing,
and to make it out we have to mark in its outlines) was, in fact, not
painted by Leonardo, who, however, painted many similar draperies

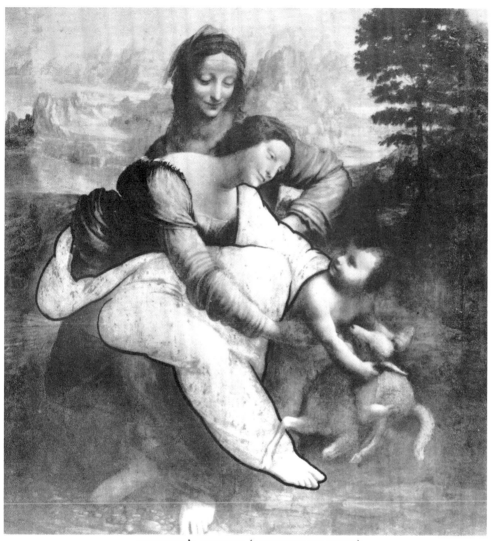

LEONARDO'S VULTURE (ACCORDING TO FREUD)

without any suggestion of a vulture's form. But that is the modern way; the small, pathetic secrets of those few men who did most to make good the honor of being man are exhumed from Time's mausoleum—with gloating satisfaction—like hapless mummies from a pyramid! Victor Hugo was obsessed by the eye, yet what interests us is not the presence of an eye in *La Conscience* but that *La Conscience* is a poem; as does the fact that the *St. Anne* is a superb creation, with or without a vulture.

How many an artist—obsessed, we shall be told, by a vulturine "familiar"—has painted without knowing it vague forms of birds of prey in works that have long since been forgotten! The idea is, they say, to get down to the man beneath the artist. So we scrape away ruthlessly at the fresco till finally we reach the plaster, and what is the result? The fresco is ruined and in hunting for the secret of the man we have lost the genius. The only biography of an artist that matters is his life-story *as an artist*, the growth of his faculty of transformation. All that does not tend directly or indirectly to enhance our awareness of his genius, by deepening our knowledge of that faculty, is as futile as it would be to try to write a history in which nothing whatever was left out.

In practice it is far from easy to decide what incidents to include in the biography of an artist. Derain, like Vlaminck, has rightly attached much importance to the day when he first set eyes on a negro mask. An artist's life is full of such encounters, but sometimes he fails to realize how much they mean to him or prefers to keep them secret. For a painter the encounter with an art of savages seemingly near akin to his own is an exciting experience; Vermeer's discovery of the affinity between a certain yellow and a certain blue was doubtless less dramatic. Though genius cannot fail to be aware of having entered its promised land, it is less sure when this happened; from the first gropings to the canvas, from the glimpse of a possible association of colors and lines to its achievement, the way is often long and devious—art is a continent whose frontiers are ill-defined. Did Latour remember the day when for the first time he replaced volumes by surfaces of a special order? Or Manet, his first discord? Yet the discovery of the means by which, after being a painter of tapestry cartoons, Goya won access to the world of *Saturn* was, even for him, no less important than the disease which played havoc with his life. That break in the line invented by Rembrandt did not determine his "Revelation," but were one or the other suppressed, though there might still be a Rembrandt, the art of Rembrandt would cease being what it is. That is why we are so eager to have at least a glimpse of the process by which, at a given moment of history, certain individual or collective elements of an artist's life led him to modify his forms in a special manner and to extract from the teeming chaos of Delacroix's "dictionary of Nature" a language at once personal and compelling

Let us, then, try to trace the career of a painter of genius near enough in Time for us to feel sure about the attributions of his works and to be able to picture fairly accurately his emotions and ambitions; yet not belonging to our epoch or subject to the bias it imposes on our judgment —an artist who passed through several styles and came in contact with several kinds of art in several countries: El Greco.

He made numerous versions of *Christ driving the Traders from the Temple* and since not only the subject but also a portion of the composition remains the same in each successive version, we can trace the way in which his art evolved. The first is one of the earliest pictures signed by him. Two others were painted after his departure from Venice and before he settled in Toledo. There is enough of Venice in the first version to show us what the Venetian school had inculcated in El Greco; and what his Roman contacts prompted him to suppress.

For a century the Italians had been crowding their compositions with ornamental elements. That decorative factor which had always obsessed Mantegna and was thought to give the work of art its quality and charm went through several metamorphoses before we find it reappearing in Tintoretto's palms. Also there prevailed in Venice a taste (hardly amounting to a style) for an angular, slightly oriental line which Tintoretto shared with Bassano and which Greco followed up. He began by taking over from it a calligraphy at once bold and flexible in which all the lines are interwoven, like seaweed on rocks, and applied

EL GRECO: CHRIST DRIVING THE TRADERS FROM THE TEMPLE (FIRST OR VENETIAN VERSION)

EL GRECO: SECOND OR ROMAN VERSION

it with striking success to the central group. To go with this he devised
a special kind of lighting, both dramatic and imprecise, involving the
tangled mass of people (of which the ragged clouds seem somehow to
form part), the statues on the walls, the volutes of the Corinthian capitals,
and the meticulously rendered figures of the children and the woman
resting her hand on the cage whose figure gives the impression of having
been added almost as an afterthought.

At first sight the second canvas looks like a simplification. Here
the lighting imposes order on the composition; Christ is in full light,
the brightly-lit elements of the nudes on the left link them up with the
woman leaning on the cage (who is treated in a less decorative manner),
while the group on the right, at the foot of the pillar, is isolated from the
luminous central figure by a patch of shadow and has been moved
farther back. The smokelike clouds no longer seem to be pouring
up from Christ's arm brandished like a torch, but are separated from it
by the horizontals of a palace. The archway, whose thickness has been

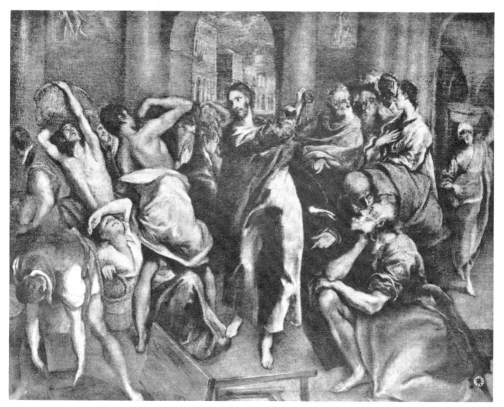

EL GRECO: THIRD OR TOLEDAN VERSION

doubled, now dominates the whole background. The statues on either side of it have gone, and so have the capitals of the pillars fronting it. The old man's basket now is empty, the cupids have become children and the changed style of Christ's garment is significant. The figures in the far room and the table have been simplified, and the chandelier has been extinguished. The coffer, the quail, the rabbits (so dear to Titian) are no longer present; the doves are no longer patches of light. The heads aligned on the extreme right (Titian, Michelangelo, Clovio and Raphael) are as deliberately interpolated, according to the Roman convention, as was the woman with the cage according to the Venetian.

Twenty years later, at Toledo, El Greco harked back to this theme; by now he had found himself triumphantly and his style was set. The scene is brought forward, "taken in close-up." Everything pertaining to the style he inherited has vanished; the pillars and the woman with the baskets slung on a stick across her shoulder are transformed; the figures in the background have been suppressed, and so has the woman

with the doves. The row of heads in the foreground is gone. If we wish to single out the elements in the other versions which did not belong to El Greco we need only note what he has discarded. The transition from his youthful to his mature art—the triumph of genius—has brought neither additions, nor observation, nor imitation.

Here there is no question of a deliberate lightening of the texture so as to make the central theme tell out more clearly; El Greco is not aiming at illusionist realism. What we see here points the way to the figures in the *Visitation* and that *Last Supper* in which the very canvas seems to throb with life. (*The Last Supper* resembles the portraits of Cézanne's gardener; why, one wonders, do those who revert towards austere styles tend so often, near the close of their career, towards that convulsed line which we are perhaps over-ready to call Baroque?)

Thus El Greco rid his canvases of the trappings of Venetian sensuality—but not **so as** to place others in their stead. In an age when the "accessory" counted for so much in art, El Greco set his face against it.

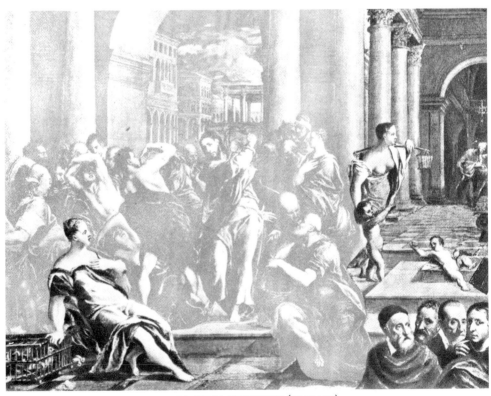

WHAT EL GRECO ELIMINATES (IN BLACK)

Now that the conventional doves were relegated to the lumber-room, what was he to paint beside the holy figures? Merely the traditional crucifix and skull, mountains, perhaps a book, a bunch of flowers, some attributes—and the wraith of Toledo. First he eliminated the elegant cupids and dogs of Italy; then from the abstract horizons and tangled groupings of his early Spanish crucifixions, from the rocky landscapes of Spain, he conjured up a Toledan Gethsemane.

Toledo itself, however, should not be overstressed; if the aspect of this city was really so impressive, why should it have needed to wait for the coming of this Greek before manifesting itself, and why did it vanish, after him, for ever? Toledo is another Marseilles, *plus* some famous edifices, and Marseilles still awaits her Greco. Then, as today, Toledo was ochre-hued; El Greco painted Toledo once only as the sole subject of a picture, and he painted it dark green. It was not a model for him, but a means of self-release.

Toledo freed him from Italy. Absurd as it would be to call his pictures ikons, we must remember that ikons were familiar to him in his youth. He was versed in the traditional art of the East and acquainted with the popular art, still widespread in the Greek islands, which combines the Byzantine will to style with a certain freedom of its own and has much in common with the painting of the Catalans and the thirteenth-century Tuscans. The view that art is no mere embellishment of the visible world was not new to him and, though he no more copied the drawing of ikons than their color, he knew that organized distortion is a legitimate method of creation.

His strong contour-lines (differing more and more from Tintoretto's) and his false highlights are utterly unlike the streaks of gold on ikons, though belonging perhaps to the same world. Toledo no doubt gave him a semblance of the Levant (of the Levant, be it noted, not of Asia or Africa); but what else did it give him? Opportunities of seeing tragic art? But whose? Coello's? An art of provincials haunted by Flanders and Italy—of three fine canvases by Morales (which actually he never saw)? No, it was he and he alone who endowed Spanish forms with those Gregorian echoes which the mere name of Toledo evokes for us today. Philip II disdained Greco and much preferred the Italian painters. There was something to be learnt from Spanish sculpture, for it refused to adjust itself to the aesthetics Italy was imposing on Europe; but from the very start El Greco went beyond its naïve emotionalism. All the same he must have detected in Spanish sculpture an outlook congenial to his own. What was more important, Romanesque and Gothic remains, so abundant in Spain, were not yet despised there, and there were traces of the Gothic manner in much sixteenth-century stone carving. In Crete, Venice and Rome where such remains would have cut the figure of intruders from "the Gothick North," he had seen few of them; here, in Toledo, they were at home.

THE CHRIST IMPERATOR OF THE TOLEDO CATHEDRAL

The supreme gift Spain made him was that of isolation from disturbing voices. A picture rises in our minds of a Rouault marooned in Peru—a self-sufficing, museum-less Peru—or of Gauguin in Tahiti. Perhaps it is easier to become great when far from great, belauded rivals!

Moreover, Spanish Christianity glowed with a flame far more intense than that of Venice. That old-world Castile we dimly conjure up today when we halt outside the grille in the Avila convent through

which St. John of the Cross, the reprobate, gave the Sacrament to St. Teresa, the suspect, was the province in which El Greco lived. He had left a city where Veronese, quaking in his shoes, had to excuse himself to the ecclesiastical authorities for the presence of dogs in one of his religious paintings. "Surely we painters can take the liberties allowed to poets and buffoons!" Whereas El Greco said to Clovio, who had called upon him to propose a stroll together and found him sitting in the dark: "No, the glare of daylight would spoil my inner light." He was not, like most of his contemporaries, a Christian merely because he had been born into that faith; he was a soul athirst for God. Toledo, we may be sure, favored the expression of his profound feeling for religion, which Venice and Rome had discouraged, to say the least of it, and with which the saints he met in the street, even if they were officially "suspects," accorded better than all those tedious gods and goddesses of antiquity. God meant for him not what He meant to the Chartres sculptors to whom He was *given,* but what He meant to votaries of the religious sects—to the saints and heresiarchs of the age: a Visitant, known in secret.

Though his coming to Spain may have been due to chance, his feeling of concord with her was not. Not being one of the Renaissance lands, Spain had no antipathy for the art of the Eastern Church. But what Spanish Gothic and probably some elements of Romanesque suggested to El Greco was not a system of forms. His nudes teem with muscles, and what Gothic artist ever painted or carved muscles? Foreshortening and soaring flight were idioms of the language that came naturally to him, and it is easy for us today to see how much there was in common between the Gothic world and his. Yet how difficult it would be to picture forms not only akin to Gothic but incorporating all the discoveries of Baroque drawing, had we not El Greco's art! Moreover, though the young Cretan deliberately migrated from Candia, a Venetian colony, to the metropolis, the Greek painter he had been became Venetian only at the cost of a "conversion"; and he became El Greco not by a return to Byzantium but through a second "conversion."

A conversion to Spanish art? But there was none at the time. Too much stress has been laid on the elongation of his figures—doubtless because this is their most striking characteristic when reproduced in black and white. When in his earliest Spanish canvases he turned away from Italy, what chiefly interested him was not this elongation (in which direction the Mannerists and even Tintoretto had gone yet farther than he); his objective was a wholly novel treatment of volumes which, had not Cézanne familiarized us with it, would still be hard to grasp. He achieved this by directing a sudden Baroque shaft of light on to the illuminated areas of the canvas and also by imparting a somewhat sculptural aspect to his figures. If none the less they break with sculpture, it is because they are built up less by the drawing than

by the painting (almost, sometimes, by the *impasto*) and also because though they exist in space they are not enveloped by it.

We see these tendencies developing in the first *St. Sebastian* and the Toledo *Resurrection* (painted two years after his coming to Toledo). They come out clearly in the figure of the man at work in the foreground of the *Espolio*, a canvas on which he also employs those almost savage brushstrokes which now seem to us so typical of Spain—though actually no other painter used them, until Goya. In *The Martyrdom of St. Maurice* he has solved the problem he had set himself. Armor had made its first, tentative appearance in the *Espolio; all* the military costumes in the *St. Maurice* are suggestive of armor—indeed Greco often seems to see in armor the perfect garment. Sometimes armor, sometimes carapaces (I am thinking of that glorious beetle he has made of Count Orgaz and the grasshoppers in his sky)—the bodies are acquiring the aspect already hinted at by Signorelli. But in El Greco's work the drawing

EL GRECO: THE BURIAL OF COUNT ORGAZ (DETAIL)

428

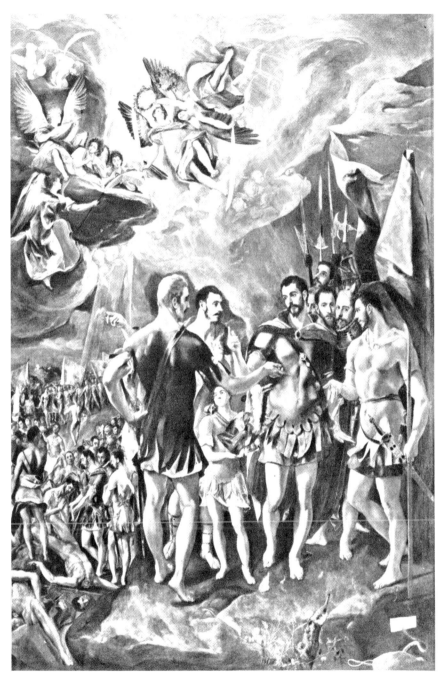

EL GRECO: THE MARTYRDOM OF SAINT MAURICE

EL GRECO: THE BURIAL OF COUNT ORGAZ (DETAIL OF THE SKY)

is bound up with the color, and both alike, instead of aiming at realism (as was the case with Signorelli), dispense with it.

The Villeneuve *Pietà* had been painted a hundred years earlier. And for a hundred years Europe had been groping for the way of rendering a scene that stretched into illimitable distance without engulfing the human figure. Just as the spaciousness of the cathedrals had not dissolved the planes of Gothic statues, so the Italian rendering of distance had not weakened, but intensified, the vivid lifelikeness of Leonardo's figures. The Renaissance artists forced the human figure to emerge from the canvas. What differentiates El Greco from his immediate predecessors, from his masters and from his own Italian works, is that, while making his figures stand out boldly, he at the same time does away with distance. And when, as in the *Last Supper*, this standing-out effect culminates in the aspect of a stained-glass window half melted in a fire, spatial recession is still suppressed. The background of the last *Visitation* is abstract, and vastly different, whatever may be said, from Salviati's schematic palaces. When did El Greco attain complete mastery of his art? When (about 1580) he painted the sky in the Louvre *Crucifixion*, a sky more like veined marble than thunderclouds and looming up behind the figures, not like infinite space nor yet recession, but *as a plane*. This plane was to persist throughout his subsequent work. Thus when we observe the tense, dynamic drawing of the *Last Supper*, of his nudes and of the *St. Maurice*, we find that the problem he had set himself was that of preserving the Baroque rendering of movement while suppressing what had led up to it: the quest of depth.

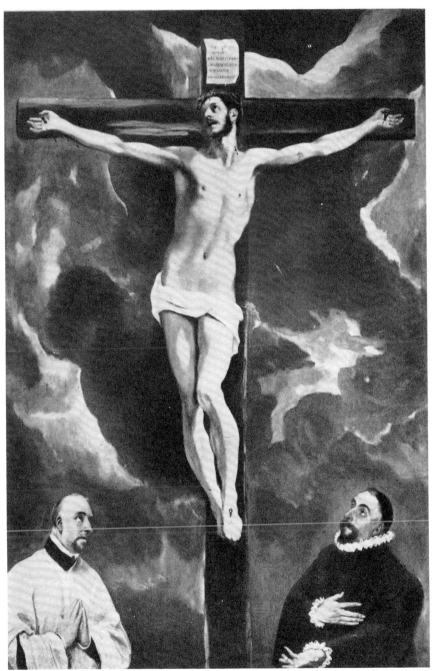

EL GRECO: THE LOUVRE CRUCIFIXION (CA. 1580-1585)

EL GRECO: THE RESURRECTION (TOLEDO VERSION)

One of the canvases that has most to tell us is the Prado *Resurrection;* especially if we compare it with the Toledo version. What could be more Baroque as to the gestures? But it is only necessary to recall Tintoretto for us to realize that what is built up by the tangled mass of bodies is not depth but a surface; and that color is not being used in a realistic way but as a means to a special kind of representation. In fact the picture is a stained-glass window, *plus* a lighting of its own and volumes. In it El Greco does not employ thick contour-lines (even those of the Venetians) but encloses figures in dark tones, whose function is like that of the strips of lead in stained-glass windows. But he is no less loyal to the oil medium he is working in than was the Chartres window-maker to his glass. It is no accident if he so persistently cuts short his line, giving his works, in the words of his visitor, Pacheco, "their look of savage sketches"; the reason being that neither his ecstatic

EL GRECO: THE RESURRECTION (THE PRADO VERSION)

EL GRECO: SACRED AND PROFANE LOVE (DETAIL)

vision nor his non-recessive space is compatible with the soft transitions of painting. He is not seeking merely to illustrate Christian subjects; he is in process of creating a Christian *style*.

So compelling is this style that it links up the zig-zag pattern of the *Last Supper* (final version), despite the chiaroscuro, with the relief of the Prado *Resurrection*, with his last figures, with the muted tonalities of the *Betrothal* and with his Toledo landscape. Baudelaire once said that Delacroix painted religious pictures; he forgot that Delacroix painted them in a "profane" style—his own. Delacroix forced Jacob and the Angel to enter into his private world; when El Greco does this to a clump of flowers, he turns it into a burning bush. The secular aspect in his work is merely incidental; long after his Venetian period it reappears in the *Angel Musicians*, but its dissolution is to be seen in the *Angelic Concert* where one feels that the painter wishes, above all, to wrest the bodies from the human and dedicate them to God—and to painting.

While the aim of his fellow-artists in Venice had been to widen their art, Greco's sole concern was to deepen his. In the solitude he had slowly built up round the walls, covered with African jasmine, of his sun-baked garden he no longer painted anything (apart from those wonderful portraits which ensured his livelihood, and those of members of his family) save what he could not see: New Testament characters, saints and prophets. A little armor, some garments, the blazing bouquets of his *Annunciations*, and, over all, that granite sky. Sometimes, too, he cast a glance at the small clay figurines hanging from his ceiling. But he stood far less in need of such accessories than of some of his earlier canvases, which he kept to spur him on to vanquish them. Thus those half-hearted nudes in the background of the *St. Maurice* came into their own thirty years later in the *Profane Love* and the *Laocoön*. His art closed with a *Visitation* without faces. Even had the world been plunged in darkness, his painting would not have heeded it.

We may regard his last figures as his Testament, for death confers on all last works a perspective that seems to reach out into infinity; yet they have no more to tell us than the landscape known as *Toledo in a Thunderstorm* (Why "in a thunderstorm"? The sky is that of the Louvre Crucifixion). He began by placing the donors underneath his Christ; later, on one side only of the Cross—while on the other side one saw Toledo. Then the donors disappeared altogether. And, lastly Christ too disappeared. Only Toledo remains in that famous landscape now in the Metropolitan Museum.

Thus all those years of creative effort, a life of solitude and but half-won fame, went to the gradual building-up of a city, *his* city, from all those *Crucifixions* and an epic "Mirror of the Sea" he had amused himself compiling. Who can credit the theory that all he was doing then was setting up an easel on the banks of the Tagus? Who can fail to see that the Toledo he sought and found was not the city before his eyes

EL GRECO: THE CRUCIFIXION (CA. 1602-1610) TOLEDO TAKES THE PLACE OF THE DONORS

EL GRECO
VIEW OF TOLEDO

but the city of his dream? It was in his studio, with its black curtains closely drawn, indifferent to the sound of the bells from the near-by church, that he ended up by crucifying Toledo; but from this Toledo which had made its first appearance beside the Cross he now had ousted Christ.

Yet from now on, whether portrayed or not, Christ is immanent in all his art; indeed He has become the driving force behind it—though Christ is put as much to the service of this painting as this painting is to Christ's. Style, Christ and city are bound up together indissolubly; El Greco has achieved the first Christian landscape.

EL GRECO: THE LAST "VISITATION" (CA. 1608-1614)

His Venetian contemporaries mastered the world's outward shows by the same methods as those by which he mastered its soul. Starting from Titian, like El Greco, Tintoretto (and many artists of the day) had the habit of modeling wax figurines and hanging them from the ceiling of his studio. So as to guide his drawing, we are told; more probably, to verify it. Before using these models he seems to have watched the divers, familiar figures of the Venetian scene, and then made angels of them. In his dealings with the world of men this is always the artist's method: to take divers and to make of them the angels he requires.

True, he was much preoccupied with rendering space. In the Louvre *Susanna* the planes are arranged in tiers, whereas the Vienna *Susanna* leads our eyes smoothly along the dark-green hedge, between the two pink-clad Elders, into the remote distance, while the mirror in the foreground conveys the same suggestion as to the width of the picture-space as the hedge does to its depth. But Susanna's body is treated differently, being almost diaphanous. Tintoretto, whose perspective, movement, lay-out and even color seem endeavoring to levitate bodies from the ground, is satisfied with the merest hint of volume; if he makes his figures look like sculpture this is chiefly so as to flood them with pale light.

438

"You can never do too much drawing," he used to say and we can see that in the *Susannas*, colorist though he was, it was on the drawing that he concentrated. He set out to improve on Titian's arabesque; not by breaking it partially like El Greco or, like Goya, totally, but by weaving it into knots. His sketches in the Daumier manner indicate what he had in mind, and indeed would suffice to enable us to guess the changes that were to come in his rendering of Susanna and the objects he would place around her. In the second version her coiffure has something of the Amazon's helmet and something of the whorls of seashells, and the intricate pattern he has thought up to replace the banal drapery serves to bring out that jewelry still life within which is a broken necklace—symbol as it were of the coming fate of Venice.

But at the back of his mind was another schema (perhaps only an amplification of the first one) whose symbol was the San Rocco palms. Reproductions of this cycle of pictures, greatly reducing, as they are bound to do, the scale of the huge originals, look like engravings, often like symphonies in black. This is probably because—with the exception of a few scenes (notably the *Crucifixion*)—the San Rocco ceiling is not "pure" painting. The dividing line between decoration and painting proper was ill-defined in Venice; thus in the Ducal Palace many

439

TINTORETTO: SAINT MARY THE EGYPTIAN

TINTORETTO: DOG (DETAIL OF THE LAST SUPPER)

compositions hover between painting and the tapestry design, indeed the *Saint Mary the Egyptian* at San Rocco is more in the nature of the latter. Here we have a special field of the creative activity which certainly belongs to art, though not to the art of the picture, for its decorative function is obvious. Thus Tintoretto was led to the "discovery" of the palm tree and that palmlike movement he imparted to so many branches, also that leaf-scroll calligraphy which he applied even to forms seemingly quite unsuited for it: the dog in the *Last Supper*, the ox in the *Nativity* and the voluted ears of the ass in *The Flight into Egypt*. Now, too, he discovered that "ornamental light" which Rubens was to turn to account and which culminated, under a vulgarized form, in theatrical scenery. Indeed the secondary scenes at San Rocco play the part of sets for the drama enacted in the *Crucifixion*. Yet this light was not merely ornamental; Tintoretto found that he could apply those crepuscular effects successfully to distant figures which he had sometimes painted in full detail, but which now look as if they were drawn in chalk. Presently the treatment of these background figures came to influence his leading figures, too; thus the technique of the wraithlike forms in the background of *The Baptism of Christ*, when applied to the figure in

TINTORETTO: THE BAPTISM OF CHRIST

TINTORETTO: DETAIL OF THE BAPTISM OF CHRIST

the foreground, becomes far more than a mannerism. The commanding presence of that tall white form, so justly famed, of Christ before Pilate derives from it. Nor would *The Flagellation* have come into being but for this discovery.

Tintoretto means so much to us not merely because he rendered movement with a mastery in the Southern manner no whit inferior to that of Rembrandt in the manner of the North; nor because his angels glide down so smoothly from on high; nor because he is a magnificent stage-manager; nor because he is assuredly the greatest decorative artist Europe has ever known. Rather, it is for his achievements in the field of color that we hail him as a master. He aspired to the conquest of Space—which was incompatible with what he asked of color; Schiavone, who was doubtless one of his masters, had come up against the same problem. In his *St. Augustine healing the Plague-stricken* (which Italy proposed to send to the San Francisco Exhibition of "unique pictures") the would-be realism of the perspective is counteracted by the brilliant color of the draperies and in the *Flagellation* the lyrical effusion of color practically annuls any illusionism. In both pictures the part played by the black patches is the same, but the chalky figures that appear in the

background of the earlier one (like the nudes in El Greco's *St. Maurice*) have moved into the foreground in the later work, and they now seem drawn in *colored* chalk. It is the deep-toned resonance of these colors, and not the palms or the nudes of his Venetian manner that convince us of Tintoretto's genius.

Quite early in life El Greco had decided to follow solely his own bent. Tintoretto, however, is one of those giants of the Renaissance age—such men of genius as Shakespeare, Lope de Vega, Rabelais— whose *œuvre* might seem the work of many hands, did we not know it was not so in fact: men who tried their hand at everything and attained the acme of perfection, without electing for any single field of the creative activity. And rarely does an all-embracing genius fix his choice on what is best in him. It was above all the stage effect that fascinated Tintoretto. Primarily because he was a visionary, a seer, like Catherine Emmerich (but a Catherine Emmerich who wrote in Alexandrines). Only those things which lent themselves to adornment, whether by the lighting or by the use of gesture, were given admittance to his world. (That the great Venetians did not paint Venice—the Venice that Carpaccio painted—was not due to chance; richly ornate though she was, she was not ornate enough for an art that lost its style whenever it cut loose from the imaginary.) Much reality goes to the making of a fairy-tale; only, in the fairy-tale, reality must grow buoyant and take wing. If he was to bring home his visions of biblical history to the spectator, Tintoretto needed to convince, and he did not omit objects that carry conviction; but, that these visions might be worthy of God, he sought to elevate them, and he did this by idealizing his drawing and with transfigurations wrought by light, by a poetic splendor of color and a composition on epic lines—and all this in pursuance of a passion for dramatic effect not unlike that of a film-producer or that of Victor Hugo in *La Légende des Siècles*. It was Tintoretto who invented the perspective that, starting flush with the ground, takes the eye by surprise, and which the cameraman was to reproduce by lowering his camera; and it was he who discovered (in *The Way to Golgotha*) the effectiveness of an ascending movement beginning from left to right and continuing from right to left. This indeed is one of his most significant works, with the far recession of its stormy sunset, the brutal figure at its highest point, the sudden patch of light on Christ's leg, that "psycho-analytical" horse and the startling flag of victory. The only captain of his soul whom Tintoretto acknowledged was the Michelangelo of the Sistine Chapel. Yet Michelangelo painted bas-reliefs and his grandeur, vehement though it be, is not related to stagecraft; how unseemly would that flag in *The Way to Golgotha* have looked in a work by Michelangelo! He does not represent, he sublimates. Tintoretto has been blamed for his fondness for putting dogs into his pictures; those dogs are symbols of his homelier art, just as the long recessions of perspective symbolize his stately art.

TINTORETTO: THE WAY TO GOLGOTHA

Examples of the latter are the mirror in *Susanna*, the vast nave in *The Finding of St. Mark's Body* which converges on a tiny, dazzling door, and the vertical stairway in *The Presentation*. His dogs, palm-trees and jewelry meant much to him, but he needed no less those flights of steps which give the impression of leading up to some Acropolis. Forever listening-in to a celestial threnody heard by him alone, he achieved its orchestration in the San Rocco *Crucifixion*, in which all the aspects of his many-sided genius are harmonized in an infinite variety of earthly forms. Indeed this is the only presentation of the sublime in terms of lavish decoration that Christianity has known; El Greco was content with a Christ solely and starkly Himself.

In *The Origin of the Milky Way* Tintoretto makes the constellations gush from Venus' breast; never has the universe been more sumptuously evoked, even by Rubens. Tintoretto painted flowers, fruit, forests, horses, a camel, figures, nudes, portraits, battles. But always in the setting of a cosmic narrative. He painted many holy feasts, but not a single still life; many set scenes, but at most four landscapes; some nudes—of goddesses. His world of allegory is less feminine than Titian's, some of whose famous works are portraits of *young* women. His so-called realism amounts to no more than the portrayal of humble objects, like that broken chair in the *Annunciation*, to which in any case the lighting lends solemnity. To grasp its meaning we need only compare his most realistic figures with those of the *Espolio*. It might seem that the holes in his "filter" were so made as to let the whole world slip through; actually, those forms alone pass through it which are the stuff of trophies. As in El Greco's last phase no forms were let through his "filter" save those which, now he had turned his back on "trophies," enabled him to subdue all else to his small black wooden crucifix.

Seldom can two painters stemming from the same masters and belonging to the same period thus have tried, the one to take over from the world all it has to offer, the other to take nothing from it. And they have shown clearly, by throwing so much light on each other, how the artist, though he cannot break free from history, *makes* it. Between the work of art and the aspect of the world it conjures up there lies the same relationship, elusive yet rich in consequences, as between the initial concept of a poem and the claims of rhyme and rhythm. The concept calls for its rhythmical expression, and this in turn stimulates the concept. The last shot of one of Eisenstein's films shows an eagle's eye slowly closing, the eyelid descending curtainwise upon the eye, the drama and the screen; also, during the creative process, man's creation and God's follow the same rhythm.

Sometimes it happens that the creative process of the artist keeps wholly to the form it took in the first uprush of inspiration, or it may change slightly; the horse in the first state of the *Three Crosses* reappears

TINTORETTO
SAINT AUGUSTINE HEALING THE PLAGUE-STRICKEN (DETAIL)

in the second state, but the other way round. Sometimes a new form emerges, or one that looks the same but is subtly different. Or a new color harmony invades the picture, a green garment becomes a landscape, or turns blue. Or the picture may be orientated by painting pure and simple, and an El Greco draw tight the black curtains of his studio against the pigeons scattering flakes of living light from the scaffolding around St. Peter's. Perhaps the dull green of his *Toledo* may have been suggested to him by a thunderstorm, but his thirty years of painting would have sufficed to conjure up that somber green. Nothing better shows the way in which the trend of genius is *directed* than the host of themes it leaves untouched. Rubens rarely painted hell and Rembrandt rarely painted paradise; Renoir painted no chairs and Van Gogh no nymphs, even in the guise of washerwomen. Though in the course of his career Matisse has changed the color of his women's dresses, that of his backgrounds and his curtains, his color has never become Rouault's. The successive states of certain works by Picasso—far more different from each other than those of El Greco's pictures, and having nothing in them that plays the part played by the Montagne Sainte-Victoire in Cézanne's canvases—sometimes recall the primitive figures of Crete or Sumer, but never the figures of Renoir or Matisse. Though Tintoretto gives the impression of having painted everything, he took good care not to venture into the world of forms that was to be Goya's. Elastic as the link may be between an artist's style and the themes he favors, it never gives way altogether, and if our imagination boggles at the notion of a *Dance of Death* by Fragonard, it is hardly less recalcitrant to Watteau's lost *Crucifixion*. Painting the face of his friend Chocquet (a subject of his own choice), Renoir handles it as easily as if it were a bunch of flowers in silver paper, but he was ill at ease with Wagner's face (it was the composer's fame that led him to paint it)—a face which would, however, have been the delight of Delacroix. The language an artist of genius discovers for himself is far from enabling him to say *everything;* but it enables him to say what he *wants* to say.

Hence the very gradual, but far-reaching change that has come over our opinion as to what constitutes the masterpiece. Nebulous as it has become, we do not admire the Moissac "Elders" and any ordinary Romanesque statue in the same way. If modern painters feel qualms about applying the term "masterpiece" to describe a work of capital importance, this is because it has come to convey a notion of perfection: a notion that leads to much confusion when applied to artists other than those who made perfection their ideal. Poussin's painting was guided by that ideal of perfection, Grünewald's obviously was not; indeed it would seem that the craving for perfection chiefly shapes such arts as deem themselves subordinate to previous types of art. Several epochs have set much store on this quality, but they have

not always agreed as to the works in which its presence is revealed. Thus, nowadays, perfect color has stolen a march on perfect drawing, and it has been possible to exclude the human figure. During a period of two centuries, Chardin's type of perfection underwent a hundred years' eclipse; for him to be reinstated, French painting has had to move forward from Corot to Braque. Every great art unearths or rediscovers its perfection, just as it discovers its ancestors; but this is always a perfection of its own and varies from one period to another. The perfection of Pheidias was not extolled by his contemporaries but by the Romans and the Alexandrians. Racine's contemporaries applauded him "for having displayed men as they are, not as they should be," but not for being Raphael's next-of-kin; while Raphael's contemporaries admired his grace and Vasari, as against him, vaunted the perfection of Michelangelo. In seventeenth-century France perfection was held to be determined by the Rules of Art and Raphael was praised in so far as he observed them, or blamed when he transgressed them; in 1662 Chambray, after inspecting an engraving of *The Massacre of the Innocents*, declared that he "would have hoped for something better from Raphael, with so promising a subject." This conception of the Rules of Art sponsored Eclecticism and led to the discovery of another Raphael in Mengs, a new Pheidias in Canova, and it merely assumed another form when pyrotechnics took the place of the set-square as the vehicle of genius. Today, however, we base our aesthetic on our direct response to the work of art, and we do not try to establish any hard-and-fast rules, but to elicit a psychology of art. Modern treatises on the subject invite assent, sometimes persuade, but never pontify. No "law of art" is deduced from the past and projected on the future. Thus, since the supreme works are those which we do in fact admire—and not those which we ought to admire—all we want to ascertain is what unites them in our admiration.

During certain periods the artist saw in "exercises" a means of trying out his talent, with a view to getting commissions for large-scale works, in which he sought to embody all he had learned from these preliminary essays, and which, if successful, would rank as masterpieces. Usually a *magnum opus* of this kind aimed at expressing the highest values; it is unlikely that the Masters of the Royal Portal of Chartres put as much of themselves into shaping the capitals of the pillars as into the Kings, or that Pheidias attached as much importance to the metopes of the Parthenon as to his statues of Athene and of Zeus. Or even that Michelangelo preferred the Uffizi *Holy Family* to the Medici Chapel or to the Sistine ceiling. Rembrandt, whose art obeyed no orders but its own, was "mobilized," so to speak, by *The Three Crosses*, as Pheidias was by *Athene*, Grünewald by the Issenheim altarpiece, and Goya by *The Shootings of May Third*. Perhaps we should see in this the origin of the misapprehension relating to the "noble subject" which over a long

period was the one that fired the artist with the most intense desire to paint. Those deep organ-notes, echoing through the ages, that Rembrandt sounded when he achieved a world worthy of Christ were sounded again by Vermeer and Chardin when they built up a world worthy of the art of painting (soon to become the supreme value for the artist) —and it is then that the "exercise" and the *magnum opus* seem to coalesce.

Then, too, that chance seems to replace premeditation; but a form of chance that is not accidental but a gift from the gods. The hierarchy in terms of which Cézanne appraised his painting was based on that *realization* (as he called it) which, he said he himself "brought off" so rarely, but which the Venetians had "brought off" so frequently. Obviously he had not in mind any illusive realism or the expression of emotion; nor did he mean that it was impossible for the spectator to imagine that the scene before him could be improved on. Those small blank spaces he left on the canvas went unnoticed by most people, and could have been filled by him alone. His soul-searchings as to the "realization" of the *picture*, not that of the scene before him, were ultimately due to the exercise of a power he knew to be precarious, intermittent. The uprush of this power had replaced (from Rembrandt onwards) all that the Italians, and most Primitives, had thought to be a matter of proficiency. Thus the artist has become a gambler—whose lucky *coup* is, now and then, the masterpiece. But when he "brings it off" what exactly has he brought off, in his eyes and in ours?

It is no more necessarily richness of texture or intensity of expression than structural form or purity, and it is no more fidelity to tradition than innocent simplicity. What survives of a great artist's work (whether he thinks he is serving beauty or God, his personality, or painting as an art) is that part of it which has the greatest *density*. An artist's supreme work is often assumed to be one in which he has employed all the means at his command. Sometimes, however, he employs them by way of suppression; Rembrandt's masterwork is not the *Night Watch* and Rubens is no less himself when the coruscations of the *Kermesse* have given place to the pale sheen of *Helena Fourment's Children*. In Great Master exhibitions it is this density, as I have called it, which characterizes the true masterpieces. The *Embarkation for Cythera* would suffer by being hung alongside *L'Enseigne de Gersaint;* at the Prado they have been wise enough to isolate *Las Meninas*, which was killing half Velazquez' works. No doubt a supreme Titian would not throw Rembrandt's *Bathsheba* into the shade, but when at the Academy of Venice we see for the first time the *Pietà* (of which black-and-white reproductions give no idea and whose dimensions rule out color reproduction) we feel at once—even before we read the name of Titian—that all the great Venetians near by cut the figure of poor relations. And how many of our Primitives can hold their own beside the Master of Villeneuve?

It should be noted that a painter of genius owes his resuscitation sometimes to a single work: Vermeer's began with the *View of Delft*, Latour's with his *St. Sebastian and St. Irene*, Grünewald's with the Issenheim *Altarpiece*. Thereafter, in each case, the one great work focused attention on the artist's total output, then on the man himself.

The powerful effect of such pictures, which do not fit in with any accepted canon of beauty, stems primarily from their autonomy—they are free creations. Usually pictures which are not ascribed to known masters are ascribed not to chance but to disciples or eclectic painters. But there was nothing eclectic about any of the above-named works; nobody could suppose the *St. Sebastian* to have been painted by some vague Northern adept of Caravaggio. In each of them a world personal to the artist finds expression and each, too, speaks, if in unfamiliar accents, a language which we recognize as that of conquest.

The presence of this language would have been detected sooner, were it not so often muted in the work of even the greatest masters. Persistent though it be, the victorious advance of genius does not reveal itself in each successive picture; painters who live by their painting do not put their best into every work. Over a long period the professional artist was obliged to paint figures he had not chosen (not to mention work commissioned by his patrons). Though great painters never discard their genius or dilute it with that of other masters, they are apt to dilute it, in minor works, with the prevailing taste of their age. Thereafter, when their fame leads imitators to degrade their genius to a "manner," which remains in fashion for some time, their works, even the greatest, gradually lose the astringent quality of a new creation and survive as but the most illustrious amongst a crowd of imitators; thus Caravaggio ended by being submerged in the horde of his disciples.

Let us imagine what would happen if the very name of Raphael had been forgotten as was Vermeer's when Thoré first set eyes on the *View of Delft*, and that the *Madonna della Sedia* were discovered in some remote church or in the attics of the Pitti. Would we not immediately have the certitude which even those who (like myself) are little moved by Raphael experience when they see this picture: that they are in the presence of a work of genius? For it would be evident that here a whole new world of art was being opened up, and once this "forgotten" master had been rediscovered and given his place in history, we would see that his genius lay in all that Ingres, at his most abstract, tried to borrow from him and not in what Guido Reni borrowed from his anecdotal pictures. With its closely knit composition, its controlled emotion and its density this *Madonna* epitomizes all that differentiates Raphael from Andrea del Sarto and Fra Bartolomeo and shows how Raphael's skillful softening of the harshness of his drawing (so well understood by Ingres) was diametrically opposed to the linework of his successors.

450

RAPHAEL: MADONNA DELLA SEDIA

Pictures in which a forgotten genius is brought to light raise problems all the more far-reaching in that they often serve to test out theories suggested by the historical sequence of an artist's *œuvre*. We do not trace Raphael's career from the *Three Graces* onwards to the *Transfiguration*, or Rembrandt's from his *Baalam* to *The Prodigal Son* in the same way that Vermeer's has been retraced from the *View of Delft* to various *Young Girls* of dubious authenticity, to the *Supper at Emmaus* on the one hand, and on the other to works that are vouched for by a signature

NAIVE ART (19th CENTURY): ROMEO AND JULIET (DETAIL)

which may or may not be his. The *plenitude* apparent in the art of Grünewald (the Issenheim Altarpiece) before his real name was found to be Neithardt, in Latour's *St. Sebastian* before anything was known about the artist, and in the *View of Delft* while Vermeer still was forgotten—this plenitude is not merely a matter of coherency. We find a certain coherency in the coloring of children's watercolors, if not in their drawing; while the elements of lunatic art are sometimes as rigorously co-ordinated as those of the most expert draftsman. But it is unity of a different nature. The automatic drawing ("doodling") with which so many listeners beguile the time in Cabinet meetings no less than in college lecture-rooms, is often coherent in its way—but its coherence is not real unity and still less plenitude. The same is true of "folk" pictures showing groups of figures; often these are quite elaborate, yet they lack that accent of mastery which we find in the great anonymous works. An accent that has nothing to do with the classical spirit of some of them: the genius of Grünewald is not less evident than Vermeer's; and an accent less concerned than it might seem with wealth of color—Greco's and Grünewald's color does not sponsor their pictures more effectively than the relatively meager color of Latour's pellucid art affects the *St. Sebastian*.

When any given work charms us by the coherence of its lay-out we expect it to be followed up by another of the same kind; yet, after the *St. Sebastian*, the *Prisoner* and the *Magdalen*, very different from it as they are, do not come as a surprise. What the "anonymous" genius conjures up is not a system but a whole domain of painting; the solitary work or the two or three works by him that have come down to us suggest an *œuvre* of which they are fragments, not the symbols. This is why genius is never a matter of technique or of lay-out. Guardi's does

GUARDI: THE LAST SUPPER (DETAIL)

GUARDI: THE LAGOON OF VENICE

not make him a Rubens or a Tintoretto, indeed it prevents his color from equaling that of Corot, whom however he foreshadows; just as Magnasco's prevents him from rivaling Goya. Though, like a true style, such a technique may operate as a "filter," it lets through only the anecdotal; Guys is pure technique. Some have regarded genius as an exceptionally pure or brilliant technique or manner of execution, instances being Raphael and Tintoretto. Yet not only is Tintoretto's technique different in kind from Guardi's, but between them lies the great gulf made by genius. When *St. Augustine Healing the Plague-stricken*, so different from the well-known Tintorettos, was exhibited at Venice, the public was not shown just "another Tintoretto," nor just a feat of skillful painting —or what a new Guardi or Magnasco would have been; instead of this they were confronted (as in the case of the anonymous masterpieces) by an unmistakable demonstration of superb and supreme *power*.

Such demonstrations affect us in the same way as the men of the Middle Ages were affected when they first set eyes on animals they had never seen before and which they knew at once to be neither automata nor monsters but forms of life existing in far lands, and they give us something of the shock of surprise a child has when a shell he is looking at on the beach suddenly begins to move. This feeling, which might be defined as "the thrill of creation," comes to us when we look at certain

Khmer heads, at *Uta*, at Michelangelo's *Adam* (Van Eyck's and Masaccio's, too), at Goya's **Burial of the Sardine**, Cézanne's *Château Noir* and Van Gogh's *Crows;* and that selfsame thrill was felt by the "discoverers" of El Greco and Vermeer after their long eclipse, as it was felt on the day when the *Koré of Euthydikos* was brought to light.

The coherence of the masterpiece is due to its conquest of the visible world and not to its technique. This is why, though it may be the most telling expression of a style whose evolution is unknown to us, the masterpiece is in no sense a symbolical expression of it; there is always an element of the personal and the unforeseen in the work of the great and truly powerful artist. Once the masterpiece has emerged, the lesser works surrounding it fall into place; and it then gives the impression of having been led up to and foreseeable, though actually it is inconceivable—or, rather, it can only be conceived of once it is there for us to see it. It is not a scene that has come alive, but a latent potentiality that has materialized. Suppose that one of the world's masterpieces were to disappear, leaving no trace behind it, not even a reproduction; even the completest knowledge of its maker's other works would not enable the next generation to visualize it. All the rest of Leonardo's *œuvre* would not enable us to visualize the *Monna Lisa;* all Rembrandt's, the *Three Crosses* or *The Prodigal Son;* all Vermeer's, *The Love Letter;* all Titian's, the Venice *Pietà;* all medieval sculpture, the Chartres *Kings* or the Naumburg *Uta*. What would another picture by the Master of Villeneuve look like? How could even the most careful study of *The Embarkation for Cythera*, or indeed that of all Watteau's other works conjure up *L'Enseigne de Gersaint*, had it disappeared? Though akin to other pictures, other sculpture, other masterworks by its creator, the true masterpiece differs from them *toto caelo*. The Louvre *Helena Fourment* is as far removed from the picture of the same name at Munich (which foreshadows Renoir) as from the *Philopoemen*. Vermeer is regarded as a genius of limited range, yet the art of the *Head of a Young Girl* is utterly different from that of the *View of Delft*. It is a far cry from the *Madonna della Sedia* to the *School of Athens*, and Raphael's assistants (or Il Sodoma, whose portrait figures in the *School*) are hardly responsible for this; is there less distance between the picture itself and the cartoon for the fresco? The wider our knowledge of the medieval painters, the more their amazing versatility becomes apparent; that of Van Eyck is plain to see, while that of Rogier van der Weyden includes his portraits and *Annunciation* with the superb *Descent from the Cross* at the Escorial; Fouquet's, his *Juvenal des Ursins* with his tricolor *Madonna;* Giotto's, his miniature scenes with his large-scale work at its most impressive. From the whole Arezzo cycle only one man—Piero himself—could have elicited the London *Nativity*. It is by a family *unlikeness* so to speak that the masterpiece can be distinguished from the forgery, even the cleverest (almost always a good "likeness"); if Van Meegeren succeeded

PIERO DELLA FRANCESCA: THE CARRYING OF THE HOLY BRIDGE

PIERO DELLA FRANCESCA: ANGEL

in hoodwinking so many connoisseurs and specialists this was because he risked faking a "Vermeer" without a model (except for the characteristic color-scheme) and without any obvious precedent in Vermeer's output.

The artist uses his early works as a starting-off point and not with an eye to "perfecting" them; he uses them thus because they confirm the personal system of relations synthesizing the facts of visual experience which his genius substitutes for life itself. It was to this total substitution that Cézanne looked for what he called his "realization." He was defeated by the Mountain when it suggested elements of the picture whose value he could visualize but which he failed to body forth; hence the feeling of being defeated by his model which he had on such occasions. But his failure when confronted by the mountain was compensated for by his success when his subject was a still life or a nude; the picture assimilated these elements almost effortlessly. Quickened and modified by each new work, Titian's creative impulse led him on from the *Nymph and Shepherd* to the *Pietà*, as Shakespeare was led on from *Macbeth* to *Hamlet*, and Dostoevski from *The Idiot* to *The Possessed*. Genius is not perfected, it is deepened. It does not so much interpret the world as fertilize itself with it; the *Enseigne de Gersaint* is not the translation of a picture-dealer's shop into the language of the *Embarkation for Cythera*; it is the emergence, in an autonomous realm, where it takes its place beside the *Embarkation*, of a new picture born of the same creative power—a power that pervades all art from the cave-man onwards. It was this power that enabled the Magdalenian artists to instill into their drawings of bison a life other than that of the animals themselves, instead of slavishly imitating them; and this same power enabled early artists to paint Madonnas who were not merely women and to create the faces of the gods. This creative freedom is the hallmark of genius, the density of the work of art is its "realization," and the masterpiece its most-favored expression.

"Most-favored" sometimes because the artist wills it so. Even today there are occasions when we can see the artist has aimed at a *magnum opus*, a summing-up of his resources; Van Gogh's *Fields under a Stormy Sky*, Courbet's *Studio*, some of Gauguin's canvases, Picasso's *Guernica*, Braque's *l'Atelier à l'Oiseau* are scored for "full orchestra" so to speak. Likewise, in every age some artists, when they felt death approaching, have been moved to making pictures which seem like their testaments: such are the last Renoirs, the *Crows*, Delacroix's last works, the *Milkwoman of Bordeaux*, the *Enseigne de Gersaint*, the *Prodigal Son*, the *Governors of the Almshouse*, the last Titians.

"Favored" almost always by an encounter, a "contact" of some kind—for which chance is only responsible in part. Because he was seeking for it the Gandharan sculptor found the secret of eyelids that droop in meditation; it is not surprising that the climax of Rembrandt's etchings was a Calvary, that El Greco's *Visitation* portrays beings who are not of this world, and that the Koré smiles. These encounters with

WATTEAU: L'ENSEIGNE DE GERSAINT (DETAIL)

a special subject, a special architecture or a special color are invited by the artist's "schema" and by the very act of creation, and may be due to a conscious quest, a flash of insight, or occasionally to mere chance. Rembrandt took lodgings in the Ghetto of Amsterdam, Renoir set up house near the Mediterranean, Gauguin migrated to Tahiti, El Greco chanced on Toledo. Such encounters lead sometimes merely to a felicitous manner of expression, but sometimes to a new avatar. More rarely, what the artist lights on is that portion of himself which dwells beneath the threshold or, it may be, intimations of some lost Arcadia; or, more rarely still, he strikes down to those well-springs of the psyche which are the common heritage of mankind, basic emotions and undying dreams—Giotto's *Nativity*, Botticelli's *Primavera*, Rembrandt's *Supper at Emmaus*, Rubens' *Kermesse*, Michelangelo's *Night*, and Goya's *Saturn*. The encounter of Aeschylus with Prometheus. . . .

"Favored," lastly, by the march of time, which converts certain works of the past into landmarks, ascribes to others the genesis of a style and involves all alike in a constant metamorphosis. Modern art, which stems from Cézanne and Van Gogh (though the artists of the nineties were so sure it would follow in Monet's footsteps) has resuscitated not Turner but El Greco. While every style which has commanded admiration has points of contact with us, the works we think most of tend to be those whose procedures seem akin to those of our contemporary art. The nineteenth century took little interest in the great Asiatic sculpture, nor would Delacroix have responded as Braque responded to the portraits of Takanobu. The status of the masterpiece is determined in any given period in terms of one of the many "languages" of art—whose languages, however, are not immortal; were a new absolute to emerge there is little doubt that many of the art treasures of the past would be consigned to the limbo of forgotten things.

But when a language of art becomes universal (painting in the Middle Ages was not a mere language but an act of bearing witness, and its message ruled out all other considerations), its masterpieces come to be regarded as such only by those who "hear" it as a language, just as the masterpieces of music exist only for those who do not regard music as mere organized noise. Under these conditions the greatest plastic works make their full effect when confronted with their distant compeers no less than when confronted with their minor next-of-kin; as does Rembrandt's *Helmeted Man* confronted by the *Portrait of Shigemori* no less than when it is confronted with the second-rate *Standard Bearer*. And the secret of their direct action on us becomes an open secret.

No participation, no *Einfühlung* accounts for the special way in which Rembrandt acts on us; we are not "carried away", nor, when we see the *Burial of Count Orgaz*, do we surrender to it unconsciously. Neither Rembrandt nor Van Meegeren leads us unawares into the inn

TAKANOBU (JAPAN, BEGINNING OF THE XIIIth CENTURY)
PORTRAIT OF TAIRA SHIGEMORI

at Emmaus. No doubt we do sometimes participate (especially in the theatre) in what is shown us, but this feeling of taking part in the action of the picture or the play may be produced by a minor work as well as by a masterpiece. Our enjoyment of a cubist picture is not the effect of its tectonic structure, for the structure of many inferior cubist works is more aggressive than that of Braque. The rhythm of a march may make us walk in step, but does not make us admire the music. It is as a creative act that the great work appeals to us, and a great artist is not autonomous because he is original, but *vice versa;* hence his august solitude. But we now have learnt in what constellation these solitary stars have their appointed place; great artists are not transcribers of the scheme of things, they are its *rivals*.

That thrill of creation which we experience when we see a master-piece is not unlike the feeling of the artist who created it; such a work is a fragment of the world which he has annexed and which belongs to him alone. The conflict of his early days (which gave rise to his genius) is over and he has lost his feeling of subjection. And for us, too, this work of art is a fragment of the world of which Man has taken charge. The artist has not only expelled his masters from the canvas, but reality as well—not necessarily the outer aspects of reality, but reality at its deepest level—the "scheme of things"—and replaced it by his own. A great portrait is primarily a picture and only secondarily the likeness (or analysis) of a face. The masterpiece is not wholly identical with truth, as the artist often thinks. It is something that was not and now *is:* not an achievement but a birth—life confronting life on its own ground and animated by the ever-rolling stream of Time, man's Time, by which it is nourished and which it transforms. And this holds good whether the masterpiece be a Toltec mask or a *Fête galante;* whether its maker be a Gislebert d'Autun, a Grünewald or a Leonardo.

Neither the sound and fury of the studios nor modern styles have succeeded in dethroning *Monna Lisa.* For it is not so easy as all that to classify the picture as "academic"; to what other artist's work is it akin? To Bouguereau's, for instance? That traditional admiration which sets it on a pedestal as "the world's most perfect picture" is based on a misunderstanding which, perhaps, accounts for the frequent dismay of the tourists who visit the Louvre to see it—but leaves the picture exactly where it was. Just as the *Madonna della Sedia* acquires its full significance—not that of any kind of "perfection" but that of the total conquest of a realm of art—when we imagine it as anonymous or compare it to the *Madonnas* of Raphael's imitators, so when we compare the *Monna Lisa* with such works by Leonardo's disciples (attractive though they are) as Melzi's *Columbina* and Luini's *Salome*, or if we try to ascertain what distinguishes it from works formerly ascribed to Leonardo, we see the difference between truly great art and its weakly inspired posterity.

BERNARDINO LUINI: SALOME (DETAIL)

LEONARDO DA VINCI: MONNA LISA (DETAIL)

Yet Leonardo's best disciples lack neither poetic feeling nor a sense of mystery. It has been maintained, on colorable grounds, that the sitter for this picture was not Monna Lisa at all, but Costanza d'Avalos. Yet the expression of the lady of high Florentine society whose smile, so legend tells us, was "held" by Leonardo through four years' sittings by having musicians and buffoons perform while he was painting her, seems unlikely to have been that of the heroic woman who defended Ischia against the armies of the King of France —despite the widow's veil worn by the woman of the portrait. Yet what does it really matter who this woman was? The picture stands alone, on its own rights, and we need but recall the work of lesser Milanese painters to feel the supreme intelligence that went to the making of what is assuredly the subtlest homage that genius has ever paid to a once living face. And there is a touch of irony in the fact that this supreme intelligence—of a pictorial and specially a calligraphic order, since Leonardo disdained color and all the pictures in which first his master or later his assistants did not take a hand are more or less in monochrome—should thus perpetuate the glory of a face whose identity remains uncertain.

While the last noises of the day are dying out in a Paris which, too, perhaps, is drawing to its end, the words of Leonardo echo in my memory: "Then it befell me to make a truly divine painting" The "truly divine painting" whether belauded or despised in its day shares in that lonely eminence which is the lot of the *Deaf Man's House* with its fantastic apparitions, of the *Head of a Young Girl*, the last Rembrandts and those great Japanese portraits of the Kamakura period that Europe has not yet discovered. We are at last beginning to discern what it is that such works have in common with so many others of their kind; in them the artist has broken free from his servitude with such compelling power that they transmit the echoes of his liberation to all who understand their message. Thus posterity, for the artist, means the gratitude of coming generations for victories which seem to promise them their own.

When falls the shadow that death casts before it, as though to close his eyes, the painter finds that though he feels the onset of old age, his painting does not feel it. He has invented his language, learned how to speak it, and this is the moment when he seems capable of interpreting every aspect of reality. Yet it now may happen that this language ceases to satisfy him, he feels a need to deepen his art so as to challenge the power of death, just as he once confronted the weakness of life. The call of the infinite becomes insistent when death adds its accent of finality; few men of genius have been like Renoir who closed his long career in a mood of genial ecstasy, in which the world's most everyday forms were transmuted into forms set free, while the half-paralysed old artist, with a short stick fastened to his crippled hand, carved *The Dance*.

464

RENOIR: TAMBOURINE DANCER (THE DANCE)

In the swan song of this great artist, amidst a red blaze of peonies, we realize how insatiable is the appeal of painting, even as we perceive it in the hideous anguish of Hals's last days and in the glorious dirge which the Rondanini *Pietà* hymns above the tomb of Michelangelo. Thus ever and again art ends by uniting the skeleton and the knight in its unflagging rhythm. And presently other painters in whom his voice still echoes will wear their eyes out, seeking to wrest from him the accent he has imposed on the realm of visual experience. From the first sculptor of the world's first god down to the modernist the most deliberately present in his canvases, every great artist has, in the depth of his heart, aspired to the same kingship. And like the life of the genius, that of mankind gives ever rise, between the artists yet to be and the glorious jetsam of the past, to that pregnant disharmony out of which is born, world without end, the conflict between the Scheme of Things and the work of human hands.

How strange is this far-flung world of ours, so transient yet eternal, which, if it is not to repeat but to renew itself, stands in such constant need of Man!

PART FOUR

AFTERMATH OF THE ABSOLUTE

I It is impossible to understand the part played in our culture by its resuscitations if we fail to realize that the art calling them forth is one that emerged from the fissures which formed in Christendom. Not in Christian faith, nor in religious thought, but in one of those vast socio-religious systems which once governed men's minds and souls, and whose last vestiges may still be seen in what India, changing as she is, and Islam in its death throes have retained of their tradition-laden past.

An Encyclopedist was farther removed from Racine in his Port-Royal retreat than Racine was from St. Bernard; for the mere notion of "retreat" had ceased to mean anything to the Encyclopedists. The idea of self-fulfillment through union with God was being replaced by the accumulation of factual knowledge and, turning her back on Being, Europe was on the way to becoming mistress of the world.

Until the sixteenth century the artist's most fertile emotion had been associated with a sense of Man's reconciliation with God (as against the dualism preceding it); thereafter it was associated with a steady weakening of the prestige of the divine. Now that it was incapable of solving the problems which have haunted men's minds since the beginning of time, those of old age and death and the seeming injustices of the human predicament, Christendom was trying to forget them. Admiration of the Primitives increased at the same time as the soul lost its cogency, and henceforth a company of Giottesque angels of the past kept vigil on the slumber of a Christ laid for ever in the tomb.

But first there came the Protestant illumination, following the epic glory of the Renaissance. It died out in a proliferation of all the forms of life, no longer rendered from the idealistic angle, and these were used to fill the void that even Rembrandt had failed to fill; hence the Dutch painting with which we are familiar.

The Dutch of those days were neither proletarians nor courtiers; the men for whom Hals, Rembrandt, Ruysdael, Terborch, Vermeer and so many "little masters" catered were the "sea-rovers" who had won their independence from Philip II and were about to defend it against Louis XIV. Victorious adversaries of the two most powerful kings in Europe, they were burghers like the Roundheads, not like Joseph Prudhomme. "They are quite ready to die for freedom. In their community none has a right to beat or roughly handle or even scold another, and the serving-women have so many privileges that even their masters dare not strike them." The reward that Leyden chose for its heroic resistance of the Spaniards was a university, so history tells us, and Taine found much to say on this. But we tend to overlook that glorious page of Dutch history, and even today you will hear people talking, as of quaint figures on picture-postcards, of a nation that put up a stout resistance to Hitler's hordes and has led the world in post-war reconstruction. If the Dutch grow tulips in the neighborhood of

Arnhem, the flowers are nourished by the bodies of their parachutists. Those to whom we would do best to liken the Dutch are the Scandinavians. But in them there is lacking a trait which neither the English, nor the Scandinavians, nor the Germans lack: a taste for the romantic —and the faculty of weaving legendary lore into their art.

When the era of her great painting dawned, Holland, unlike Germany, had no strong Gothic tradition. Even today, the past has not in Holland the emphasis it has elsewhere. Her parachutists settle down again, wearing the local costumes, in those old houses which look as if they had been built only yesterday. Amsterdam is the only seventeenth-century city—by rights it should have the "color" of Versailles or Aachen—which it has been possible to repaint from roof-tree to cellar without a hint of vandalism, and which seems relatively unaffected by the passing centuries. Romanticism (including that of Rubens' saints) being ruled out, nothing was left to the Dutch artist, so we are told, except the portrait; but this seems a narrow view, considering that within a few years landscapes and still lifes as well as portraits were being turned out simultaneously in great numbers. Or should these be regarded as "portraits of the natural world"? A Ruysdael landscape is hardly less transfigured than a landscape by Rembrandt, but it is transfigured in a different way. In any case Ruysdael and Rembrandt went to their graves unhonored; at a pinch the Dutchman tolerated a transfiguration of oak trees, but not of his neighbor's faces. Man, the individual, must neither be idealized nor ridiculed; the butts in the comedies of Steen and the Ostades were always generalized types. We smile at the showy costumes worn by Hals's models (they soon went out of fashion) but turn a blind eye to our own, and forget that, if these men were obviously proud of their accoutrement, they had quite as much right to take pride in it as had Cromwell's Roundheads or the Russians of the first five-year plans. "Their army is so good," the Venetian ambassadors said, "that any soldier could be captain in an Italian army, and an Italian captain would not be accepted as a private soldier." In Hals's last portraits there is a grandiose vindictiveness; but, as for irony, it is we who read it into them. He did not laugh at these people whom he made no effort to romanticize. What then was dying in Holland was the Italian manner of portraying Man.

Or, it might be said, the Catholic way of portraying him. True, there is a drab, middle-class type of Protestant portrait which never rises above the second rank. But, by its very nature, Protestantism did not aim at any equivalent of the great Catholic world order, any more than it aimed at building another St. Peter's. In England, at once Protestant and monarchical, it was the monarchy that set the portrait's tone, while the Reformation sought to restore to St. Augustine's voice its dark reverberations and to assert the independence of the individual man. Both Reformation and monarchy repudiated the Roman hierarchy.

Though the Primitives and the great Renaissance artists often painted landscapes, still lifes and interiors, they did not paint them by themselves, for their own sakes, as the Dutch did, but used them as compositional elements. The reason was that to their thinking such subjects had no point or value unless they served some higher end. The Dutch were not the first to paint fish on a plate, but they were the first to cease treating it as food for the apostles. Caravaggio's art was realistic, and he did not feel called on to idealize every figure; nevertheless, he accepted the Italian hierarchy of values, and his aim was to convey in the most convincing manner possible the presence of an ideal world. When in *The Madonna of the Ostlers* he covered St. Anne's face with wrinkles, their function was to stress the purity of her daughter's face —a purity different from Raphael's but no less intense. Even the few still lifes he painted look like passages in some large-scale composition from which they have been cut away. Until now, all forms of realism had (like early Gothic) aimed at suggesting other-worldly associations, particularly scenes related to the Gospel narrative; thus Bosch's torturers and the Master of Alkmaar's beggars, whether or not Christ figures in the picture, are associated with His presence. But in the canvases of Hals and Terborch neither Christ nor beauty has a place. True, the social order for which Dutch painting catered sought to dictate its themes and outlook on the world; nevertheless the genius of the great Dutch painters ranged far beyond these. Hals is not an improved Van der Helst, nor Vermeer a refined version of Pieter de Hooch (not to mention Rembrandt). The fact that the tradition of the portrait was so strong in the Low Countries made for the rapid growth of a school of expert craftsmen. But a portrait is more than a copy of the sitter's features, and how could a social order that had lost touch with the medieval portrait and equally disliked Spanish austerity and, brilliant though it was, the sensuality of the Venetians, have called forth a great painter other than one whose genius stood for a new value?

It was Hals who inaugurated—timidly, yet with a touch of bravado to begin with—that conflict between the painter and his model which characterizes modern art. (Manet was the first to understand this.) Like Rubens, Hals took from the Venetians both their color (which indeed owed something to the North) and their sweeping brushstrokes. But in Venetian art these were used to *serve* the model, exalting the human element across the haze of broken lights of the last Titians, towards a God, soon to become a Jesuit God; just as, presently, they were to plunge the Flemish peasantry, indeed the whole visible world, into the Bacchanalia of Antwerp. Kings had commissioned Titian and Rubens to paint their portraits—painters who could be counted on to give their faces regal grandeur. But grandeur was no longer called for; Hals's brushstroke does not exalt his model, but transmutes him into painting.

Rembrandt, who owed little to him, engaged in the same conflict. But his Protestantism was not a more or less rationalized Catholicism; his temperament was that of a Prophet—a God-possessed man, brother to Dostoevski, and teeming with the future, a future he bore within him as the Hebrew prophets bore within them the coming of the Messiah, and as he bore within himself the past. For it was not the picturesqueness of the Jews that fascinated him, but the element of the eternal that was their birthright. A convert, an outlaw less because of what he did than by reason of his temperament, a lover of servant-girls one of whom went mad (one of Hals's sons, too, died in an asylum), he rebelled with all the fervor of his genius against the world of appearances and a social order in which he saw a blind wall shutting him off from Christ. In his parleyings with the angel who alternately overwhelmed him and abandoned him only two figures existed on earth, Christ and himself

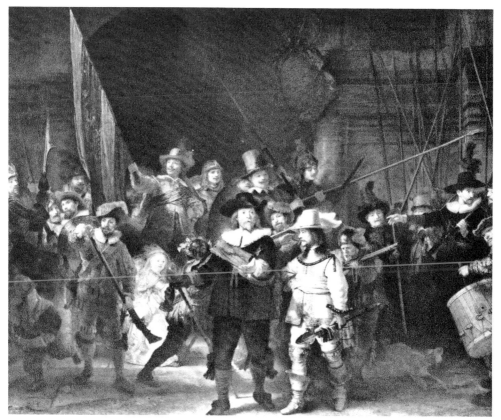

REMBRANDT: THE NIGHT WATCH

REMBRANDT: THE NIGHT WATCH (DETAIL)

—and the man confronting Christ was not Mijnheer Rembrandt Harmenzoon of Amsterdam but an embodiment of all that suffering humanity to which Christ's message was addressed. It was through the individual man that the Reformation interpreted that message, and Rembrandt was haunted by his own face, which he portrayed under many guises—not, as some have thought, to make it interesting, but to multiply its intonations. Indeed even the women's faces in his pictures have a family likeness, because all are like his own, and we seem to see his features (which recall Molière's) glimmering even through those of Christ in the "Hundred Guilder Print."

He is one of the few biblical poets of Western Christendom, and this is why his painting, which does not illustrate his poetry but expresses it, encountered (once he freed it from convention) bitterer hostility than Frans Hals had to face. The ill-success of *The Night Watch* was inevitable. Captain Banninck Cock and his brother officers wanted to have their portraits painted and commissioned the excellent painter who was responsible for *The Anatomy Lesson of Dr Tulp*, a by no means "daring" canvas, for the task. Rembrandt, however, did not paint their portraits, which did not interest him at all; there were not the makings of a picture in the scene that followed the gallant Captain's order to "turn out the guard." So he built up that queerly assorted group in which figure not only the officers but a dwarf and one of those strange women of his who seem to have stepped out of the Psalms; and he shows us a world whose rhythmic play of light and shade seem the stuff of music, soon to become a world where God is omnipresent. Unfortunately for the painter, the pasty-faced Goyesque personage into whom he converted the officer towering above the Captain was not at all to that worthy's liking; he had wanted to cut a stately figure, not to be shepherded with his patrol into a vision of the Day of Judgment!

In short, these Dutch militia officers expected him to give them their "Sunday faces" as Van der Helst—to whom they resorted after this setback—would have done, and failed to realize that Rembrandt's Sunday was not theirs. With the Venetians, idealization had not meant truckling to their sitters' vanity; it came naturally to them, as can be seen if we compare Tintoretto's portraits (at the Academy of Venice) with those of Rembrandt. For Rembrandt's portraiture meant neither idealization nor the rendering of expression; it struck deeper, to the soul, and its symbol is that *Woman Sweeping* who is not even humble and, if confronted by Christ, would have made the most poignant Woman of Samaria ever painted.

It is a curious fact that the fullest response to men's vast yearning for human fellowship should be found in the dialogue of a solitary soul with God. This was the truth that Rembrandt realized in his art, and at the very time when non-religious painting was coming to the fore, his hands alone, grasping the mantle of Him who walked beside

REMBRANDT: WOMAN SWEEPING

the wayfarers to Emmaus, upheld that truth among men. His art had no forerunners, and no successors. Lastman and Elsheimer, like Boel and Aert de Gelder, have much of his manner, but nothing of his incommunicable genius.

But this seventeenth-century Michelangelo had no Pope Julius II; his reverent praise of God did not extend to glorification of the contemporary scene, still less of its great men. Nor could his biblical characters find a home in the Protestant churches, which excluded images. The heroic age of Protestantism was drawing to its close in a land where Protestantism was now the birthright of all and no longer the fulfillment of a pledge made secretly to God. Moreover his pictures, taken singly, had a less compelling impact on his contemporaries than has his work, viewed as a whole, on us. To carry on the torch that Rembrandt lit (the same was true of Dostoevski) what would have been needed was not only a great painter but also a spirit akin to his and capable, like his, of forging for itself the language of its dialogue with Christ. Another Tolstoi: a successor, not a follower. But none was to be to him what Tintoretto was to Titian. If he was to make good, the Protestant painter of those days needed either to display genius or to make shift with values of a non-spiritual order: to belong to the aristocratic school of English painting or to the bourgeois school of contemporary Holland. Thus he applied himself to exploring a world, still in the making, of the nonreligious, and this was the contribution that he made to European art.

These little masters were in the saddle when Rembrandt died, forsaken by all. For many centuries his unquiet spirit was to haunt the museums, telling these lesser men what was lacking in their work. Their realism had a narrow range; apart from landscape, all they did was to raise to a slightly higher level the tavern picture, the conversation piece, the dinner-party or gay-life scene. One is surprised by the fewness of subjects and their repetitiveness, yet this was inevitable, since every style tends to impose its subjects as well as its own manner. What they depicted was the *hollowness* of the world, though, as is the way with an art which aspires to decorate the home, they camuflaged its hollowness with the anecdotal and the sentimental. Not that these artists were incapable of painting excellent pictures; their completely unromantic approach prevented them from lapsing into the meretricious. One of them, indeed, proved that a man of genius, though seeming to limit himself to the world of Pieter de Hooch, could vie with Rembrandt by bringing out a truth that Hals had strongly, Terborch confusedly, adumbrated—a truth that Rembrandt's obsession with the absolute had inhibited him from realizing: that the depiction of a world devoid of value can be magnificently justified by an artist who treats *painting itself* as the supreme value.

The sociologist regards Vermeer as an "Intimist," an illustrator of Dutch home life, and not as a painter. But by the time he was thirty

VERMEER: GIRL WRITING A LETTER (DETAIL)

Vermeer was already tiring of the anecdote, which bulks so large in most Dutch painting. He had nothing of the sentimentalism of his fellow artists in his make-up; the atmosphere of his art, far more refined than theirs, is essentially poetic, and his technique differs as much from that of Pieter de Hooch, to whose it used to be compared (we have only to contrast de Hooch's *Woman Weighing Gold* with Vermeer's treatment of the same subject) as from that of Terborch or even the best of Fabritius.

This misconception has arisen from the fact that Vermeer's subjects were the same as those of his fellow-artists; but, like Chardin and Corot, though he used the stock subjects of his age, he handled them with detachment. His anecdotes are not really anecdotes, his sentiment is not sentimental, his scenes are hardly scenes; twenty of the forty pictures known to us contain only one figure and yet they are not quite portraits in the ordinary sense. He seems to disindividualize his models, just as he strips his world of non-essentials, the result being that they are not "types" but, rather, highly sensitive abstractions in the manner of certain Greek *Korés*. Vermeer's modeling is not de Hooch's emotive modeling linked up with appearances and depth. Often he resorts to a sort of "flattening" which seems to counterbalance some other part of the picture. Thus the smooth expanse of water in the *View of Delft* acts as a counterpoint to the rippling movement of the tiles; the face of the *Young Girl* to the shadows of her turban, so clean-cut that we see each brushstroke; the bodice of the *Girl Reading a Letter* to the dark-blue patches of the chairs; the shadow of the *Woman Weighing Pearls* to the pearls themselves and to the young woman's face—a face worthy of Piero della Francesca. How easy it is for us now, when we contemplate that face, to see the genius hidden for two centuries beneath

VERMEER: WOMAN WEIGHING PEARLS (DETAIL)

craftsmanship lavish to the point of prodigality and an air of consciously sought-after charm! In this picture the volumes are subjected to that bold simplification which imparts to the *Head of a Young Girl* its effect of some translucent stone smoothed by the sea, and to his figures in low relief their affinity to Corot's figures. In this discreetly stylized treatment of volumes distance is tacitly ignored. Some have spoken of the "recessions" in the *View of Delft* and the *Street in Delft*. Actually, when we examine the originals—which contrast in this respect with so many contemporary canvases in the Rijksmuseum and Mauritshuis —we are struck by their lay-out in large planes perpendicular to the spectator. Vermeer merely makes notches in these, whereas other Dutch landscapes, even urban views, frankly employ illusionist perspective. Hobbema was almost his contemporary, yet there is a vast gap between the *View of Delft* and the elaborate recession of *The Avenue*. Like his best figures, his landscapes triumph over Space in quite the modern manner and this is what gives the *Street in Delft*, as against so many pictures of the same period and using the same bricks, its

HOBBEMA: THE AVENUE, MIDDELHARNIS

VERMEER: A STREET IN DELFT

imperishable style. A style less compelling and revealing in the *Head of a Young Girl* than in *The Love Letter*, which was perhaps one of Vermeer's last canvases, less famous than the others because of its less obvious charm.

The scene is framed in an abstract foreground, the left part of which (despite the oblique line) links up with the curtain, the chair and the wall, which blend into each other almost indistinguishably. The Intimists would have treated this spatial recession corridor-wise, according to the canons of a set perspective and with gradated values; Vermeer uses the wall at the back as a backcloth defining the picture space. Between the two planes, back and front, treating this space as a cube, he paints the servant—to whom the broadness of the style and the intensity of the tones impart the solidity of a caryatid—and the woman playing the lute, whose paradoxically massive lightness and almost bovine gaze make us forget that her face is constructed like the faces of the *Young Woman with a Water Jug* and the *Woman Weighing Pearls*. The tiles extending from the door to the two women and harmonizing so well with the slippers and domestic objects which create a well-defined depth, might symbolize this architecturally ordered schema. The letter has no importance, and the woman none. Nor has the world in which letters are delivered; all has been transmuted into painting.

Nevertheless, modern art has not yet begun. This transfiguration of the world into painting, far from being boldly announced, has in Vermeer's art an almost furtive quality and is as cunningly disguised as in Velazquez's *Las Meninas*. Here, reality is not subordinated to painting, indeed painting seems the handmaid of reality, though we can feel it tending towards a procedure which, while not at the mercy of appearances, is not as yet in conflict with them—a balanced compromise. In 1670 Hals and Rembrandt were dead, and a whole epoch had died with them. Coming after them as modern art followed on Romanticism, Vermeer ushered in a new phase of art; but two centuries were to pass before this fact was realized.

But Velazquez, too, was dead, and so was Poussin. Now that the Protestant illumination, after having brought the landscape into view, was reduced to a glimmer of candlelight, the gradual eclipse of the divine element in the Catholic world progressed through vast, successive zones of shadow. Something unprecedented was happening at the close of the seventeenth century, something that was to transform both art and culture; for the first time a religion was being threatened otherwise than by the birth of another religion about to take its place. In its long evolution from the numinous awe of its beginning to the concept of a loving God, the religious sentiment had frequently assumed new forms. The cult of Science and Reason that now ensued was not just another metamorphosis of the religious sentiment, but its negation. The new generation would hear nothing of religion, though presently they replaced it by the cult of a Supreme Being.

To begin with, it was not so much a question of a decline of Christianity as of its transition from the absolute to the relative. A Corneille still could busy himself versifying the *Imitation of Christ;* Racine turned his back on his age; Couperin's genius came into its own in sacred music, and Bach was perhaps no less significant of the times than Fragonard. French culture imposed its pattern on Europe because it stood for one of the mightiest hierarchies the world had known, and imposed an architectural order on the teeming chaos of the Renaissance—yet this order still converged on God. But at the close of the next century the Racine of *Athalie*, Poussin, Rembrandt, even Velazquez (whom his daughter's death moved to paint his *Christ at the Column*), Bach and Handel—all were of the past. What Christian culture was discarding was more than one or another of its values and something even more vital than a faith; it was the notion of Man orientated towards Being—who was soon to be replaced by the man capable of being swayed by ideas and acts; value was being disintegrated into a plurality of values. What was disappearing from the Western world was the Absolute.

The glimmer of the little oil-lamps clamped to the walls of the Catacombs had made those who climbed from their solemn twilight to the light of day regard the gaudy splendors of Imperial Rome as no more than a carnival of madmen. Would those early Christians have regarded otherwise eighteenth-century Rome? What is here in question is not the form assumed by a religion but that impulse of the soul which wrests man from his life on earth and unites him with the Eternal. Athirst for personal salvation, the West forgets that many religions had but a vague notion of the life beyond the grave; true, all great religions stake a claim on eternity, but not necessarily on man's eternal life.

In such oriental religions as are familiar to us the links with eternity are plain to see; are they less evident in Buddhism, with its insistence on the Wheel (so as to escape from it for ever), or in Brahmanism, which is rooted in eternity? The anti-religious mood of the eighteenth century looked for precursors; but, though there had been Greek sceptics, there had never been a culture pledged to scepticism (and ours is not conditioned by our agnosticism but by our conquest of the world). Confucianism, cautious as it is, needs its Son of Heaven. Venus envelops all in a caress that knows no end; Amphitrite merges in her ocean all men and their generations, which drift across her like ripples on the water's face. With the doubtful exception of Roman culture, all early cultures became involved in passionate attempts to compass their eternity.

But now eternity withdrew itself from the world, and our culture became as unresponsive to the voice of Christianity as to the stellar myths and Druid trees. We have heard overmuch of the "decadences" of Antiquity, in which the cry "Great Pan is dead!" made a horde of lurking, half-forgotten gods rise up into the light; the Eternal in its death throes was not replaced by any sorry substitute, until an adversary worthy

of it had been discovered, a new Eternal. What was set up against it was the only enemy of the Eternal which the human mind could find to cope with it; and that enemy was—History.

But ideas deriving from an interpretation of the past cannot have the same emotive drive as those by means of which man once freed himself from Time. And, since it is only when the deepest levels of their personality are engaged that artists embark on a metamorphosis of forms, the passing of the absolute in art was bound to be accompanied by upheavals of much violence. The surprising thing is not that art was affected by this passing of the absolute, but that it was not affected still more. One reason is that many centuries had gone to the discovering of the forms of Christendom and the losing of them was likewise a slow process. Also, the Christians and their antagonists lived side by side (like the Catholics and Protestants). Rembrandt's art did not destroy the art of Rubens; nor Courbet's that of Delacroix. What is more, some of those who were creating a new language of the secret places of the heart pictured themselves, like Nietzsche, as being the bitterest opponents of Christ. Finally, though conflict does not replace the absolute, it helps men to forget it.

The heat and dust of the war which the philosophers were waging against the Church blurred the limits between it and their second front, their war on Christianity as such. Despite the common belief, the eighteenth century was not an age of skepticism, but it was combative, and in foisting on the world a Goddess of Reason it was following a plan of campaign. What was then being substituted for the Christian religion was not so much the values which were used as slogans by its enemies as the fervor generated by the vehemence of their attack. Actually what was being assailed in many cases was not the Christian faith but a formal piety from which all sacred elements had disappeared. Emotions centering on the People and the Nation are—anyhow in times of conflict—forms of communion, and the "war values" of the period enabled Reason to replace the absolute by fervor for the new Enlightenment. Perhaps history one day will regard the soldiers of Year II as successors of the Crusaders, and the French People and the Nation as a substitute for God. But it is not so much such entities as the People or the Nation that call forth art, as the epic story of their heroisms, their sufferings or liberation. The symbols and the passions of a political system that owed much to Rousseau led yet again to the replacement of a Church by what set up to be a Gospel. Modeled no less than the gods of Greece on human values (though on very different lines), the political deity of the nineteenth century stepped into the place of the God of the Jesuits. And soon it, too, rang hollow. "The world has been empty since the Romans!" Saint-Just might have put it more accurately: "Let the world be full as in Roman times, so that men of my breed may live in it!" Louis David chose out Romans who would fit in, more or

less, with the Empire. But already political exaltation was wearing thin. It was not in France that the hinge of the century was being hammered into shape; true, the man who heard again that immemorial voice was "a man of the Enlightenment"—but his name was Goya.

Though the ideas behind *The Shootings of May Third* are Justice, the People and the Nation, the attitudes of the victims bring to mind a Crucifixion; that dark underworld in which Goya's art struck root had nothing in common with the brave new world of Rationalism "The horses of death are beginning to neigh" Like Hugo and Goya, Byron, Schiller, Michelet and even Gœthe were creators of monsters.

It is noteworthy that so many great poets, and likewise great minds —Nerval, Baudelaire, Goethe, Dostoevski—tended to give so large a place to the dark powers of the underworld; in Spain, however, Goya's genius came into its own when the horned devil was transmuted into the spectre of the tortured man.

After the tide of violence had ebbed, the revolutionary was replaced by the man in revolt, *Cromwell* by *Hernani;* as Goya's *Executions* were followed by his *Saturn.* But in the social order in which the rebel artist now made his appearance the middle class was playing a new part.

The French bourgeois was very different from the Dutch burgher of the seventeenth century, for the rise to power of a Protestant middle class had been associated with a return to God. And it was no more a new aristocracy than rationalism was a new religion. Members of the middle class took over posts and functions hitherto reserved for the nobility; but, different though it was from the religious Orders, the aristocracy, too, had been more an Order than a privileged caste. They had fought in the royal armies; as fighting men and legislators they had participated in the "divine right" of the monarch and, once that participation ceased, were swept away. If I refer specially to the French nobility this is because the French Revolution had such world-wide influence and because Paris played a leading part in all nineteenth-century painting; also and above all because the French Revolution was directed against the Christian religion as well as the King—as was not the case with Cromwell or Washington. But its leaders in 1790 were monarchists at heart, not republicans; had Napoleon been able to enlist under the aegis of his nobility an immense Legion of Honor and to keep on good terms with the Church, he would have tried (though doubtless too late) to renovate the French monarchy, with a King crowned at Rheims and placed at the apex of an hierarchy that claimed man's allegiance emotionally as well as legally, and in which Reason played a negligible part. But when the world order that had lasted so many centuries fell in pieces, the middle class made no effort to re-establish it. Neither the virtues nor the failings of that class were in question; Danton and Carnot were bourgeois, Saint-Just belonged to

the petty nobility, and all three were far superior to the princes they expelled. But they did not aim at setting up a monarchy without a monarch, their aim was to exalt the Nation—the Nation of Year II, and a fraternity of citizens no longer subjects. When, after the brief triumph of egalitarianism, the Rights of Man were replaced by the rights of the middle class, the result was that the caste which had sponsored hitherto the highest secular values of the West abdicated in favor of a new ruling class, competent enough but without values of its own. Formerly its values had been the Christian values, but Christ had come on earth to redeem *all* men. Heroism had been a value endorsed by soldiers and citizens alike and in discarding this the middle class rejeted simultaneously the Empire and the Revolution; while owing allegiance to no supreme value of their own, they discarded those which until now had been shared by all—or endorsed them only in so far as they served their turn. The reason why the relations between the nineteenth-century artist and the bourgeois of the period of Louis Philippe were so different from those between the artist of an earlier age and (for example) the Dutch sea-rovers, the Medicean middle class or that of the Flemish cities, was that those earlier middle classes had belonged to a coherent world, whereas the world of the nineteenth-century bourgeois was a disrupted world. Were the Hindus to abolish the caste system, the changes in India would be greater than if the power of the rajahs were transferred to Indian, British or Russian rulers. Christendom was not totalitarian—totalitarianism inevitably dispenses with religion; nevertheless, it had formed a more or less united whole. But in the nineteenth century, for the first time, the artists and the ruling class ceased having the same values.

The fulminations of the nineteenth-century artists against the bourgeois often strike us as far-fetched and even puerile, the reason being that the artists were mistaken as to the true reasons of their grievances against the bourgeois. They accused him of knowing nothing about art—but had the aristocracy understood it so well as all that? Were Géricault, Delacroix, Corot and Manet appreciated in Court circles any more than by the working class, and did the workers, under the new order, show any taste for Courbet's pictures? The artist no longer addressed himself to the man in the street, or to any social class, but solely to a small, select minority whose values were the same as his. What he respected in the past, as in the Revolution, was an order based on values. To his thinking the middle class had usurped the power they now had, not because they had not won it in fair fight, but because it was unjustified.

Did the bourgeoisie hope that Ingres' message would do it the same service as Raphael's had done the papal aristocracy? But now there was no Julius II and, greatest lack of all, no Christ. Ingres' intellectual values were those suggested by Voltaire's tragedies. Like Sainte-Beuve,

INGRES: PORTRAIT OF MONSIEUR BERTIN

DAUMIER: CHARLES DE LAMETH

Ingres thought in terms of a vanished world; he would have been the ideal painter for a France that had not gone through a revolution and whose middle class had fared as did the middle class in England, where the King retained his throne. Like Balzac he recast in the mold of the Restoration the vast social change going on around him and, while the tide was strongly making towards Daumier, swam against it. We find no great bourgeois portraiture after Ingres, though there still were some portraits in the grand manner, such as Delacroix's *Chopin* and Courbet's *Baudelaire*—but these, be it noted, are portraits not of bourgeois but of artists, and the painters were in sympathy with their models. In other cases the portrait developed into a solo, so to speak, by the painter or by his sitter; there was no common ground between them. *Madame Charpentier* is a Renoir, not the portrait of a lady of society, and the opposite is true of Bonnat's *Madame Cahen d'Anvers*. To realize this we have only to imagine these two pictures hung side by side in an 1890 drawing-room. That is why, though there were styles during the bourgeois epoch, there was no great style of the bourgeoisie. Corot was the first painter who had the idea of treating the figure as a landscape; soon the gaze, which hitherto had meant so much was to disappear —or, if it remained, so much the worse for the model! For the first ruling class to fail to find its portraitists found very soon its caricaturists.

Geneva had been ruled by the middle class; but the spirit of Calvin was dominant there—and the Calvinist, in any case, had little use for art. True, Vermeer had found favor with the Dutch burghers; none the less, the spirit of Vermeer's art was not theirs, "pure" art was not what they wanted. Though there was the common factor of a religion in its early, fervent phase, this did not conceal the gulf between Rembrandt and Hals and their environment; yet, if Rembrandt was not a painter of the middle class, at least he shared their faith. Thus a great art could express bourgeois values—but only when they were subordinated to other, transcendent values.

Deprived of the stabilizing influence of the Christian monarchy and equally aloof from the heroic age of the Convention, the French bourgeois felt uneasy when he remembered that the rise to power of his class—in the name of the People—was the result of two revolutions, and he now was threatened from two directions, both by the masses and by those who still hankered after the lost glories of the Napoleonic era. Indeed all the bourgeois asked of art was the illustrative and imaginary. The nineteenth century—like Victor Hugo in his *Quatre-vingt-treize*—had its revolutionary and reactionary myths; never a bourgeois myth. Throughout the eighteenth century the grip of the imaginary on men's minds had been tightening. Such was the obsession with all things Roman that the Revolution had proceeded like a stage play whose protagonists were Roman heroes. Thereafter, the imaginary lost touch with the march of history, for the good reason that contem-

CORMON: CAIN

porary events, unless of a world-shaking order, offer it little scope, and also because fantasy is a condition of its exercise. In his family memoirs Michelet speaks of "the vast boredom of the Empire," and many years had to elapse before Napoleon's figure acquired its legendary glamor. Then historical reincarnations lost their appeal; it took eighty years for the Revolution to regain its "Roman" accent; neither 1848 nor the Commune were to regain that of the Convention. The only art of the imaginary that the victorious bourgeoisie called to life was one that scornfully rejected it. What was there in common between the bourgeoisie and Delacroix's *Crusaders*, or even Couture's *Caesar*, even Cormon's *Cain*? While denying the bourgeois right of entry into the world of the imaginary, the artists welcomed into it all that flouted him. The Western European artist of middle-class extraction vaunted such legendary precedents as that of Byron, the aristocrat in revolt against his country's aristocracy. And the more the bourgeois, unable now to find in art a style congenial to him, came to ask of art a mere pleasure of the eye—switching over from a cult of Racine to a devotion to Augier, from glorification of Ingres to a passion for Meissonier—the more the artists, from Hugo to Rimbaud, from Delacroix to Van Gogh, broadened the scope of their revolt. And now the purport of this revolt began to show itself.

As against a structureless world in which the one remaining power was of a practical order, Romanticism invoked the power of genius; in Dante, Shakespeare, Cervantes, Michelangelo, Titian, Rembrandt

and Goya, the artist found criteria as definitive as Reason and classical antiquity once had been. But these criteria were of a different nature; art was now choosing out its heroes and championing them.

The masters who transformed Western art, those for whom painting had been the means of access to a cosmic or transcendental realm (as it had sometimes been, for their precursors, to the Kingdom of God), have all the less influence today because the worst kind of painting has persisted, ludicrously enough—the theatrical being the parody of the sublime—in claiming descent from them. Though they carry less weight with modern art than El Greco, Chardin or Piero, they are still identified with the highest spiritual values, for our culture as a whole and not only for our modern Romanticism. Why is it that Michelangelo at Florence, Rembrandt in his last phase, set us thinking rather of Beethoven

REMBRANDT: THE THREE CROSSES

MICHELANGELO: RONCALLI OR RONDANINI PIETA (DETAIL)

than of Bach? The realm of art that once was theirs is a lost kingdom for the modern artist, for these men brought, each to his respective art, something that was not limited by that art. Maillol could not have carved either the Chartres *David* or the Rondanini *Pietà*; Ravel is not Bach, nor Mallarmé Shakespeare. But in that Valley of the Illustrious Dead in which the nineteenth century placed Shakespeare beside Beethoven and Michelangelo beside Rembrandt, it associated them all with the heroes, saints and sages of all time; they were witnesses to the divine spark in man, sponsors and begetters of the Coming Man. All the great myths of that century—liberty, democracy, science, progress— converged on the greatest hope mankind had known since the days of the Catacombs. And when the tides of time have done their work of slow attrition and this fervent dream has joined so many outworn hopes in the limbo of oblivion, it will be seen that none other aspired so ardently to confer on all men whatever greatness is man's due. But although the murmur of these buried voices still is audible under all that is best in our time; though no modern man of culture repudiates them; and though the Western world would be inconceivable without them, Rembrandt and Michelangelo share the lot of Shakespeare no less than that of their fellow-artists—just as the transcendental element in certain mosaics at Monreale and in the Knights of Chartres and Rheims shares the lot of Dante no less than that of Naumburg and Vézelay.

Thus during the nineteenth century all the past was being engulfed in the deep yet narrow chasm these great visionaries had opened, and just as there had been isolated from their works, not a repertory of legendary lore, but an heroic attitude which seemed to tower above history, so Manet and modern art set to isolating an *artistic* attitude from the legacy of the past.

The term "bourgeois" is apt to be misleading; the true enemy of modern art in those days was not a Prudhomme or a Homais, but Count Nieuwerkerke, Curator of the Louvre. Though the "Independent" artists were of very different kinds, we tend to regard them as a single body, which suggests that they had but a single enemy. Actually the art upheld by officialdom was not only the "official" art; besides religious art whose object was to edify, there were at least two other kinds of art it sponsored: the academic and the "furniture" picture. The starting point of the former was a cult of Roman Italianism and its aim was to obtain orders for pictures from the Government; the awards that qualified the painter for such orders were made by the professors of the art schools, who were mostly at the beck and call of the authorities. Hence Winterhalter on the one hand, and, on the other, Napoleon's battles painted for Napoleon III and the Battles of Jemmapes for Jules Grévy; hence, too, the "rectifications" of Michelangelo to suit the taste of small-town officials and so many canvases painted for art

galleries in the provinces. "Private" art was somewhat different; it was intended to "go with" the furniture (invariably antique) and much resembled that of the little Dutch masters and the French artists in vogue during the eighteenth century; Meissonier was to be the figurehead of this art. The middle-class picture-buyer sometimes acquired another by-product of art, and one which is apt to be overlooked: the fake. A petition to the Italian Senate asking that the export of works of art should continue to be authorized mentions that in a single city, Florence, no less than eleven hundred forgers were working full time at the close of the nineteenth century. One of the productions of this "school" was the third-rate fifteenth-century portrait—which in fact had never existed. In the eyes of the public of the day all good art was necessarily "ancient" and thus the faker knew what was expected of him and had no difficulty in forcing his way into the art museums. While the Independents took stock only of such elements in the museum pictures as belonged to painting *qua* painting, the middle class was interested in the subjects, historical, fashionable or anecdotal, of these pictures and hailed their makers as great artists. With the best works of bad painters they linked up the minor or "pot-boiling" works of good ones, and succeeded in making Corot figure as a sentimental landscapist. Even now Millet's great talent is obscured for us by the meretricious glamor of *The Angelus*. The art championed by the middle class was seldom of its own choosing; indeed the immense prestige of such art would be inexplicable were it not known to have been vigorously backed by the Fine Arts authorities. Both officials and the public attributed to art (and, indeed, forced on it) a function quite different from its function in the era of Christendom and even under the great monarchies; both alike seemed bent on stripping art of every supreme value, and making it pander to a social order which was rapidly losing its awareness that such values existed. The bourgeois, now in the saddle, wanted a world made to his measure, devoid of intimations and owing allegiance to nothing that transcended it; but such a world was abhorrent to the artist, whose conception of the scheme of things involved a transcendent value—his art.

Thus there now existed side by side not two schools but two distinct functions of painting. They developed almost simultaneously and from the same break with the past. If one day our works of art are the sole survivors of a Europe blasted out of recognition and lost to memory, the historians of that age will be led to assume that in Paris, between 1870 and 1914, two antagonistic civilizations, in water-tight compartments, confronted each other. Different as was Byzantine art from Giotto's there was no less difference between the art-world of Bonnat, Cormon, Bouguereau and Roll and that of Manet, Seurat, Van Gogh and Cézanne. How great a mistake it is to think that the painting of a period necessarily expresses its authentic values! It expresses some

of its idiosyncrasies—but that is quite another matter and, perhaps, a few of its values, if it has any. Otherwise it makes do with pseudo-values, that is to say (at best) the period taste. What is expressed by *Cain*, the style of which resembles the work of some eclectic calendar-artist, with a fondness for Leconte de Lisle? No school so futile as that of the "official" artists of that period is known to us, though some such school may well have existed in Rome before the Retrogression or in China after the end of the Ming Dynasty. All true painters, all those for whom painting meant a *value*, were nauseated by these pictures —*Portrait of a Great Surgeon Operating* and the like—because they saw in them not just a tedious kind of painting, but the absolute negation of painting. Such art was no less obnoxious to the Pre-Raphaelites and the early moderns than to the heirs of the romantic spirit; to Gustave Moreau and Rodin than to Cézanne and Degas. This antagonism had nothing to do with the way the artists had been trained; many of the Independents had learnt art in the same studios as their adversaries. Though the forward-looking artists (whose attitude towards politics was usually one of scornful detachment) disliked middle-class values, they had no illusions about the proletariat who, on the rare occasions when they lingered at a picture-dealer's window, much preferred Bonnat to Degas. Here the sociologist should go warily; the kind of art which followed the art bought formerly by the aristocrats was not one bought by the middle class—it was one that *nobody* bought.

Though pioneers of a so-called "outcast art," Rembrandt and Goya did not regard loneliness as a necessary condition of their vocation. Nevertheless in Goya's case it was solitude that brought home to him his vocation, and in the nineteenth century a special kind of solitude, at once contemptuous and creative, soon came to seem the natural lot of the sincere artist. This was a new development. It is unlikely that Villon, though he knew himself to be a vagabond as well as a great poet, blamed the monarchy for the plight to which his genius was reduced. Pheidias was no more an enemy of Pericles, or a Sumerian sculptor of King Gudea, than was Titian of his Republic, of the Emperor Charles V or King Francis I. The break between the nineteenth-century artist and a tradition that had lasted four thousand years was no less drastic than that between the machine age and all preceding ages, for now the painters ceased catering for the general public or any given class; they appealed to a strictly limited group who recognized the same values as they did.

Inevitably this isolation led to the forming of a clan. Although in the seventeenth century all the arts had tended to accept the same aesthetic canons, painters, poets and musicians rarely met each other. After the end of the eighteenth century the arts diverged, but the artists began to get together and to launch concerted attacks on the culture

they disliked. With the coming of Romanticism, painters, poets and musicians joined in trying to build up a world of their own, in which the relations of objects between themselves were of a special order. However diverse their creative efforts, all bore the stamp of a refusal to conform. "No man on whom a good fairy has not bestowed at birth the spirit of Divine Discontent with all existing things will ever find out anything new." Each artist brought back to the clan of friendly rivals the spoils of his victories, which, while they constantly broadened the rift between him and society, tended to anchor him ever more firmly in the tribal haven where art was man's whole *raison d'être*. All our great solitaries, from Baudelaire to Rimbaud, frequented literary cafés; cantankerous though he was, Gauguin attended Mallarmé's "Tuesdays," and Mallarmé was a close friend of Manet, as Baudelaire had been of Delacroix—indeed it was not the art critics but the poets (Baudelaire and Mallarmé) who were the best judges of contemporary painting. The vocabulary used by the artists in their aphorisms, casual remarks and private letters (as apart from their occasional writings on aesthetics) recalls the language of religious mystics—stepped up by the use of *argot*.

Humanistic styles had glorified the cultures to which they belonged; now, however, the coming of styles tending to make art an end in itself alienated the artist from his social environment and led him to foregather with his fellow artists. Anacreon, even Racine, meant little to artists obsessed first with Velazquez, then with the Primitives. There had been no precedent, even in Florence, for a closed circle of artists of this kind, but art had now become a specialized activity, for which life furnished merely the raw material. The value of each member of the clan was judged in terms of his ability for bodying forth a world created by himself. Thus there came into being a sect of dedicated men, bent more on transmitting their values than on enforcing them; regarding its saints (and its eccentrics, too) as the salt of the earth; more gratified, like all sects, than its votaries admitted by the clandestine nature of their quest; and prepared to suffer, if needs were, in the cause of a Truth none the less cogent for its vagueness.

Manet and Cézanne, proclaimed far more categorically than Delacroix, that the mere tourist is very different from the pioneer and that it is not by imitating the works of men whom he admires that the painter proves himself worthy of them. Though our great modern artists appealed to the judgment of posterity, they often cast a backward glance, ardent and fraternal, on those they held to be their masters. To their mind, all true painting carried its posterity in its womb—true painting being such painting as did not seem subordinated to anything outside itself, the hard core of art. With the widening of historical knowledge and a growing awareness of the infinite diversity of painting, the problem of what it is that makes the work of art immortal—that "survival value" of which the beauty that arose on the shores of the Mediterranean had

been but a fugitive expression—came to the fore, and with it an ambition to recapture and perpetuate this language whose beginnings were lost in the mists of time. In its service the artist took poverty for his bedfellow, and the usual tale of sacrifice went on, from Baudelaire to Verlaine, from Daumier to Modigliani, and how many others! Rarely can so many great artists have made so many sacrifices to an unknown god—unknown because those who served him, though vividly conscious of his presence, could describe it only in their own language: painting. Even the artist most disdainful of the bourgeois (i.e. the unbeliever), when painting his most ambitious picture, felt qualms about employing the vocabulary which would have conveyed to others his ambition.

Though none of the artists spoke of "truth," all of them in stigmatizing the works of their enemies spoke of "lies." When the phrase "art for art's sake" came into vogue—eliciting a smile from Baudelaire—what did it imply? Simply the picturesque. But no one was disposed to smile once it began to be suspected that what was involved was neither art for picturesqueness' sake, nor art for beauty's sake, but a faculty which, overleaping the centuries, recalls to life dead works of art; and that the artist's faith, like all other faiths, staked a claim on eternity. The outcast artist had taken his place in history; haunted henceforth by visions of his own absolute, while confronted by a culture growing ever less sure of itself, the modern painter came to find in his very ostracism the source of an amazing fertility. Thus, after having traced on the map of Paris, like wavering blood-trails, so many sad migrations from tenement to tenement, the inspiration issuing from those humble studios where Van Gogh and Gauguin met—flooded the world with a glory equaling Leonardo's. Cézanne believed that his canvases would find their way to the Louvre, but he did not foresee that reproductions of them would be welcomed in all the towns of the Americas; Van Gogh suspected that he was a great painter, but not that, fifty years after his death, he would be more famous than Raphael in Japan.

Every day the incapacity of modern civilization for giving forms to its spiritual values—even by way of Rome—becomes more apparent. Where once soared the cathdral, now rises ignominiously some pseudo-romanesque or pseudo-gothic edifice—or else the "modern" church, from which Christ is absent. There remains the Mass said on the mountain-top (whose insidious perils the Church was quick to realize). Indeed the only setting worthy of itself—outside the Church—that the Mass has found in our times was within the barbed wire of the camps. It is a thought-provoking fact that Christianity, though it still delivers men from the fear of death's extinction, and alone gives form (in the highest sense of the term) to their last end, should be so incapable today of giving its churches a style enabling Christ to be Himself in them, and of combining artistic quality with spiritual values in the figures of the saints.

Here we have something more than a conflict between religion and individualism, for if the modern Christian came to be really moved by Rouault's art, he could not fail to be moved by the art of the Middle Ages and the Church would call for another Villeneuve *Pietà* before commissioning a *Descent from the Cross* by Rouault. This conflict exists wherever a machine-age culture has made good. Only in regions where they are immune from it have Islam, India and China preserved their sacred forms; not so at Cairo, Bombay and Shanghai. And they find no new forms to replace these. Surely that little pseudo-gothic church on Broadway, hidden amongst the skyscrapers, is symbolic of the age! On the whole face of the globe the civilization that has conquered it has failed to build a temple or a tomb.

Agnosticism is no new thing; what is new is an agnostic culture. Whether Cesare Borgia believed in God or not, he reverently bore the sacred relics, and, while he was blaspheming among his boon companions, St. Peter's was being built. The art of a living religion is not an insurance against death but man's defence against the iron hand of destiny by means of a vast communion. The nature of this communion has varied with the ages; sometimes it instilled in man a fellow-feeling for his neighbor, for all who suffer, or even for all forms of life; sometimes it was of a vaguer order, sentimental or metaphysical. Our culture is the first to have lost all sense of it, and it has also lost its trust in Reason, now that the knowledge that the thinking mind is incapable of regulating even the most ordinary activities of life has come to play a leading part in our modern civilization—which, moreover, declines to regulate its irrationality. Thus, thrown back on himself, the individual realizes that he counts for pitiably little, and that even the "supermen" who once fired his enthusiasm were human, all too human. An individualism which has got beyond the stage of hedonism tends to yield to the lure of the grandiose. It was not man, the individual, nor even the Supreme Being, that Robespierre set up against Christ; it was that Leviathan, the Nation. The myth of Man—which both preceded that of the individual and outlasted it—was similarly affected. The very question "Is man dead?" carries an implication that he is Man, not a mere by-product of creative evolution, in so far as he applies himself to building up his personality in terms of what is loftiest in him—that part of his Ego which is rarely centered wholly on himself.

A culture based on man regarded as an isolated unit seldom lasts long, and our eighteenth-century rationalism led up to that outburst of passionate hope which has left its mark on history; but the culture of that century summoned back to life whatever in the past shored up its rationalism, whereas the present century revives all that seems to sponsor our irrationalism.

496

II It was as systems of forms, carrying a wide range of significances, that the rediscovered arts impressed our artists to begin with. And, paradoxically enough, certain African statues, not one curve of whose noses could have been varied by the image-maker without the risk of his being put to death by order of the witch-doctor, struck them as the acme of artistic freedom. When Cézanne in his old age, drawing almost all modern art in his train, announced that "we must now do Poussins—but from life," young painters came to realize that, if his last watercolors were to be transcended, a fetish had more to offer them than *The Rape of the Sabine Women*. Thus the so-called Primitive arts rendered them the same service as Antiquity had rendered to the Renaissance, pointing the way towards new and promising methods of expression.

It was as adversaries of illusionist realism and sentimentality, and as antidotes to Baroque, that these arts emerged. In the art of the Steppes violent movement obliterates the natural forms of the animals portrayed. That of Tibet, with its violence and its objective delineation

TIBET: A YIDAM AND HIS SAKTI

497

of fantastic beings, is out of place even in the modern art museum; its products are more in the nature of "curios." Yet though the theatrical arts seem, provisionally anyhow, doomed to oblivion, the presence of an hieratic quality is not enough to ensure the survival of the others. Though the figures in them are immobile, Persian miniatures have had little influence on our art. The reason is that, like all Chinese art subsequent to the great Buddhist styles, these miniatures have a seemingly humanistic refinement, and this is not what we are looking for. In fact our resuscitations are selective and though we have ransacked the ends of the earth, we have not taken over all the arts that came to light. However remote the Chinaman of the painted screen (so dear to Diderot) may have been from the real Chinese, however remote Montesquieu's Persian from the real Persian, it was not without good reason that the eighteenth century found in them a kinship which it denied to India and even to Islam. No doubt the savage races have for us the appeal of all newcomers—but do we wish to hear the voices of civilization? Only one civilization was familiar to us, that of the Mediterranean, until quite recently. The eighteenth and nineteenth centuries knew only the decorative side of Asiatic art, and it was only at the beginning of the present century that the high cultures of India and China became known outside a little group of specialists. Their medieval forms (and only these) have an immediate impact on our modern sensibility, which finds so much that is congenial in the rock-face carvings of Yun Kang and is stirred by the painting of the Sung dynasty—whereas a Ming painting makes no impression on it. The enthusiasm for Japanese prints and lacquer work did not survive the revelation of the great Buddhist art of Japan; what modern artist would dream of pitting Hokusai against the Nara frescos? The forms which are recalled to life by our own forms have always more in them than a mere resemblance to the latter; thus though the Fayum portraits are like some modern portraits, they are simulacra of the dead. And, while we have hunted out all the world's arts, we do not find a place for all in our symposium.

We take over Byzantine art despite its gold; but, all for God, the Byzantines almost entirely ignored man; the reason why an art, if it is to be resuscitated, must not sponsor an idea of civilization is that we resent the presence in it of any kind of humanism.

But is humanism the determining factor? Behind the conflict that arose between modern art and museum art in 1860 lay an implicit challenge of the values the museum stood for. No doubt mistaken ideas regarding Greece were current at the time; thus Goethe, Keats, Renan and even Anatole France saw in Hellas an ally in their struggle to break free from the constraints of Christianity. But the revolt they read into the Renaissance was not imaginary; only it had begun much earlier, when Greece (after Crete) set herself up against the East. Though, when

CHINA (6TH CENTURY?). YUN KANG: BODHISATTVA

KAFIRISTAN: FUNERARY FIGURE

comparing certain Greek figures with the noble forms of Egypt or Chaldaea, we may think less of the former, we cannot help feeling that they, too, are forms proclaiming emphatically man's freedom. From Tanagra statuettes to stelae, from Greek dolls to the statuary of Olympia, all move to a subtly dancing rhythm that defies the hieratic immobility of the East. With the resurgence of the forms of Egypt and the Euphrates, then those of Romanesque, and their challenge to the forms of antiquity, man—trembling victim of the gods—has made once again his appearance on the scene. For after discovering these forms, then those of savages, we have harked back to the so-called retrograde arts of Kafiristan and Central Asia, and finally to that of the great thousand-years "decadence," and have travelled ever farther up the stream of Time—towards (as we thought) the fountainhead of instinct. And, as by-products of our quest of ever more archaic primitives, we have discovered the art of children, folk arts and the art of the insane.

I have spoken of the miracles, so easily come by, in the art of children. No doubt there is an element of play in the pleasure it gives us, for, charming as children's watercolors often are, we soon tire of them. Also, we are less inclined than we profess to be, to assimilate even carefully selected specimens of child art at its happy best to the language achieved by the most seemingly childlike of our painters.

Popular or folk art—the art that ranges from the color-sheets dear to the peasantry to the wayside crucifixes—is of a different order.

The creations of the rustic picture-makers are no more the result of accident than are those of recognized masters; these picture-makers knew their public. When an art of the rich exists alongside, this is essentially the poor man's art. Attuned to the simplified forms familiar to the peasantry, it draws on their legendary lore, whose roots strike deep in Time, and in every "sheet of saints" there is something of the ikon. Copperplate engraving was costly, the painted picture still more costly. Perhaps the humbler classes did not feel cold-shouldered by the Jesuit picture, but they certainly felt that Poussin, Watteau and Gainsborough were not for them. With the popular picture-sheet they could feel at ease. Still, though the sentimentalism of the masses was gratified by a form of expression that seemed akin to them, they could also appreciate other forms of expression, provided they, too, struck a sentimental note. Thus Georgin's successor on the walls of village inns was not some Breton folk-artist, but Detaille; and the successors of those who carved the wayside crosses were the statue-makers of St. Sulpice.

At the time when modern art was born (round about 1860) popular art was dying out, along with the Midsummer Night's fires, Carnival and the maypoles; it entered the world of our artists at the very moment when it was *in extremis*. It had broken with aristocratic art at the time when a secular culture was superimposed on that of Christendom, and it remained linked up with Gothic art in so far as this art had expressed the same emotions as its own; the "Protat Woodcut" is, so to speak, the small change of Gothic art—but Georgin is not the small change of Delacroix. Our folk-picture makers had their reasons for perpetuating

THE PROTAT WOODCUT (CA. 1460)

501

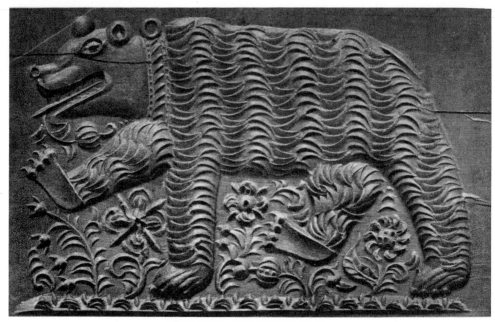

SWISS FOLK ART: BUTTER MOLD

Giotto's knights, remote in time as these were; it was Napoleon that the famous Epinal colored sheets substituted for pictures of the saints during the nineteenth century. Though all popular arts have dealings with religious and legendary lore, it was above all in Western Europe that they kept their Gothic accent. And at the same time throughout the whole of Europe (once another idiom, that of the Celtic coins, which seems to go back to prehistory and perhaps belonged to the great migrations, had died out) popular art continued to employ a still more rudimentary script, that of the butter print and the bread mold, common to both Slavs and Westerners. Gothic art was in fact a development of this humble art of humble folk, and we might be led—wrongly—to draw the inference from its most widespread forms that every folk art has a touch of Gothic. But this suggestion is conveyed only by the folk art of Europe; in its Chinese counterpart our "shepherd's-crook" style is practically non-existent, Africa and Polynesia add to it their characteristic angles, and the pictures Islam is giving us today are pure calligraphy. What makes us associate Gothic with a certain kind of folk art—which seems to us, though mistakenly, to typify all such arts—is a combination of sentimentality and stiffness. But neither the popular art of Asia, nor Gheber pottery—in which we find that rare thing, a hint of one of the Byzantine popular arts—shows any tendency towards the Gothic broken line and fluted drapery. In Central Europe the

BYZANTINE CROCKERY

arabesque, which, by way of Baroque, found its way into popular art,
ceases to express depth and movement and develops a sinuosity sometimes
like that of the East or a calligraphy that is at once naïve and poetic;
its drawing reminds us more of Dufy than of medieval woodcuts.
Whatever their linear patterns, popular arts seek to perpetuate that
expression of the past which is imperiled by the advance of civilization
and the aristocratic art it sponsors: an expression of that uncharted sea
of time across which civilizations, like lost armadas, glide into oblivion.

POLISH FOLK ART

POLISH FOLK ART

CZECH FOLK ART

These forms draw all the "historical" arts from which they arise into a common melting pot, in which they merge saints and knights of old, Cartouche, Mandrin, Judith, Robin Hood, giving them a rigidity, imparted even to the scroll-work, for which the woodblock process is not sufficient to account. This is particularly evident in Breton art, which has produced works of an almost monumental order, whose dates are known. Its famous "Calvaries" which began with the Renaissance have been struggling against the Renaissance ever since; the figures in these "Calvaries" seek to take over those of the royal tombs, and alongside the ancient faces of peasants or apostles, poor relations of those wonderful pre-Romanesque figures of Auvergne, we find plumed feudal lords whose stiffness suggests an interpretation on heavier lines

THE PLEYBEN CALVARY (16TH AND 17TH CENTURY): THE MAGI

of their Spanish counterparts—following the same process as that which, inside Breton churches, was to impose a rustic heaviness on the dancing, golden grace of Italy.

The color of folk art (from the picture-sheets to those small doll-like figurines known in Provence as "santons") is not less different from the color of the art museum than is folk drawing from academic drawing; indeed its handling of color is far more independent than its drawing, which is often unmistakably derivative. The early Provençal santons are little more than blobs of color—so much so that when modern santon-makers enlarge them into statuettes and give them real faces, all their distinctive quality is lost. Like that of the early color-prints, though more subtly, their color is neither Romanesque nor Gothic, but more

507

like that of the turquoise and coral plaques of the lands of snow; of the glassware trinkets of savage races, their feather jewelry and ceremonial costumes—one of the world's oldest languages. Indeed these arts belong to a culture as far removed from ours in Time as many others are in Space; to the domain of the mystery play (and the Punch-and-Judy show), but not to that of the theater. For us to get from them more than a vaguely condescending satisfaction, all that they need is that spark of immortality struck forth by genius.

To this domain of art (perhaps of color, too) the Douanier Rousseau belongs. Let us rule out the second-rate, which bulks regrettably large in his output: over-simplified landscapes, conventional lay figures. He is a painter to be treated anthologically (as indeed all modern painting should be treated, more or less). And the same holds good for the masters of the past, whose world-famous names conjure up for us not the by-products of a studio but a few majestic works. The Douanier's best canvases are the work of a great colorist, and one whose color is anything but naïve. The garish hues of the popular color-print are absent, and usually the harmonies are discreet, even if they sometimes tend towards tonal combinations which have a popular appeal; those of uniforms, for instance. But you will never find the blue of the *Wedding* and the *Poet and his Muse*, or the white of *The Tollhouse*, in the Paris Flea Market; nor the colors of *The Snake Charmer*, in which the yellow edging of the irises is far from realistic. Sometimes, when reproduced in black and white, his pictures may be confused with naïve art; but never, when we see the pictures themselves. The naïve painters lived outside the art world, whereas Rousseau counted painters and poets among his friends; moreover, we can tabulate his works chronologically, as we do those of the great masters. But of the naïve painters who preceded him (and even those who have followed him) we know only isolated works. More noteworthy still: at a time when painting and poetry seemed to have parted company, he renewed that incantation which we find in Piero di Cosimo, and which was to reappear in Chirico, but which is no longer heard; and perhaps Apollinaire would have responded less readily to that timeless color, had not a certain poetic accent, unmistakable to him, whispered in his ear of genius.

True, there is little or nothing of the child—visibly, anyhow—in any of the great poets; yet no one who has come in contact with several of them can have failed to recognize the type at once infantile, forceful and a shade sophisticated, to which they so often belong. There is something of Verlaine in the Douanier. Those young writers who thought they were making of him a figure of fun were to hear long after his death, sounding in their ears, the waltzes played to them by the ghost of one they never could forget. They called on the old artist "just to have a good laugh" (so they said, untruthfully); they were to be the builders of his fame. Even had he never painted a canvas, this man

who could gather under Picasso's roof—comic though the occasion was meant to be—Braque, Apollinaire, Salmon and Gertrude Stein was to set future generations dreaming. When by way of a joke some art students sent a man made up to look like Puvis de Chavannes to call on him, he calmly replied: "I was expecting you." It was only in the manner of Dostoevski's "Idiot" that the name fitted this man of genius. "There is a terrible power in humility."

The Douanier is less a naïve artist than the interpreter of an immemorial language. Had he not been able to paint his virgin forests, he would have painted his suburban scenes quite differently. In the *Hungry Lion* of 1905 he reverts to that theme of fighting animals which lasted through four millennia, from Sumer to Alexandria, and is found even at the foot of the Great Wall. And above the lion which he never saw in Mexico (where there are none) he places the owl of the Zoological Gardens, ancient symbol of the devil. The horse in his *War* is exactly the horse of the Magdelenian paintings. Thus his greatest paintings

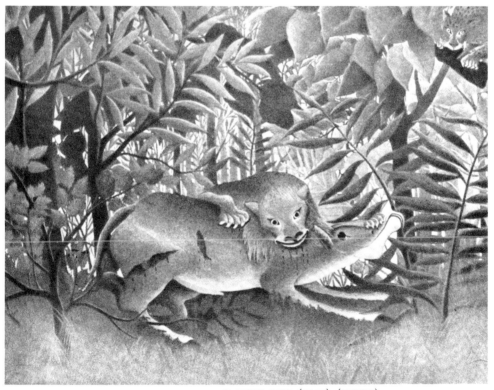

HENRI ROUSSEAU: THE HUNGRY LION (1905) (DETAIL)

link up with a prehistoric past. Rousseau was not indispensable for our rediscovery of naïve painting; the Primitives would have sufficed. Nevertheless he sponsored it, as the great masters of the past have sponsored their disciples; and this "innocent," this inspired journeyman, has won a place in art history, as did the abstract painter in succession to the Cubists. Dead, the Douanier has become the leader of a school. But his true school is not that of the naïve painters who are imitating him today. For though he measured the noses of his sitters, his art, meticulous as it is (like that of Bosch), is steeped in fantasy. It is not conditioned by visual experience—and this though Impressionism was in its heyday, for Rousseau was nine years senior to Van Gogh—but by the very stuff of dreams. Though *The Tollhouse* is worthy of Uccello, it is also the landscape of a dream—we need only look at that odd figure posted on a wall.

PHOTOGRAPH OF THE PLAISANCE TOLLHOUSE IN ROUSSEAU'S TIME

510

HENRI ROUSSEAU: THE TOLLHOUSE

Like the poet of the Seasons, Rousseau tells us of their eternal cycle—bare branches etched against the sky, red-brown leaves freckling the dark soil—with the same seemingly ingenuous felicity as the Primitives when they voice religious sentiment. It is not only his talent, it is his escape from the Wheel of art history, giving us, too, a sense of liberation, that assimilates him to those early artists we are now rediscovering; and not his naïvety, which was but the price he paid for this escape.

This, far more than his forms (though an escape of this order called for a certain kind of forms), is why his art means so much more than that of the Sunday painter he once seemed to be, and links up with the remotest realm of popular art. We find those animals of his, rendered in flat planes, sometimes dark and sometimes white but usually of a wraithlike hue, in the American Primitives—in the Whitney Museum *Horse* and the Santa Barbara *Buffalo Hunter*. Thanks to that poetic feeling which, rescuing certain of his canvases from a style that was

AMERICAN PRIMITIVE ART: THE BUFFALO HUNTER (CA. 1830)

HENRI ROUSSEAU: THE SNAKE CHARMER (DETAIL)

looked down on at first, forces us to see them *all;* and thanks to the rarefied emotion present in some other canvases, his color and a special handling of forms (in *Summer, Les Buttes Chaumont* and several landscapes) as remote from the art of his day as from that of the naïve artists—by all these means he recalled to life these latter much as (on a far larger scale of course) the Renaissance artists had resuscitated the art of antiquity. Such is the high privilege of truly creative art throughout the ages. Thus on lonely evenings the gray hair of the widower playing his flute before the *Portrait of Clemence, my Wife,* was lightly, soothingly, caressed by that same august hand with which Michelangelo summoned the *Laocoön* from its long sleep, and in the humble studio in a Parisian suburb that primitive tune, played also by the *Snake Charmer,* conjured up the fetishes and the world's oldest dreams.

There is no longer any popular art because there is no longer a "people" and, assimilated even in the countryside to the city-dwellers, the modern masses are as different from the artisans and peasants of the recent past as from those of the Middle Ages. That term "the people" when Retz applied it to the Parisians already sounded inappropriate; the Cardinal would have done better to speak of the populace or the bourgeoisie. The "people," buyers of picture-sheets and singers of folk songs, stemmed from the oldest civilizations on earth and hardly knew how to read.

Once the part songs sung at home were replaced by the radio, woodcuts by the magazine photograph, and the tales of derring-do by the detective story, there was talk of an art of the masses; that is to say, art was confused with the methods of fiction. There is a type of novel made for the masses, but no Stendhal for the masses; a music for the masses, but no Bach—nor, whatever may be said, a Beethoven; a painting for the masses, but neither a Piero nor a Michelangelo.

It is generally agreed that the work of fiction appeals to the collective imagination because it acts as a compensation; each of us pictures himself playing the part of the hero. But the films in which the millionaire marries the little shop-girl do not monopolize the cinema any more than tales in which the prince marries the shepherdess monopolize the legend —or than Hercules monopolized classical mythology. The legend of Saturn is not a compensation. Nor is the world of fiction so much a world of "stories" as is generally believed. No adventures need occur in the Happy Isles—which are a wonder in themselves. The wonderful (like the sacrosanct, of which it often seems to be an annex) belongs to the "Other World"—a world that is sometimes comforting and sometimes terrifying, but always quite unlike the real world. Though servant-girls may dream of marrying a prince, preferably a Prince Charming, *Cinderella* is not a mere wishful success story; the rats transformed into footmen, the pumpkin changed into a coach play quite as large a part

in it as the wedding. The tale is the tale of Cinderella, but it is also the tale of an enchantment; the true hero of every fairy story is the fairy. The spiritual home of man set free, that wonderland has given sanctuary to many different races, and captivated all. The record of its successive conquests is enlightening. Though the tragic myths, from that of Saturn to the love-potion of Isolde, are always present in it, they have never ousted the immemorial fairy-fold; the fairy tales were christianized, the Golden Legend permeated Europe and the romances of chivalry came into their own. For many centuries that collective day-dream was not a mere fantasia of wild imaginings but a sequence of organized creations. Then came a day when the hero ceased to exist; or, more accurately, lost his soul.

From the seventeenth century on, the outlaw entrenched himself, ever more solidly, in the land of the imaginary. The rise to popularity of the gentleman-burglar, a character no less (and no more) real than Puss-in-Boots, was quite other than the idealization (a relatively late development) of the condottiere. One reason why the anecdotal element died out of painting in the mid-nineteenth century may well be that the artists had ceased believing, not only in the legendary characters of the past but also in those of contemporary fiction. It was poetry, not the novel, that inspired Delacroix when he painted legendary scenes. No artist painted the heroes of *The Mysteries of Paris* which, nevertheless, had fired the imagination of all Europe, and from the days of Balzac onwards the novel was made over to the illustrator. *The Three Musketeers* and *Les Misérables* were the last legends; then came the age of Flaubert. In quest of wonder, art turned to history and the exotic, and in exploring these fields gradually eliminated the fantastic. The last French hero, in the exact meaning of the term, was Napoleon; Meissonier was shrewd enough to depict him in defeat—and we have difficulty in imagining a portrait of him by Cézanne. No other figure has replaced his; a shattered inner world finds its equivalent in an imaginary world deserted by its saints and by its heroes.

It would be rash to assume that the emotions the modern crowd expects from art are necessarily profound ones; on the contrary, they are often superficial and puerile, and rarely go beyond a taste for violence, for religious or amatory sentimentalism, a spice of cruelty, collective vanity and sensuality. When the men or women who were united in the Resistance with so many unknown brothers-in-arms go to the cinema in quest of a world of romantic make-believe they want something other than an expression of fraternity; the thrills of the romantic do not unite men, but isolate them. Thousands of individuals may be united by a revolutionary faith or hope, but (except in the jargon of propaganda) they are not "masses" but human beings with the same ideal; often

united in action and always by that faith in something that, to their mind, counts for more than their individual selves. Every collective virtue stems from a communion. And no deeply felt communion is merely a matter of emotion; Christianity and Buddhism gave rise to emotive arts, but, once Christ had been discarded we found neither a new Chartres nor a new Rembrandt—but only Greuze. In civilizations whose unity was based on a supreme Truth art nourished the best in man by the loftiest type of fiction. But once a collective faith is shattered, fiction has for its province not an ideal world but a world of untrammeled imagination. Art may try to impose standards on it, but fiction can dispense with them, and cathedrals are replaced by picture-palaces. The creative imagination is put to the service of amusement and, with the break-up of man's inner world, the arts of delectation—entertainment for its own sake—sweep the board.

It is remarkable that even bad painting, bad music and bad architecture should have only one term, "the arts", to describe them all

TADDEO GADDI: MADONNA (DETAIL)

alike. The term "painting" applies equally to the Sistine ceiling and the most ignoble color-print. But what in our eyes makes painting an art is not the mere arrangement of colors on a surface, but the quality of the arrangement. Perhaps the reason why we have only one word available for such different things is that until comparatively recently no "bad painting" existed; thus there is no bad Gothic painting in our sense of the word "bad." This does not mean that all Gothic painting was necessarily good; but what distinguishes Giotto from even the feeblest of his disciples is something of a different nature from that which differentiates Renoir from the illustrators of *La Vie Parisienne* on the one hand and the academics on the other. All works of art produced in an age of Faith express the same attitude on the artists' part and ascribe to painting the same function. Between Giotto and the Gaddis the difference is a matter of talent, whereas that between Degas and his fellow-student Bonnat is a schism; between Cézanne and "official" painting it is not merely the contrast between two monologues, so to speak, but also that

GIOTTO: MADONNA (DETAIL)

517

BONNAT: PORTRAIT OF MADAME CAHEN D'ANVERS

CÉZANNE: YOUTH WITH A SKULL

between two dialogues; in addressing himself to us, Cézanne is not "out to charm." If we have only one word for that which makes of lines, sounds or words the expression of certain age-old languages of Man (for "music" means not only Bach but also the most sickly-sweet tango and even the sound of the instruments), this is because there was once a time when it was unnecessary to draw distinctions; the music played in those days was bound to be real music, since no other kind existed. The conflict between the arts and their means of expression was unknown in earlier ages; it began with the School of Bologna, and thus with eclecticism; during the Romanesque period it would have been unthinkable. We may find the symbol of an art that is fully understood by the people in a coherent (by which I do not mean totalitarian) civilization, in the Black Virgin. Until the beginning of this century many of the Virgins in the great places of pilgrimage were black, for the reason that being the least human, they were the most sacred. Magazine illustrations, portraits of Hitler and Stalin and the picture on the cover of *Sherlock Holmes* are not Black Virgins. The only art which spoke to the masses without lying to them was based, not on realism, but on an hierarchy oriented by the supernatural and a vision of the unseen world; it was this art that, from Sumer to the Cathedrals, held its ground —in ages before the mere notion of "art" had crossed men's minds.

The success of the arts of delectation is less dependent on technique than is generally supposed. No doubt the success of a song that "makes a hit" throughout the Western world has more in common with that of the "Bébé Cadum" soap poster or a publicity slogan than with the genius of Bach; song, poster and slogan exploit certain basic, universal emotions for the benefit of the man who has devised them. A bombing plane hovering above the Cadum baby's head would make a much more efficacious poster for world peace than Picasso's famous dove. But efficacity in this field is due to a happy inspiration of the inventor, not to a technique, this "inspiration" being a crystallization of the collective sensibility achieved by a man who shares in that sensibility—though sometimes for the profit of a man who is far from sharing in it.

Our sensibility is worked on by exactly the same means (sounds, rhythms, words, forms, colors) as those employed by art. The question is: In the service of *what* are these means employed? That an artist can express with genius the sentiments of the race to which he belongs has been proved by Goya and by many others; indeed it rarely happens that an artist speaks for himself alone. He does not turn his back on the masses in the manner of an aristocrat; in the ages of Faith his genius was inseparable from the dialogue he carried on with them. In present-day communities he turns his back on what they ask of him, but these communities are by no means identical with the people and the proletariat (though these may be included in them). Thus in the eighteenth

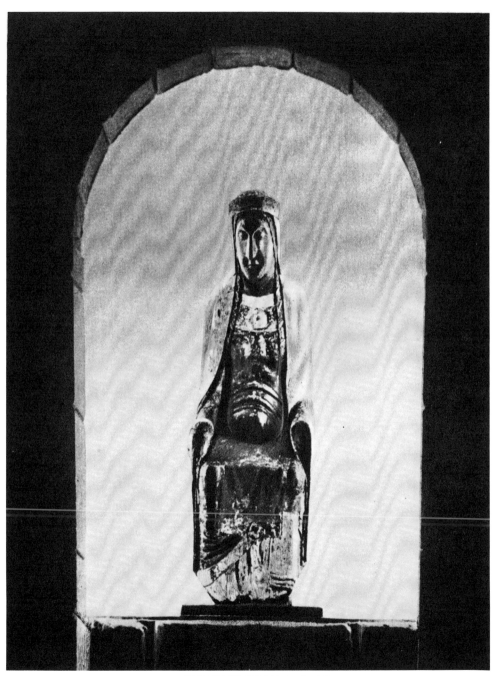

THE BLACK VIRGIN OF DIJON

century the social order was ecclesiastical and bourgeois, and during the nineteenth century the art of delectation, which had become the "official" art, owed its unprecedented popularity to the middle class.

So brilliant was the victory won by the Independents that we are apt to look on the "official" artist as being no less defunct than Jesuit painting. Thus we see the air around us only when its thickness makes it blue. But, though expelled from painting (*qua* painting), everywhere else the aesthetic of officialdom reigned and still reigns supreme; even in 1952 the spirit of Rochegrosse and Bouguereau more than holds its own against reproductions of Picasso. Moreover, by discarding much of the prudery of the past (bathing costumes are dispensed with) it has gained in strength. For several generations bourgeois painting has been "suggestive." The catalogue of the 1905 official Salon, while quite unlike that of the Indépendants of 1950, looks uncommonly like a modern

SOVIET ART (1939): TARASS BOULBA (LITHOGRAPH)

illustrated magazine. Nor does the political régime in force make any difference; the West ranks Cabanel alone above Horace Vernet, while the Russians rank Detaille (whom they imitate) above Cabanel, who is unknown to them. Such arts as affect the masses otherwise than through a community of feeling are the direct heirs of bourgeois painting, and as a whole, aside from some outstanding modern works in which humor plays a part—Charlie Chaplin's art has much of the fairy-tale, but he dilutes it with sentimentality—all these arts are on the way to atrophy. Quality, when they think of it at all, is never their aim, but merely one of their means. We can appreciate some highly gifted poster artists, though we know that none of them is a Michelangelo, nor yet a Klee. They are most admired in countries where art has a long cultural tradition, and more for the prestige of their talent than for the efficacity of their representation; for the most efficient publicity is the American publicity, which exploits conditioned reflexes and is making for its canned goods a Museum without Walls of foodstuffs. In any case the masses are less affected by the poster, which they do not take seriously, than by the tendentious photographs in magazines and films. The film and the detective story (made to "sell") act on their public by their narrative technique and often by an exploitation of sexuality and violence. The Soviet mass-produced film aims at transporting its public into an imaginary world and does this by substituting for the saga of the Revolution—or the dangers threatening Russia—a pious legend, and all that this implies; while Soviet propaganda sponsors the same world by infusing a crude form of Manicheism into Marxism. Toselli was out for popular success and achieved it by means of a blend of sentiment and sensuality. Did the composers of the folk songs want to "make a hit" à la Toselli? No doubt the makers of the picture-sheets and chivalric romances wanted to sell them, but the intoxication which every publisher (and author) of crime stories hopes to induce in his readers is different in kind from the excitement provided by the exploits of Don Quixote. True, the Don was mad, but he was bent on becoming a true and valiant knight. Even the Baroque stories and paintings of martyrdoms were not deliberate essays in gruesomeness. However, the distinctive quality of these arts of delectation is not their violence; many truly great works make an assault on the reader's or spectator's nerves, and this violence does not detract from our admiration of Grünewald, the painters of the *Pietàs*, Shakespeare, Balzac, Dostoevski—and Beethoven. Nor does this distinctive quality consist merely in the use of means of action almost physical in nature—sentimentalism and sex-appeal (tears, raptures, heartbreaks)—nor do the true masters always dispense with these.

The difference lies in the purpose for which these means are employed: Shakespeare's violence is put to the service of Prospero, Grünewald's and Dostoevski's to that of Christ.

GRUNEWALD: DETAIL OF THE CRUCIFIXION OF THE ISSENHEIM ALTARPIECE

Every authentic work of art devotes its means (even the most brutal) to the service of some part of Man passionately or obscurely sponsored by the artist. No more blood is shed in the most sensational gangster story than in the *Oresteia* or in *Oedipus Rex;* but in these the blood has a different significance. "Life is a tale told by an idiot, full of sound and fury, signifying nothing." That was Macbeth's view, but the witches, sounding the deep organ-notes of destiny under the tumult of the trumpets, "clamorous harbingers of blood and death," make *Macbeth* signify something. Grünewald and Goya signify something. We must not confuse our pin-up girls with Greek or Indian nudes, whose sexual implications—different as these were in Greece and India—associate Man with the Cosmos. There is no such thing as a styleless art, and every style implies a significance of Man, his orientation by a supreme value, overt or immanent, whether the source of this significance is termed "art" or, as is the case with modern art, "painting." But delectation is not concerned with values, only with sensations and thus with moments only; whereas true arts and cultures relate Man to duration, sometimes to eternity, and make of him something other than the most-favored denizen of a universe founded on absurdity.

It is futile trying to ascertain whether the means of expression of the cinema will enable it to develop into an art; though for several decades its means have exceeded those of the stage play. But, convincingly as the cinema can bring to life the fictive and vast as is its public, this does not affect the fact that while the cinema can, like the novel, appeal to or enthral the masses, essentially, it is not at their mercy. The great novel is not the result of an amelioration of the inferior novel, but of being the privileged expression of the tragic sense of life and the human predicament. *Crime and Punishment* is not a first-rate crime story but a first-rate novel whose plot happens to be based on a crime. Novels and films made for the masses call for one talent only, that of story-telling, which ensures the fiction-writer's grip on his reader, in the same way as sentimental sensuality ensures the effect of dance-music and a gift for representation that of painting. Even the greatest genius cannot make a masterpiece of a story concocted solely for the reader's delectation; even Victor Hugo could not build up a great myth with the hackneyed themes of *Les Misérables.* The "treatment" may serve as a decoration applied to a wall, but, art because it operates *in depth,* cannot be something superadded.

Thus the arts of delectation are not inferior arts but, operating as they do in the opposite way to that of all true art, might be called anti-arts. Also they show us how greatly the influence of sociologies, conditionings and determinisms on the *means* of art differs from the influence they profess to exercise on art itself. Though our modern culture often sees in its own art no more than a product of superior taste, it singles out from all the forms of the past those in which the artist has transmitted

DETAIL OF THE VILLENEUVE PIETA

BRAQUE: HORSE'S HEAD

either the spark of the divine or the streak of the diabolical in his psyche. It matters little to us today that we know nothing about the gods of the cavemen, and that the very notion of art was unknown to the men of the Magdalenian period. All attempts to rouse our enthusiasm for the little Dutch masters who were not Vermeers are doomed to fail. We feel that in Greece and during the Renaissance men were in unison with their gods and not reduced to the gratification of their senses; we know, too, that the emotional art of the Master of the Villeneuve *Pietà* and the very personal art of Braque, though so unlike each other, have the same adversary. For the arts of religions in which we do not believe act more strongly on us than non-religious arts or those of religions which have lapsed into mere convention; since China means, for us, the Shang vases, Wei sculpture, Sung painting; India, the Brahmanism and Buddhism of the High Epochs; and, in our eyes, Greece died with Pheidias. The arts of delectation are not modern versions of folk arts, they were born of the latters' death. The extinction of African and Oceanian arts in all the seaports where the white men buy fetishes casts a sinister light on what becomes of art when the values of the artist, so different from those of the collector, are scaled down to the collector's taste. Such mercenary arts are not the only causes of the metamorphosis of the original folk arts, but they throw into striking contrast the essential purity of the latter. A revelation all the more effective, because for the first time in the history of our Latin civilization they are showing themselves clearly for what they are; in ancient Rome the nearest thing to the commercial cinema was the Circus and its Games. But though

this painting frankly subservient to delectation is something new, delectation often had a place in painting; classical art began as a conquest and ended as a mere amenity. Now that we have an inkling as to why it is that our art, itself so aggressively secular, is resuscitating so many religious arts, we are beginning to see how its seemingly unco-ordinated "resurrections" fall into place; they cover all that is, or seems to be, opposed to delectation, and reject all that panders to it.

Though we know next to nothing of the psychological make-up of the Egyptian sculptors of the Old Kingdom, we feel instinctively that that of Greuze was very different from theirs. Once the art of delectation rears its head, we promptly feel repelled. Hence our admiration for the great Baroque creators, for Michelangelo and El Greco, and our disdain for Baroque in its heyday; our appreciation of some works by Rubens, our distaste for others. Hence, too, the indecision of our feelings towards Raphael and our indifference to his disciples. Stendhal

GREUZE: THE PARALYSED MAN AND HIS CHILDREN

saw, and admired, in Leonardo the master of the Lombard school, whereas what we admire in Leonardo is that painterly intelligence which makes all the difference between the *Monna Lisa* and those numerous *Daughters of Herodias* painted by the minor Lombards. The school of Bologna has gone under, and the deference paid by the great English portraitists to social prestige makes their figures seem to us less rewarding than their landscapes (and sometimes made them feel this, themselves!). Though we can appreciate the lesser Primitives, we waste no admiration on the second-rate art of the eighteenth century—because it was not merely a question of the painter's carrying out the orders of the man who paid him; he catered deliberately and exclusively for the sentimentality or licentiousness of the dilettanti of the day. Boucher's sensuality is quite other than that of Titian or Rubens; Greuze knew so well what he was about that his sketches were often quite different from the finished pictures and resembled Fragonard's. And Fragonard in *Les Amants*

GREUZE: SKETCH FOR "AEGINA AND JUPITER"

Heureux comes very near Rubens, but not Boucher. With him and with Chardin a great change took place; art came under the sway of painting as an end in itself. But had not painters in earlier days been even more under the sway of the Church? We esteem those alone who sincerely felt that by way of painting they were entering into union with God: the Gothic, but not the Jesuit artists. Suger (in the twelfth century) chose the subjects for the Saint-Denis statues; the sculptors approved of his choice, and they were right. Prayer in common is far more than the common pleasure of going to Mass on Sundays; but like that of Boucher and his pupils every self-seeking art of delectation thrives on complicity, not communion.

Though we wish to annex all that the past offers us, that world in which Christ was Perfect Man (the world of Nicholas of Cusa and Raphael) is becoming more and more remote from us. Yet its art was a noble conquest, at once the last achievement of the Christian world and the first of ours. From the seventeenth century on, the art of delectation was steadily encroaching wherever Christian art was disintegrating; and finally it triumphed with sentimental rhetoric, the licentious print and "pious" painting. The emotions these provide are utterly different from the emotions on which successive civilizations have based their commerce with the cosmos and with death; men gratify their tastes, but dedicate themselves to their values. True values are those values on whose behalf they will accept poverty, contumely and sometimes death. Thus in the eighteenth century Justice and Reason counted amongst those values, whereas sentimentality and licentiousness certainly did not. This, too, is why painting (as modern artists understand it) forms part of these values. Whatever—like the sensualism of Alexandria or modern sentimentalism, and like all that is rejected both by our art and by what is most vital in our culture—caters solely for the pleasure of the moment belongs to that bastard art which comes to birth wherever values are dying out. It does not replace them.

III Thus our resuscitation of certain outstanding manifestations of art on an elementary level, in which the artist is, as it were, talking to himself and not concerned with any pleasure he may give others, is not so capricious as it might seem.

Of all these gratuitous types of expression that of the insane makes the most direct assault on our sensibility, owing to the mental anguish behind it; and its combination of meticulous drawing with pent-up rage produces a curiously disturbing effect. Perhaps, too, it throws light on the ambiguities of our contemporary attitude to art. It should be noted, however, that we are interested only in the works of certain madmen: works that have been selected by artists or doctors. An exhibition to which *all* lunatics who paint contributed would be more like the exhibitions held in prisoners' camps than the selections of works by the insane we find in monographs. Still there certainly exists a characteristic "madman's style" in which the elements of the picture are built into an abstract pattern never found outside asylums.

LUNATIC ART: WATERCOLOR

The art of the insane does not appeal to us by reason of the madness infusing it; on the contrary, when the insanity is too pronounced and, instead of anguish expressed *indirectly*, the artist shows us merely macabre or sadistic scenes, we lose interest. For though we know this style is necessarily "hag-ridden," we prefer to regard it as that of men who, insane in other respects, were not insane *qua* painters; and as though they had invented a way of expressing the fantastic, not by a rational delineation of fantastic scenes, but in a style appropriate to their obsession. Their painting ceases to appeal to us when it imitates. When, however, it does not imitate, it breaks away from the dialogue implicit in so many forms of art; far more coherent than the work of children, it destroys in the same way, but more forcibly, the conventional relations between the artist and the outside world. This destruction always takes the form of a monologue; the artist speaks solely for and to himself.

Here, again, we come up against a paradox; like the arts of savages (actually the least independent arts that have ever existed), the art of the insane has the look of being an expression of total freedom. Formerly madness was regarded as expression of a world turned topsy-turvy. But we now tend to regard it as a sort of second sight and a liberation. Thus its value has risen considerably in our esteem—but perhaps because that of the "real" world has considerably dwindled.

The prestige of folly is traditional; it would be easy to make an anthology of irrational literature, and the "crazy shows" of the Middle Ages had as big a public as the work of Bosch. But the best composer of drolleries was a jurist, and Bosch himself a member of the Confraternity of Notre-Dame. The maker of *soties* and the *fayseur de dyables* had accepted places in society, their attacks on it were not pressed home, their "madness" was like that of the court jester and their public ready to enter into "the spirit of the game." But the real madman, since he is not playing a game, has a sphere of action shared with the artist; he, too, has broken with the outside world. And every break of this sort has the appearance, anyhow, of a conquest. If we did not instinctively assume (though we know it to be false) that every man is capable of painting in his own manner—and though actually this "everyman's" painting is always a more or less adroit pastiche—we would easily understand why the art of the insane makes so deep an impression on us. But the madman is fettered by the predicament to which he owes his seeming freedom; his break with the world is not a conquest, a victory over other works of art, but forced on him, and it is aimless. In this respect his painting resembles that of children which, owing to the inexperience of childhood, has nothing of the pastiche. The artist's break with the world sponsors a flash of genius; the madman's is his prison. And when he paints his private world (and this is all he paints), it fascinates us as a madman often fascinates, but not as *Hamlet*.

LUNATIC ART: DRAWING

FRENCH NAIVE ART (CA. 1820): THE FALL INTO THE CELLAR

We discovered this art at the same time as that of the naïve artists. No great painter ever compared these latter to the masters, even when they had gained a hearing thanks to Rousseau, who belongs to them, but not to them alone. The weakness of their drawing is obvious, but the pleasure they can give us undeniable. Though their "school" has no masters, it has a style of its own, different from all historical styles, manifold as these have been. Moreover, they make no concessions, never indulge in a dialogue in which the artist plays a servile part.

Their art belongs to the nineteenth century, when anyone could buy colors ready-made and paint for his own satisfaction; not as in the past because he had pledged himself to make an *ex-voto* to some saint. Until the first World War the naïve painter was "banned" in a mild way; that is to say, he was looked on as a trifle daft and smiled at by his friends. But he went on painting. His art was a monologue; unschooled, untamed and humble, it paid no heed to the opinion of others.

What does the naïve painter think about when he gives no thought to others? About what he likes, so we are often told. But this is not the whole of the story. Certainly he likes what he paints but, obliged

as he is to puzzle out for himself the whole technique of representation, he would soon lose heart if the reproduction of scenes that caught his fancy were all he had in mind. Most of these unschooled painters could without great trouble make their works more "lifelike," yet we find them often sacrificing lifelikeness to their style. With an artist of this kind, it is what he makes of the visible world—what that world *becomes* in his pictures—that pleases him: a sort of tentative wonderland, a happy blend of scraps of reality, the old-fashioned pantomine and his vision of Nature in her Sunday best. The Douanier was not alone in being moved by autumn tints and the dusk falling on city squares; indeed everyone responds more or less to the emotions that prompted him to paint. When we observe the extreme accuracy of the naïve painter's city scenes and still lifes, we are apt to regard him as slavishly copying his model. Actually, however (I am of course referring to the naïve painter whose work commands our interest for its painterly qualities) his chief aim—even when he uses a calligraphy as literal as Vivin's—

VIVIN: LE MOULIN DE LA GALETTE (DETAIL)

O'BRADY: THE STREET

is to incorporate the scene before him in his own domain: that private world in which he sets off a promiscuous assortment of *ex-votos*, cutlet frills, mushrooms, cats, boats, railways, windmills, the Eiffel Tower, pinned butterflies, against landscapes of an artificial tidiness and sleekness, like stage sets for toy theatres. In some of these pictures the element of naïve magic is barely perceptible, yet all alike, even if the subject be a seemingly quite prosaic street and though the Christmas-card figures we expect are absent, evoke a lingering echo of O'Brady's *Street* and the Douanier's *Tollhouse;* in the nightbound jungle of Rousseau's dream the Snake Charmer plays her eerie melody to all these unschooled artists. In their hands quite common objects become a pretext for an act of dutiful thanksgiving to all things, great and small; they are humbly grateful to the paper frill around a leg-of-mutton for its poetic charm and to the sugar-candy pipe for its mere existence. While pleased if admiration comes their way, they do not paint with this in view, but so as to take possession of a world which, though shared by everyone, they seek within themselves alone. They do not trouble to proclaim its merits or try to vie with the art of the illustrated magazine. When there were no picture-dealers or poets to back them, our nineteenth-century naïve artists found solace in the company of a few admirers, neighbors or friends.

Hence both the coherence of their art and their relative obscurity as individuals. Awkward as it sometimes may be, their style is not a consequence of lack of skill, but the style that all were aiming at.

In their art we find neither the servile dialogue of the arts of delectation nor the imperious accent of the great masters. Content with building up those "ideal homes" which haunt the dreams of the domesticated alley cat drowsing on the hearthrug, they amend the world around them solely for their own satisfaction. They, too, have broken with it, but theirs is not the drastic break of the madman or the child; like the post-classicists who constructed an embellished world, they construct worlds of their own, but—and this makes all the difference—without recourse to models. Not, perhaps, without suggestions from precursors —though, in the days when naïve painting was sometimes to be seen in it, the Flea Market was far from being a Louvre. Once a naïve painter discovers that painting is not a pleasure but a language of its own, and takes to using each successive work of his as a stepping-stone towards improvement on his earlier efforts and replaces the discreet color-range of his would-be realistic dreamworld by Utrillo's palette—then he becomes a painter, not to say a professional painter. If we place a Utrillo amongst a group of naïve works, we promptly see the difference; it has that leaven of dissonance in its harmony which we found in the small *Bar des Folies-Bergère*. For Utrillo was brought up in the art world, lived amongst paintings and knew their specific language; his color belongs to art history, not to its periphery, and with a landscape he does not make a wonderland, but a painting. Séraphine was obviously unsophisticated, but her painting is not; it lies just this side of that realm of madness where lunatics, children and the truly naïve painter join in that rupture with the past, which not being itself a conquest, conquers nothing outside itself.

Alongside these arts we have rediscovered those of savages, whose works seem uncontrolled and guided only by the instinct, though we can feel that they express certain dark, uncharted regions of the human personality. The problems they raise are of a more momentous order, and the modern artist, engaged in a struggle between that supreme value which in his heart of hearts he accords to art alone and the pseudo-values which he regards as interlopers, tends to hail as kinsmen these artists of a netherworld of blood and fate-fraught stars. Or, if not as kinsmen, anyhow as allies; for even if this art (which sometimes strikes him as being the acme of freedom) be under control, it is not under the control of the world with which he is at war. Thus beginning by taking note of what the fetishes attack, he soon becomes fascinated by what they are defending.

One of the reasons why the modern artist is so responsive to the work of savage artists may be that he vaguely hopes to find in it the primordial stuff of art. There is a remarkable parallelism between the

ideology which set out to rationalize Impressionism and the modern attempt to rationalize the forms of savages. The former, in rationalizing Manet's art, found itself confronted by Cézanne and Van Gogh; the latter, in rationalizing the geometrical, often monochrome forms of the Congo, comes up against the polychrome sculpture of the New Hebrides. The artist feels that he can make use of some of these forms, but is less aware that the gods lurking behind them are seeking to make use of *him*. For fetishes and surrealist "objects" are not just quaint museum-pieces; they are indictments.

Though Impressionism did not arraign the culture within which it took its rise, Gauguin and Van Gogh soon proceeded to do so. At the beginning of the present century it was the painters claiming to be the most "advanced"—in other words, to stake a claim on the future—who most zealously ransacked the past. From Cézanne who applied to landscape the planes of Gothic statues, to Gauguin whose sculpture was a metamorphosis of South Seas art, and to Derain and Picasso who recalled to life the Fayum paintings and Sumerian idols, our artists explored every realm of art save that which was their birthright. They realized how false it had become, that bygone concept of man at peace with himself; and all that they resuscitated (like their own works) seemed aimed at the fatal flaws of the culture that penned them in.

"I throw in my hand," said Dostoevski through the mouth of Ivan Karamazov, "if the ransom of the world calls for the torture of a single innocent child by a brute." After his return from penal servitude he had never ceased flinging in the face of the social order of his day the torture of innocent children, the insoluble problem of the consumptive in *The Idiot*,

PICASSO: HEAD

SUMERIAN ART (3rd MILLENNIUM B.C.): FERTILITY (DETAIL)

the problem restated by Tolstoi in Ivan Ilyitch. Politically, an indictment of the social situation leads to the destruction of the forms that countenance it; in art, an indictment of the human situation leads to the destruction of the art forms that take it for granted. No culture has ever delivered man from death, but the great cultures have sometimes managed to transform his outlook on it, and almost always to justify its existence. Thus death was man's true life for the Egyptian, and life an idle dream. What the tragic art of modern times is trying to do away with is the gag of lies with which civilization stifles the voice of destiny.

Many of our resuscitations call in question not only painting as we know it, but man as he is today. For what all the painted idols and Polynesian forms of the Autun tympanum are challenging is, primarily, Western optimism. The last three centuries, hard-pressed today by the millennia called back to life, have abruptly come to seem a *résumé* of all that our Western culture stands for. From the fall of Rome to the end of the Renaissance Europeans did not visit Asia as conquerors; the artist hardly as a foreigner. The landscapes in the medieval miniatures of Europe, Persia, India and China had all a vague family likeness— soon to be dispelled by the lightning flash of Rembrandt's art. Leonardo, who was the first (despite his almost Chinese sketches of waves and rocks) to undermine this unity, was already making blueprints of machines. It would seem that if the art of these recent centuries is to resist all that our Museum without Walls is adding to, or setting up against it, it must begin by getting rid of its congenital optimism, and by making Rembrandt, not Raphael, its spokesman. The sombre figures of the *Governors of the Haarlem Almshouse* which have eclipsed for us the painter's earlier Archers and Topers in their gay attire sound the dirge of Hals' old age, when like Ivan Ilyitch he withdrew from the world, with death his last and only refuge. At about the same time the proud humility of Rembrandt was working a miracle of transfiguration on his *Woman Sweeping*. True, these first tragic intimations were soon effaced by the dawn of a new hope for humanity. Yet that hope which Victor Hugo and Whitman, Renan and Berthelot placed in progress, science, enlightenment, democracy—their faith in man the conqueror of the world— soon lost its self-assurance. Not that a frontal attack was made on science; what was questioned, devastatingly, was its ability of solving metaphysical problems. When those great hopes first arose in Europe there was nothing to belie them. But we know now that peace in our time is as vulnerable as it ever was; that democracy has latent in it the germs of capitalist and totalitarian policies; that Progress and Science mean the atom bomb; that the human predicament is not amenable to logic. For the nineteenth-century man civilization primarily meant peace and freedom broadening down; but from Rousseau's days up to the Freudian age it has not been freedom that has broadened down from

precedent to precedent. Many of those nineteenth-century artists who strike through the joint in our mental armor—Balzac, Vigny Baudelaire, Flaubert, Delacroix and almost all the painters until Cézanne and Van Gogh—belonged, like the Renaissance masters, to a limbo of negations; they had little faith in traditional man, and no more faith in the "coming man." Already the gods of their day—whom their art left out—were mustering their attendant devils; history, which now obsesses Europe, much as Buddha's pyrrhonism disintegrated Asia, was coming into its own. No longer a mere chronicle of events, it was becoming an anxious scrutiny of the past for any light it might cast on the dark vista of the future. Western culture was losing faith in itself. The diabolical principle—from war, that major devil, to its train of minor devils, fears and complexes—which is more or less subtly present in all savage art, was coming to the fore again.

The diabolical principle stands for all in man that aims at his destruction, and the demons of Babylon, of the early Church and the Freudian subconscious all have the same visage. And the more ground the new devils gain in Europe, the more her art tends to draw on earlier cultures which, too, were plagued by their contemporary demons. The devil, who always paints in two dimensions, has become the most eminent of the artists of the past; almost all the works in which he shows his hand are coming back to life today, and we can hear a muttered colloquy beginning between the great fetishes and the statues of the Royal Portal, both alike voicing an accusation, different as are the voices of the dark gods of the jungle from those of the Christian dispensation. For when an art is groping for its own truth, all forms are allies that indict the arts whose falsity it knows.

This Europe of phantom cities is not herself more devastated than is the concept of Man that once was hers. What nineteenth-century government would have dared to systematize torture? Squatting like Parcae in their museums going up in flames, prescient fetishes watched the gutted cities of the West, now grown akin to the primitive world which gave them birth, mingling their last thin wisps of smoke with the dense clouds rising from the death-ovens.

Some twenty years ago, when pointing out (at the University of Berlin) the curiously intoxicating effect produced on the spectator by modern art, I reminded my hearers of a theory current in the East that smoked opium acts as an antidote to opium poisoning, and added that Europe, then at the height of her power, seemed to be calling in the arts of the non-European world to counteract the poison in her blood. From the ends of the earth these arts had answered our appeal and now, when visiting the art galleries of Europe, which formerly were haunted by so many sad, bewildered phantoms, from Gauguin to Van Gogh, we saw them bathed in a sudden light of freedom. In

those men who died before their time but ranked beside the glorious veterans, Van Gogh beside Rodin, Modigliani beside Matisse, we found the same triumphant vigor rifling, with wounded hands albeit, the most ancient treasure-hoard of human images. But that fine exhilaration is waning, the hoard nearing exhaustion, and our hope of a beneficent conquest of the world by science has proved an idle dream. Threatened in its prime, the European spirit is undergoing a metamorphosis as did the spirit of the Middle Ages when, in the stress of never-ending wars, it built its fifteenth-century hell with the great lost hope of the cathedrals. Whether dying or not, menaced assuredly, and haunted by the demonic presences she has recalled from oblivion, Europe seems now to contemplate her future less in terms of freedom than in terms of destiny.

IVORY COAST: MASK

IV However, our Renaissance of the art of savages is more than a rebirth of fatalism. If the fetishes were to enter our Museum without Walls charged with their full significance, it was necessary that not merely a handful of artists and connoisseurs but the white races as a whole should abandon that belief in Free Will which since the days of Rome had been the white man's birthright. He had to consent to the supremacy of that part of him which belongs to the dark underworld of being.

To its avowed supremacy, not merely to its incorporation in his culture. Thus there was no question of deciding what place in the museum should be assigned to these primitive arts; for once they are allowed fully and freely to voice their message, they do not merely invade the museum; they burn it down. Yet, whether Europe listens to that ancient lamentation of civilizations under threat of death, or whether she shuts her ears, the culture and art of the West are not dependent solely on her fate; a metamorphosis of modern art is bound to come, but this metamorphosis may well be linked up with the birth of an American culture, the triumph of Russian communism—or, perhaps, a resurrection of Europe. Persian art swept India after Timur's conquests, and half the world has acclaimed for many centuries the glory that was Greece. History gives short shrift to any theory that art values are rooted in a country's native soil. Though our culture may listen to the voices clamoring for its abdication, it has not yet relinquished its will to conquest. The Uffizi at Florence have not given place to the Museum of Ethnology, nor as yet have fetishes found their way into the factory or farm, or the drawing-room.

KWAKIUTL: MYTHICAL MONSTER, MASK

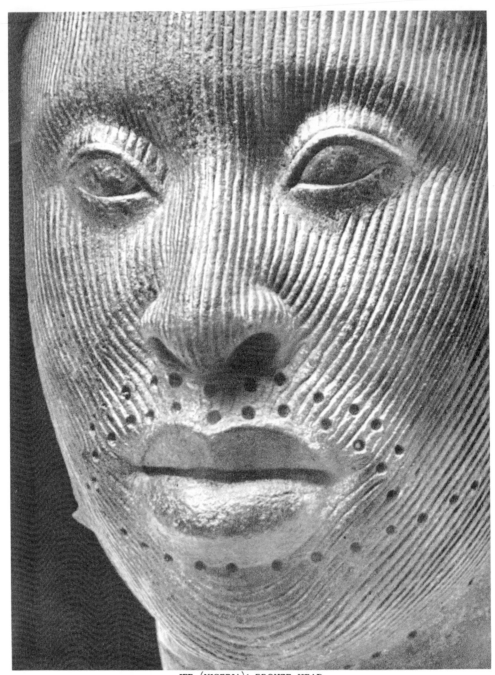

IFE (NIGERIA): BRONZE HEAD

Obviously there is no Negro art; there are *various* African arts. If we leave prehistory out of account, we find a black man's art following a course that has become familiar to us: not only in Benin and Ife but also in the Bakuba tribe, in the figures of Bushongo kings. Whatever be the material used in this architectonic and ornate stylization (which makes us think of a Byzantine art with Christ omitted), one feels that bronze is its true medium. Though representing kings, when called on to do so, this art often deals with themes of daily life, and it stylized

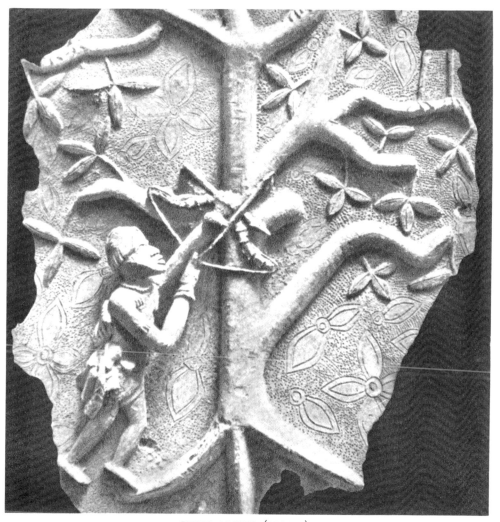

BENIN: ARCHER (BRONZE)

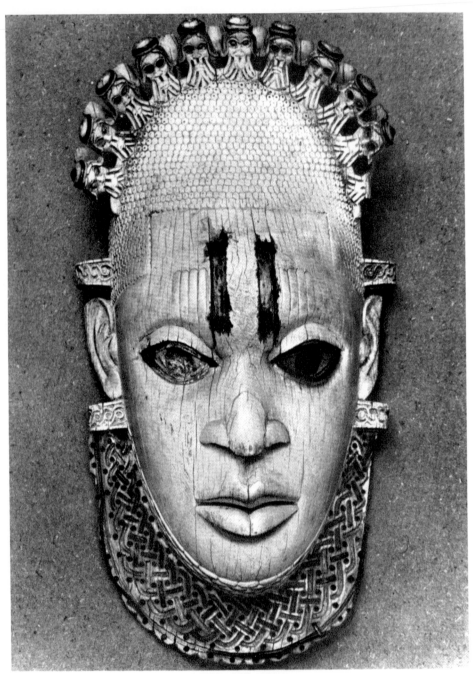

YORUBAS (?): IVORY

our sixteenth-century adventurers with a quite Caucasian brio. Then we have what are often miscalled fetishes—masks and figures of ancestors: an art of a collective subjectivism, so to speak, in which the artist invents forms deriving from his inner consciousness, yet recognizable by all, thus mastering with his art not only what the eye perceives but what it cannot see. On the one hand, we have the ivories and bronzes of Benin and, on the other, the fabulous hunters of the rockface paintings

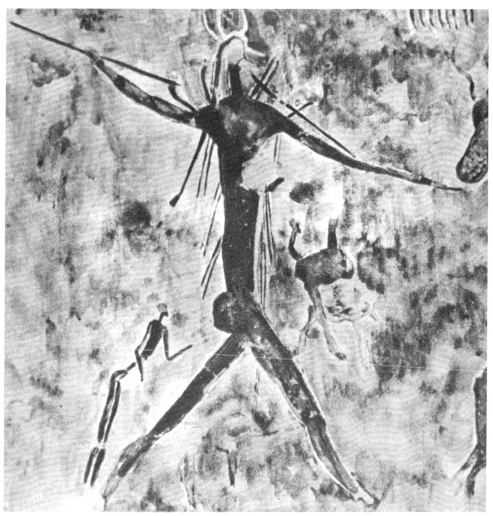

SOUTH AFRICA: BASUTOLAND ROCK-FACE PAINTING

547

and all that art puts to their service; in that haunted dusk, whence sally forth the panther-men and antelope-men, we see the mask wherewith the sorcerer wearing his necklet of bird's skulls harks back to the age of Saturn. In Oceania, too, both tendencies are manifest, and a buckler from the Trobiands differs no less from a New Britain clay-moulded skull than from a woven New Guinea mask. What is the link between a Congo mask and the pre-dynastic knife-handle of Gebel el Arak or the Sumerian figures of the third millennary before Christ? However steeped these are in the darkness of an elemental world or in that realm of blood whence come the Aztec figures, they speak for an

KOREDUGA VULTURE MAN

attitude of man defying the universe—that attitude which founds kingdoms and builds cities. Sumerian art was much obsessed with death, yet it spread from Sumer to the Caucasus, after conquering Babylon. Remote in space and time, a Mayan figure may evoke a realm of forms whose purport is still a mystery, but it is not a realm of formlessness; and below the immemorial faces hewn in granite or lava-rock the carved prows of the Polynesian canoes dance like flotsam of a day. The supreme language of blood, like that of love, is the temple. And lacking this, the nomads of the Mongolian steppes found a substitute in the Empire.

Thus we are beginning to see, in all the regions of the world our culture has recently taken over, a certain order, if not an hierarchy;

PREDYNASTIC EGYPT: GEBEL EL ARAK. KNIFE HANDLE

Benin art is definitely an historical art, and some of the Congo styles give rise to figures in which man is no less present than in Egyptian art. The striped masks of the Baluba tribe are more different from *The Beggar Woman* or the statue of an ancestor in the Antwerp Hessenhuis than are these latter from certain Romanesque figures. Through being ever more and more extended, the "fan" of savage arts is splitting up; the striped masks seem as far from the almost Cingalese figures of Benin as are the carvings of Hopi Indians from the Mayan bas-reliefs.

BELGIAN CONGO: BALUBAS. ANCESTOR (NOW IN THE HESSENHUIS)

BELGIAN CONGO: BALUBAS. MASK

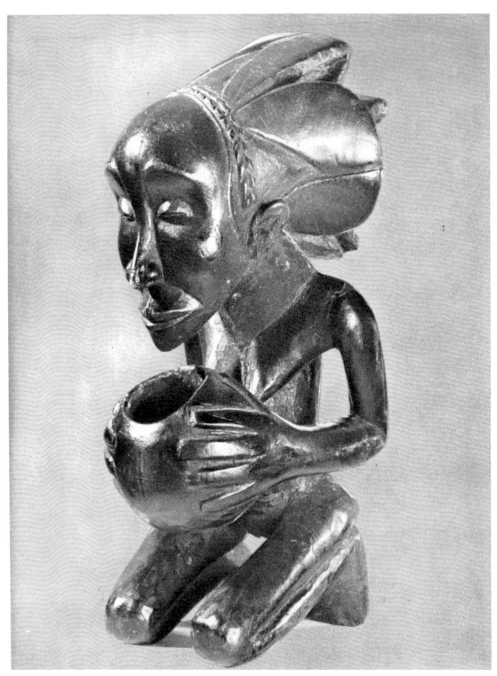

BELGIAN CONGO: BALUBAS. THE BEGGAR WOMAN

The successive discoveries of recent years, seconded by our enthusiasm, have led us on from African to Oceanian art, which is akin to it; then to arts at a short remove from it; and finally to arts whose forms are utterly unlike its forms. The arts of Oceania differ from those of Africa in being more colorful; there are brown, angular, sometimes Pre-Columbian looking figures in New Zealand; white, brown and red in New Ireland and the Bismarck Archipelago; polychrome in the New Hebrides. But these last are of a different order; they are molded and bear no marks of the knife. They affect us by their color, sometimes subtle, sometimes fantastically strident, this stridency being due (in the more recent works) to contrasts of deep ultramarines, pinks and miniums, which our painters have not yet indulged in (but they will). In combination with the dull, crackled clay these colors give the bright, ornamental

NEW GUINEA (SEPIK VALLEY): MASK

TWO ASPECTS OF OCEANIAN ART. I. NEW BRITAIN (BAININGS): MASK

2. THE MARQUESAS: TIKI

passages the vividness of pastels and are very different from the archi-tectonic color we find in other savage arts. (Here, again, our modern taste leads us to prefer the spurious "glamour" due to decomposition to the rich pigmentation of these works in their first state.) One step more and we arrive at the plumed Hawaiian helmet of the Musée de l'Homme, and the Peruvian feather cloaks. What trace is here of Nigerian "cubism" or the architectonic planes of Senegambia? The vital difference between Polynesian and African art is not that the former is two-dimensional (which, in fact, it not invariably is), but that it sets up against an architecture of masses the calculated formlessness of, for instance, the rush masks of the Sepik River; it is, indeed, the only art to which such terms apply. The modeling of the skulls overlaid with clay is not haphazard, any more than is the modeling of the New Hebrides ancestors, or the way in which the woven masks are plaited. All the same, these shocks of hair made out of reeds, feathers and vegetable fiber, and the spatulate noses, are not always arranged so as to to build up a structural pattern. Incoherence, inventing its own laws and enforcing its authority, sometimes has the emotive drive of Rimbaud's poetry; indeed the art of the New Hebrides parallels Rimbaud much as Greco-Buddhist art parallels St. John Perse; only its shrillness and grotesqueness rasp our nerves, without taking effect on our culture. Despite their plastic vigor, so much superior to that of the Sepik rush masks (but not to all Sepik art), the masks and ancestors of the New Hebrides are not statues, hardly sculpture at all; but oftener paintings, and always of concrete objects.

"How can you admire them and at the same time admire Poussin and Michelangelo?" we may be asked simultaneously both by Poussin's champions and by votaries of the savage arts; by Molière's bourgeois and the playboys of Montparnasse. Yet the attempts of the latter to whittle down the legacy of the ages to some exotic by-products are as futile as the excessive rationalism of the former; indeed I do not know of a single great modern painter who does not respond (if in differing degrees) both to certain works by savages and to Poussin.

When the first mask reached Europe what bond of kinship had been discerned to exist between Poussin and Grünewald, between Michel-angelo and Chartres? Let us begin by noting that Poussin stands for a good deal more than the "tapestries" of Rome and Versailles that his name conjures up for us, and that his imitators can bring off as well as he; we have in mind that subtle crystalline Cézannesque quality to which his imitators are blind, but which came to Cézanne so naturally. Though Grünewald's unrestrained emotionalism has nothing in common with this accent, it too has an accent, and we cannot understand painting without recognizing these accents. They resemble that element in poems which it is impossible to convey in translation—and which is

NEW HEBRIDES
MASK

the basic stuff of poetry. Thus, if we disregard provisionally (as we may do for the "rational" elements of the poem) what painting has to tell us on its rational level, we find that the accents of the masters, even if there is no direct kinship between them—in the sense in which Poussin's, Corot's and Cézanne's accents are obviously akin—have nevertheless something in common, and our response to art is affected by the presence of that something, as poetry is affected by the element in it that could not conceivably be prose. It is the accent the *Housewife* would acquire if interpreted by Braque, the Villeneuve *Pietà* interpreted by Cézanne, or the Issenheim altar interpreted by Van Gogh. In art that word "accent" carries two meanings, and the connection between them is enlightening. The accents of the painter (not to be confused with his "touches") are often those with which he disintegrates the visible world; but he is not a great painter unless, after being arranged so as to create *his* accent, they effectuate its reintegration. Far from being eclectic and taking pleasure in diversity of forms, our modern pluralism stems from our discovery of the elements that even the most seemingly disparate works of art have in common.

Those accents and this accent (as defined above), those dissociations and this oneness, are no less present in the fetish when it is a masterpiece. They could fully reveal themselves to us only after the Angel of Rheims had ceased being an angel, and the *Thinker* being, primarily, an heroic figure. But for us today the mask or the ancestor is no more a magical or numinous object than a medieval Virgin is *the* Virgin. If painting has a language of its own, and is more than a means of representation or suggestion, that language is present whatever the representation or suggestion—or even abstraction—with which it happens to be associated may be. Thus we credit a man who can see what Masaccio has in common with Cézanne and in what ways he diverges from him, with a truer understanding of Masaccio than that possessed by Quattrocento specialists, to whom Cézanne would mean nothing. The reason why our pluralism welcomes the fetish is that no mode of plastic expression is foreign to this universal language. Thus we may fancy music, after being for many centuries inseparable from words (the unmusical man still thinks they necessarily "go together"), being one day set free from them; then and then only would it be possible to appreciate the true power of music: its aptitude for invocation of the divine—no less the soaring splendors of a Beethoven than the delicate appeal of the rebeck crossed by the plaintive accents of the bagpipes. Thus, now that the specific language of painting has been isolated for us (the painters themselves have always known of it) we can grasp the meaning of the vast repertory of forms hostile to illusionist realism, from old Bibles to grotesques. Provided we have art, not culture, in mind, the African mask and Poussin, the ancestor and Michelangelo are seen to be not adversaries, but polarities.

Once civilization had ceased being under the sway of the gods, and the affinity of the various accents of the different arts was recognized, *all* art emerged as a *continuum*, a world existing in its own right, and it was as a whole that art acquired, in the eyes of a certain category of men, the power of refashioning the scheme of things and setting up its transient eternity against man's yet more transient life. This desire to hear the passionate appeal addressed by a masterpiece to other master-pieces, and then to all works qualified to hear it, characterizes every artist and every true art-lover; and likewise a desire to ally with new accents the echoes that each deep-sounding accent conjures up—from one Romanesque tympanum to another, from one Tuscan school to another, from style to style in Mesopotamia and, calling from archipelago to archipelago, the Oceanian figures. A painter uninterested in music may none the less admire a great musical work if he happens to hear it and even see what it is aiming at; but an encounter with a great work of plastic art is, for him, a far more vital experience. To be a musician does not mean just liking music, it means going out of one's way to hear it; and being a painter does not mean just looking at a picture, in passing. And thus it has always been, whatever the artist's special interest may be: Roman excavation, the Ethnological Museum or Chartres Cathedral. The supreme power of art, and of love, is that they urge us to exhaust in them the inexhaustible! This eagerness to enjoy art to the full is no new thing; what *is* new is that it is leading to the rediscoveries of works whose message fascinates us alike, whether their values seem friendly to us or hostile.

For, though today we can respond both to the accent of the mask and to that of Poussin, Negro art and Poussin's do not play the same part in our culture.

Nevertheless, the paintings of the Pygmies fail to interest us; perhaps, indeed, total savagery is incompatible with art. Like the cannibal, the "noble savage" has left the scene. We know that the Tahitians were much less cruel than the Confucianist sages who enacted so many hideously cruel laws; for us, culture does not involve gentleness, but self-awareness and self-mastery.

The savage as we picture him today is neither goodnatured nor ferocious; we regard him as a man possessed, and we accept his blood-thirsty rites as the night-side of those tribal dances in which the male dancers suddenly make way for the young girls who, painted black and motionless as Egyptian figures, accompany their singing with rippling movements of the white flowers they hold festooned between them. Yet if an art associated with the most hideous sacrifices holds our interest, is this because of the glimpses it gives of a world of elemental chaos and not, rather, for its expression of man's ability to escape from chaos, even though the way of escape lies through blood and darkness?

NEW ZEALAND: MUMMIFIED AND PAINTED MAORI HEAD

The problem becomes still more confusing once the Ethnological Museum starts calling itself "Le Musée de l'Homme" and is treated as a means for the enlargement of history in scope and depth—a form of history that soon tends to merge into biology. Though ostensibly the prehistorian is engaged in the same quest as the historian, his discoveries are not those the true historian looks for. Prehistory is not a vaguer, more comprehensive kind of history; it is another species of history.

Perhaps the culture of Oceania is (as its specialists believe) a survival of the culture of the megalithic age; after all, since that culture lasted in Europe three thousand year longer than in Egypt, why should it not have persisted two or three thousand years longer in Oceania than in Europe? It seems certain that this culture, vestiges of which are found in India and Australia, covered half the world and we may see a manifestation of its last phase in the art of the "folklore man," whose figures, sometimes so much like those of savages, throw much light on the creative processes and evolution of the latter.

THE CHRIST OF NOWY TARG (POLAND)

Some Breton wooden crucifixes are, like the Nowy Targ *Christ*, Christian only in appearrance. They belong not so much to a degenerate form of Christian art as to something far older than Christianity, a vital impulse existing since time immemorial which assumed a Christian form after assuming many others. This is an intensely human art and it clothes itself in the forms of successive periods of history, much as the moon's impartial light bathes men's successive palaces. True, there are palaces in ruins as well, and this is why it is so difficult to say where history proper ends and prehistory begins; yet between the historical arts and these earlier arts there is the same irreconcilable difference as between the epoch of the kingdoms and that of the cavemen. Moreover, the fully developed art of the prehistoric age, that of Altamira in particular, suggests a mentality radically different from that of the dim, primordial figure to which man inevitably reverts with the ebb-tide of every culture. This primordial figure stems from the age of Saturn and those festivals

of the cycles of the seasons whose traces survive in our feast-days and calendar. The true symbol of this culture is not the Nowy Targ *Christ* but the festival; and that of the beginning of our cultural era is the Pyramids. The Nowy Targ *Christ* and the Merovingian figures are, so to speak, impure, because those who made them had seen other portrayals of Christ; likewise the makers of the Swiss peasant masks had, of course, seen churches. The purity of all that lies not only outside history but seems to lie outside time as well, usually finds expression in objects that do not last; thus the New Hebridean when he wishes to give the "ancestors" a voice carves them on hollow tree-trunks converted into tom-toms, using a particularly perishable wood (that of the tree-fern) and covers them with spiders' webs. Where the cultural "decomposition" is total there is no more carving and in the wind of the immemorial the straw-men sway

MOI ART (INDOCHINA): STRAW FIGURE

ALTAMIRA: SUPERIMPOSED ANIMAL FIGURES

But it is not the straw-men we have resuscitated. We no longer assume that the man whose place lies outside history must have been an ill-adjusted precursor of historical man—a sort of cultural "sport"—; we see him as a different human type. For we now know that, while historical cultures have determined the trend of the arts that enter into art history, the unrecorded ages gave rise to more than buffalo-heads mounted on pikes or rags tied to dead trees on the Pamir hills; they had their own *styles* as well: those, for example, of the men of Altamira. And we have also learnt that style, though bound up with history throughout the historical era, can exist without it.

Those who formerly praised Negro art as an expression of the unconscious viewed it, in effect, from the same angle as those who disdained it; both its admirers and detractors saw it as an art of children. But the prevailing habit of regarding the works of savages, of children and of the insane as being all of a kind confuses together very different forms of the creative activity. Childish expression is a sort of monologue; the madman's is a dialogue whose "opposite number" plays a passive part; whereas the art of savages, though it strikes us as a monologue because it is not addressed to *us*, is a monologue only in the manner of Romanesque or Gothic art. True, it does not try to please us, but it is addressed to the gods, and only by way of them to men. Children's

GABOON: PONGWE MASK

SWITZERLAND: FOLK MASK FROM LOTSCHENTAL

drawings have a calligraphy, not a style; whereas the masks of savage races, which illustrate a precise conception of the world, definitely have one. In much the same way as the Italian styles from the thirteenth to the sixteenth century progressively achieved illusive realism, so some African styles seem gradually to have annexed whatever links man up with the dark, invincible powers of an elemental world.

What does the African artist aim at? Often he gives no thought to resemblance. Expression, yes—if we mean a type of expression as specific as that of music and quite different from such emotive expressions of the face as those of Japanese masks and Greco-Roman comedy. So different, indeed, that what, at a first glance, distinguishes an African mask from a European peasant mask is precisely the specific expression of the former and the "expressionism" of the latter. Negro art never aims at suggesting anything by means of realism, even of a grotesque or emotive order (in which it fares quite badly), except when it is copying foreign models. An African mask is not a fixation of a human expression; it is an apparition. Its carver does not impose a geometrical pattern on a phantom of which he knows nothing, but conjures one up by his geometry; the more a mask is like a man, the less effective it is, and the more it is unlike a man, the greater its potency. The animal masks, too, are not animals, the antelope mask is not an antelope but *the* spirit-antelope and what "spiritualizes" it is its style. For the black sculptor, we are told, the best mask is the most potent mask, and its potency depends on the completeness of its style.

If we could rid ourselves of the illusions of sight and instinct, we would soon see what is the function of this style. The extreme stylization of the images of the Hopi Indians (of which there was so fine a collection in Paris, at the Trocadero, some years ago) surprises us less when we learn that all these fantastic figures are household gods, and the image would no longer be a household god, were it made differently. Our medieval *imagiers* were capable of supplying "a faithful likeness of the devil Beelzebub" and Christian art demurs at painting angels without wings; lacking wings, they would cease being angels. The style of the figures of New Ireland ancestors is no less rigorously fixed than that of the Hopis and has the same function; what does not conform to it is not an ancestor. Thus these styles give us an impression of being bound up with an iconography which enabled those for whom the sculptors worked to recognize at once the very presence of the ancestor or god, and, when they so desired, to enter into magical communication with him.

But here, again, we are misled by the illusion of a "neutral style"; to which an iconography has been added. In all parts of the world the rule holds good, that a styleless iconography is devoid of "power." The figures carved on Sundays by the Hopi Indians now employed in atom-bomb factories and by Melanesians employed in the plantations are no more regarded by us as works of art than they are regarded as

HOPI IMAGES

566

vehicles of magic by their makers. Iconography may provide such figures with a means of identification (as the crown of thorns designates Christ), but is not enough to give them individual value, since their very existence derives from the style which the iconography calls for —and which has sometimes modified it—just as the existence of Romanesque works derived from the Romanesque style: a style inseparable from an awareness of the universe that was profound and anything but puerile. Even today we are more influenced than we realize by the grotesque figure that used to be foisted on us, of a black man with a beaming smile proudly exhibiting the wooden effigy of an enormously fat woman in whom he sees a "Venus," much as child sees a doll in some rags he has tied together. Year by year ethnological research is revealing new constellations of the peoples of the night. Totem animals link up the life of the tribe with that of the remotest past; the soft-wood New Ireland ancestors form the court of the Great Primordial Ancestor, the sculptures in the house of worship suggest him, music is his voice, the festivals converge on him and the dance mimes his gestures as it mimes the tribe's heroic past, the epiphanies of the sun, the moon and death, the fertility of the soil, life-giving rain, the rhythms of the firmament. Thus, though the paths they follow are other than those of the great religions, the arts of savages are likewise means to a communion with the universe; and this is why they die wherever the coming of the Westerners has shattered that communion. A communion based, not as in Greece on resemblance, but, as it once was in the East, on unlikeness. Is such a communion inconceivable to us? Yet it certainly existed at Byzantium

Indeed all these arts, far from being spontaneous, are Byzantinisms: methods of creating spirits and angels, demons and the dead, methods which stem from a convention in which both the collective sentiments of the tribe and the cult and cunning of the witch-doctor play a part, and in which artistic creation is creation *tout court*. Like the Byzantine artists, these artists might be described as manufacturers of the numinous—but the numinous object is manufactured only for people who can put it to appropriate use, and the strict control of the styles of savage races is due to the fact that the objects the artist is allowed to make are solely those which every tribesman can recognize.

Nevertheless it sometimes happens that the sculptor varies the forms of evocation—but he always shows the same cautiousness as the early European sculptors when they modified the forms of representation. Sometimes he does this by stressing the angularities of the figures he evokes, sometimes by ornamenting them with copies of tattoo-marks (as in the large Bakuba figures), or again by making them more complex (as in the polished masks of the Ivory Coast), or more architectural and

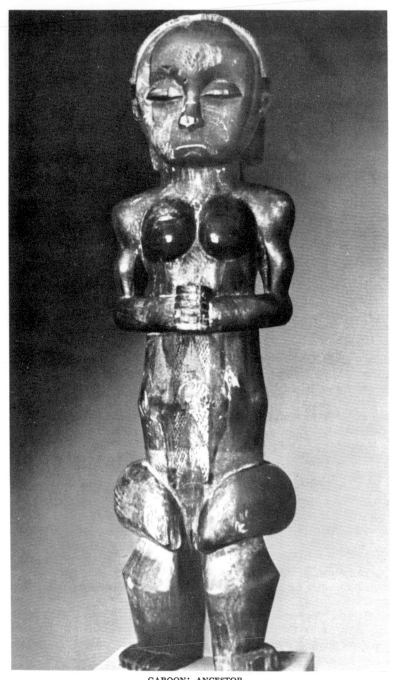

GABOON: ANCESTOR

compact (as with certain ancestors of the Gaboon), or by stripping them down to essentials and (as in some Pongwe masks, akin to certain Oceanian masks) scoring them with clean-cut lines. In the making of these wooden effigies, though they lie only on the fringe of historical art, chance plays no more part than in the making of the Benin bronzes and, like these, they aspire to a quality over and above that of instruments of magic, though not conflicting with it. Indeed it is generally accepted that aesthetic considerations play a large part in the work of some Polynesian groups, by whom God is defined as "the source of harmony." Often, no doubt, Negroes are artists because they set out to create another world; but sometimes, too, they create it because they are born artists. Or, again, they create, like Prophets, forms that will fix the tribal style for centuries; and, at other times, like sculptors, forms that will fix it for a few score years.

Even when the African style is conditioned by the supernatural to the point of becoming an ecstatic geometry, we can trace (or, anyhow, surmise) the lines on which it has advanced from strength to strength.

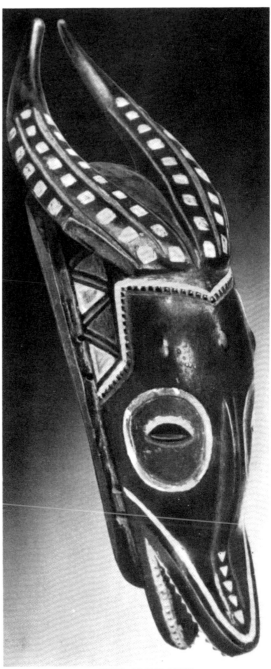

IVORY COAST: MASK

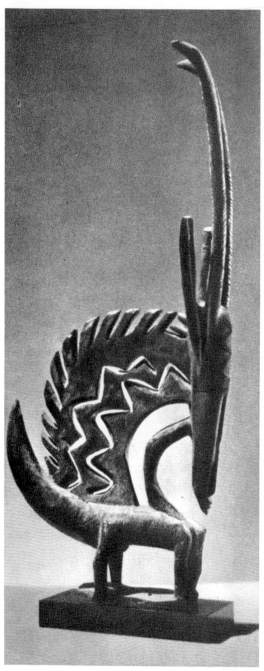

SUDAN: MASK CREST: ANTELOPE

The ground-plan of the spirit-
antelope is more than a sign.
The limbs of Europeanized
fetishes look like limbs; those
of the best effigies of ances-
tors *signify* limbs but do not
resemble them; they are *in-
vented*. The genius of certain
black sculptors leads them
to impose on their figures the
unity of a style; Poussin
"embellishes" each arm in
terms of his picture as such,
while the Negro sculptor
schematizes or invents an
arm so as to make his work
an organic whole. Both
alike aim at excluding from
their work all that is extra-
neous to it and the drawing
of the Pongwe mask (which
reminds us of Klee) links
up with the most emphatic
Dogon figures, the most ar-
chitectural Guinea ancestor,
the most angular Sepik an-
cestor (and perhaps, too,
with the most emotive color-
patches of the New Hebrides)
by reason of the unmistakable
impact of a controlling pres-
ence. That controlling pres-
ence is clearly the artist's
personality, for even the most
exalted cosmic sense would
not account for the invention
of the New Ireland style,
nor the sincerest faith for the
Elders of Moissac; neverthe-
less implicit in these creations
is an awareness of the uni-
verse, an awareness quite dif-
ferent from ours and uncon-
cerned with history, involv-
ing a union with the cosmos

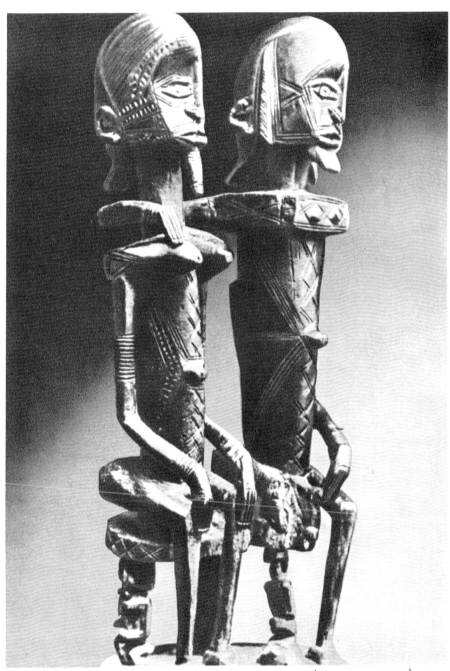

SUDAN. DOGONS: THE MALE AND FEMALE PRINCIPALS (FUNERARY FIGURES)

and not a surrender to chaos: a conquest, not an abdication. From Benin to Polynesia, by way of thousands of tentative or triumphant images, we respond to the significance with which this compelling presence invests an effigy in straw.

The interest our artists showed in African art from the moment it invaded the European scene was directed less towards individual works than to certain means of expression which pitted new values (with a quite unprecedented truculence) against the values of the academic artist. The Gothics had made a similar incursion, but with this difference that our art museums made haste to "filter" them (it is interesting, in this context, to compare the great medieval German works with the paintings on view in our provincial museums, and even in the Bavarian Museum). Now that the shock of that first contact is beginning to wear off, we limit our attention to the masterpieces of savage art; but, just as the Kings of Chartres are no longer regarded as expressions of compelling but barbaric genius, but as expressions of the early Christian genius, so when we refer to a masterpiece of the Congo, we have in mind a Congo figure and *also* a masterpiece; while belonging to a savage art, this figure has a culture of its own implicit in it. Nor do we necessarily regard as masterpieces those works which come nearest our own art, *The Beggar Woman*, for example; the New Hebrides effigies which we prefer are only very distantly related to it. None the less we have singled out "good fetishes" as we single out good drawings by children and good naïve pictures.

Though we hardly know what the Baluba kings, who refrained from having their effigies made when no "good sculptor" was available, meant by a "good sculptor," we have a fairly definite idea of what *we* mean by a good fetish. At first sight this might seem merely to signify a striking work of sculpture; but it must (to be "good") continue to be striking even when its style has become familiar to us. It is, in fact, a work apart, standing out from the common run of fetishes produced in series. Should we conclude that such exceptional works were the prototypes of these series? The assumption is a risky one, and it would be equally risky to make it with reference to the works of the "high periods." Like ours, the arts of savages have their curiosity shop productions (in the sense in which the curiosity shop differs from the art museum)—by-products or mass-produced works of an inferior order. Though the slow evolution of such arts and our scanty knowledge of them make it difficult, not to say impossible, to decide which were the prototypes, this does not prevent us from distinguishing in certain figures a voice other than that of the collective chorus of the style to which they belong This is due to their nature as well as to their quality, and to what their quality owes to their nature. We sometimes fancy we can glimpse a masterpiece, the summing-up and symbol of Romanesque art, across a haze like that which in the seventeenth century

enveloped the masterpieces of "antique" art, which were quite unlike those of Pheidias. Thus we picture this symbolical masterpiece as combining Romanesque craftsmanship, Romanesque conventions, all that the word "Romanesque" connotes; but it is not the Autun tympanum, nor that of Moissac, nor that of Vézelay, nor even that of Cabestany. It is the masterpiece *which does not exist*. In the existing masterpiece, though it is linked up with the style to which it belongs, there is always an accent peculiar to itself. The ascription of some fine Venetian pictures may be a moot point, but what painter could imagine a major work by Tintoretto being mistakenly attributed to Titian? Here we see again that autonomy, that expression of the artist's break-away from others' influences, which is the hallmark of every supreme work of art. Works belonging to the arts of which we know little or which we have ceased observing ("antique" art, for instance) strike us as stereotyped; but the same interested observation which rescues an art from

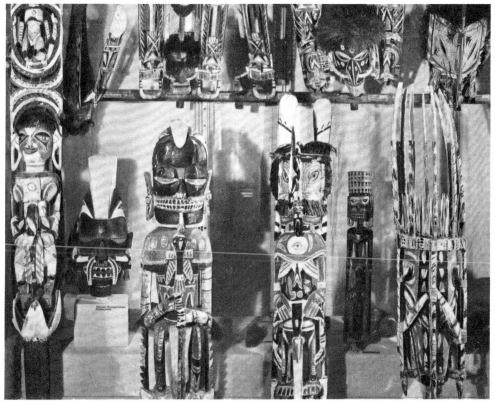

NEW IRELAND: CARVINGS

573

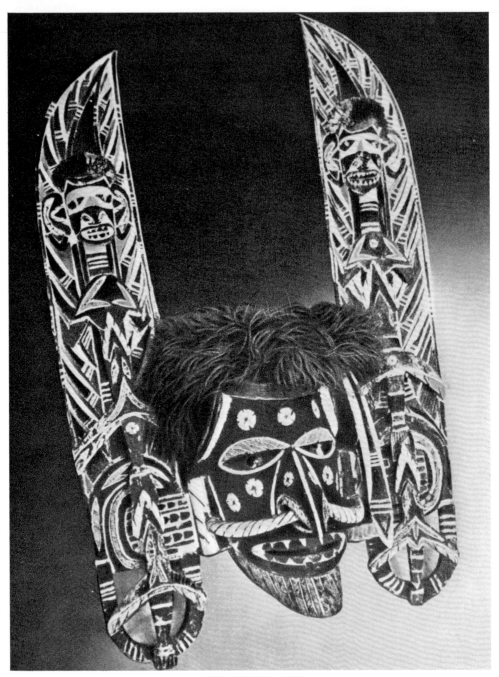

NEW IRELAND: MASK

oblivion or disregard, distinguishes its essential genius from the stereo-typed forms encumbering it.

The forms of savages impressed us *en masse*, to begin with, by the sheer weight of their numbers, but now we take notice of only a selected few. This company of the seeming-dispossessed loses by being herded together and, after seeing a hundred New Ireland figures, we prefer to isolate two or three and toy with the illusion that they are the work of some great mythical sculptor (of no time, yet a little of ours) who may take his place beside some others bearing the names of Congo, Gaboon, Haïda, Sepik and the like. Indeed already we are substituting in some cases the individual artist for the collective style; thus we know some ten other works by the man who made *The Beggar Woman*. Yet though such cases (which are exceptional) give us, like our modern masterpieces, the feeling of a conquest, we also have the feeling when visiting an ethnolog-ical museum that the art around us is that of a prehistoric carnival in which man is dispossessed of his prerogative in favor of the denizens of some phantasmagoric pageant of the powers of darkness: a dispossession plunging him into an elemental world, profound yet fragile as those Melanesian ancestors carved in wood confronted by the basalt forms of Sumer. Much as they may suggest, the mass-produced effigies make little impression on us; though associated with fertility and death rites and murmurous though they are with long-forgotten voices, they fall (unless redeemed by art) into the category of "curios," products of ephemeral schools. Those colors of the New Hebrides, intense or muted, are employed by dressmakers and theatrical designers; indeed when a great number of these figures are brought together in a museum, we have a sudden feeling of being invited to see a *haute couture* of Death. These glittering ghosts really belong to poetry, which is why the Surreal-ists make so much of them. But Surrealism, far from proposing to further culture, repudiates it in favor of the dream. Our artistic culture, however, does not repudiate the dream, but seeks to annex it to itself. Our Middle Ages, too, suggest to us what the festival deriving from the prehistoric ages may have been; but once his Carnival was over, medieval man fell to building cathedrals, and his rulers had not "ances-tors," but forbears.

What our anxiety-ridden age is trying to discern in the arts of savages is not only the expression of another world, but also that of those monsters of the abyss which the psychoanalyst fishes for with nets, and politics or war, with dynamite. Like the Chinese and the eighteenth-century "noble savage," our Primitives step forth obligingly when bidden from their retreats. But Jean-Jacques Rousseau had not the least wish to become a Tahitian, nor Diderot a Chinese, nor Montesquieu a Persian; they merely wished to enlist the wonders and the wisdom of these mythical exotics on their side and invited them to arraign the culture of the day, not with a view to destroying, but to perfecting it.

We must not undervalue these messengers who ushered in so many changes (including the Revolution); but the message brought by their successors, the savage artists, is of more immediate import; its dark forebodings have no less compulsion in so far as our European culture is threatened (primarily from within) than in so far as it seems to hold its own. For even if their coming marked the beginning of a death agony, it would also mark the last phase of a conquest. We can admire Aztec figures, but our admiration is not proportioned to the number of skulls bedecking them. The pomp of sexual and funeral rites has persisted for many centuries in India, and the bas-relief of the *Kiss* at Ellora and the *Dances of Death* are charged with a more pregnant darkness than the Taras of Tibetan banners; nevertheless the Dance of Death has a cosmic significance only in virtue of its specific accent and when it loses this seems as futile as any Jesuit "saint." Like the great fetishes, Siva responds to the call of the abyss by integrating it into the cosmos; so thoroughly indeed that those who know little of Hinduism fail to see that the god is trampling a dwarf underfoot, and to recognize in him a symbol of death and resurrection. Every work that makes us feel its aesthetic value links up the dark compulsions it expresses with the world of men; it testifies to a victorious element in man, even though he be a man possessed. Indeed we soon may come to wonder whether these voices of the abyss have any value other than that of making man more vividly aware of his prerogative as Man.

After some tentative moves in that direction the great resuscitation of primitive forms began a century ago. From the time when Romanesque and Assyrian sculpture first entered the Louvre and the British Museum until the recent rise to favor of the arts of savages, all the discoveries which at first sight seemed destined to undermine the Western style, now seem to have combined to reinforce its authority.

Delacroix and even Manet vied with the accent of the old masters; the rivalry of styles began only with Cézanne. His wish was to hark back to Poussin, but Poussin had pointed the way to nothing; whereas Cézanne with his synthesis of Gothic planes and Doric art prefigured twentieth-century architecture. In his art painting and sculpture are united. In the rediscoveries which began with Manet's triumph sculpture played only a minor part. Sometimes in Rodin's, always in Degas' sculpture we find the mastery and freedom of the painters who "drew with the brush"; but when modern art looked for forerunners amongst the masters who had rejected illusionist realism, where could it find a better precedent for the freedom of a Rembrandt or a Goya than in the Masters of Romanesque? Thus the *indirect* action of the great styles of sculpture contributed to the birth of the painting most intrinsically painting that has ever been; whilst the "resurrections" which this pure painting led to focused attention on these styles—and on the architectural elements implicit in them.

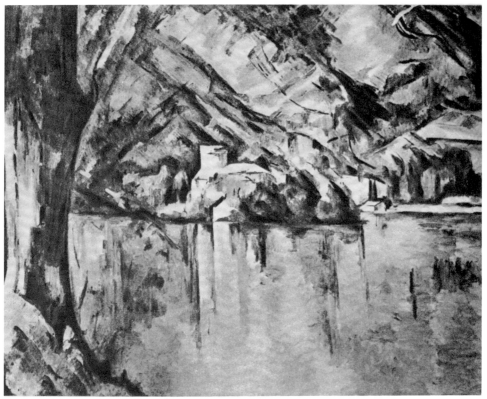

CÉZANNE: THE LAKE OF ANNECY

The style that is coming into being now that all the world's arts are under review is neither the expression of any given period, such as the Gothic period, nor is it conditioned by some mythical Golden Age which it seeks to perpetuate. The most intellectual style that has ever existed, so far as we can judge, it is no longer the appanage of any specific culture. The genius of Piero della Francesca, El Greco, Latour and Vermeer—painters whom our age has promoted or restored to the front rank—stems from their presence in the picture; but what we now have in mind is not that dazzling freedom of brushwork which led it to be said of Hals that he painted "broadly." Their presence was the presence of a *style*. Botticelli looks decorative when compared with Piero, as does Ribera when compared with El Greco, and so do all the anecdotal works of the little Dutch masters when compared with the *Head of a Young Girl;* and this resuscitation is not merely that of a family of forms, since Grünewald and Chardin are included in it. Somehow we feel that Chardin's tranquil mastery links up with the tragic genius of

577

DEL PIOMBO: CHRIST IN LIMBO

Grünewald, as with Van Gogh's madness. But we know well that the thick brushstrokes converging like deep furrows on the Church of Les Saintes-Maries or the horizon of Auvers were not guided by madness; on the contrary, they have an undertone of triumph, the artist's victory over his infirmity. Sometimes, as with Nietzsche, madness gets the upper hand; but the more instant the threat of mental collapse, and the darker the shadows, the more fervent is Nietzsche's cult of grandeur. "Dying, Zarathustra clasps the whole earth in his embrace." He was already mad when he wrote this. It was not Grünewald's madness but his anguish and the plenitude of his genius that Van Gogh resuscitated. The Baroque elements in his drawing are less akin to those in Rubens than to Viking ships and Scythian plaques; and his so-called copies of Millet and, above all, Delacroix explain why we can admire him alongside Cézanne, and Grünewald simultaneously with Piero. For different as these painters are, they agree in respect of all that they *exclude* from their art; in Cézanne's copy of Sebastiano del Piombo we find the same ruling passion as in Van Gogh's copies of Delacroix, and it resembles them. These latter, if we view them apart from their models, look like the skeletons of trees after a forest fire, and these skeletons are present in all Van Gogh's best works, just as an architectural design is present in all of Cézanne's.

CÉZANNE: COPY OF DEL PIOMBO'S CHRIST IN LIMBO

DELACROIX: PIETA

COPY BY VAN GOGH

In them the world seems to be transmuted *from the inside* into the essential stuff of painting—just as hitherto it had been transmuted externally, and less boldly, by lavish pigmentation and visible brush-strokes. Manet pointed the way to Derain and Soutine by what he brought to art, to Picasso and Léger by all that he destroyed, and to Matisse by both. The contrast between Baroque restlessness and classical stability loses much of its force once we perceive beneath the seeming "wildness" of El Greco, Grünewald and certain Tintorettos a directive will not unlike that behind *The Housewife* and *The Love Letter;* and once Van Gogh's steely brushstrokes, tempered in the fires of madness, come to affect us in the same manner as Cézanne's crystallizations. At the end of an epoch during which art was perpetually harassed by determinism under many guises we are learning to hear the challenge of the man who is master of his art to those who gamble on the miracle. Indeed this mastery is the common measure of all great works of art, however extravagant they may appear; it is link between them and the rock-face figures of China, the pediment of Olympia, Romanesque statuary, the Sumerian priest-kings; and this style whose rise to recognition synchronized with the "renaissance" of the art of savages is perhaps the greatest style the West has ever sponsored.

OLYMPIA (5th CENTURY B.C.): LAPITH

VERMEER: HEAD OF A YOUNG GIRL

PIERO DELLA FRANCESCA: THE FINDING OF THE TRUE CROSS (DETAIL)

NARA (7th CENTURY): BODHISATTVA

DETAIL OF THE VILLENEUVE PIETA

GRUNEWALD: DETAIL OF THE ISSENHEIM ALTARPIECE

MEXICO. MONTE ALBAN: THE LORD OF THE DEAD (GOLD PECTORAL)

JAVA (9th CENTURY): SIVA

Romanticism has always tended to read into the artist the magician and the man "possessed." When the Romantic artist staked his claim to greatness on the answers man still gave the gods receding from the world, even though his voice echoed on the void, the teeming denizens of the underworld began to rear their heads. We have seen how in Goya as in Goethe, Nerval and Baudelaire witches often served as midwives in the birth of the new art. And there now became apparent a curiously persistent affinity between the obscure side of certain great works of art and the dark places of man's heart. (A circumstance regarding which psychoanalysis, legitimately for once, may find much to say.) Is *The Shootings of May Third* superior to the *Dos de Mayo*, its companion picture, because it is better painted and not, rather, because implicit in it is a vision of Spain's common cause, of martyrdom, and of that secret fire which glows in the gaze of Goya's "monsters"? These intimations of the dark, demonic side of man's nature were nothing new in art. The wings of *The Victory of Samothrace* did not merely implement its triumphant line; they had been the wings of the sphinxes and harpies, and were, later, to be those of angels. The loss of the head of Niké is regrettable, no more than that; the loss of her wings would have been the end of her

Yet though the expression, even indirect, of these obscure emotions, the legacy of archaic man, may give a specific resonance to the masterpiece, this recourse to the dark powers is always put to the service of the royal accent in the work of art; no monstrous form, in art, is an end in itself. The language of death that the devil seeking our destruction tried to make us listen to is transmuted into that of a communion with the dead. Though a surrender to the dark powers may tempt the artist as a man, figures expressing that uncharted world of unknown powers fascinate him, as an artist, by reason of the domination which they require. Just as the masterpieces express the liberation of the artist from his servitude, these figures link us up with that incessant conquest which is the life of art—and this whether it allies the artist with the gods or leads him to defy them; whether it dedicates him to the gods of Babylon, to Christ, or to the service of his art alone. Nothing can overcome the vigilance, like a deep-sea diver's, of genius; no "careless rapture" prevented Goya from making his retouches or Rimbaud from making his erasures. The maker of masks may be possessed by his familiar spirits, but he hears in them one of the world's voices and, *qua* sculptor, masters and takes possession of them. The face of an Indonesian Siva tells of a conquest of the death's head above it; and though the Chartres sculptor was certainly "possessed" by Christ, it was not Christ who carved the Royal Portal.

V Not every day, nor even every century, does the type of man arise who, abandoning an established attitude towards the cosmos, conquers the world anew. It was not on behalf of the spirit of Macedonia that the Hellenistic spirit abdicated; nor on behalf of the Roman spirit that a Colosseum and some churches decorated with mosaics survive amongst the brambles to tell us of Rome's past; whereas, paradoxically enough, it is on the authority of the European spirit and its discoveries that Asia today is casting off European domination. After disinterring three thousand years of history, Europe now dreams of conquering the entire past, a conquest never yet achieved; some epochs, indeed, could hardly reconquer their immediate past. What has our vast and varied resuscitation in common with the archaizing taste of the Alexandrians? We know much about the archaism of certain ancient cultures (and the Chinese); it was on a par with the penchant of our Empire style for Egypt, and that of the nineteenth century for Gothic decoration. But, amongst us, it is not the admirers of Rheims who admire pseudo-Gothic architecture; it is, rather, those who do not care for Rheims. Our resemblances with Alexandria are of the slightest in this modern world which, in a mere hundred years, has been stripped of the dreams Europe had cherished since the age of the cave man.

The masks and ancestors which interest us are being made no longer, and while they are entering our museums, even the stupidest of our own figures are enough to kill them off in Africa. Piously we recall the frescoes of burnt-out Nara, while modern Japanese artists waste their time imitating Montparnassian painters whose fame does not extend even to Lyons. We have photographed Ajanta, but the painters of the Calcutta school are Pre-Raphaelites; and the (much superior) art of the modern Mexicans has become familiar to us. It is high time for us to recognize that, for three hundred years, the world has not produced a single work of art comparable with the supreme works of the West. What is challenged in our culture is challenged by the *past* of other cultures; it is as if the all-conquering but chaotic culture that is ours were trying to destroy its humanistic heritage with the sole object of achieving an international humanism and incorporating both what is apparently nearest to its own art and that which is most profoundly foreign to it.

The affinity we tend to discern between our reconstitutions of the past and modern art seems all the more baffling now we are beginning to suspect that, though we know much about the *forms* of our art, we know far less about its *spirit*. Obviously, the more individualist an art, the more diverse are its manifestations. It is above all if we are still obsessed by the idea that plastic art aims primarily at nature-imitation, that this diversity bewilders us. Once that illusion is dispelled, we find that Sisley, who painted landscapes not as they look to the average man but as the painter wished to see them (i.e. subordinated to the

picture), is not really so far removed from Braque who paints a still life as he wishes to paint it. A naked woman painted by Degas was a nude, in other words, a picture, not a naked woman. But in ceasing to be subservient to representation, modern art was not committing itself to pure abstraction. And if the dramatic fixation of one element of the visible—of light with Monet, movement with Degas—was a means, not an end, was that end merely an individualization of the world? Though in an individualist age each individual is a separate entity, individualism is common to all. Impressionism and even modern art are collective movements. When we visit an exhibition of our pictures in Russia, in an Islamic country, or in Asia, what particularly strikes us is the aggressive nature of our revolt against appearance during the last hundred years. Obviously this revolt, in respect of which modern art makes common cause with almost all it has resuscitated, is no more due to a special way of seeing the world than to the individual artist's compulsion to express himself; for, while every great modern painter conquers and annexes the world, all these annexations coalesce. What is being called in question once again is the *value* of the world of appearances.

Though we tend to ignore it, the truth is that Europe has never regarded the world of appearance as inimical, and European art whenever it repudiates appearance merely brushes it aside. Whereas in India and the Far East appearance is identified with illusion—in other words, with evil: "evil" in the metaphysical, not the Christian sense—and all Eastern art is a victory over the lie of the cosmos. The Sung landscapes were not painted "from life," even when described as representing views along a river (but not in any precise spot) or aspects of some sacred mountain. The Chinese name for "landscape" is "water-and-mountains," which explains why the latter are so persistently present, though actually mountainous regions are no commoner in China than in France. Their relations with the water signify those between the *yin* and the *yang:* sometimes clearly indicated, sometimes fading out into the Buddhist mist. These landscapes are as carefully built up as Poussin's, and in a more complex manner. They are not scenes, but visions wrested from the universe and charged with intimations of divinity; whereas the "impure" landscapes around us are but earthbound fragments of the world of appearances.

When arts of the past broke with appearances, their object (like that of ordinary idealization) was to invest the thing seen with quality; as, for example, Byzantine art invested the world with holiness. But the Byzantines knew what they were after, whereas our modern artists, though they emancipate their portrayals from the world of appearances no less passionately than the Buddhist artists, would be hard put to it to say what higher purpose they are serving.

We realize that the *transformative* activity of modern art stems from

our culture, which aims far more at transfiguring the world than at adapting itself to its environment or even at accepting certain chosen elements of it. Modern science, too, has built up a world of its own, abstracted from appearances; but we know how alien science is to our art. Nor can we forget that our universalism, voracious though it be, takes good heed not to include *everything* in its repast.

Are we really sure that the strictly plastic value of a portrait by Gainsborough, of a scene by Mieris, Annibale Carracci, Solimena or Murillo, or by any of those English and Dutch painters who were thought so much of in the nineteenth century, is inferior to that of a second-rank Romanesque fresco? We are apt to read into the modern quest of tectonic form and often of effects of stridency, a deeper meaning, the quest of some *arcanum*. Akin to all styles that express the transcendental and unlike all others, our style seems to belong to some religion of which it is unaware. Yet it owes its affinity with the former not to the expression of faith in an unseen world but, rather, to its exclusion, and is as it were a photographic negative of the styles of the transcendent.

Needless to say, no style has ever been put wholly to the service of nature-imitation (we have seen why this is so). The Mediterranean ideal of beauty repudiated imitation, in its own manner. No less whole-heartedly than Hellenic culture challenged the mystery of the cosmos and asserted man's prerogative, other civilizations challenged his prerogative, setting up against it the Eternal or, more simply, the non-human. Yet neither death, nor the dark lures of the underworld, nor the menaces of doom-fraught stars have at all times prevailed against that soaring hope which enabled human aspiration, winged with love, to confront the palpitating vastness of the nebulae with the puny yet indomitable forms of Galilean fishermen or shepherds of Arcadia. On the one hand are the forms of all that belongs essentially to the human, from the beauty of women to the fellowship of men, from Titian's *Venus* to his *Pietà*. On the other are all the forms that crush or baffle man, from Sphinx to fetish. The outspread hands of him who kneels in gratitude before his Maker and the arms clamped to the body of the oriental worshiper —how many gestures, varying with the ages, are those of man communing with the sacrosanct! But each form of the sacrosanct was regarded by members of the culture which gave rise to it as a revelation of the Truth; at Byzantium it was not a mere hypothesis that was sponsored by the majesty of the Byzantine style. To us, however, these forms make their appeal as forms alone—in other words, as they would be were they the work of a contemporary (and, since actually this is unthinkable, they affect us in a puzzling manner); or else as so many grandiose vestiges of a faith that has died out. We look at them from outside; they are still emotive, but they are no longer true. Thus we deprive them of what was their most vital element; for a religious civilization that regarded what it revered as a mere hypothesis is inconceivable.

MEXICO. PIEDRAS NEGRAS: STELE 26

In all parts of the world and in every age the styles of sacred art declined to imitate life and insisted on transforming or transcending it. And because everything they portray belonged to a world apart, a world of divine revelation, they stand to the arts that followed them as do the Hebrew prophets to our novelists. In all works of this order the relations between forms are deliberately estranged from those of "real life," differing from them not only because of their esoteric quality but also, as in the art of Sumer, Byzantium and (sometimes) Mexico, because of their uncompromising autonomy. Thus these works of art, when their religious function has passed away, exhibit a characteristic common to them all, their discrepancy from "the real." Indeed, since the style of a sacred art derives largely from the means it employs for creating figures that in some respect supersede the human, a sacred art subordinated to mere appearances is all but inconceivable. The quality modern art has in common with the sacred arts is not that, like them, it has any

SUMERIAN ART: THE GOVERNOR OF LAGASH (DETAIL)

transcendental significance, but that, like them, it sponsors only such forms as are discrepant from visual experience.

This is why Expressionism failed to deflect the course of modern art. All that claims to be a direct expression of man and things—an expression that the artist has accepted, indeed chosen, as the vehicle of his art—stems ultimately from the first smile of Greece or China and is bound up with man, like Goethe's "characteristic" and the caricature. Even this latter, the antithesis of idealization, is less opposed to it than to the discrepant which, in lieu of caricatures, gives rise to monsters. Underlying both Expressionism and Impressionism was the same trend; but an accusation, if it is to make good, needs to set up against the order of things which it indicts something that transcends this; that is to say, in art, a style discrepant from reality. From Van Gogh to Rouault, by way of the Flemish and German Expressionists, the will to expression was always conditioned by the will to style; as it was, if to less happy effect, in Byzantium, from St. Luke's in Phocis to Daphni, and has been in our times, more significantly. We need but compare Daumier's lawyers and judges with Rouault's dramatic, then frankly tragic judges.

DAUMIER: LAWYERS CONVERSING

ROUAULT: JUDGES

Like that of the Eastern Church our style is based on a conviction that the only world which matters is other than the world of appearances, which it does not so much express as parallel. An ikon does not claim to be Christ's likeness but to offer a convincing symbol of it; in the same way modern art is the creation, or invocation, of a world foreign to the real world, not its expression. It does not express a unique, overriding value as Byzantine mosaics expressed the majesty of God. It is not, nor does it set out to be, the expression of any specific emotion predominating in a culture based on that emotion; it is, perhaps, because our age prefers aspects of the non-real whose purport it cannot grasp that it is so ready to admire all that it does not understand. Whereas the sacrosanct does not merely sponsor an absolute; it also implies that the whole life of the community in which it emerges is swayed and guided by that absolute.

When the French Government decided to decorate the Panthéon with murals they called in a few talented artists and many mediocrities; but would men like Renoir and Cézanne have been willing to participate? If not, we may be told, the reason is that painting had become divorced from architecture. Nevertheless Cézanne's art is architectural, and Renoir's, on occasion, more so than the Venetians', and at least as much as Maillol's. It was not that Renoir was incapable of covering that fine expanse of wall; it was "The Crowning of Charlemagne" that he could not, *would* not, paint. (The mere thought of it makes us smile!) But Delacroix would have painted it.

Whether or not Renoir as a man endorsed the values which were to lord it in that peculiar House of Fame, his painting had no truck with them. In it there was no place for a modern Panthéon; that old-time church, haunted by so many illustrious Shades, had become neither a sanctuary nor even a mausoleum; merely a cemetery to which our politicians send, one after another, the coffins of their opponents. I have seen a small boy bouncing his ball under those huge Italian vaults. *"Aux grands hommes, la Patrie reconnaissante."* Yet how far we are here from the Taj Mahal whose marble solitudes are the playground of squirrels from the near-by jungle; or the Ming tombs with their seneschals of rusted iron, gazing across the vastness of the wheatfields, a crow perched on each shoulder; or Attila's grave in the Danube bed!

No other place reveals more cruelly the fatuity of our present-day civilization whose desire to honor the dead leads to cheap theatrical effect, and is satisfied by this. Renoir was not satisfied by it; he, anyhow, was aware of a supreme value—Painting—and the tawdriness of our Panthéon would have been out of place in the temple of his dream. Had a "Homage to France" been asked of him, the wisest thing would have been to append this title to his noblest picture; for even had he painted frescoes like his sculpture, he could not have painted them in the

RENOIR: THE SAONE AND THE RHONE

Panthéon without a feeling of *malaise*. Even *The Saône and the Rhône*, an admirable allegory, that however, plays fast and loose with history (a picture he kept with him until his death), never got beyond the stage of a sketch, for this condition of a sketch enabled it to remain within the sphere of painting as an end in itself, and when painting ranks as the supreme value it has no concern with, and no place in, a social order that, itself, lacks any supreme value.

What exactly is a modern picture? That compendious term "easel picture" covers a wide field: a Braque still life obviously differs *toto coelo* from one by a Dutch little master; indeed a Cézanne still life is equally remote from it; and many of Manet's were something unique in painting when he made them and as unlike Chardin's as they were unlike the Dutch still lifes of foodstuffs. Modern pictures are not objects intended to be hung on a drawing-room wall to ornament it—even if we do hang them there. It is possible that, thanks to the process of metamorphosis, Picasso may come to be aligned, in the year 2200, with the Persian ceramists; but this will happen only if people of that day have ceased to understand the first thing about his art. The gestures we make when handling pictures we admire (not only masterpieces) are those befitting precious objects: but also, let us not forget, objects claiming veneration. Once a mere collection, the art museum is by way of becoming a sort of shrine, the only one of the modern age; the man who looks at an *Annunciation* in the National Gallery of Washington is moved by it no less profoundly than the man who sees it in an Italian church. True, a Braque still life is not a sacred object; nevertheless, though not a Byzantine miniature, it, too, belongs to another world and it is hallowed by its association with a vague deity known as Art, as the miniature was hallowed by its association with Christ Pantocrator.

In this context the religious vocabulary may jar on us; but unhappily we have no other. Though this art is not a god, but an absolute, it has, like a god, its fanatics and its martyrs and is far from being an abstraction. The Independents who spoke so charily of their art, so rarely laid down the law, and whose favorite mode of expression was the more or less witty repartee, saw in the function attributed to art by their official adversaries (more than in their works, at which they merely mocked) not only a misconception but something positively revolting. The most fanatical went so far as to frown on even purely personal gestures which looked like truckling to the enemy; thus Renoir's break with Degas was the result of an insulting letter Degas sent him when he was awarded the Cross of the Legion of Honor (which he had never solicited). How could they have regarded an Impressionist who reverted to academic painting as other than a renegade? And how, then, could an indictment of the contemporary world fail to have a certain kinship with the religious sentiment?

From the Romantic period onward art became more and more the object of a cult; the indignation felt at Jan Van Eyck's having been employed to design stucco decorations came from a feeling that this was nothing short of sacrilege. Else why be so much distressed at the thought that the great Italian Masters painted the figures on marriage coffers, but not by the fact that they painted those on the predellas? The artist's personal life had come to be regarded as the mere vehicle of his art. Such men as Velazquez and Leonardo who painted only when commissioned were very different from Cézanne for whom painting was a *vocation*. Though it may not convey a precise idea of human significance at its highest level, modern art often illustrates a precise conception of the artist.

There was no longer any question of an unavowed absolute like Vermeer's; our moderns made no secret of their intention to dominate appearances and build anew the world that had vanished from Europe, a world that had known and venerated supreme values. Less and less hampered by the "lifelike," the artist's vision harked back to the sacrosanct figures of that autonomous world which had passed away.

This would have been better understood had not the religious element in art been confused, from the time of the Romantics (and by them most of all), with the powerful expression of some vague religious emotion. Nothing has misled our art historians more than the "artistic" Masses celebrated by violinists in concert-halls beneath Beethoven's mask and facing plaster casts of Michelangelo. Art is not a dream and those dreamlike figures dear to the Pre-Raphaelites, to Puvis and to Gustave Moreau are being more and more obliterated by the advance of modern art, which does not sponsor any makeshift absolute but, at least in the artist's eyes, has stepped into its—the absolute's—place.

It is not a religion, but a faith. Not a sacrament, but the negation of a tainted world. Its rejection of appearances and its distortions derive from an impulse very different from that behind the art of savages and even Romanesque art, yet akin to these by reason of the intimate relation they create between the painter and the thing created. Hence the curious mingling of acceptance and rejection of the world that we find in the art of the late nineteenth-century masters. Cézanne, Renoir and Van Gogh did not reject it as did Ivan Karamazov, but they rejected more than the social order of their day. Van Gogh's art in his best period had become no more than indirectly Christian; indeed, it was a substitute for his faith. If Cézanne, the good Catholic, had painted Crucifixions, they would have been Cézannesque, and that is doubtless why he painted none. As against representation of the visible world, artists try to create another world (not only another representation) for their personal use. Talk of a modern art "of the masses" is mere wishful thinking: the expression of a desire to combine a taste for art

with one for human brotherhood. An art acts on the masses only when it is at the service of *their* absolute and inseparable from it; when it creates Virgins, not just statues. Though, needless to say, the Byzantine artist did not see people in the street like figures in ikons, any more than Braque sees fruit-dishes in fragments, the forms of Braque cannot mean to twentieth-century France what the forms of Daphni meant to Macedonian Byzantium. If Picasso had painted Stalin in Russia, he would have had to do so in a style repudiating that of all his pictures, including *Guernica*. For a modern artist any genuine attempt to appeal to the masses would necessitate his "conversion," a change of absolute. Sacred art and religious art can exist only in a community, a social group swayed by the same belief, and if that group dies out or is dispersed, these arts are forced to undergo a metamorphosis. The only "community" available to the artist consists of those who more or less are of his own kind (their number nowadays is on the increase). At the same time as it is gaining ground, modern art is growing more and more indifferent to the perpetuation of that realm of art which sponsored it from the days of Sumer to the time when the first rifts developed in Christendom: the realm of the gods, living or dead, of scriptures and of legends. The sculptors of the Old Kingdom and the Empire, of the Acropolis, of the Chinese figures hewn in the rock-face, of Angkor and Elephanta, no less than the painters of the Villeneuve *Pietà* and the Nara frescoes and, later, Michelangelo, Titian, Rubens and Rembrandt linked men up with the universe; as did even Goya, flinging them his gifts of darkness. As for the art of today—does it not tend to bring to men only that scission of the consciousness, whence it took its rise?

VI It is the high place assigned in our culture to the spirit of enquiry that differentiates it from all the cultures of the past with the exception of the Greek, and it is to this spirit that modern science owes the alarming power it now possesses. Our art, too, is becoming an uneasy questioning of the scheme of things.

Never indeed since the Renaissance has this spirit relaxed its supremacy, save in appearance. The ornate shadow of Versailles, lengthening out across the whole of the seventeenth century, tends to hide from us its harassed soul; beneath the rich profusion of the Jesuit churches the rifts in Christendom were ever widening. Leonardo had been interrogation incarnate, yet this enabled him to come to terms with the universe on Far-Eastern lines—a solution of which his drawings of clouds may be regarded as the symbol. Later, when that spirit of questioning probed deeper, until man no longer was an ally of the outside world but its foe—when, with the factory replacing the cathedral, the artist felt himself shut out from this new world man had conquered —the history of our art seemed to be that of a conquest of the world by the individual, acting alone. We are told that our individualist art has touched its limit, and its expression can go no farther. That has often been said; but if it cannot go farther, it still may go elsewhere. The great Christian art did not die because all possible forms had been used up; it died because faith was being transformed into piety. Now, the same conquest of the outside world that brought in our modern individualism, so different from that of the Renaissance, is by way of relativizing the individual. It is plain to see that man's faculty of transformation, which began by a remaking of the natural world, has ended by calling man himself in question. Still too strong to be a slave, and not strong enough to remain the lord of creation, the individual man, while by no means willing to renounce his conquests, is ceasing to find in them his *raison d'être;* the devalued individual of the five-year plans and the Tennessee Valley is losing nothing of his strength, but individualist art is losing its power to annex the world.

Thus it is that a Picasso steps into the place of a Cézanne and the sense of conquest, of man triumphant, is replaced by a spirit of questioning, sometimes serene, but usually anxious and perplexed. And thus it is that the *negative values* which bulk so large in our civilization as well as in our art come to the fore and the fetishes force their way into our culture. For the men who made them, these fetishes were not necessarily disturbing elements, but for us, when we discover them, they are. All our art, even the least denunciatory, Renoir's or Braque's for instance, contains a challenge of a world that it disowns, and we refuse, no less emphatically than Byzantium, to be dominated by the world of visual experience. Whereas Van Gogh saw himself as the pioneer of the art of the future, an art in which the lost plenitude of the art of the past would reappear, Picasso has learnt that were it to re-emerge it would

re-emerge *against* him. But for the painter always his art comes first; inseparable from the will to art, his questioning serves him as a means of furthering it, as it furthers that of the great poets. Shakespeare's interrogation of the meaning of life is the source of his noblest poetry; however passionate the denunciation of the scheme of things in Dostoevski's novels, it changes its nature and becomes art in the scene where Muishkin and Rogojin are keeping vigil over Nastasia Philippovna's dead body. Indeed Dostoevski himself wrote: "The great thing is to make my *Brothers Karamazov* a work of art." Despite the insatiable questioning basic to Greek thought, the impression Greek art made on the world for many centuries was one of a triumphant affirmation.

Our Museum without Walls is taking form while the long struggle between official art and forward - looking art is drawing to a close. Everywhere except in Soviet Russia the "banned" art is triumphant; official teaching has become irrelevant and the Prix de Rome an obsolete survival. But this triumph, that of the individual, is coming to look to us as precarious as it is spectacular. Seconded by the Museum without Walls which it called into being, modern art confirms the autonomy of painting. For a tradition—that is to say a culture conscious of its claims on every field of human activity—it has substituted a culture that sets up no such claim: a culture that is not categorical but explorative. In this quest the artist, and perhaps modern man in general, knows only his starting-point, his methods and his bearings, and follows the uncharted path of the great sea-venturers.

But even today, can we conceive of a culture on the lines of the great voyages of discovery? Haunted by a mythical past and imbued with a religious faith that had lost nothing of its hold on the minds of men, the Renaissance had only fleeting glimpses of this possibility.

Victorious as it is, our modern art fears it may not outlast its victory without undergoing a metamorphosis; foreseeing that painting may very well cease following the graph begun by Manet and passing through Cézanne to Picasso, it is persistently scanning the horizon for its successor. How far does contemporary art reflect contemporary culture? It is quite possible that the successor of the art we call "modern" will be still more individualist; and it is not impossible that it will assume, to begin with, the form of a resuscitation before developing into a new art, vaster in scope and deeper, born of this resuscitation.

For our art has brought to us not only those arts which are akin to it. Every art that greatly differs from its predecessor involves a transformation of taste and this is often the point of departure for further changes. We have seen how it led in cultures mindful of the past to the re-emergence of forms seemingly or actually akin to its own; but this resuscitation was due not to any specifically artistic quality in those earlier works but to values of another order, and often of a national order. Thus certain revivals of the past in Persia and the Far East, and

even the Italian Renaissance, suggest a harking back to racial traditions and glorious memories in order to efface from art the traces of a foreign conqueror. Sometimes these values were of a subtler nature. Thus sixteenth-century Rome took over all the forms of the past which seemed to contain intimations of the Christian harmony she sponsored. This harmony was by way of replacing the earlier Christian values in a realm which was not that of art alone, since art did not as yet exist in its own right, but was dedicated primarily to the service of that communion which was the Christian ideal.

Modern art, by substituting art's *specific* value for the values to which hitherto art had been subordinated, is bringing about a resuscitation whose various elements seem to be superimposed one on the other. The most obvious of these, if perhaps the most superficial, caters to our contemporary taste. It is not always concerned with forms, yet is sometimes of a wholly plastic order, and in such cases-corresponds to an element of our art whose mode of expression, or symbol, is the patch of color irrelevant both to the structure of the picture and to its composition (in the traditional meaning of the term). It does not serve as an accent stressing any detail of the execution nor, as in Japan, some feature of the thing portrayed; rather it seems to exist capriciously, as though it had been put in for its own sake only.

Nevertheless, in the work of those who make use of the patch we can almost always see that it has a certain relevance: in the case of Picasso with a passionate constructivism; in Bonnard's, then in Braque's, with an effect of harmony; in Léger's, with an architectural lay-out. Sometimes, too, the patch sounds a high-pitched note keyed to the calligraphy (from Dufy onwards to the blood-red splashes of André Masson). But in the art of Miro, as formerly in that of Kandinsky and as in the art of Klee, the patch often exists in its own right, apart from any reference to the picture's content, and we are tempted to speak of a one-dimensional art. Often this obsession with the patch seems to incite the painter to blot out the picture itself, as does the calligraphy in some of Picasso's works. Indeed in Picasso's case as in Miro's it pointed the way to ceramics; as though the artists were groping for some pictorial outlet other than the easel picture. But there is no question here of decorative art; it is a far cry from these earthenware objects to what some gay vase painted by Renoir might have been, or to the tapestry cartoons of Poussin, or Goya's in his first period. "You can eat off them," Picasso says, pointing to his plates, knowing quite well that most of them are calculated to prevent one's eating off them. This unpredictable, dazzling, tempestuous art of his, the Baroque of individualism, brings to mind the darkly glowing patches on some Persian crockery, above all when it comes to us in fragments. Like that of the Kumishah vases, the modern patch is combined with a delicate naïve calligraphy, seemingly quite alien to it, yet in fact developing its full

value when brought in contact with the patch. Actually, the Persian patches made their impression without reference to the objects to which they belonged, and which no one would have thought of likening to pictures. None the less they have much to tell us about the picture; and not, appearances notwithstanding, about the *objet d'art*.

The frontiers of art have often been modified and there are colors other than those of oil painting. However, we have not here an entirely new departure like the invention of the stained-glass window. What we have is simply the extreme limit (for the time being) of modern painting: something that stands in much the same relation to our art culture as does the "savage" feather cloak, which in fact is sponsored by

the patch; for the annexation of the fetish has been the work of the modernist, who integrates it in his art. (An "absolutely free" art does not lead to the picture or to statuary, but to *objects*.) Our modern use of the patch goes much farther than the splashes of color in folk art (which were not always due to carelessness on the part of the stenciler or colorer) and those on the white-ground lecythi; it suggests a form of "pure painting" in which certain works of the past would seem to have participated to a greater or a less extent. For we must not forget that the triumph of modern art was also the triumph of color: Impressionists, Expressionists and Fauves successively promoted it and the analytic Cubism of Léger, Picasso and even Braque (despite a good many quiet, almost monochrome compositions) ended up in a blaze of color. Shadows were

ART OF THE HAIDA INDIANS: PIPE (DETAIL)

JOAN MIRO
CERAMIC

eliminated and with them broken colors, and everything opposed to these came back into favor: from Haïda "objects" to Coptic fabrics, from the household gods of the Hopis to Gallic coins. In the plastic arts, as in music, literature, and the theater, stridency had become the order of the day.

Works of this order would figure prominently amongst our present-day rediscoveries, were it *only* color that we were rediscovering, and did we tend to substitute the occasional "lucky fluke" for conscious mastery. But the "thrills" of Haïda art soon began to pall, and the Hopis are far from being Sumerians. We describe the New Hebridean ancestors as effigies ("paintings" would fit them quite as well) but we do not call them statues. Whilst certain arts that ours has resuscitated have been so thoroughly integrated into our culture as to transform it, others merely strike us as new schools and, like all new schools, either hold their ground or pass away. Thus our resuscitations sometimes answer to a desire for strong sensations, for works which engender new dialogues with new interlocutors; sometimes to an atavistic yearning for the mysterious; and sometimes to the modern appreciation of all arts which, like the work of our great European painters, give rise to a dialogue that strikes ever deeper, and indeed seems inexhaustible.

If we could picture a great artist acquainted, in addition to contemporary works, with only the specifically plastic qualities of the works of the past, such a man would seem to us the superior type of the modern barbarian: one whose barbarianism is not, as in an earlier age, definable by his rejection of the status of citizen, but by his rejection of the estate of Man. Were our culture to be restricted solely to our response (lively though it is) to forms and colors, and their vivid expression in contemporary art—surely the name of "culture" could hardly be applied to it! But it is far from being thus restricted. For alongside the resuscitation of works akin to those of our own art another factor is coming into play: one whose consequences it is as yet impossible to foresee. Though some artists and aestheticians still maintain that modern art, the arts of savages and certain ancient forms are incompatible, the general public finds no difficulty in feeling a like enthusiasm for them all; its taste for modern painting leads it to crowd the Louvre, not to desert it.

No real pluralism in art was known to Europe until the simultaneous acceptance of the Northern and Mediterranean traditions which took place, not at the Renaissance, but when the supremacy of Rome was challenged by a coalition of Venice, Spain and the North during the nineteenth century. Raphael painted *The Liberation of St. Peter* over a fresco by Piero della Francesca; the leaders of the Renaissance neither accepted nor opposed the Gothics, they disdained them. Nevertheless like the Gothics (though for other reasons) and like the classical artists of a later age, they saw art as a system of forms akin to each other and placed at the service of certain accepted values. The Romantics put to the service of a Promethean concept of Man a plurality of forms,

but these forms still were of one family. Our age seemed at first to wish to base the unity of all the arts it sponsored on a kinship of forms alone; thus it assimilated the pier-statue on the strength of its affinities with Cézanne. But though modern art by way of these affinities between its styles and the hitherto ignored styles of earlier ages, and by its rejection of any set rules of aesthetics, enabled the statue in question to rank quite naturally beside a picture by Cézanne, and by the same token beside a Wei statue, the pier-statue did not thereby become either a Romanesque Queen or even a statue pure and simple.

For, in actual fact, our recognition of the specific language of the various arts involved not only the discovery of their accents, but that of their voices—their message—as well. This would have been noticed sooner if during the early phase of modern art the academic artists had not set themselves up as champions of the past, while the Independents (who in fact were resuscitating it) claimed to be sponsoring the future. But the academicians' championship of the past was growing less and less defensible, and if they held their ground the reason was that they were so ready to truckle to the public and assign to painting the same function as the public assigned to it. It is curious to see an art of mere delectation claiming descent from Michelangelo, Bonnat from Rembrandt. But it seems hardly less surprising that an art which found its values in itself alone should have resuscitated so many values foreign to its own; that Manet and Braque should have acted as interpreters of the language in which the Sumerians, the Pre-Columbians and the great Buddhist arts address us. Perhaps I was wrong to use the word "interpreters"; what Braque and Manet have done is to enable us to "hear" that language; the surgeon who removes a cataract does not interpret the world to his patient but gives it, or restores it, to him. Before the coming of modern art no one *saw* a Khmer head, still less a Polynesian sculpture, for the good reason that no one looked at them. Just as in the twelfth century no one looked at Greek art, or in the seventeenth at medieval art. Though we resuscitate pre-Romanesque art on the strength of its Expressionism, our culture, while rehabilitating other arts by way of its own, does not always insist on their being similar to these. We recognize that the great Buddhist, Egyptian and Gothic works can claim equality with Giotto and Rembrandt in our admiration. We expect to discover other works as well which, while not relaying those nameless artists of the past as obviously as Rembrandt takes over the torch from Michelangelo, will perhaps differ from the above-mentioned works no less than they differ from one another. Though the work of art is an answer to man's interrogation of the universe and admired as such, it sometimes happens, during periods of great changes in the world of art, that it silences interrogations which had hitherto been taken for granted. Now that the very concept of art has become an open question, it has ceased to be predeterminable. We all know

that an inferior imitator of Rembrandt is not an echo of Rembrandt but an echo of the void; for a present-day Rembrandt would be no more like the real Rembrandt than the latter is like the Villeneuve *Pietà* or a Piero della Francesca like the *Koré of Euthydikos*. The reason why epigones of Rembrandt and pseudo-Michelangelos exasperate us is perhaps that the presence of Michelangelo and Rembrandt, not in our art museums only but also in our hearts, is far more real and vital than it was in the age when their imitators were admired. The dialogue between frankly opposing forms of creativity is richer in intimations than the colloquy between true genius and its followers; it is when we confront *Night* or the *Rondanini Pietà* with a New-Hebridean figure or a Dogon mask that we appreciate their significance most intensely; thus, too, a lamp shines brightest in the heart of darkness. Though we sometimes have inklings of an underlying affinity in all art forms (close enough to hint at the existence of some common denominator of a complex order and so far unelucidated), it does not prevail against their constant metamorphosis or our knowledge that the continuity of art is ensured by new discoveries. No traditional aesthetic has "spread" from Greece to Oceania; but it is true to say that a new idea of art has arisen in our times, as it arose when Leonardo's art and Titian's replaced that of the nameless sculptors of the cathedrals. And it is because this idea is not based on any aesthetic preconception that for the first time it covers the whole world.

The rise to power of history, which began with the decline of Christendom and even of Christianity, is due neither to modern science nor to historical research into the lives of Christ and Buddha, but to the fact that history pigeonholes each religion within a temporal context, thus depriving it of its value as an absolute, a value which syncretic systems such as theosophy are obviously unable to replace. But this concept of religion as an absolute had ruled out the possibility of any mutual understanding on a deeper, universal level. In the age of Bajazet, Islam was not regarded as an hypothesis but as a deadly peril; and, as such, anathema. In the twelfth century there could have been no question of contrasting or comparing a Wei statue with a Romanesque statue; on the one hand there was an idol, on the other, a Saint. Similarly in the seventeenth century a Sung painting would not have been contrasted with a work by Poussin, for this would have meant comparing a "queer" outlandish landscape with a "noble work of art." Yet if that Sung landscape were not appraised primarily as a work of art, it simply did not exist. Its significance was repudiated not by Poussin's artistic talent but by the conception of art for which that talent catered and from which it was inseparable. From the immense and grandiose domain of Far-Eastern art our Classicism took over only the *chinoiserie* and our early modern artists took over Japanese prints, whereas our art today is importing into our culture statues worthy of those of the

European Middle Ages—Buddhist paintings and frescoes, Sung wash-drawings, the Braque-like scrolls of the Tairas. In the past no art was viewed separately from the exclusive, not the specific, values which it served and which made all types of art which did not serve these become, so to speak, invisible. The conflict ceased once art came to be seen as constituting *its own value*. Though Khmer heads did not thereby become "modern," they became, anyhow, visible and, compared with other heads (or amongst themselves) some of them became what they actually are, i.e., works of art, even if the men who carved them had no inkling of our idea of art. Thus many works of vanished civilizations are acquiring for the first time their common language.

AFRICAN ART: BAKUBA IRON OX

But that language never emerged in isolation; whatever their purely sculptural qualities, the holy effigies of India and Mexico were not cubist or abstract sculptures—and could never become such entirely. For in the eyes of the artists who discovered these figures "abstraction" in art still meant an abstraction from some existing thing and was not

TEOTIHUACAN: COLOSSAL STATUE OF THE WATER GODDESS

an end in itself. We should be wrong to infer from the fact that in art no "content" exists independently of the form expressing it that the difference between Soutine's *Flayed Ox* and Rembrandt's is only a difference in the talent of the two artists; indeed even now we can hardly bring ourselves to look at a Negro mask in the same manner as we look at a sculpture by Picasso.

SOUTINE: THE FLAYED OX

REMBRANDT: THE FLAYED OX

Do there exist forms expressing nothing? Obviously we can conceive of lines and patches being arranged in such a way as to form a composition consisting of organized, meaningful or emotive ideograms: i.e., the "schema" or "blueprint" in its purest state. But the civilizations of the past knew nothing of the modern forms which seem so passionately intent on expressing nothing, and are in fact fighting forms. A non-orientated representation of the forms of life is possible (a non-orientated *allusion* to them is not even possible) only if we assume it absolutely, photographically faithful to appearance. But the forms transmitted to us by our Museum without Walls are not forms of real life; the *Elders* of Moissac, the Pre-Columbian figures and the Ravenna mosaics were not literal records of things seen. Since the plastic arts can no more be solely representative than they can be solely signs, and since the work of genius is not a mere lucky fluke but an act of autonomous creative power, how could that power, a power the creator had to win for himself, have failed to have an orientation?

That this question should arise at all is due to the nature of our art, which believed itself to be annexing all that it resuscitated; and also to that notion of perfection which, jumbling together art, taste and nature imitation, fostered the theory that Giotto was an improved Taddeo Gaddi or a purified Cimabue, and that Rembrandt was an improved Aart de Gelder or a glorified Elsheimer. It is certain that painting has a history, but less certain that creation has one, for representation is more obviously conditioned by history than is genius. Corneille's poetry does not follow Shakespeare's in the same way as Corneille's stage craft succeeds and replaces that of Schélandre. It is the presence of the basic values expressed in the works of the great art periods that enables these works to move us as they do and imparts to them their autonomy, an autonomy to which they have no claim if they are the works of epigones, not of an original creator. Though sometimes we may fail to distinguish the follower from the creator, we do not confuse the creator with his followers; the *Auriga* and the *Kings* of Chartres are assuredly not the work of epigones. The transition from the master to his imitators is often so gradual as to be almost imperceptible; but from true mystical experience to the habit of going to Mass on Sundays there is also a slow gradation. Gradual as the process may be and though it may be modified by metamorphoses, this does not blind us to the gulf between a work that merely appeals to our taste and one whose autonomy gives us the feeling of a conquest. All analysis of our response to art is futile if it applies equally to two pictures one of which is, and the other is not, a work of art. The new values brought into existence by creators in the course of history enter into contact with that basic value in which all participate and which makes them into art, not in the sense that aesthetes give this word, but in the sense in which we use it to express the special quality of some prehistoric painting no less than that of a

portrait by Raphael. If the Magdalenian bison is more than a sign and also more than a piece of illusionist realism—if, in short, it is a bison *other than the real bison*—is this merely due to chance? It is not a likeness any more than the fetish is, or Aphrodite, or a Sumerian goddess. The evolution of the Egyptian style, the expression of its struggle with the visible world, did not consist in the growing lifelikeness of its portraits (shared with other cultures), but in its invention of "frontalism." How could that rigid frontal pose have been discovered by an artist foreign to the values of Egypt, or the Gothic incarnation by artists knowing nothing of Christian values? Not that the depth of the artist's faith is any guarantee of that of his art; but the give-and-take which united the Egypt of the Pharaohs with its sculpture and, at the same time, opposed them to each other could, if the sculptor were not an Egyptian, never have arisen, just as similar relations could not have arisen in the age of faith between Christendom and the statues of the cathedrals, had the sculptors not been Christians. A forger can copy or concoct an *Eve*, but it will not be the *Eve* of Autun. Ingres might call one of his pictures a *Virgin* but it was not *the* Virgin that he was vying with, but with other pictures; like the bison of Altamira, the *Virgin* of Amiens belonged to another world. It was an easy transition from the Bible to legendary lore and the poetic quality that painting now sought and found was not regarded as a mere décor by the Masters of the Renaissance. Before the landscape could first dwarf, then oust, the figures, it had to cease being a setting and no more. And surely it would be quite obvious that the long history of the portrait—from the Lagash "Princes," by way of the recumbent effigies, to the portrait of today—is a record of the progressive annexation of the model by the painter's supreme value, were it not for the belief, held even by artists, that modern art has nothing to do with values of any kind whatever.

This belief is partly due to the fact that we tend to confuse values with a didactic element, a "message." No doubt there is a message of an ethical order in Michelangelo's art, as in Rembrandt's and in Dostoevski's. There is an aesthetic message behind Poussin's. These messages were intended to shore up imperiled values; but the fundamental values behind the organized culture of the sculptors of Sumer, Egypt, Greece (up to the age of Pericles), Chartres and Yün Kang were taken for granted, and the artists did not feel the least temptation to break away from them—even if they did not preach them or even give a thought to them. Pheidias did not trouble himself with speculations as to the divinity of Athene, or the Masters of Chartres as to that of Christ. The Westerner of the second half of the nineteenth century was as remote from ancient Egypt as from the age of the cave man, and knew still less about it; though he knew all about the religious art of the past and only too well the paintings that professed to carry on its message. Thus he imagined he was setting up against them a painting purged of all didactic

elements and depending on its pictorial qualities alone; a painting which specialized in harmonies or skilfully contrived discords—what the artists called "good painting." Nevertheless when, far from Europe, we look through a book illustrating the modern masters, we do not find in their art a triumph of taste or a resuscitation of the Persian miniature; what strikes us, even in their most delicately worked-out paintings, is their common will to stylization and the almost Roman pertinacity with which they keep to this. For there *is* a fundamental value of modern art, and one that goes far deeper than a mere quest of the pleasure of the eye. Its annexation of the visible world was but a preliminary move, and it stands for that immemorial impulse of creative art: the desire to build up a world apart and self-contained, existing in its own right: a desire which, for the first time in the history of art, has become the be-all and the end-all of the artist.

This is why our modern masters paint their pictures as the artists of ancient civilizations carved or painted gods. And, when all is said and done, is their emergence in the history of art more unaccountable than that of modern man in history? Never before had any civilization owed allegiance to values so little embodied in its *mores*. It is as true today as fifty years ago when Maurice Denis coined the expression, that "colors arranged in a certain order" are inseparable from the demiurgic power of art (in the strict sense of the word "demiurgic"). This is the god to whom great painters dedicate their lives, and not to any desire to compete with decorators or *grands couturiers*. Cézanne, who would have refused to change a green in any one of his pictures, even if this meant his admission to the Institute of France, once said: "I am a Catholic because I'm weak and I rely on my sister, who relies on her Father Confessor, who relies on Rome." But he would have flung out of his studio any artist who dared to talk of painting as he talked of religion. In ceasing to subordinate creative power to any supreme value, modern art has brought home to us the presence of that creative power throughout the whole history of art.

It was the recognition of this power which, in a period all for geometrical forms, brought about the resuscitation of Delacroix's and Rubens' sketches, and which led artists to see in the work of the English portraitists, the lesser Dutch painters, Italian eclectics, the Ming painters and the Moghul miniaturists manifestations of forms of art unworthy of esteem, since, though not without successes to their credit, they were not autonomous. That Roman sculpture, after being extolled for three centuries, has come to mean so little to us is due to the fact that it strikes us now as merely rhetorical and not creative. The theatrical hellenism of its style expresses neither the grandeur that was Rome nor the indomitable spirit of the Romans. Modern art does not rule out all significance from the forms it brings back to light because, in revealing a power of autonomy implicit in all genius, it associates these works with the

616

means by which that autonomy has been achieved. Picasso may sometimes paint a picture that is self-sufficient, following exactly the same procedure as that which gave the animals of the Altamira cavern their magical independence; nevertheless Picasso's own autonomy is of a different order.

It must not be forgotten that we are the first to realize that every art is closely bound up with a significance peculiar to itself; until our times such forms as did not tally with a preconceived significance of art were not linked up with *other* significances, but relegated to the scrapheap. Actually, however, the works we now rediscover are often those charged most intensely with spiritual overtones; there was nothing lukewarm in the religious emotion behind the *Kings* of Chartres, the *Christ in Prayer* or the work of Grünewald. In appraising these works the modern painter or sculptor may seem to act on the assumption that in making them the artists' faith was put to the service of their art, but he is not blind to what these works owe to the artists' faith—the debt so many rediscovered works owe to a spiritual communion that has passed away. The public on whom modern art has operated (successfully) for its cataract welcomes all that these rediscovered works suggest, in the same spirit as the Romantic public welcomed the "message" vaguely sensed in Romanesque and Gothic art once their forms had won approval.

Today we do not merely accept the presence of these resuscitated forms; we invite some of them to join us. Thus many early works to which the "official" artists had to shut their eyes *ex officio* and to which the Independents gave only a casual glance, have found their way into our culture as modern pictures have found their way into our art museums: the Villeneuve *Pietà* on the same footing as Cézanne, the Wei sculptors as Gauguin, the Byzantines as the Derain of *The Last Supper*, Negro artists as Picasso. Modern art gives the impression of continuing these works, but that is only on the surface. A fervent and art-loving Christian of today sees in the medieval masterpieces an expression, more cogent than any other, of his faith; none the less, such faith as Van Gogh's was rare even in the thirteenth century. But the faith the medieval works transmit to us is no longer quite what it was to their makers; it, too, has undergone a metamorphosis, whose effects are more apparent when they concern a remoter past. The Altamira bison is neither a *graffito* nor a modern drawing, but it tells us nothing (except that creative art existed even in a prehistoric age) about the Magdalenians, and very little about the kind of magic it stands for. The meaning of the holy figures of Egypt, though these belong to an historical art, is hinted at rather than transmitted to us. For since the great languages of the past reach us only by way of a metamorphosis, they are no longer the original languages; each masterwork, in transmitting one of these languages, gives us the impression that this was the language of a single artist, unique creator of all the spiritual values he

KHMER ART (END OF 12th CENTURY): BUDDHIST HEAD

expresses. Thus, too, though we know that behind a Khmer head lie centuries of Buddhism, we look at it as if its spirituality and complexity must have been the invention of its maker. It conveys to us a "relativized absolute." In short, we look at great works of the remote past— whether their purport be cosmic, magical, religious or transcendental— as so many Zarathustras invented by so many Nietzsches.

The fragments of the past that are most eagerly snapped up by our museums are neither happily inspired "patches", nor striking arrangements of "volumes"; they are *heads*. Modern art is not to be regarded as antithetical to our resuscitations of the past; on the contrary it has arisen simultaneously with them, swept into the light on the same wave. And though in the process man has lost his visage, this same "disfeatured" man has redeemed the world's noblest faces from oblivion.

How different would be our notion of many vanished civilizations if we did not know their arts! Apollo still looks proudly down on the waters of oblivion that have engulfed the gods of Tyre who disdained poems and statues. We knew the art of the Sumerians when it was still described as Chaldean, before a separate Sumerian culture was known to have existed. We know more about the painting of the Magdalenian man than about his prehistoric background; more of the *Lady of Elché* than of the Ibero-Phoenicians; more of Scythian plaques than of the tribes which once roamed the Steppes. The religions and customs of Pre-Columbian groups are known to specialists only, and lovers of Hindu sculpture are not necessarily versed in Indian history or the Vedanta. The Asiatic arts are beginning to form part of our culture, whereas during the last thirty years the myth of the East has been dwindling into a sort of standardized "Antiquity." Why has the German theory of cultures (meaning civilizations regarded as independent organisms that die out in due course) won so much favor? Because by subordinating all religions to the organic life of the cultures assumed to have engendered them, this theory can in its dealings with religious civilizations assign to religion a secondary place, without limiting itself to forms. Yet somehow *The Decline of the West* gives an impression of having started as a meditation on the destinies of art forms, a meditation which gradually amplified in scope and depth. Even assuming that vanished civilizations have utterly died out, their art has not; even if the Egyptian of the Old Kingdom is destined to remain a mystery to us, his statues are in our museums and they have much to tell.

We are too apt to talk of the past as if we saw it embedded in our culture like an ancient monument in a modern city; yet we know this is far from being the case. For a very small number of men, keenly interested in history, it is a complex of riddles asking to be solved, whose progressive elucidation is a series of victories over chaos. For the vast majority it comes back to life only when it is presented as a romantic saga, invested with a legendary glamour. What is the basic stuff of

619

which this "legend" is composed? What, for example, do Greece, Rome and the Middle ages conjure up in our minds save statues, edifices and poetry (meaning more than "verses")? That the name of Alexander rings through the centuries with a clang of bronze is due far less to his campaigns than to the undying dream he conjures up, a dream whose each expression gives him a new lease of fame. So long as the artist pays no heed to him, a conqueror is a mere victorious soldier; Caesar's relatively small conquests mean more to us than all Genghiz Khan's far-flung triumphs. It is not the historian who confers immortality; it is the artist with his power over men's dreams. For it is art whose forms suggest those of a history which, though not the true one, yet is the one men take to their hearts; had they come back to life, the Roman worthies would never have swayed the Convention as Plutarch did.

But for the Sistine Chapel the myth of the Renaissance would have had far less effect, and an intriguing poetry wells up from those dim hinterlands which history has not yet explored. In that composite art of the *Sivas* of the Chams, Malayan refinement thrusts up through a savage mental undergrowth, as in the jungle clearings its temples soar through a glittering haze of giant spiders' webs. This is the poetry of the art of the great racial frontiers: where Java merges into Polynesia, China into the Steppes, Egypt into Greece, Byzantium into Persia, or Islam into Spain, Spain into Mexico. That same poetic quality is present in the proto-Etruscan *Warrior of Capestrano*, and when we look

CHAM ART (9th CENTURY): SIVA

INDIA. HARAPPA (3rd MILLENNIUM B.C.): TORSO

at that enigmatic figure or at the "Mediterranean" torso of Harappa (two thousand years anterior to Greece), no less than when we see the cave men's painting and so many illustrations of a text forever lost, how can we fail to hear a voice calling across the ages, like the summons that sounded once across the foam of perilous seas, a call attuned in some elusive manner to that aura with which the genius of great artists has enhanced our knowledge and to the peal of silver bells which Michelangelo launches above the tombs of Florence—the same bells as those whose muffled chime rises from cities buried in the sea?

For such is the scope of our Museum without Walls that it makes any historical knowledge it calls for seem superficial. So as to impose an order on the vast recession of the centuries, history resorts to various expedients; either it assumes that Man has remained the same over untold millennia, or else it posits the existence of human "constants," or, as a last resort, tries to elicit sequences of distinct human types: to circumscribe the Sumerian as ethnology seeks to circumscribe the Papuan or the Dogon. How strange would be the history of Japan if we had no notion of what a Japanese is like! Yet what we know of the twelfth-century Japanese is quite incompatible with the obvious fact that in Takanobu's portraits we have one of the peak-points of the world's painting. History may clarify our understanding of the supreme work of art, but can never account for it completely; for the Time of art is not the same as the Time of history. It is inasmuch as the work of art, even if inseparable from some given moment of the past, stakes out a claim for itself in the *artistic present*, that our culture is assuming its actual form; the past of a picture does not belong wholly to a bygone age, yet does not wholly belong to the present. The creative process behind the work of art functions no less potently in the darker tracts of history than in its triumphal periods; all that Versailles could produce in its hour of glory was a Lebrun, whereas Spain in her darkest hour gave birth to Goya. An ordinary Greek Koré belongs both to history and to archeology, but the *Koré of Euthydikos* does not belong to these alone. Every attempt to elucidate the past presents it as an evolutionary process or one of blind fatality, carrying a message either of hope or of despair to the generation to wich it is addressed. A history of art, however (provided it is not a mere chronology of "influences"), can no more be the history of a constant progress than that of an eternal return. Once we know that the very essence of creation is a break with the past, art links up with history, so to speak, in reverse. Indeed the history of art, so far as genius is concerned, is one long record of successive emancipations, since while history aims merely at transposing destiny on to the plane of consciousness, art transmutes it into freedom.

Every art of the past impresses us as being the expression of some specific culture; but we have rid ourselves less than we imagine of the notion, dear to the eighteenth century, that a culture should be

defined in terms of the concept of, and amenities for, happiness it sponsors. Thus after many centuries' disregard of the Mesopotamian and Egyptian civilizations, then regarded as unbearably austere, Europeans developed an interest in them, once their refinement had been brought to light. Now art, while often unconcerned with happiness and even with refinement, is not indifferent to men's efforts—whether conscious or not—to attune their lives to the value, whatever it be, that they hold supreme. (*Our* supreme value does not seem to be expressed by our art; the modern work of art cannot supply the "present help in time of need" that was once provided by the gods of Delphi and the saints of Rheims—for the good reason that a culture that has lost its bearings has no holy figures; thus ours has to fall back on resuscitating those of other cultures.) When we appraise cultures of the past with reference to their own values, Reason is seen to weigh on Robespierre as Christ did on St. Louis. Similarly the Aztec social order is now regarded not as mere savagery but as a cruel culture, and its art not as a gloating over human sacrifices but as a communion with the Saturnian underworld.

Thus we perceive that art is not the result of any pressure brought upon the artist from without, a "conditioning," but that the pressure comes from within: a pressure that is not in any sense a compulsion. But to express a community in terms of its values is far from expressing its true nature or all it stands for. The will to creation, however obscurely felt (yet no great sculptor, even a Melanesian, wishes to make just any kind of figure), also plays a part in giving art its direction; the plant, born of a seed let fall by the art preceding it, owes no less to its species than to the soil on which it grows. Though there is no such thing as art-in-itself, the artist's creative impulse involves a will to transcend his immediate forerunners,—not to follow them slavishly —and to annex new territory. The Goyas of the "Deaf Man's House" are not embellished nightmares; they are pictures. The blood-smeared fetish is not a savage, the molded and painted death's-head not a skull. Debased as was Roman art in the tenth century, it does not show us that hapless Pope, John XVI, his eyes gouged out, his nose cut off, whom the other Pope, the victor, forced to listen to the gibes of the populace and to sing, despite his mutilated tongue, till nightfall: "It is just that I be treated thus!" The mosaics of Byzantium do not portray tortures, nor the best Aztec sculptures massacres. The ghastliness of even the most violent Spanish *Crucifixions* is fundamentally different from wanton cruelty. Always, however brutal an age may actually have been, its style transmits its music only; our Museum without Walls is the song of history, not its news-reel.

However closely bound up with the culture whence it springs, art often ranges farther than that culture, or even transcends it, seeming to draw its inspiration from sources untapped by the spirit of the age

and from a loftier conception of Man. Thus, whereas living humanity transmits, from generation to generation, a legacy of "monsters" with its blood, the dead artists transmit another message, however cruel was the age they lived in. Despite those torturer-kings who figure in the bas-reliefs, it is by the majesty of its *Dying Lioness* that Assyrian art grips our imagination, and one of the emotions the *Lioness* arouses in us is that of pity.

Reconstituting as it does a world as different from the real world as is the masterpiece from a mere passing show, the art museum brings to us from the inscrutable recession of the ages, as on a vast tide, the flotsam of a visionary past which, out of so many gods and devils, deposits on the foreshore of the Present only those which were scaled down to the human. In art's retrospect Sumer, Thebes, Nineveh and Palenque have come to mean to us only the hymns arising from their abysmal darkness; the sordid annals of Byzantium are effaced by the majesty of Christ Pantocrator, the dust and squalor of the Steppes by the gold plaques, the lazar-houses of the Middle Ages by the Pietàs. I saw the fetishes of the Nuremberg Museum justify their age-old leer as they gazed down at the last wisps of smoke curling up from the ruins, through which a girl on a bicycle, carrying a sheaf of lilac, steered an erratic course amid singing Negro truck-drivers; yet had there been an art of the prison-camp incinerators, only that day extinguished, it would have shown us not the murderers but the martyrs.

ASSYRIAN ART (7th CENTURY B.C.): THE DYING LIONESS

Let God on the Day of Judgment confront the forms of those who lived on earth with the company of the statues! It is not the world **they** made, the world of men, that will bear witness to **their** presence; it is the world made by the artists. That august company which came into being along the cathedral walls illustrates the Christian world as it might be, did it possess a deep and true assurance of its faith, remembering that "while men sleep in darkness Christ is suffering on the Cross." There has been on earth only one Christian people without sin—the **people of the** statues.

All art is an object-lesson for the gods. Islam's true paradise is peopled not by houris but by arabesques. Florence's last agony is vibrant beneath the brooding splendor of Michelangelo's *Night*, which is rather her soul redeemed than a symbol of her sorrows, and Spanish honor has a bright facet whose name is—Goya. "Carthage" is no more today than the echo of a grandeur for ever blotted out. Nailed like the dead eagles to the wall of the Doge's Palace in Venice, the flag of Lepanto is but a heraldic fetish, as compared with Titian; and that vision of the galleys of the Republic putting out to sea leaves its vast wake in our hearts only because it is immortalized in Tintoretto's heroic rhythms. To make Venice as she was in her hour of triumph come to life again, it was not enough for the cinema to lay hands on the costumes, the palaces and the *Bucintoro;* in order to achieve its gaudy travesty of Tintoretto's world of form and color, it had to purloin the old dyer's composition and have him reshape that farrago of dusty glories with his heavily beringed fingers, retrieving them from time's obloquy.

The most drastic metamorphosis of our age is the change that has come over our attitude to art. We no longer apply the term "art" to any particular form it may have assumed in any given place or period, but give it a wider application, covering more than all the forms so far accepted. Gazing at the horses of the Acropolis and those of the Lascaux caves, we do not have the same emotion as was Plato's gazing at the former; nor that of Suger when gazing at the St. Denis statues. Our emotional responses are such as neither Plato nor Suger could experience, for implicit in them is our visual experience of all the glorious debris we have salvaged from the past. On this plane the *Koré of Euthydikos* is a sister to the most poignant Christ Crucified; *The Thinker*, a Pre-Columbian figure, even *The Beggar Woman, The Three Crosses* and the best Buddhist paintings share in the glory of the Panathenaic frieze, in the cosmic frenzies of Rubens' *Kermesse*, the brooding horror of *The Shootings of May Third*—and perhaps in that purity of heart which Cézanne and Van Gogh brought to painting. All the same we do not share the feelings of Plato contemplating the Acropolis in its perfection, or those of Suger contemplating his basilica. We are coming to understand (our modern churches make this all too plain) that a sacred edifice is not a decorated house but *something else,*

and that the world of art is no more an emotionalized world than a glorified world, but *another* world, the same as that of music and architecture. The solemn plainsong of the interiors of Santa Sophia and the Egyptian hypogea, of the Imperial Mosque of Ispahan and of the aisles of Bourges Cathedral gives their full meaning to the colonnades of Karnak and the Parthenon, to the epic towers of Laon, to the Capitolium—to the statues accompanying them and to the whole Museum without Walls. How remote they seem now: both the Romantic conception of beauty under a dual aspect and the long-drawn conflict between pagan and Christian art in Europe! The avenues of shadow which throughout their infinite recession impose the stamp of the human on that which seems least human—on the void—seem a symbol of what the art of the past is coming to mean to us: one of man's very rare *creations*, inventive though man is. The feeling of being in the presence of something with a life of its own that we experience when confronted by the masterpiece, is conveyed to us, though less vividly, by that never-ending process of transmutation running parallel to history which enabled the Egyptians to body forth a People of the Dead, the Negro races simulacra of their spirits, and so many others men-like-gods. Thus, too, Grünewald was enabled to build up from the plague victims of Alsace the *Christ Crucified* of Issenheim, Michelangelo to ennoble with the imprint of his indomitable style a dying slave, Rubens and Goya to transmute a country fair and a corpse respectively into the cosmic visions of the *Kermesse* and *Nada*, Chardin and Cézanne to conjure up with a pitcher or a dish of apples a whole secret kingdom. "Humanization" this process might be called in the deepest, certainly the most enigmatic, sense of the word. The art resuscitated by our metamorphosis is a realm as vast and varied as was life itself in ages previous to ours. We subject that art to a passionate enquiry, akin to that questioning of the scheme of things inherent in our present-day art and culture. Just as the crucial historical event of the nineteenth century was the birth of a new consciousness of history, so the crucial expression of the metamorphosis of this century is our consciousness of it. Thus today art means to us that underlying continuity due to a latent kinship between the works of art of all ages which is an historical continuity, since never does an art destroy *all* that it has inherited; El Greco broke with Titian, but not by painting pictures like Cézanne's. But art also involves a constant metamorphosis of forms due both to the nature of the creative act and to the ineluctable march of Time. For Time includes all the forms of the past in the evolutionary change it imposes on the whole world of human experience; indeed our awareness of this process coincides with our awareness of duration itself. With us this awareness is no longer like the feeling of the traveler who himself remains unchanged in the changing scenes of Space and Time; it is more like the feeling symbolized by the seed which grows into the tree. Every art of the living

BYZANTIUM (8th CENTURY): INDIA

gives a leading place to Man in its vast metamorphosis of the art of the dead; our resuscitations of so-called retrograde arts, the welcome we give to the arts of savages and the metamorphosis our century has brought to works of the Greek archaics, the Wei Masters, to Grünewald, Leonardo, Michelangelo, Rubens, Chardin and Goya, stem all alike from the fact that these manifestations of the creative spirit reveal a latent power they all possessed, though unawares: that mysterious power, peculiar to great artists, of revealing Man upon his highest level. Each manifestation of this power has come to mean to us, beyond and above what it purported to be, an incarnation of that which sponsors their underlying unity—and perhaps other, as yet unknown, powers. Thus now, behind this immemorial pageant in which the gods march side by side with creative man in a fraternity at last accepted, we are beginning to glimpse that which the gods sometimes embodied, sometimes fought against, and sometimes bowed to: the Might of Destiny.

VII In this connection Greek tragedy can mislead us much as it misleads us regarding the history of Greek culture. In that world of chaos and catastrophe which the spectator of Œdipus was invited to explore, what fascinated him more than the vengeful satisfaction which the sight of kings rolled in the dust gave the Greek populace was its simultaneous revelation of human servitude and man's indomitable faculty of transcending his estate, making his very subjection testify to his greatness. For when the tragedy was over, the Athenian spectator decided to see the play again, not to put out his eyes; when he saw the Eumenides massed on the tawny rocks of the orchestra (like the man who sees a statue of the Crucified, or a pictured face, or a landscape), he had a feeling that Man was holding his own amongst those blind forces of which he had once been the vassal and escaping from a destiny-ridden world into a world controlled by human minds.

We know only too well what that word "destiny" implies: the mortal element in all that is doomed to die. There is a "fault" (as a geologist might call it), sometimes plain to see and sometimes imperceptible, in the human personality, from which no god can always guard us; the saints call it a "dryness of the soul", and, for Christendom, that cry "Why hast Thou forsaken me?" is the most human of all cries. Time flows—perhaps towards eternity; assuredly towards death. But destiny is not death; it consists of all that forces on us the awareness of our human predicament, and even the happiness of such a man as Rubens is not immune from it, for destiny means something lying deeper than misfortune. This is why, seeking escape, man has so often made love his refuge; and it is why religions defend man against destiny (even when they do not defend him against death) by linking him up with God or with the cosmos. That part of man's nature which yearns for transcendence and for immortality is familiar to us. We know, too, that a man's consciousness of himself functions through channels other than those of his awareness of the outside world; every man's self is a tissue of fantastic dreams. I have written elsewhere of the man who fails to recognize his own voice on the gramophone, because he is hearing it for the first time through his ears and not through his throat; and because our throat alone transmits to us our inner voice, I called this book *La Condition Humaine* (Man's Fate). The function of those other voices which are art's is but to ensure the transmission of this inner voice. Our Museum without Walls teaches us that the rule of destiny is threatened whenever a world of Man, whatever be the nature of that world, emerges from the world *tout court*. For every masterpiece, implicitly or openly, tells of a human victory over the blind force of destiny. The artist's voice owes its power to the fact that it arises from a pregnant solitude that conjures up the universe so as to impose on it a human accent; and what survives for us in the great arts of the past is the indefeasible inner voice of civilizations that have

passed away. But this surviving, yet not immortal, voice soaring towards the gods has for its accompaniment the tireless orchestra of death. Our awareness of destiny, as profound as that of the Oriental, but covering a far wider field of reference, stands in the same relation to the various "fates" of the past as does our Museum without Walls to the Collections of Antiquities of our forefathers; indifferent to those wraithlike marble forms, it is the obsession of the twentieth century and it is to counter this that there is tentatively taking form, for the first time in history, the concept of a world-wide humanism.

In the same way as Goya defied syphilis by recapturing the nightmare visions of primeval man, and Watteau fought consumption with melodious dreams of beauty, so some civilizations seem to combat destiny by allying themselves with the cosmic rhythms, and others by obliterating them. Nevertheless, in our eyes, the art of all has this in common, that it expresses a *defense* against fatality; for a non-Christian the company of statues in the cathedrals expresses not so much Christ as the defense, by means of Christ, of Christians against destiny. Any art that takes no part in this age-old dialogue is a mere art of delectation, and as such, dead to our thinking. Earlier civilizations when they retrieved the past read into it "messages" apt to solve contemporary problems; whereas our art culture makes no attempt to search the past for precedents, but transforms the entire past into a sequence of provisional responses to a problem that remains intact.

A culture survives—or revives—not because of what it actually was; it interests us in virtue of the notion of man that it discloses or of the values it transmits. No doubt these values undergo a metamorphosis in the process of transmission, all the more marked because, though in the civilizations of the past the notion of man was felt as a totality (the men of the thirteenth century, the Greeks of the age of Pericles and the Chinese of the T'ang dynasty did not regard themselves as men of a special period but simply as "men"), the consummation of each epoch discloses to us that part of man on which it set most store.

A culture, in so far as it is a heritage, comprises both a sum of knowledge (in which the arts have but a small place) and a legendary past. Every culture might be styled "Plutarchian" in the sense that it hands down to future generations an exemplary picture of man as a totality, if it is a strongly developed culture, and exemplary elements of man if it is a weak one. The epitaph of those who died at Thermopylae: "Go tell the Spartans, thou who passest by, That here obedient to their laws we lie," and the Chinese funerary inscription in honor of dead enemies: "In your next life, Do us the honor of being reborn in our midst" are counterbalanced by other concepts of man: the thinker, the saint, Prince Siddhartha leaving his father's palace when he discovered the misery of man's estate, and Prospero's "we are such stuff

as dreams are made on." Every culture aspires to perpetuate, enrich or transform, without impairing it, the ideal concept of man sponsored by those who are building it up. When we see countries eager for the future, Russia and the Americas, paying more and more attention to the past, it means that culture is the heritage of the *quality* of the world.

Quality—which is not always arrived at by the same paths and in which the arts do not always play the same part. The culture of medieval man did not consist in knowledge of the *Roman d'Alexandre* or even of Aristotle's works, then regarded as a primer of the technique of thinking; it was based on the Bible, the writings of the Saints and Fathers of the Church: it was a culture of the soul. Its art belonged wholly to the present. The Renaissance recognized the prestige of the artist and was no longer restricted to a present whose windows opened only on eternity. The men of the Renaissance looked to the past for a revelation of that pagan beauty which had left the world, and for forms that did not invariably clash with Christian forms, but which Faith had not imparted to them: on the one hand, that which differentiated Venus from Agnes Sorel, on the other hand all that differentiated Alexander and Cincinnatus from a sixteenth-century knight. By the time that splendid, vaguely apprehended vision of the past came to mean no more than a decorative setting, the sixteenth century had been completely mastered by it and its art deteriorated; perhaps French poetry's long eclipse was due to the fact that Ronsard preferred Theocritean settings to the enchanted woodlands of Spencer and Shakespeare. One has a feeling that what the Renaissance was seeking for in its excited treasure-hunt across the Greco-Roman past was everything that might undermine the power of the devil, and perhaps God's as well. For it was in Titian's patriarchate, when emperor and kings were visiting that inspired backwoodsman so as to feast their eyes on a pagan display of nudes and half-veiled figures, that the Renaissance touched high-water mark. The senses became the courtiers of the artistic sense, which conferred nobility on them; and the voluptuous nude became a form of the sublime. The culture of the seventeenth century was primarily intellectual, and many of its greatest painters seem to stand outside the period; what has Rembrandt in common with Racine and the values Racine stood for? What that century aimed at in its investigation of the past was a well-balanced judgment of man and the world he lives in—indeed all culture was tied up with the "humanities." With the eighteenth century science became an element of culture, which now sponsored knowledge, not self-awareness, and despite its obsession with Rome, envisaged the future rather than the past.

Over-simplified as is this summary, it suggests why the cultures of civilizations that have died out strike us not so much as being radically different, but as being cultures of different parts of the same plant. All the same, their sequence cannot be syncretized into a sort of cultural

theosophy, for the good reason that mankind proceeds in terms of metamorphoses of a deep-seated order, it is not a matter of mere accretions or even of a continuous growth; Athens was not the childhood of Rome—still less was Sumer. We can affiliate the knowledge of the Fathers of the Church to that of the great Indian thinkers, but not the Christian experience of the former to the Hinduist experience of the latter; that is to say we can affiliate everything except essentials.

Thus our culture is not built up of earlier cultures reconciled with each other, but of irreconcilable fragments of the past. We know that it is not an inventory, but a heritage involving a metamorphosis; that the past is something to be conquered and annexed; also that it is within us and through us that the dialogue of Shades (that favorite art-form of the rhetorician) comes to life. If Aristotle and the Prophets of Israel met on the banks of the Styx, what would they exchange but insults? Montaigne had to be born before the dialogue between Christ and Plato could arise. Our resuscitations are not conditioned by any preconceived humanism; like Montaigne, they point the way to a humanism unconceived as yet.

When we survey the charnel-house of dead values, we realize that values live and die in conjunction with the vicissitudes of man. Like the individuals who express the highest values, they are man's form of defense; each hero, saint or sage stands for a victory over the human situation. All the same the Buddhist saints could no more resemble St. Peter and St. Augustine than Leonidas resembled Bayard, or Socrates resembled Gandhi. The succession of values, changing with each civilization—the ethic of Taoism, Hindu submission to the scheme of things, the Greek spirit of enquiry, the medieval communion of men, the cult of Reason and then that of history—all show still more clearly how values decline once they lose their power of rescuing man from his human bondage.

Similarly the values which are incarnated or created by artistic genius (genius and not the mere portrayal of an epoch) decline in the eyes of the human groups to which they make their appeal (whether a Christian community or a sect), once they cease to defend those groups, and reappear when they seem to be defending others. We do not seek to find in any of them an anticipation of our present-day values; we are the heirs not so much of this or that value in particular (or of each and all) as of something that runs deeper: that undercurrent of the steam of human consciousness which brought them into being. We have at last become aware of their true nature, in the same manner as Hegelianism became aware not of forgotten values but of history; it is art as an organic whole, liberated by our modern art, that our culture for the first time is arraying against destiny. The men of the Renaissance did not prefer the few great Greek works they had set eyes upon to the Alexandrine statues, and would not have preferred the *Koré of Euthydikos*

MICHELANGELO: BRUTUS

to the *Laocoön*. It is we, the men of today, who are bringing to light the treasures of the ages, now that creation itself has become for our artists a supreme value; we who are wresting from the dead past the living past of the museum. Thus our characteristic response to the mutilated statue, the bronze dug up from the earth, is revealing. It is not that we prefer time-worn bas-reliefs, or rusted statuettes as such, nor is it the vestiges of death that grip us in them, but those of life. Mutilation is the scar left by the struggle with Time, and a reminder of it—Time which is as much a part of ancient works of art as the material they are made of, and thrusts up through the fissures, from a dark underworld where all is at once chaos and determinism. Hercules' mutilated torso is the symbol of all the world's museums.

Hercules' new adversary and Destiny's most recent incarnation is history; but though created by history, man as revealed in the museum is little more historical than the gods of old. True, some works of art, such as Grünewald's, are obviously bound up with their age, but others seem unaffected by it; while the Baroque Michelangelo is familiar to us, the *Rondanini Pietà* and even *Night* suggest far more a Bourdelle miraculously incarnating Michelangelo than any Italian sculptor. Thus, too, the *Brutus* is not a Florentine head, and though we all know the Baroque Rembrandt, *The Three Crosses* and *The Supper at Emmaus* belong neither to the seventeenth century nor to Holland. Like the pediment of a classic temple, Racine crowns the culture of his age; Rembrandt like the tremulous glow of a far-off conflagration. History, where art is concerned, has a limit which is destiny itself; for it does not act upon the artist merely by confronting him with new generations of patrons but because each successive epoch involves a form of collective destiny which it enforces on everything attempting to withstand it, and this process can be counteracted only by other forms of destiny. The "Age of Enlightenment" did not prevail against Goya's malady, nor the splendors of Rome against Michelangelo's tormented genius, nor seventeenth-century Holland against Rembrandt's Revelation. The vast realm of art which is emerging from the ocean of the past is neither eternal nor extraneous to history; it bears the same relation to history as Michelangelo did to Signor Buonarroti, being at once involved in it and breaking free from it. Its past is not a mere bygone age, but pregnant with the *possible;* it does not stand for the inevitable, but links up with ages as yet unborn. Though the Wei Bodhisattvas and those of Nara, Khmer and Javanese sculpture and Sung painting do not express the same communion with the cosmos as does a Romanesque tympanum, a Dance of Siva or the horsemen of the Parthenon, all alike express a communion of one kind or another, and so does even Rubens in *The Kermesse.* We need but glance at any Greek masterpiece to see at once that its triumph over the mystery-laden East does not stem from any process of the reasoning mind, but from "the innumerable laughter of the waves."

GREEK ART (5th CENTURY B.C.): THE BIRTH OF APHRODITE

Like a muted orchestra the surge and thunder, already so remote, of ancient tragedy accompanies but does not drown Antigone's immortal cry: "I was not born to share in hatred but to share in love." Far from being an art of solitude, Greek art stood for a communion with the universe—from which Rome was to sever it. Whenever becoming or fatality usurps the place of being, history usurps that of theology, and both the plurality and the endless transfigurations of art become apparent; and then the absolutes which the rediscovered arts have transfigured re-establish with a past they have remolded the link between the Greek gods and the cosmos. In the same sense as that in which Amphitrite was the sea goddess who made the waves benign to man, the art of Greece is for us the true god of Greece. This god it is and not the rulers of Olympus, who shows us Greece under her noblest aspect, victorious over time and near to us even today, for it is through her art alone that Greece invokes our love. Greek art stands for what was once, by way of Hellas and inseparable from her, a special manifestation of that divine power to which all art bears witness. That power has taken many forms, but all alike reveal Man as protagonist in new greatest of all dramas and also the undying root whence thrust up the growths of creative art, now mingling, now in isolation; each victory he won over the dark gods

636

of Babylon still wakes an echo in the secret places of our hearts. From the *Birth of Aphrodite* to Goya's *Saturn*, and to the Aztec crystal skulls, the radiant or tragic archetypes he has begotten tell of sudden stirrings in the deep yet restless sleep of that eternal element in Man which lies beneath the conscious threshold, and each of these voices tells of a human power sometimes exercised, sometimes in abeyance, and often lost. In these flashes of vision the phantasmagoria of the dream-monster fall for a moment into order and the Saturnian nightmare quiets down into a tranquil and refreshing dream. For Man, dreamer of better

AZTEC ART: ROCK CRYSTAL SKULL

NARA (7th CENTURY?): BUDDHIST FIGURE

dreams, strikes his roots as deep in time as does man the brute; he conjures up for us a picture of that first glacial night on which a species of gorilla, looking up at the stars, felt itself suddenly, mysteriously, akin to them. Almost all the great works of the past have this in common: their submission to the dialogue, impassioned or serene, maintained by each with that part of his soul which the artist deemed the holiest; yet in these dialogues which we instinctively link with the dead faiths that gave them birth, as the *Vita Nuova* is associated with Beatrix or *La Tristesse d'Olympio* with Juliette Drouet, the religions stand for but the loftiest regions of the human spirit; for those who believe Christian art to have been called into being by Christ do not believe that Buddhist art was called into being by Buddha or Sivaic forms by Siva. Art does not deliver man from being a mere by-product of the universe; yet it is the soul of the past in the same sense that each ancient religion was a soul of the world. In times when man feels stranded and alone, it assures to its votaries that deep communion which would else have passed away with the passing of the gods.

When we welcome amongst us all these antagonistic elements, is it not obvious that our eclecticism, defying history, merges them in a past whose whole conception is other than that of the real past, and which acts as a defense, in depth, of our own culture? Under the beaten gold of the Mycenean masks where once men saw only the dust of a dead beauty, there throbbed a secret power whose rumor, echoing down the ages, at last we can hear again. And issuing from the darkness of ancient empires, the voices of the statues that sang at sunrise murmur an answer to Klee's gossamer brushstrokes and the blue of Braque's grapes. Though always tied up with history, the creative act has never changed its nature from the far-off days of Sumer to those of the School of Paris, but has vouched throughout the ages for a conquest as old as man. Though a Byzantine mosaic, a Rubens, a work by Rembrandt and one by Cézanne display a mastery distinct in kind, each imbued in its own manner with that which has been mastered, all unite with the paintings of the Magdalenian epoch in speaking the immemorial language of Man the conqueror, though the territory conquered was not the same. The lesson of the Nara Buddha and of the Sivaic Death Dancers is not a lesson of Buddhism or Hinduism, and our Museum without Walls opens up a field of infinite possibilities bequeathed us by the past, revealing long-forgotten vestiges of that unflagging creative drive which affirms man's victorious presence. Each of the masterpieces is a purification of the world, but their common message is that of their existence, and the victory of each individual artist over his servitude, spreading like ripples on the sea of time, implements art's eternal victory over the human situation.

All art is a revolt against man's fate.

When the Greek spirit was at its freest the Greeks felt as much at home at the court of the Achaemenidae as did the Byzantines at the Sassanian court; photographic reconstructions of a Roman street with its shops and stalls, its men in togas and veiled women, remind us less of a street in Washington or even one in London than of a street in Benares; it was when they "discovered" Islam that the Romantic artists felt they had a living picture before them of classical antiquity. Our present age is the first to have lost touch with the Asiatic background of its past and to have broken the pact which once bound together five millennia of agricultural civilization as mother earth unites the forests and men's graves. The civilization born of man's conquest of the whole globe has brought about a metamorphosis as complete as those effected by the great religions; perhaps the world-wide mechanization of today has but one precedent; the discovery of fire.

Inevitably the great resuscitation now in progress called for modern art, but the form under which that art is known to us is nearing its end; brought into being by a conflict (like the philosophy of the Enlightenment), it cannot outlive its victory intact. Nevertheless our rediscoveries of the past are constantly covering a wider territory and drawing more into their net, as happened with the rediscovery of antiquity after the end of the Renaissance and with Gothic after the passing of Romanticism; indeed they endorse our art, for no age that can appreciate *simultaneously* the Greek archaics, the Egyptians, Wei sculpture and Michelangelo can reject Cézanne. Our problems are not those of Babylon, Alexandria or Byzantium, and even if it is to be "atomized" tomorrow, our civilization will not have been like that of Egypt in her death-throes, nor is the hand which is feverishly wresting from the earth the buried past the same hand as that which carved the last Tanagras; at Alexandria the so-called art museum was but an academy. The first culture to include the whole world's art, this culture of ours, which will certainly transform modern art (by which until now it was given its lead), does not stand for an invasion but for one of the crowning victories of the West. Whether we desire it or not, Western man will light his path only, by the torch he carries, even if it burns his hands, and what that torch is seeking to throw light on is everything that can enhance the power of Man. How can even an agnostic civilization rule out what transcends and often magnifies it? If the quality of the world constitutes the basic stuff of every culture, its aim is the quality of Man, and this it is which makes a culture not a mere compendium of knowledge but an heir and sponsor of Man's greatness. Hence it is that our artistic culture, aware that more is asked of it than the expression, however subtle, of our modern sensibility, seeks guidance from the figures, songs and poems that are the legacy of the past under its noblest aspect—because it is today sole heir to that bequest.

Rome welcomed in her Pantheon the gods of the defeated.

The day may come when, contemplating a world given back to the primeval forest, a human survivor will have no means even of guessing how much intelligence Man once imposed upon the forms of the earth, when he set up the stones of Florence in the billowing expanse of the Tuscan olive-groves. No trace will then be left of the palaces which saw Michelangelo pass by, nursing his grievances against Raphael; and nothing of the little Paris cafés where Renoir once sat beside Cézanne, Van Gogh beside Gauguin. Solitude, vicegerent of Eternity, vanquishes men's dreams no less than armies, and men have known this ever since they came into being and realized that they must die.

Nietzsche has written that when we see a meadow ablaze with the flowers of spring, the thought that the whole human race is no more than a luxuriant growth of the same order, created to no end by some blind force, would be unbearable, could we bring ourselves to realize all that the thought implies. Perhaps. Yet I have often seen the Malayan seas at night starred with phosphorescent medusas as far as eye could reach, and then I have watched the shimmering cloud of the fireflies, dancing along the hillsides up to the jungle's edge, fade gradually out as dawn spread up the sky, and I have told myself that even though the life of man were futile as that short-lived radiance, the implacable indifference of the sunlight was after all no stronger than that phosphorescent medusa which carved the tomb of the Medici in vanquished Florence or that which etched *The Three Crosses* in solitude and neglect. What did Rembrandt matter to the drift of the nebulae? Yet if it is Man whom the stars so icily repudiate, it was to Man, too, that Rembrandt spoke. Pitiful, indeed may seem the lot of Man whose little days ends in a black night of nothingness; yet though humanity may mean so little in the scheme of things, it is weak, human hands—forever delving in the earth which bears alike the traces of the Aurignacian half-man half-brute and those of the death of empires—that draw forth images whose aloofness or communion alike bear witness to the dignity of Man: no manifestation of grandeur is separable from that which upholds it, and such is Man's prerogative. All other forms of life are subject, uncreative, flies without light.

But is Man obsessed with Eternity and not rather with a longing to escape from that inexorable subjection of which death is a constant, tedious reminder? Feeble indeed may seem that brief survival of his works which does not last long enough to see the light die out from stars already dead! Yet surely no less impotent is that nothingness of which he seems to be the prey, if all the thousands of years piled above his dust are unable to stifle the voice of a great artist once he is in his coffin. Survival is not measurable by duration, and death is not assured of its victory, when challenged by a dialogue echoing down the ages. Survival is the form taken by the victory of a creator over Destiny and this form, when the man himself is dead, starts out on its unpredictable

life. That victory which brought his work into being endows it with a voice of which the man himself was unaware. Those statues more Egyptian than the Egyptians, more Christian than the Christians, more Michelangelesque than Michelangelo—more human than mankind—which aspired to body forth an ultimate, timeless truth, are still murmurous with the myriad secret voices which generations yet unborn will elicit from them. The most glorious bodies are not those lying in the tombs.

Humanism does not consist in saying: "No animal could have done what we have done," but in declaring: "We have refused to do what the beast within us willed to do, and we wish to rediscover Man wherever we discover that which seeks to crush him to the dust." True, for a religious-minded man this long debate of metamorphosis and rediscoveries is but an echo of a divine voice, for a man becomes truly Man only when in quest of what is most exalted in him; yet there is beauty in the thought that this animal who knows that he must die can wrest from the disdainful splendor of the nebulae the music of the spheres and broadcast it across the years to come, bestowing on them messages as yet unknown. In that house of shadows where Rembrandt still plies his brush, all the illustrious Shades, from the artists of the caverns onwards, follow each movement of the trembling hand that is drafting for them a new lease of survival—or of sleep.

And that hand whose waverings in the gloom are watched by ages immemorial is vibrant with one of the loftiest of the secret yet compelling testimonies to the power and the glory of being Man.

1935-1951.

SYNOPSIS AND LISTS OF ILLUSTRATIONS

SYNOPSIS

PART ONE : MUSEUM WITHOUT WALLS

I. — The museumless ages, 13 - The Art Museum, a purely European growth, is an assemblage of metamorphoses, 14 - Necessarily incomplete, it conjures up thoughts of an ideal art museum, 15 - The Grand Tour of art, 15 - Reproduction, 16 - The plastic arts have invented their own printing-press, 16.

II. — Reproduction, 17 - End of the unchallenged sovereignty of Italy, 18 - Interpretation of sculpture by reproduction in black-and-white, 21 - by centering, 21 - by lighting, 21 - Works of art lose their dimensions, 21 - Fictive or suggested arts, 24 - The detail, 25 - Modernization of works of art by photography, 27 - Color reproduction, 30 - The history of art: a history of what can be photographed, 30 - Specific problems set by color: the intrusion of gray, mannerist color, the Spanish Baroque palette, 30 - The miniature, 31 - Tapestry, 36 - Stained glass, 37 - the poetic expression of a monumental art, 38 - brought to life by sunlight, 38 - The oriental carpet, 41 - Sung painting, 44 - Styles come to seem like individual artists, the art book playing the part of an accelerated film, 46 - Reproduction is bringing before us, for the first time, the whole world's art, 46.

III. — This heritage is the product of a vast metamorphosis, 47 - The Greek statues have turned white, 47 - All the remote past reaches us colorless, 49 - Why the isolated, reconstructed work of art is a monstrosity, 47-50 - Was Greek painting two-dimensional until the Vth century B.C.? 50 - Every resuscitation "filters" what it resuscitates, 53 - The universe transfigured, 54 - For many centuries painting was the most-favored form of poetic expression, 54 - Leonardo a greater poet than Ronsard, 54 - Painting, "a form of poetry made to be seen," 54 - From the pseudo-poetry of the plastic arts to the XIXth century, 56 - Mannerist poetry, 61 - Revival of the poetry of the dream, 63 - Baudelaire and Michelangelo, 65 - The basic emotions, 66 - A Titian is not a XVIth century Renoir, 67 - Time, 67 - The lapse of time disintegrates a work, but also re-integrates it, 68 - The dialogue indefeasible by Time, 69.

IV. — The effect of modern art on the composition of the existing art museum and that of the ideal art museum, 70 - From the XIth to the XVIth century western art aimed at more and more "illusionism,"

PART TWO: THE METAMORPHOSES OF APOLLO

PART THREE: THE CREATIVE PROCESS

II. — Every great artist's way of seeing conditioned by works of art, 281 - Giotto did not copy sheep but Cimabue's figures, 281 - The artist's mature work does not stem from his childhood sketches, 281 - All artists of genius begin by copying others, not by imitating nature, 281 - Prehistoric styles, developed styles, 283 - Art and visual experience, 285 - Children often artistic, but not artists; such art ends with the ending of childhood, 286 - Folk art: its style not instinctive, but traditional, 287 - Naïve art: only sixty miles (but radically different schools) separate a Polish primitive from a Russian even more than from a Breton, 291 - Rousseau the Douanier: his sketches. "My manner is the result of long years of persistent work," 293 - Séraphine of Senlis, 294 - Portrait and likeness, 294.

The homage paid to Nature by great artists, e.g. Chardin, Corot, 295 - But Daumier "could not draw from nature" and Corot had to finish his pictures in his studio, 296 - Accuracy in art, 297 - Nature as visualized by the Impressionists, 298 - Unlike the classicists, their way of seeing, far from inviting the spectator's assent, disclaimed it, 298 - The Byzantines did not see men in the semblance of ikons, nor does Braque see fruit-dishes in fragments, 299. Types of realism, 299 - There is no absolute realism; only realistic readjustments of existing styles, 301 - Photography realistic only when it pays no heed to art, 302 - Submission to nature (and to instinct) is overruled, in the case of the great artist, by his will to style, 302.

The myth of "the great medieval craftsman," guided by instinct and a humble copyist of all God's works, 303 - The sponsors of instinct-guided art fall back on the art of savages, 307 - The bronze-workers of the Steppes, 308 - For us the artist is a creator of forms; the artisan their copyist, 310 - The artist builds up his forms from other forms; the raw material of an art that is emerging is never life, but an art preceding it, 311.

III. — Every artist starts off with the pastiche, 312 - The artist, "prisoner of a style," 314 - All compositional design is that of a school or a new creation; there is no such thing as a *neutral style*, 316 - Does the artist, anyhow, *choose* his masters? 316 - Those who affect him so strongly as to lead him to imitate them do not so much please him as *fascinate* him, 317 - Vocation and freedom of choice, 317 - Harlequins and fruit-dishes in Japan, 319 - The discovery of painting as a world quite other than the real world, 319 - Style and significance, 320 - Michelangelo's *Last Judgment*, 324 - Representation, a means to style, 333 - Every great style a reduction of the Cosmos to Man's measure, an arrangement of the visible world orienting him towards one of its essential parts, 334 - The great artist achieves his own style by starting out from one of the forms the world has assumed in the hands of one of his recent predecessors, 334.

PART FOUR: AFTERMATH OF THE ABSOLUTE

LIST OF ILLUSTRATIONS

NOTE: It has not been feasible to reproduce the color illustrations in this paperback edition, and they have accordingly been converted to black and white. The list of regular black and white text illustrations follows on page 655.

LIST OF TEXT ILLUSTRATIONS

655

656

657

661